THE
GRAND
TOUR

HIPHOTELS

Published by **HIP** HOTELS
Copyright © HIP Media Group LTD
HIP HOTELS is a registered trademark of HIP Media Group LTD

Project Coordinator: Gianpaolo Alfano

Text and storytelling: Fiorenza Lago

Layout: Herbert Ypma

Photography: Herbert Ypma, Emanuele Rambaldi

Design: Iana Ianakieva, Nick Otway

Printed and bound in Italy

A catalogue record for this book is available from the British Library

ISBN 978-0-9935577-0-5

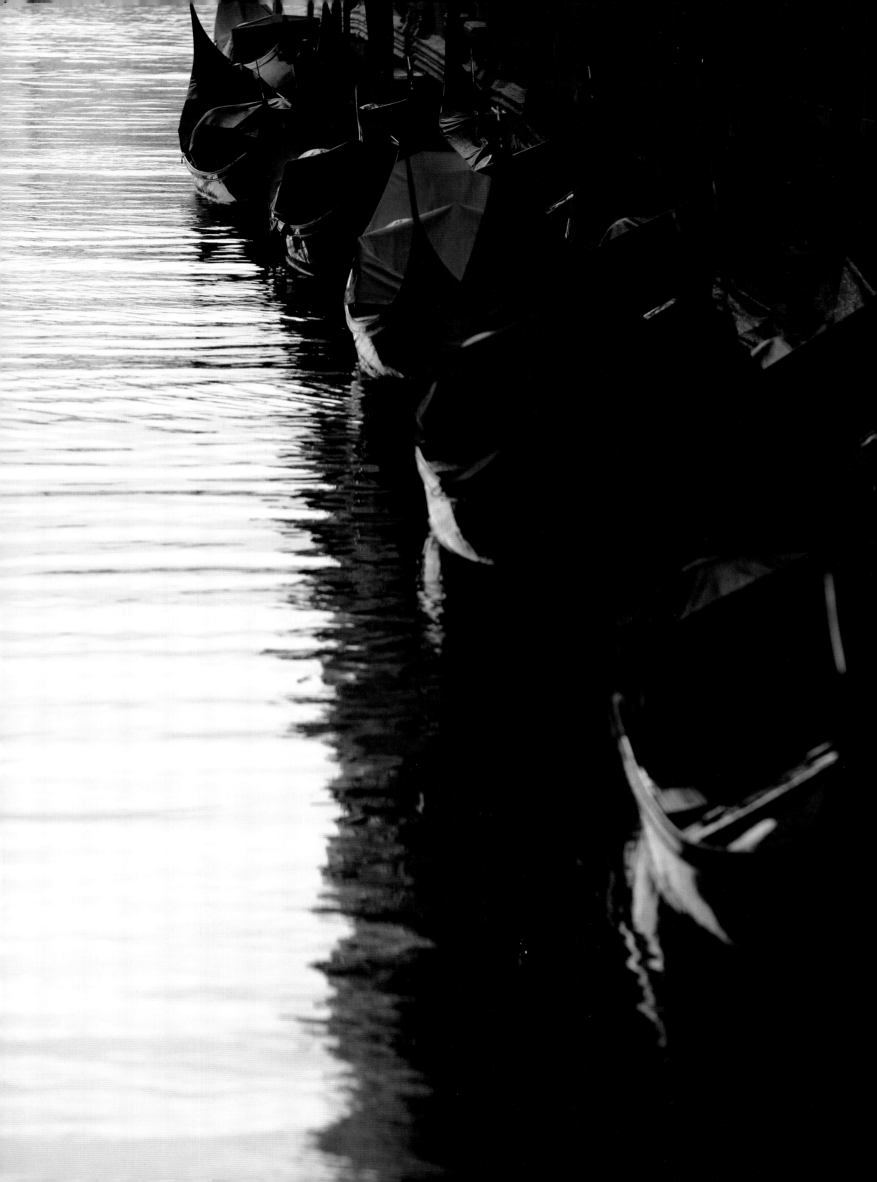

Hotel Armentarola Hotel Ambra

Grand Hotel Charming VENETO
Tre Rose DD 724 & 727
Bulgari Ca'Maria Adele Dei Dogi
Grand Hotel Novecento Villa Pisani
et de Milan Palazzina historical
Milanescala Relais Villa Bella TRIESTE
LOMBARDIA The Gentleman

La Villa EMILIA STRAF of Verona
PIEMONTE ROMAGNA
Relais Palazzo Viviani

TOSCANA Castello
di Vicarello al Colle Borgo
Locanda Pieve
*Villa Armena
Gallery Hotel Arts Mai
Hotel Continental Casa Roy
Riva Lofts UMBRIA
Sopra no Borgo di Carpiano
Sina Castello di Petroia
Argentario LAZIO Eremito Seneca
Palazzo Maestà
Corte della Maestà
Babuino 181 Castelluccia
Casa Montani Locarno dei
Hotel de Russie Mario 3 & 4 PUGLIA Masseria Alchimia
Margutta 54 Fiori Masseria
AMALFI Masseria Montelauro
Casa Angelina Masseria Prosperi
Capri COAST BASILICATA Sextanto
Palace Grand Hotel le Notte della
Hotel & Spa Villa della
Convento Giulia
Sassi Hotel

L'Agnata di
De André Faro Capo
Spartivento EOLIE
SARDEGNA Hotel Signum

SICILY Casa Talia
Hotel Gutkowski
Masseria Susafa
Monaci delle
Terre Nere
Villa Neri
Villa Ducale

I am extremely proud to present a contemporary HIP Hotels concept, perfectly interpreted in this first book of the new HIP series.

HIP Hotels proposes a distinct way of travelling that draws inspiration from the famous Grand Tour and is presented in a new, enriching manner.

Our travel and experiential platform serves as a guide for an unforgettable journey where unique places will generate emotions and desires to live life at its fullest.

Equally unique are the hotels that were selected by HIP Hotels for The Grand Tour, all according to a new way of spending invaluable free time dedicated to 'experiencing' these destinations in all their essence, philosophy, history and beauty.

The HIP Hotels Grand Tour should inspire and become an invaluable travel companion or a unique window on the world in the making.

RAFFAELE COSTA
HIP HOTELS CHAIRMAN

CONTENTS

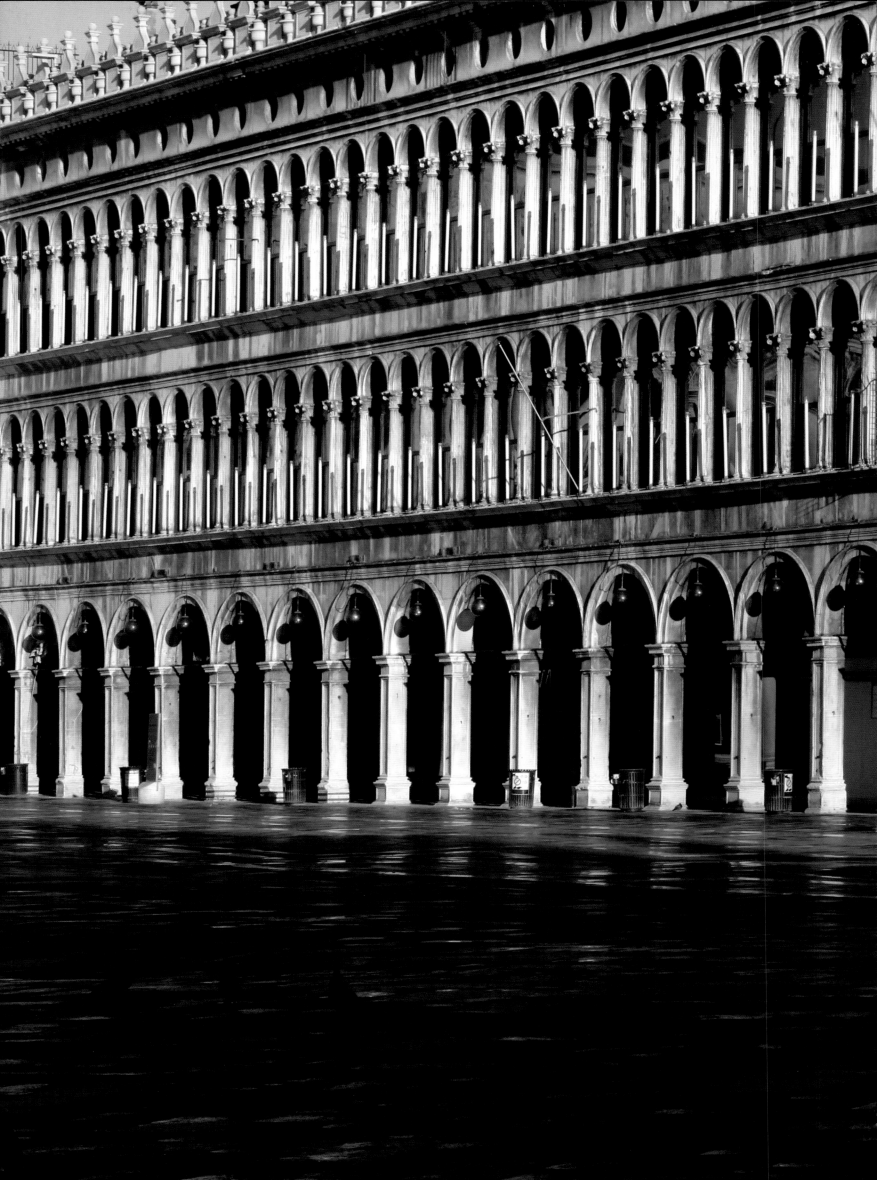

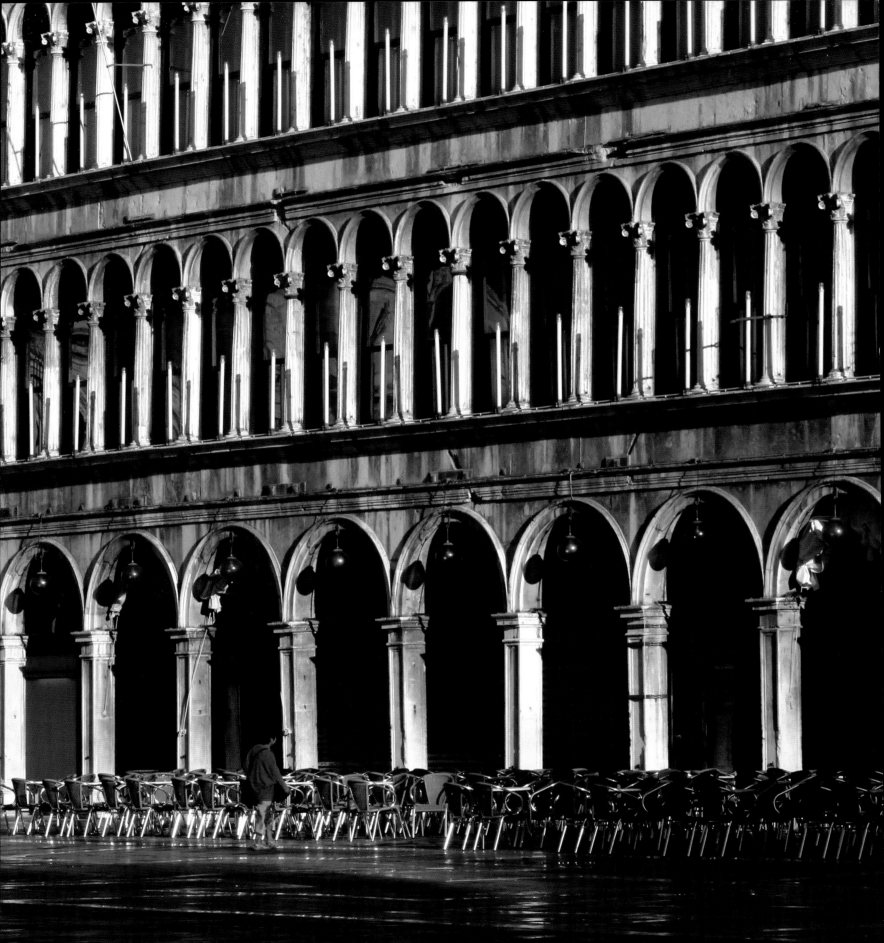

FOREWORD

Infinite books and rivers of ink have flowed to explain the extraordinary beauty of Italy and The Grand Tour, which celebrated the richness of this invaluable country for hundreds of years. Indeed, the expression 'Grand Tour' seems to have first appeared in 1697 in Richard Lassels' book *A Voyage Through Italy*, where Lassels recounted Italy's undying love affair with creativity, craftsmanship, science, art and culture. Soon after, The Grand Tour became a romantic rite of passage and indispensable tour for young aristocrats with European aspirations. The landscape and culture of Italy has always provided an abundance of revolutionary experiences from which noblemen returned the most knowledgable and impeccable of creatures.

Italy has provided a mix of pastoral, glamorous, therapeutic and saturnine connotations; it is a 'sentimental' country and has always been so. From Stendhal who commented 'My God, how well I've done to come to Italy!'[1] to Carlo Levi who noted 'a journey in Italy, transposed and crystallised around figures that make the fleeting encounter of things and their fragile, multiform spell into something lasting'[2], Italy has always brought its visitors to the limits of Romanticism.

From the Roman era to the Renaissance to the 21st century, Italy has provided the world with 'legends' in architecture from Da Vinci to Palladio and from Michelangelo to Renzo Piano, in art with the likes of Tiziano, Tintoretto and Botticelli, in fashion with Salvatore Ferragamo, Gucci, Miuccia Prada and Roberto Cavalli, to name but a few. Italy is a treasure of all things beautiful.

Here at HIP Hotels, we wanted to take our traveller on a different Grand Tour, on an inspirational journey through Italy's most individual hotels scattered all over the peninsula, all whilst letting our readers discover the myriad of culture that there is to learn from every corner of this great country. We unpacked Italy from the highest tip of the *Dolomites* to the most remote caves of *Matera*, so that you may travel from the stars to the stones, from the sea to the mountains, from the city to the countryside. This book is a celebration of Italy's hidden gems, of its entrepreneurial spirit, of its majestic and idyllic natural beauty and infinite history so that you may experience it firsthand. Living, breathing, sleeping and admiring the Italy that has inspired travellers to visit her for centuries. This is what this book is all about: the glorious beauty of Italy.

[1] Stendhal, *Rome, Naples and Florence* (Paris, 1865) p.368
[2] Carlo Levi *Roma, Napoli e Firenze di Stendhal* in *Prima e dopo le parole: scritti e discorsi sulla letteratura* (Rome, 2001) p.135

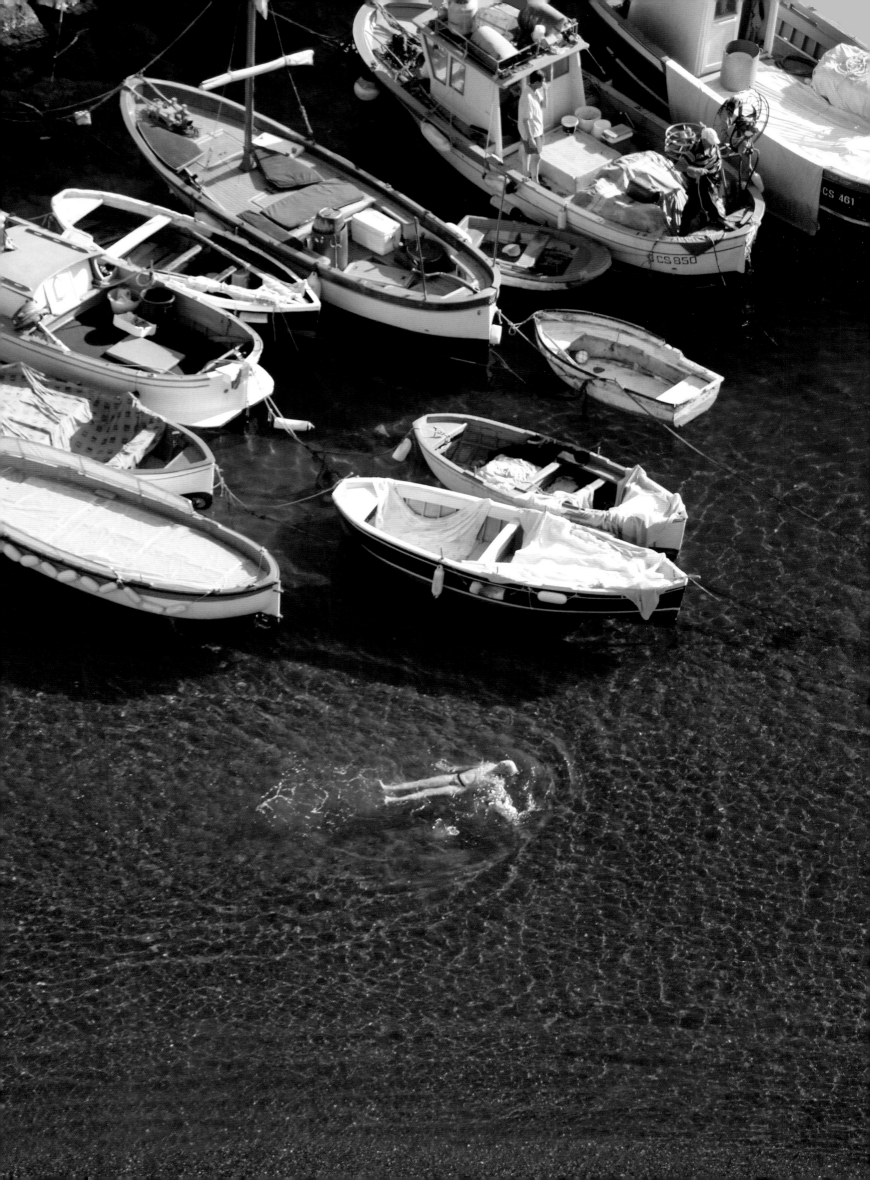

AMALFI COAST

Colour inspiration: This is an area flooded with vivid colours, towns nestled like jewels on the coast, charming houses reflecting in the deep blue sea, the incredible lush greenery, the bright yellow lemons, the passionate traditions when cooking, the strong sweetness of chilled limoncello on warm summer evenings, the lights like stars illuminating the coast at night.

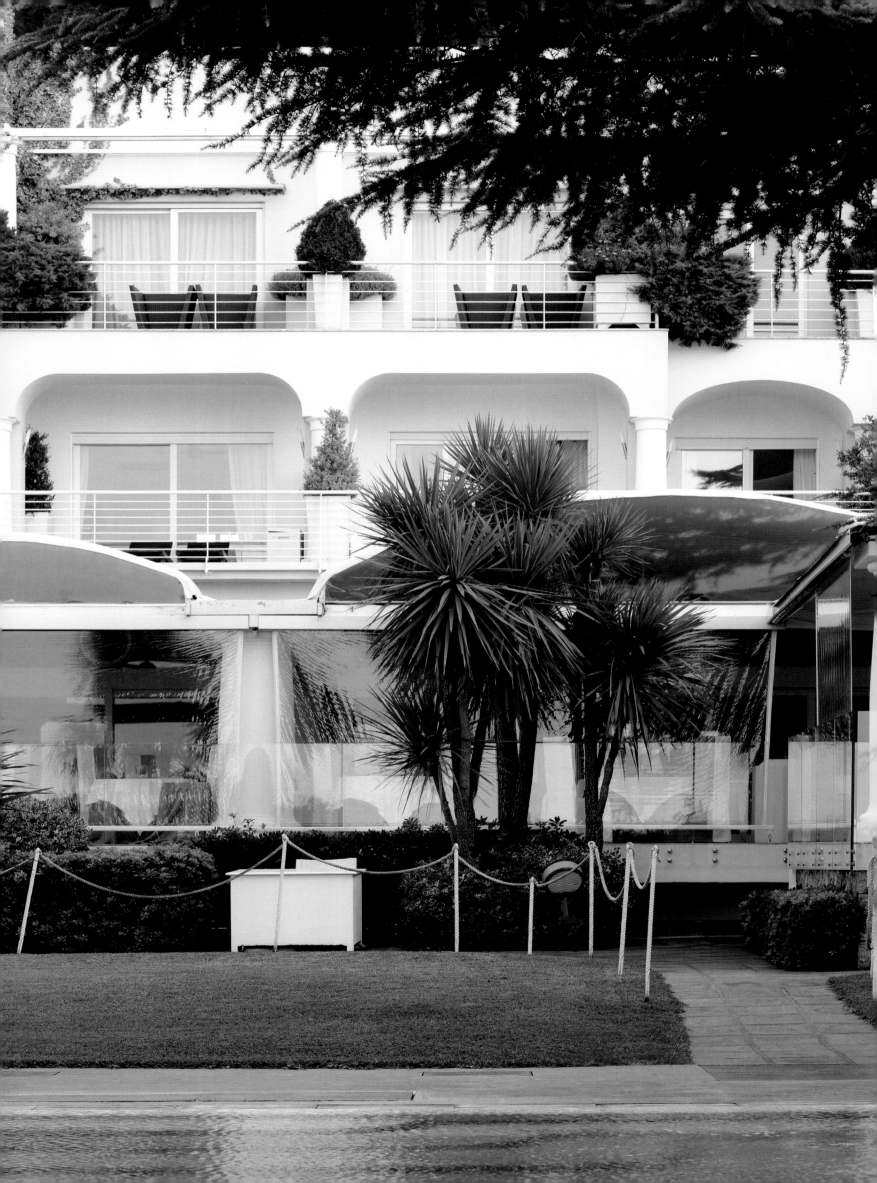

CAPRI PALACE
HOTEL & SPA

*'The island of Capri reminded me of a cloud. It was a silver stain above the expanse of limitless blue sea
and sky. An air of unreality hung over the place.'*
Norman Douglas, *South Wind*

'The most exclusive residence on the island', this is how this majestic hotel is known to locals and visitors alike. *Capri* is perhaps the most glamorous and picturesque island, located just south from the *Golfo di Napoli*. One of the first resorts in Italy, it has been popular since Roman times, when Augustus built temples, villas, aqueducts and private gardens to enjoy this corner of paradise. Tiberius also built his villa, Jovis, on *Capri*, and is today one of the best-preserved Roman villas in the country.

Capri also became a prominent stop on The Grand Tour, with poets, aristocrats, writers and painters falling for the enchantment of the island in the latter half of the 19th century. The book that began the fascination for French, German and English travellers was 'The Discovery of the Blue Grotto on the Isle of Capri' by German painter and writer August Kopisch, with John Singer Sargent and Frank Hyde also choosing this mystical island for their artistic inspiration. During the 20th century, *Capri* continued to be highly rated by the jet set of the time with Liz Taylor, Grace Kelly, Charlie Chaplin, Faye Dunaway and Jacqueline Kennedy strolling along *Via Vittorio Emanuele*, to name but a few.

Today's Grand Tour traveller can enjoy the more sedate side of the island at *Anacapri*, home of the Capri Palace Hotel. Built inside an ancient Neapolitan palace from the 18th century, it still features original arches, vaults and columns transporting guests to the refined elegance of the past. Owner Tonino Cacace inherited the hotel from his father in 1975, when he was just 23 years old. The hotel, then called Europe Palace was a 4-star hotel, and with no managerial experience and a degree in art and philosophy, managing the hotel proved to be a challenge. However, Tonino soon discovered he had two key allies: philosophy and art. The first helped him 'think differently' and the second led him to the 'pursuit of beauty'. These two allies helped him develop what is one of the best hotels not only of the island but the country, today expertly managed by Ermanno Zanini.

Capri Palace Hotel can be described as a living museum, where art surrounds each room and each common area of the hotel. Creating a true art hotel, where art was everywhere, where artists even had large and bright studio workrooms, fascinated Tonino. He calls it his 'White Museum', where Velasco designed the mosaic forming the basis of the pool and Tonelli painted the rooms, drawing inspiration from Magritte and Warhol. At the entrance, Plessi has installed an old boat used to take tourists to the Blue Grotto, with monitors depicting the deep blue waves. Then there is the wonderful installation of Arnaldo Pomodoro, 'Riva dei Mari', a 40-metre artwork created for the entrance wall. As Pomodoro himself stated, it 'belongs more to the outer area than the hotel'.

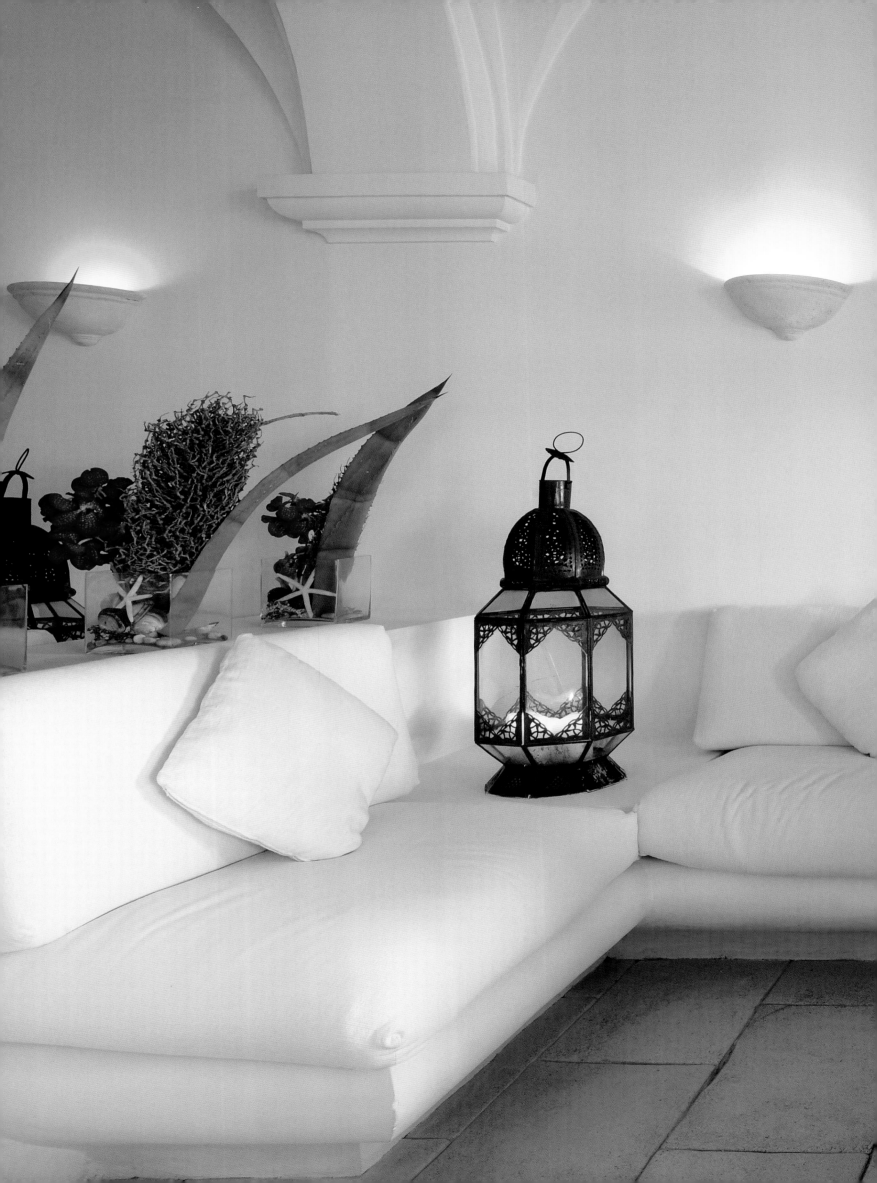

White in all its shades is the star, with white furniture dominating, leaving the Mediterranean scenery, contemporary art and beauty of this island centre stage.

The seventy three rooms are each impeccably designed, with Presidential Suite Paltrow, dedicated to actress Gwyneth Paltrow, combining art deco style with authentic antique furniture. What marvels most of all is the terrace and garden, surrounded by the beauty of the island, where there is a 360-degree view of the village of *Anacapri*, the island of *Ischia* and the fairytale-like bay of *Naples*. The main bedroom also features a magical ceiling window, where you can fall asleep in the arms of Morpheus admiring the *Capri* stars and moon.

The spa at Capri Palace is a must-visit destination. Expertly led by Professor Francesco Canonaco since 1995, his Capri Beauty Farm has the objective of putting together paths to bring the body to its peak physical and mental wellbeing. What is most innovative is its 'Leg School'; a methodology formulated and patented by Professor Canonaco which is a unique treatment exclusive to Capri Palace Hotel that aids in vascular insufficiency.

The restaurants at Capri Palace Hotel are nothing less than you would expect. L'Olivo is the only restaurant on the island to boast two coveted Michelin stars. Expertly led by Chef Andrea Migliaccio, he blends traditional flavours of the *Campania* region in a modern fashion. Facing the sea and the pool, with scattered works of art, white furniture and impeccable service, this restaurant provides a true Mediterranean feeling. Last but not least is the famous Il Riccio, the hotel's own beach club and restaurant, which boasts a Michelin star. Perched on a terrace near the *Blue Grotto*, the restaurant is decorated in fresh tones of blue and white, with the open view kitchen decorated in majolica tiles from *Vietri*. There is nothing more magical than to enjoy a platter of raw fish or a grilled lobster and spaghetti with venus clams, enjoying the sunset over what is the most magical bay in the world.

Capri Palace Hotel & Spa is a place of dreams, harmony, art, splendid food, good wine and wellbeing – a must-visit hotel.

White is the colour that dominates, in perfect contrast to the blue of the sea that blends with the turquoise of the sky, in a game of natural chromotherapy.

The beautiful, colourful sculptures in Murano glass by renowned artist Alfredo Sosabravo interrupt the perfection of white, almost as if they want to bring inside the powerful colours of nature. The design elements of the furniture are light and strike a contrast with the bold paintings of Patricia Carstens that adorn the walls.

It is also white that gives a chic and fashionable charm to the rooms, that each have magical terraces that open onto a panorama that is bound to take each guest's breathe away.

At the foot of Casa Angelina, old fishermen's houses have been knowledgably transformed into the Eusada Experience, suites that open onto the enchanted *Baia di Gavitella*, a bay of crystalline blue water.

After a day exploring these wonderful places or an afternoon spent basking in the sunshine by the infinity pool overlooking the sea, an aperitivo is a must on the terrace of the Marrakech Bar, whilst anxiously waiting for the sunset to unfold. Dinner is then served in the 'blu dipinto di blu', on the fourth floor where another terrace houses Un Piano dal Cielo (literally 'a floor away from the sky'), this appropriately named restaurant brings to its guests traditional delicacies and wines of excellent quality that are synonymous with this land.

Under the stars, in front of the sea of the *Amalfi Coast* 'per qualche tempo non sarete capaci di vedere altro' ('for a while you will not be able to admire anything else'). Indeed, you will have been bewitched by the enchantment of Casa Angelina.

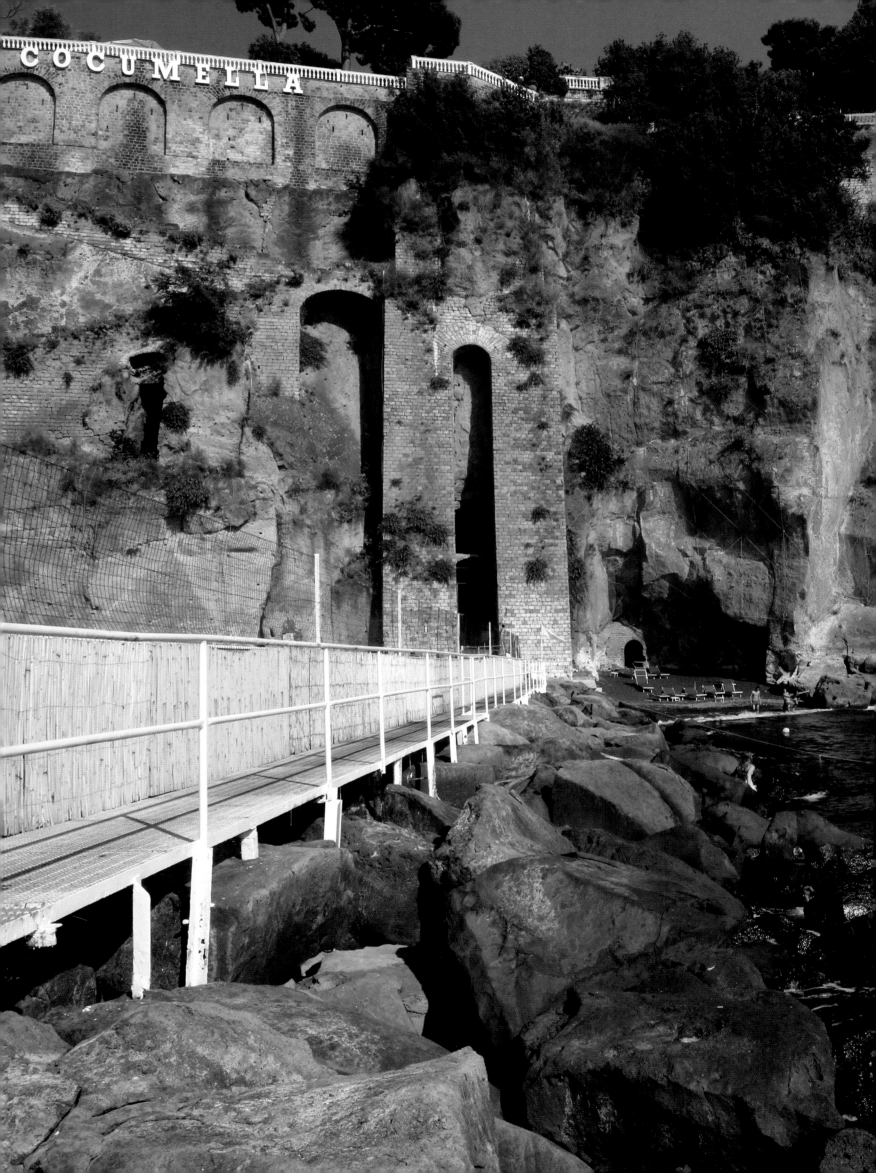

GRAND HOTEL COCUMELLA

'vide 'o mare de Surriento,
che tesoro tene funno:
chi ha girato tutto 'munno
non l'ha visto como ca'
Torna a Surriento, canzone in Napoletano,
di E. De Curtis, G.B. De Curtis, A. Mazzucchi

'Look at the sea of Sorrento
the buried treasure it has!
those who travelled all over the world
have never seen anything like it!'
Torna a Surriento, song in Neapolitan,
by E. De Curtis, G.B. De Curtis, A. Mazzucchi

Sorrento is what can be defined as a whirlwind of emotions: the beauty of the location, the richness in its art, the history that goes back centuries, the nature that offers enchanting colours such as the deep blue of the sea that blends with the sky and with the different shades of the houses. One can breathe in all this majesty – an incredible, natural chromotherapy.

'Vide 'o mare quant'è bello spira tanto sentimento. Guarda, guarda ca chistu giardino: siente, siè sti sciure arance, un profumo accussi fino intau core se ne va'… This song has become the very essence of Sorrento describing its gardens, its sea and the passions it inspires, and has been sung by the most famous singers in the world including Luciano Pavarotti. Close your eyes and you will be transported to the life of this ancient city; open them and you will want to pack your bags and go there!

Legend recounts that mermaids seduced Ulysses with their songs on these cliffs, and from here comes the name 'Sorrento'. Perhaps this legend is true, as the mermaids of Sorrento will certainly seduce the most disenchanted traveller. Its mild climate made Sorrento a favourite choice for emperors and roman aristocrats from the Imperial age, and *Villa Pollio Felice* pays witness to those days.

Sorrento has been a favourite stop on The Grand Tour, with Keats, Lord Byron, Goethe, Ibsen and Wagner, to name but a few, stopping to admire the allure of this area.

Grand Hotel Cocumella is undoubtedly part of the vast history and lives of the famous people that have stepped onto the shores of Sorrento. This is a luxurious residence, a few steps away from the small town of *Sant'Agnello*, with utterly breathtaking views. The doors of Grand Hotel Cocumella open onto a postcard-perfect scenery, where the bay takes on different colours as the day passes, culminating at night with the view of all the lights of the *Costiera Amalfitana* lighting up the sky like thousands of twinkling stars.

Grand Hotel Cocumella is located in a former Jesuit monastery from the 1500s. The monks chose this piece of land that descended onto the sea of Sorrento as it was full of lemon and orange trees. History recounts that the Gods gave the task of looking after this orchard and its adjacent garden to the nymph Colomeide. The nymph offered a gift to all visitors that visited her garden: silence.

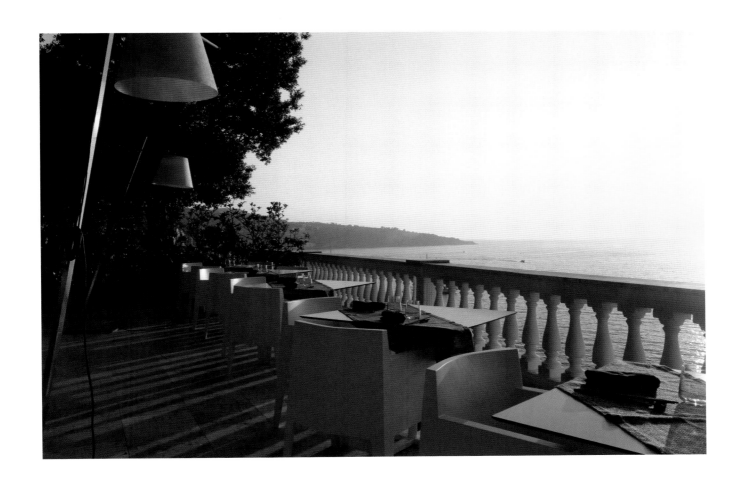

At the end of the 18ᵗʰ century the building was restored and became a hotel, where travellers would stop to enjoy the climate and relax; this was the first 'holiday hotel' on the Sorrento peninsula.

Most recently architect Nino del Papa has transformed this building into a contemporary hotel that nonetheless has maintained its ancient splendour. Together with the owner Lionello del Papa they lovingly curated this ancient and historical residence.

Many illustrious personalities have stayed in this magical hotel; from Goethe, the Duke of Wellington and Mary Shelley to Hans Christian Andersen and the famous Italian poet Alberto Moravia, who signed the jealously preserved guestbook.

The unique rooms of Grand Hotel Cocumella preserve the atmosphere of this ancient Jesuit residence, with discreet furnishings blending with a joyous Mediterranean style. Some of the suites even have an outdoor Jacuzzi on the terrace, to enjoy a relaxing bath whilst soaking up the astonishing views.

This is a hotel that must be lived 'outdoors'; from the beautiful swimming pool nestled in the greenery of the spectacular Mediterranean park to the charming private beach that can be reached by a wonderful staircase via the cliffs.

A day out at sea can be enjoyed aboard Vera, the hotel's ancient sailing ship which dates from 1880, where a dive out into the deep blue can be enjoyed in a truly fairytale setting.

At sunset an aperitivo cannot be missed on the terrace of Coku, which in the evening is transformed into an eclectic Japanese restaurant with Mediterranean fusion. Traditional flavours created with the excellent local produce can be enjoyed in the Scintilla restaurant's lush garden, which has an enviable wine list featuring local wineries.

The smell of authentic Neapolitan coffee wakes guests up in the morning, accompanied by homemade cakes and biscuits, as well as natural fruit juices and smoothies. As Sigmund Freud wrote when visiting Grand Hotel Cocumella at the beginning of 1900: 'On the silver trees the golden fruits are sparkling... Down there Naples... The setting is magnificent. It is impossible to move and seek other landscapes. Our days here are consecrated to the sea and the dolce farniente'. This dolce farniente (meaning 'pleasant idleness') absolutely has to be tried!

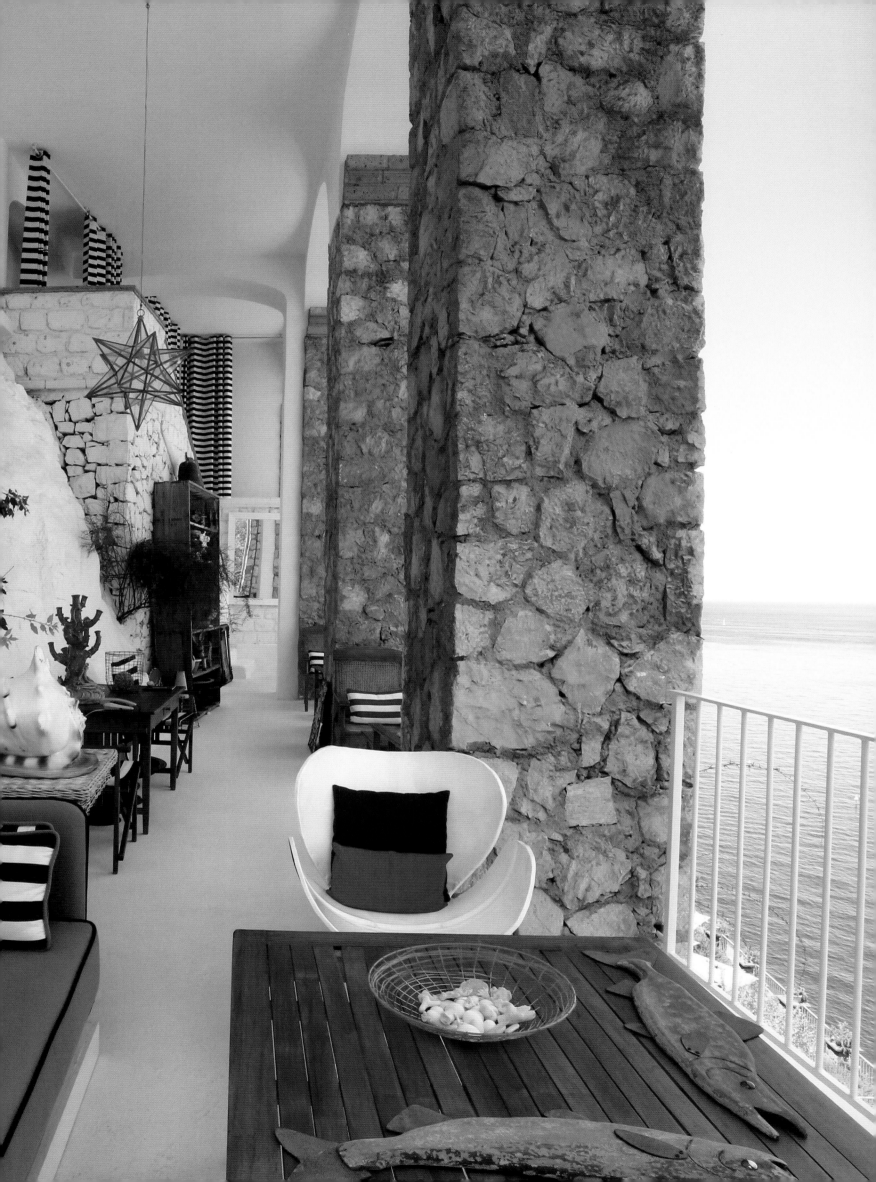

After 30 years of management by outsiders, the small hotel finally returned to the Cacace family in 2003, and an ambitious project of restoration and refurbishment commenced. This was led by Anna Cacace and her son Marco, interior designer and scenographer by profession. The result is the same colour blaze and joy that can be felt when in Sorrento. Marco says, 'Today La Minervetta has become my personal house, but also a traveller's house. There are furnishings from my family collection, memoirs from my travels. Design objects, art, ceramics from Vietri and lots of books'.

There are twelve rooms, each with a view that will leave its guests breathless, overlooking the sea and *Marina Grande*. Each one is unique, with a different colour palette and furniture pieces created for each room. The large windows flood the rooms with an extraordinary light, and the vivacious stripes brighten the rooms. The joyful and warm atmosphere is further enhanced with the choice of brightly coloured tiles on the floor and walls, creating games of symmetry that will prove hard not to constantly photograph!

La Minervetta's philosophy is all about blending modern elements with traditional essentials.

Light is the protagonist in the open-plan living room as in the cute kitchen, at the heart of the house, where every morning a delicious breakfast is served.

A small Mediterranean garden is graciously perched between the cliffs where the splendid pool is located. Swimming in the midst of greenery and sea with a view of Vesuvius has never been more appealing!

The absolute star of La Minervetta is the large terrace with an astounding view of Sorrento and its gulf, where a glass of limoncello after dinner admiring the stars that illuminate the bay is a must.

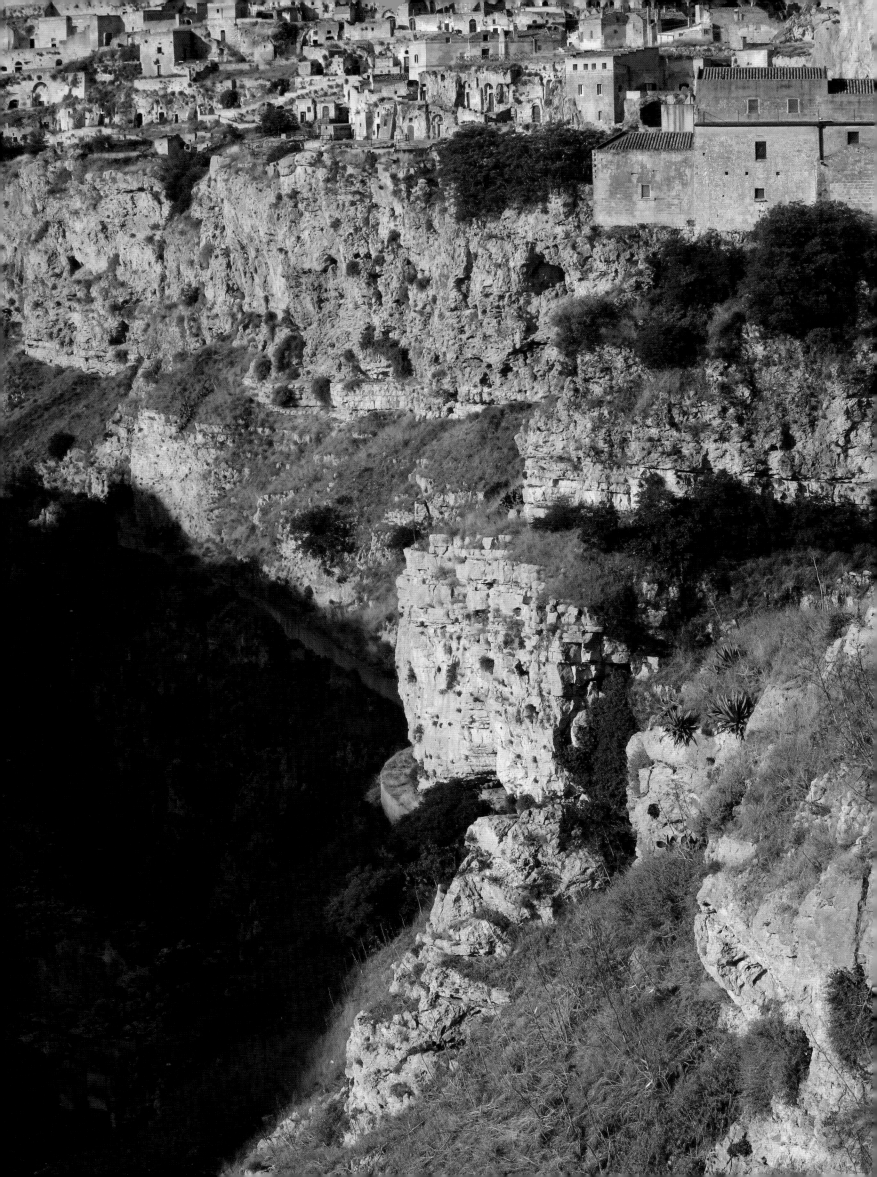

BASILICATA

Uniqueness inspiration: Matera is one of the world's most ancient cities, an incredible chapter written by man through the centuries, it holds the title of World Heritage Site by UNESCO, and will be the European capital for culture in 2019.

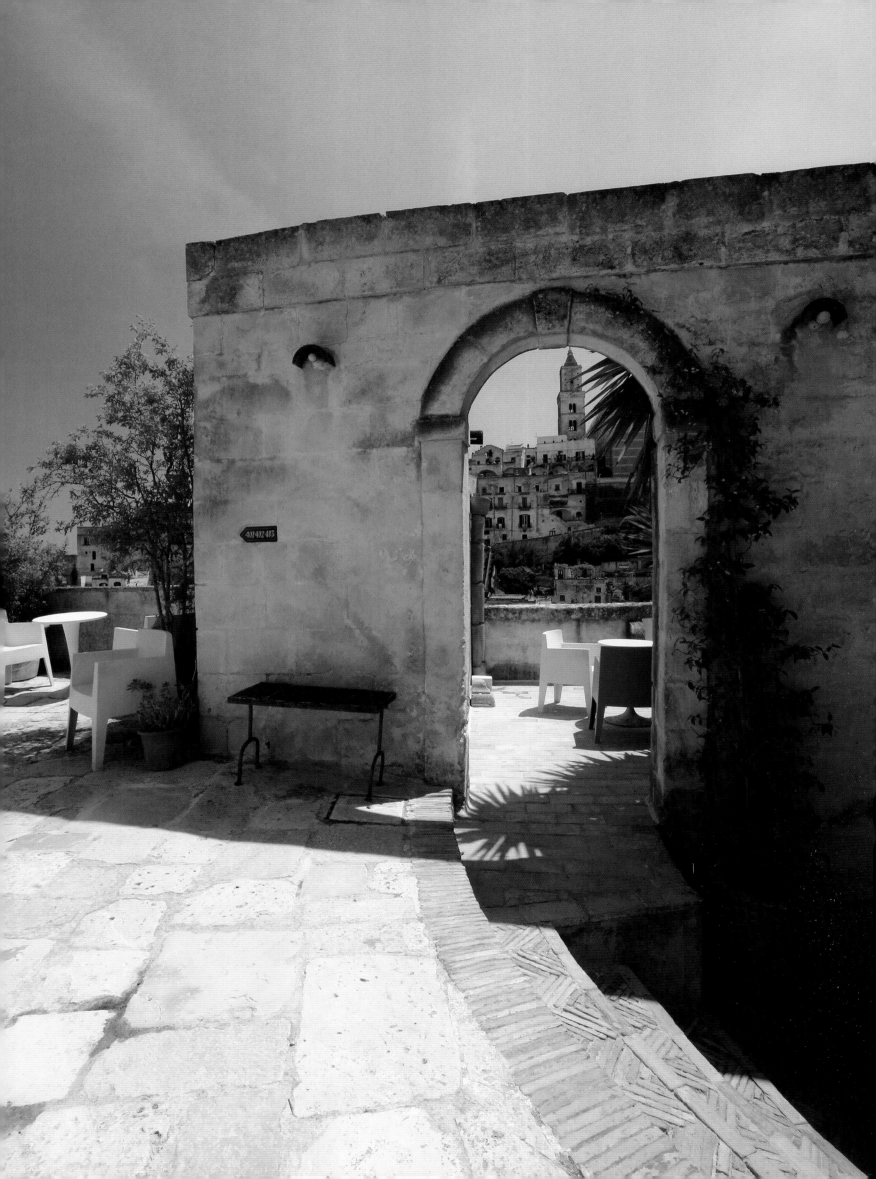

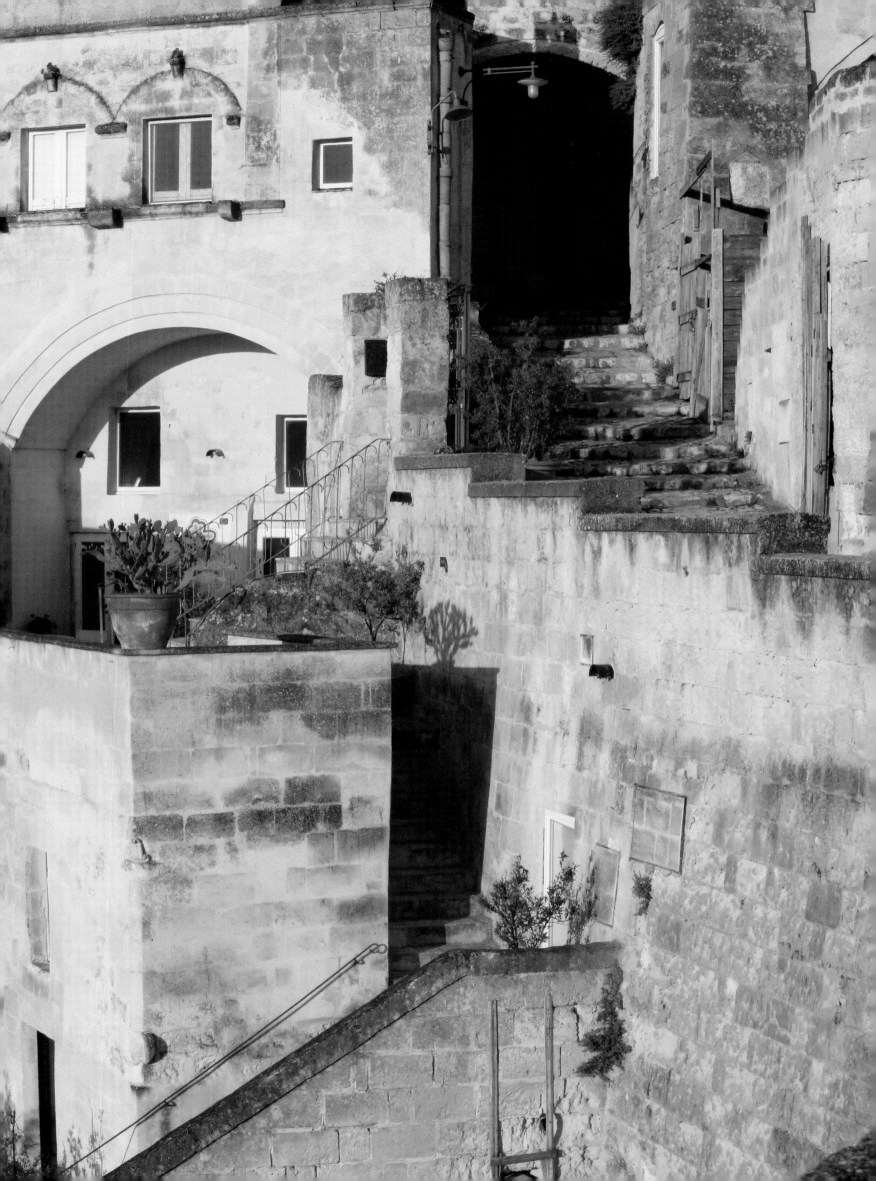

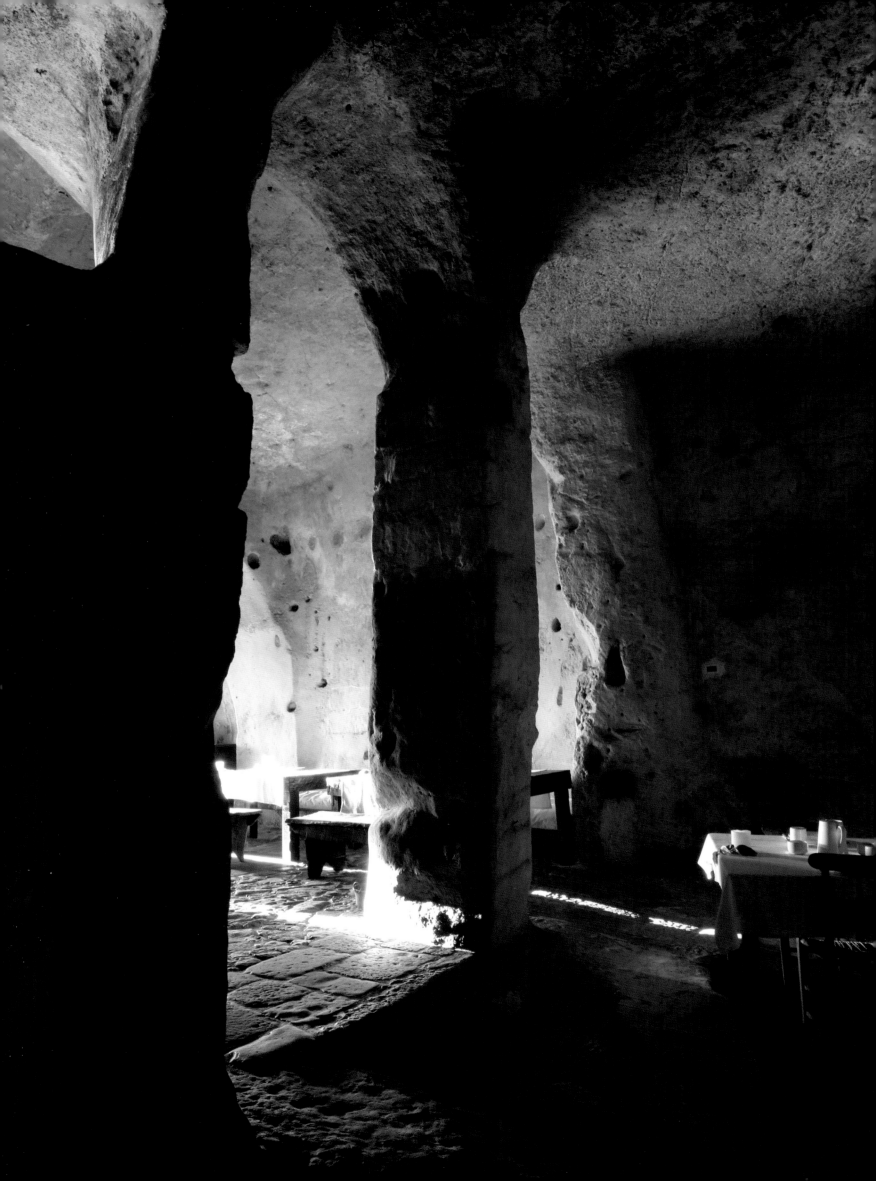

SEXTANTIO LE GROTTE DELLA CIVITA

'Questi coni rovesciati, questi imbuti, si chiamano Sassi. Hanno la forma con cui, a scuola, immaginavamo l'inferno di Dante.'
Carlo Levi, *Cristo si è fermato a Eboli*

'These upside down cones, these funnels, I learned, were called Sassi. They were like a schoolboy's idea of Dante's Inferno.'
Carlo Levi, *Christ has stopped at Eboli*

Even though 'unique place' has been over-used in travel books and location descriptions, there is not a more precise description for the town of *Matera*. Indeed there is no place like it in the world. The 'sassi' (caves) in the ancient town of *Matera* are a series of lodgings carved directly into the stone of the hill on which *Matera* is nestled and which were the homes of peasants and monks for more than 2,500 years. One of the most ancient inhabited areas of Italy since Palaeolithic times, these caves were long abandoned, with the local population choosing to move to the new town of *Matera* built close by. However, they have been a UNESCO World Heritage Site since 1993, because of their distinctiveness and link to the inextricable relationship between nature and man.

Grotte della Civita is an 'albergo diffuso', a new definition of an Italian hotel. Literally meaning 'diffused hotel', it implies that the urban planning and architecture of the original, historic site have remained untouched. Indeed, at Grotte della Civita, the lounge area of the hotel has been created from a church built inside the rock. The historic soul of the caves has been left untouched, leaving the seductive landscape and architectural beauty in full control. The rooms are scattered around an area of the town, creating a true sense of authenticity and making this a 'home away from home'. Owner, Daniele Kihlgren, found the caves in a state of complete abandon, and spent ten years doing restoration work where the original spaces were preserved yet renovated with traditional materials and minimal furnishings. Being a conservationist and philosopher at heart, he strives to preserve Italy's local heritage and breathe new life into Italy's fading past.

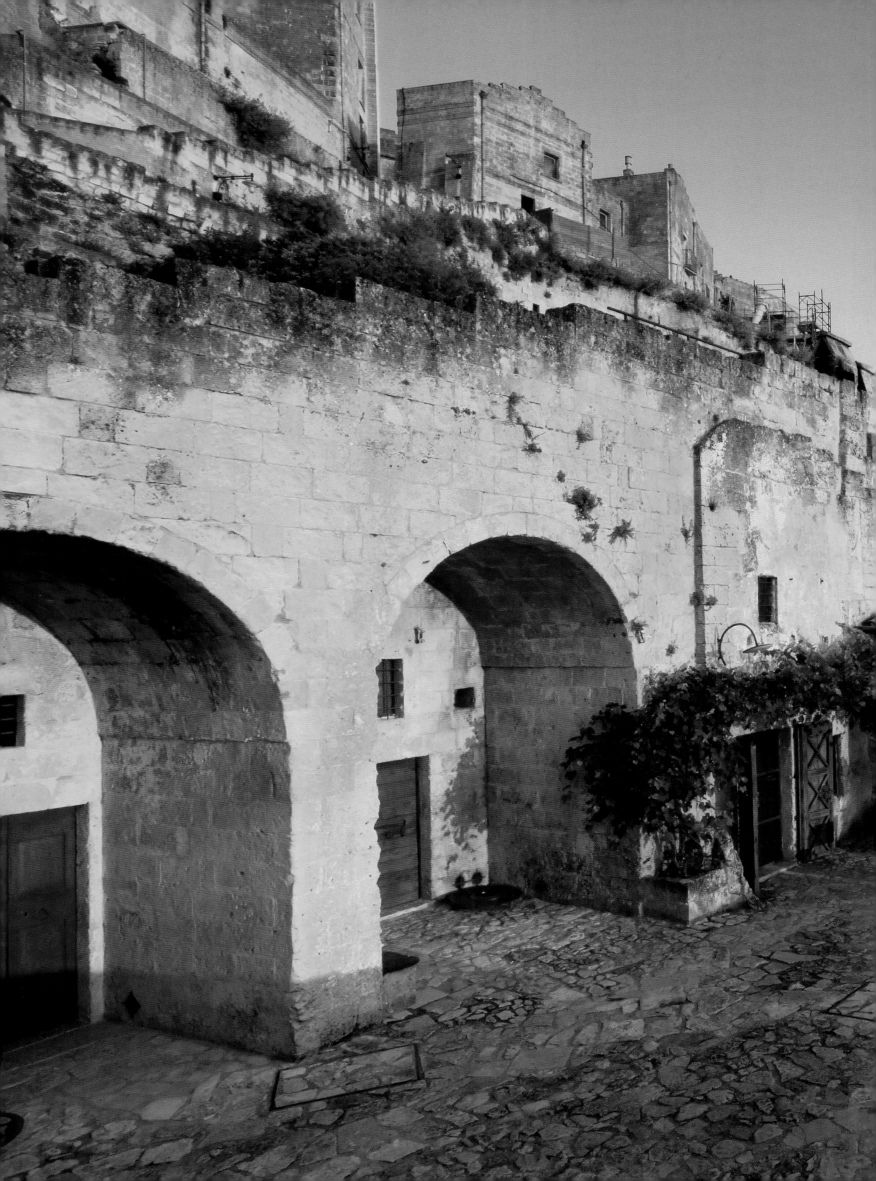

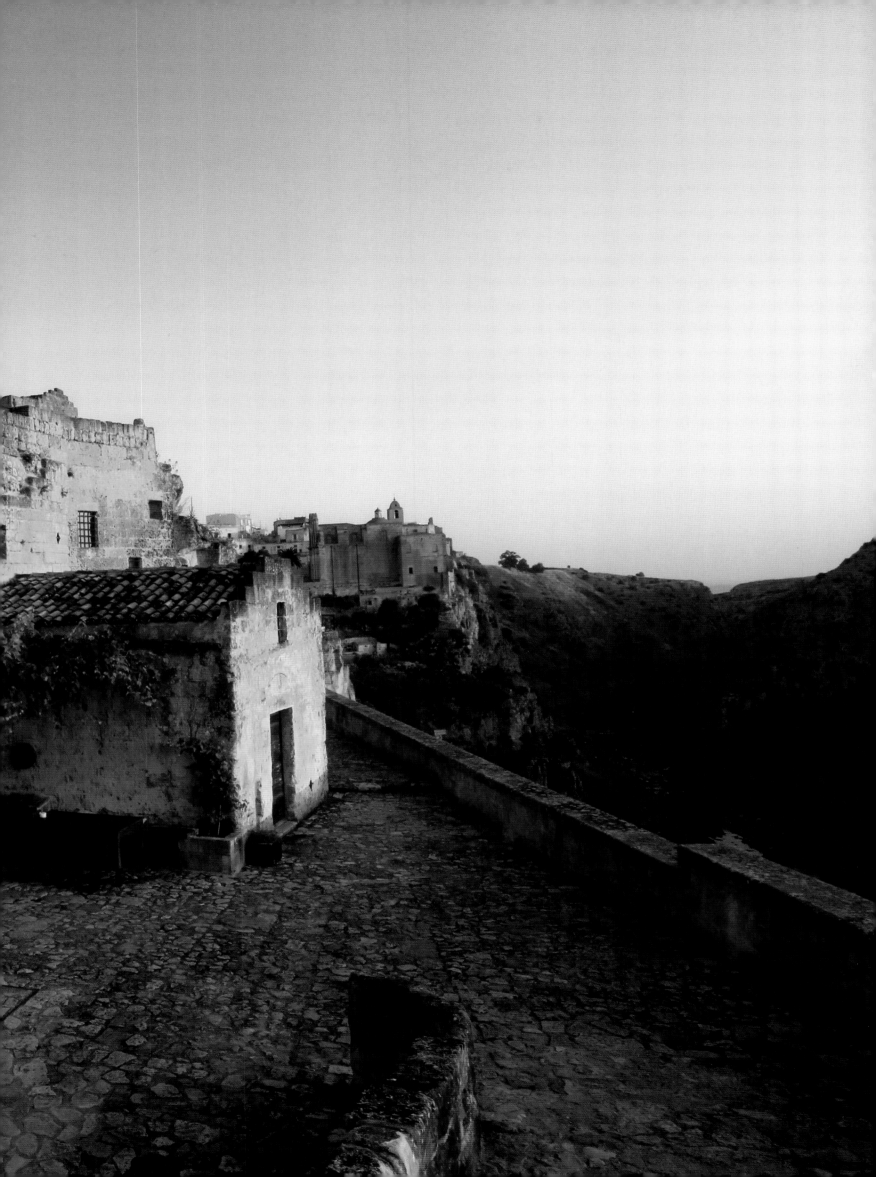

There are eighteen exquisitely designed cave-rooms at Grotte della Civita, hidden under secret passages yet full of light, facing the imposing *Parco Naturale della Murgia*. From when a guest walks into the reception, the lack of artificial light and technological accessories, with just candlelight and classical music infusing the air creates an immediate sense of calm and is instantly soothing. The rooms have been created using traditional craftsmanship to make the beds and seating. Further, original stone sinks and hand-wrought glass windows have been added as an ode to civilisations long gone. Some rooms feature enormous bathtubs, creating a sensuous and romantic experience.

For a truly magical experience the 13th century deconsecrated church can be rented for an exclusive dinner with traditional delicacies from the *Basilicata* region. An ethereal scenario awaits with the huge stone room lit solely by candlelight, classical music infusing the air and a lit fireplace to create a truly unique location. Cooking courses can also be organised in the church area, where the ancient art of handmade pasta and authentic *Lucanian* cuisine can be tried and tested.

Breakfast is also served in the cave church, with homemade cakes, marmalades, biscuits and more hailing from local organic farms and trusted artisan producers from the area; the perfect way to enjoy a typical southern Italian breakfast.

During the early evenings of your stay, an aperitivo with a glass of local wine and taralli crackers is a must, whilst relaxing on the terrace of Grotte della Civita with the dramatic views of the *Murgia Materana* blushing in the early evening sunlight.

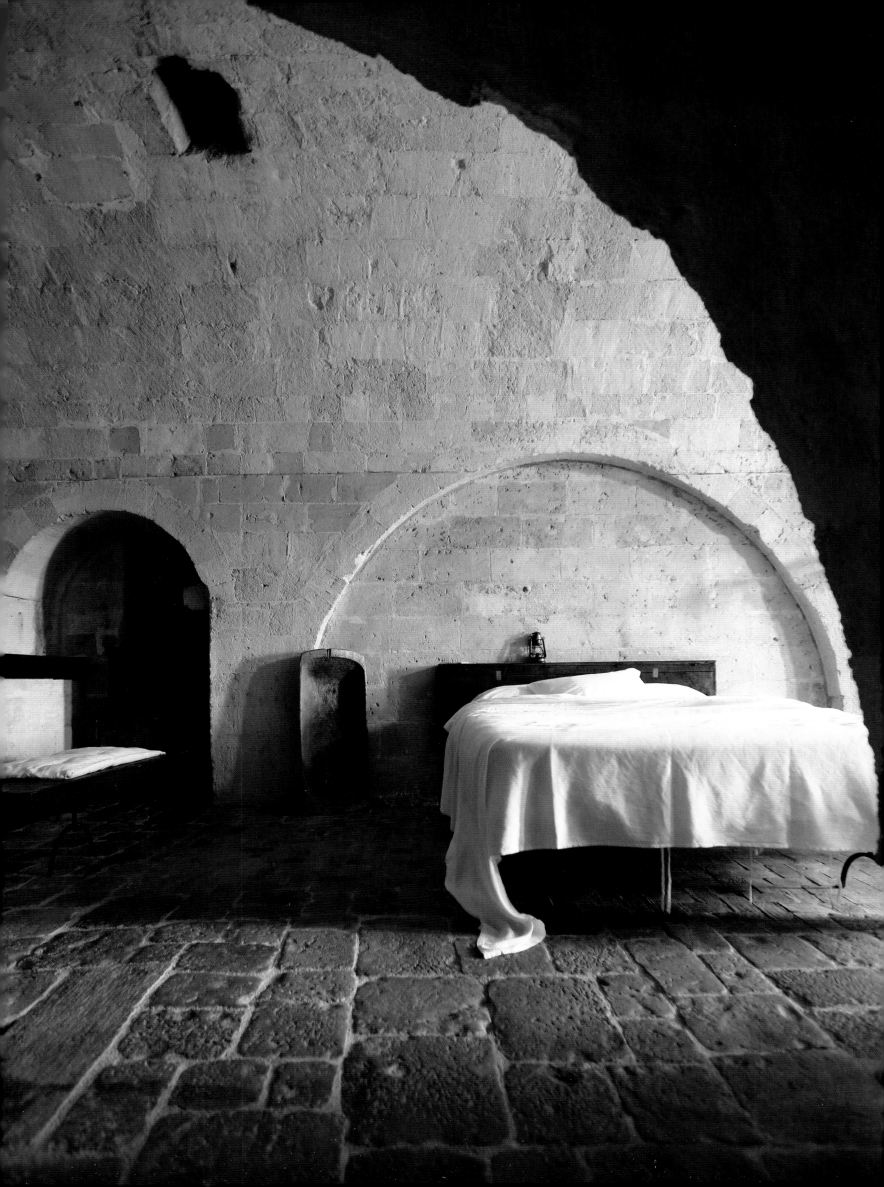

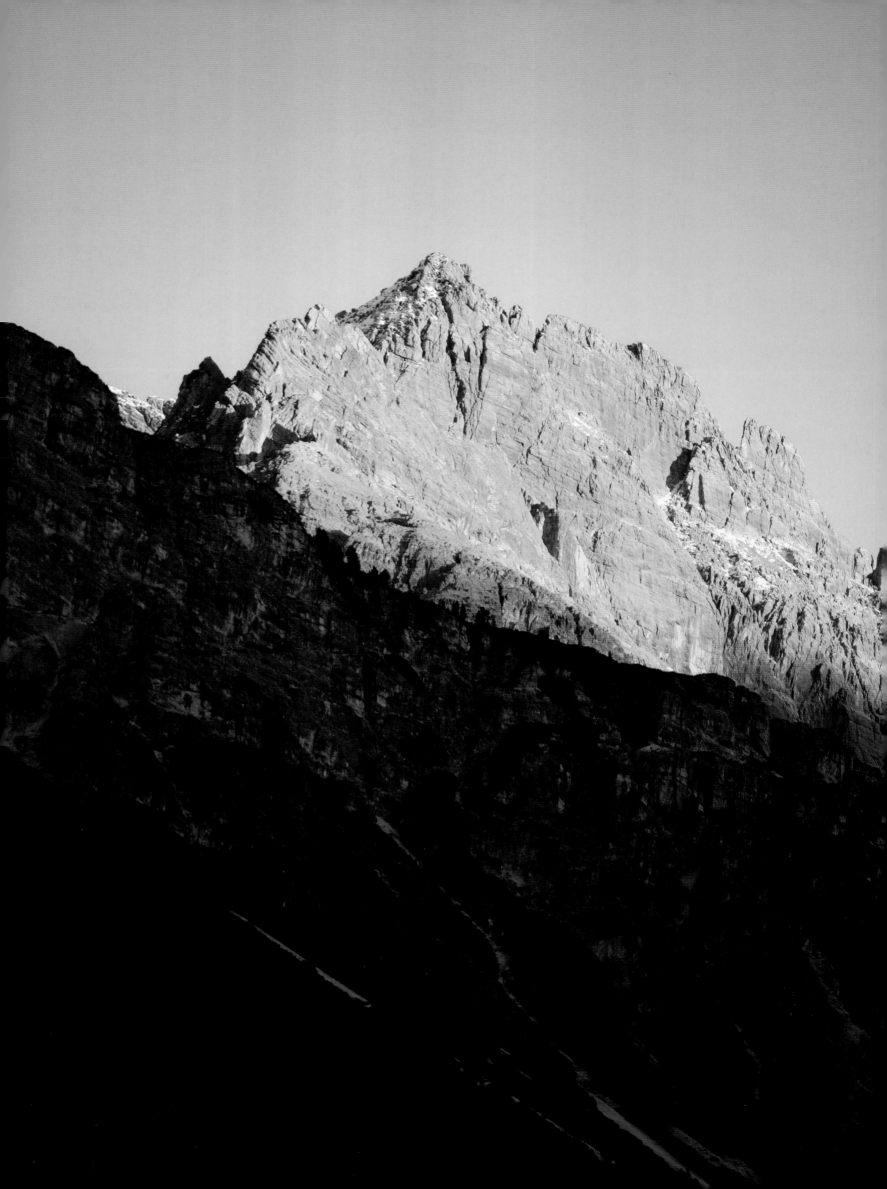

DOLOMITES

Pink inspiration: The sun at dawn and at dusk offers these mountains a myriad of pink shades from pale pink at dawn to fire red at sunset. *Le Corbusier* defined them the 'best architectural masterpiece in the world'. Enchanting in the winter, magical in the spring and sensual in the summer.

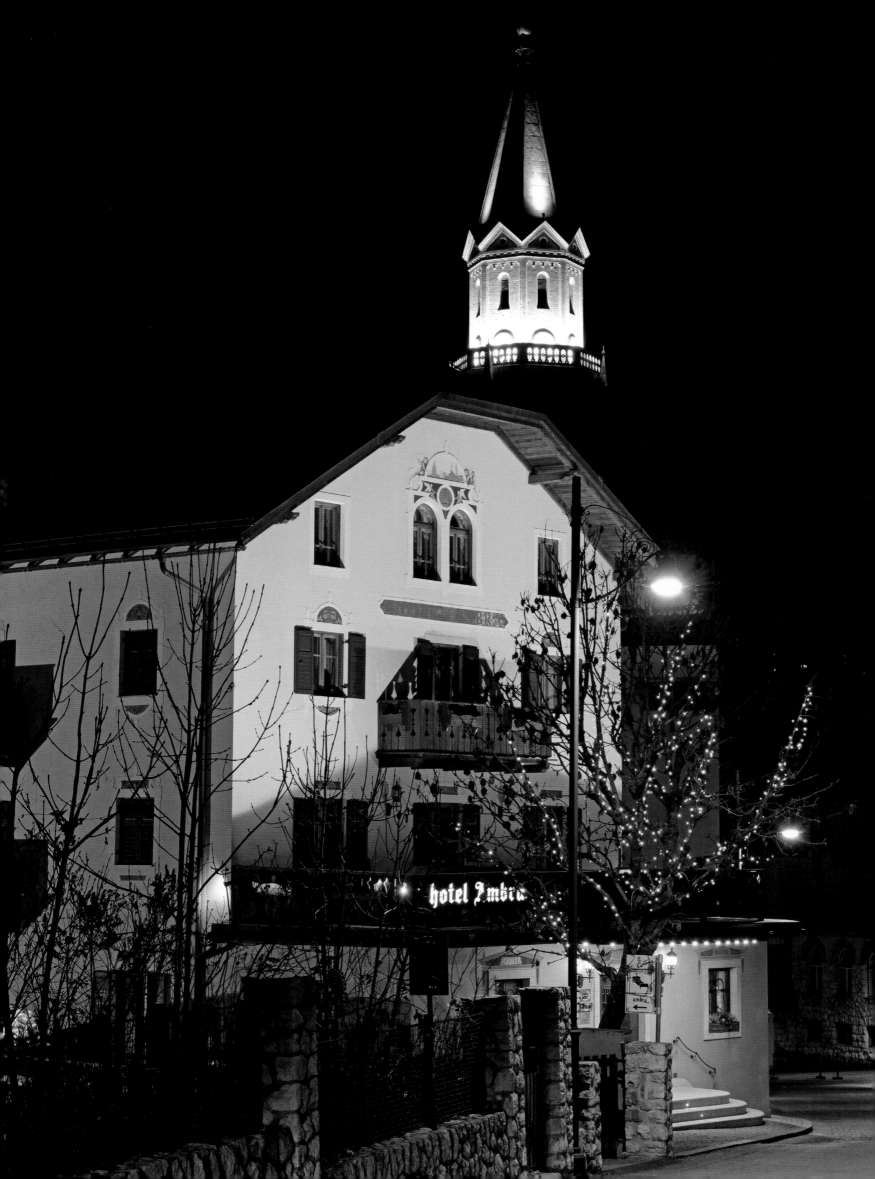

HOTEL AMBRA CORTINA

'Are not the mountains, waves and skies as much a part of me, as I of them?'
Lord Byron

ortina d'Ampezzo located in the heart of the southern *Dolomites* is undoubtedly Italy's most fashionable and chic mountain destination, and an unmissable stop on today's Grand Tour. Located at more than 1,220 metres high in the *Ampezzo* valley, this excellent mountain resort is surrounded by some of the tallest and most beautiful peaks rising from the striking wooded valleys; from the *Tofane* to the *Crystal*.

Cortina has attracted many distinguished guests, often inspiring them in their creative work. From Ernest Hemingway who wrote Out of Season in these very peaks, to one of Italy's best-loved actors Vittorio Gassman, writer Leonardo Sciascia and Nobel prize winner Saul Bellow, who all chose *Cortina* as their holiday destination.

A much coveted skiing destination, in 1956 *Cortina* hosted the Winter Olympics, and to this day has some of the most enjoyable piste skiing opportunities with breathtaking scenery. Dramatic limestone facades, cliffs and peaks that are tinged pink at dawn and flame red at dusk, surround the town.

At the heart of Cortina d'Ampezzo is one of the town's oldest hotels: Hotel Ambra Cortina. The glamorous and exceptional owner of the hotel is Elisabetta Dotto, who describes herself as Hotelier 2.0 because of her innovative approach to hospitality. Hailing from a family of hoteliers, she has spent her whole life working in the hospitality business, and with Hotel Ambra Cortina has finally fulfilled her dream of owning a gem in the 'Queen of the Dolomites', *Cortina*. Previously called Pensione Emiliana, the hotel has been passionately transformed into an art lovers' paradise that blends fashion and luxury with genuine, traditional interiors and exquisite service.

With an enviable location, just a few steps away from *Corso Italia* and from *Cortina's* bell tower, the hotel is personalised by a characteristic deep yellow facade with typical wooden balconies and decorated windows.

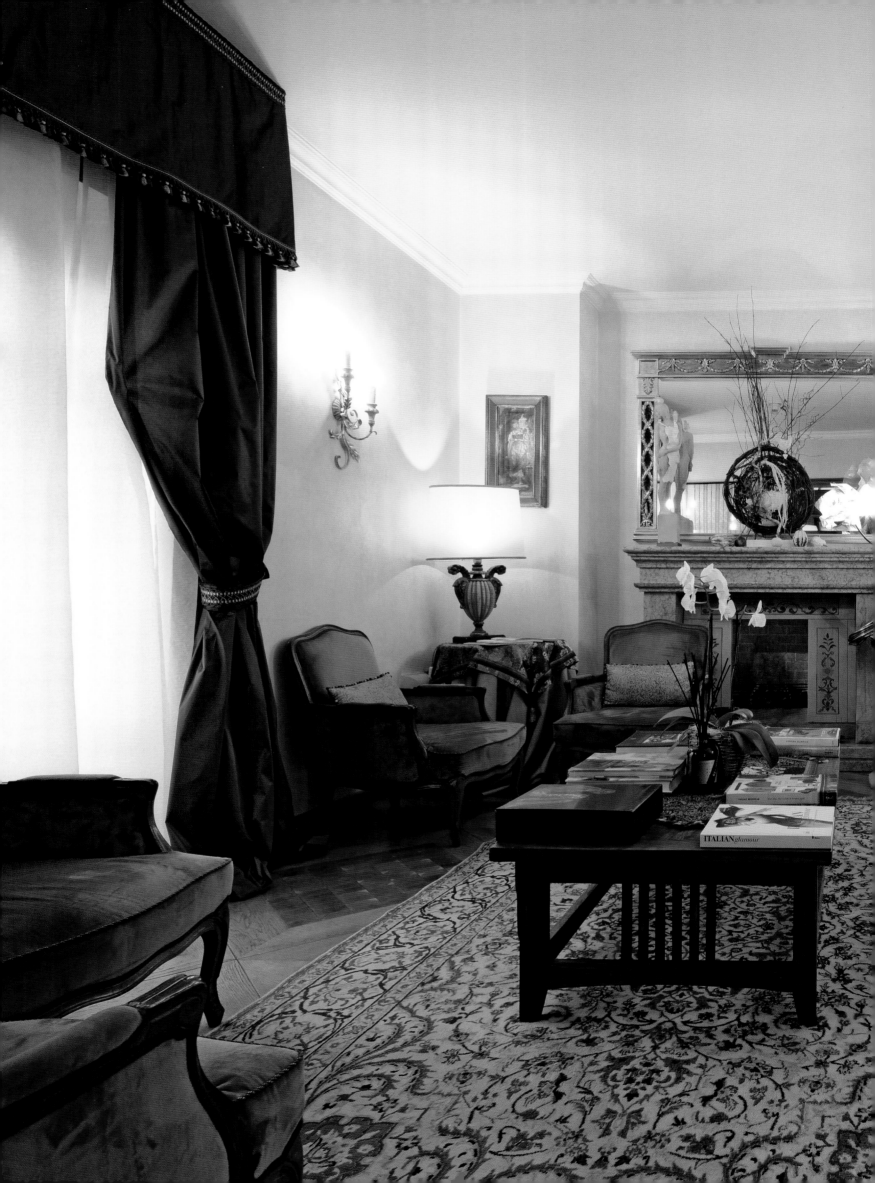

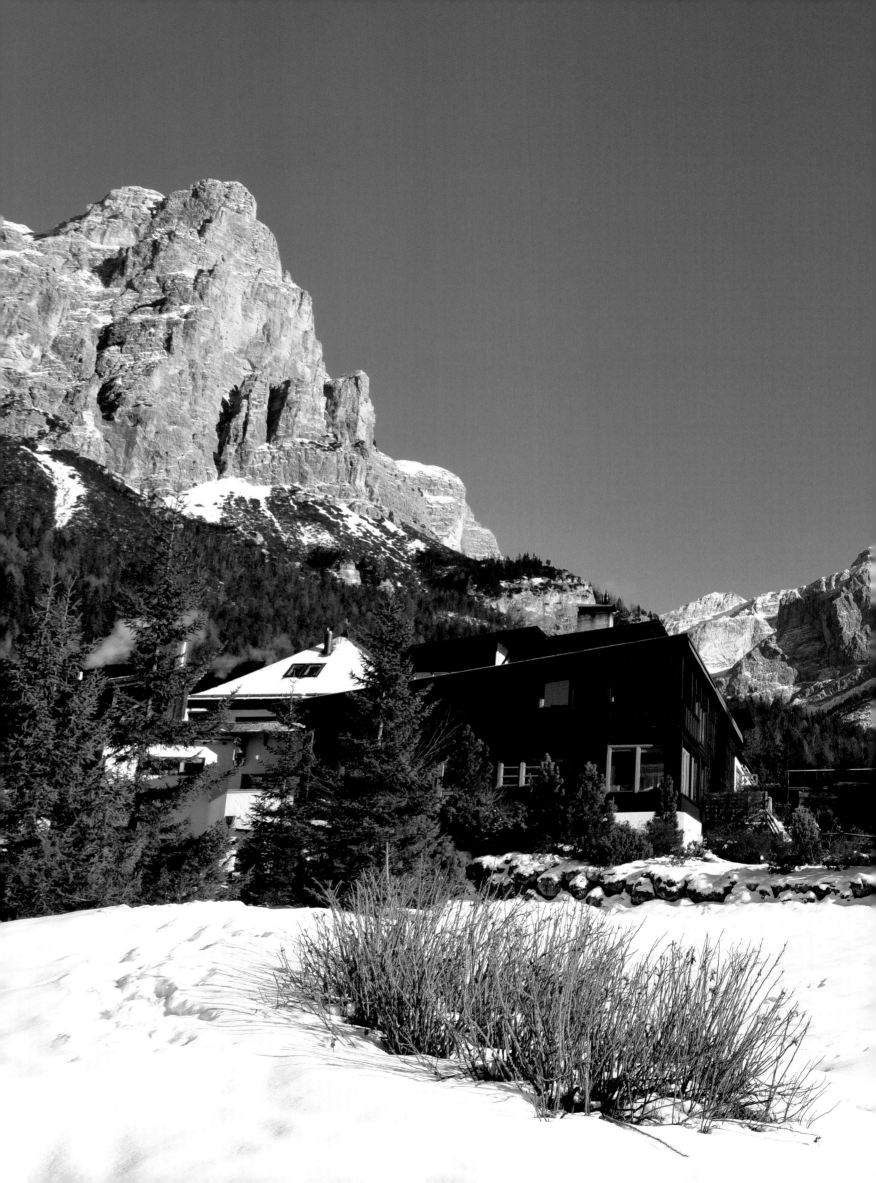

HOTEL ARMENTAROLA

'You see, the sky was so blue and everything was so green, perfumed, that I had to be part of it. The mountain was taking me higher, higher, as if she wanted me to touch the clouds too.'
Howard Lindsey & Russell Crouse, *The Sound of Music*

This is a place that casts a spell upon each visitor. An enchanting location in any season, the spectacle offered by this corner of Italy is sure to leave each guest starstruck. The majesty of nature can be felt here at its highest level, blended with a unique beauty. *San Cassiano* is a small mountain town in *Alta Badia* at the foot of the splendid *Dolomites* that proudly dominate the whole landscape. Such is their beauty that in 2009 they were awarded the title of World Heritage Site.

At the foot of the rocky mountains named *Lavarella*, *Contirines* and *Lagazuoi*, the town of *San Cassiano* is a corner of paradise for all that adore the mountains in all its variations; from advanced skiing to simple mountain walks admiring the glory of the landscape.

Hotel Armentarola is nestled in this fabulous corner of the *Dolomites*, beneath the massif of *Massiccio del Sella* and the towering *Sassongher* mountain. Nature can be enjoyed completely here among the imposing peaks and in winter on the spectacular ski slopes, voted as some of the best in Europe.

The history of Hotel Armentarola, name of the ancient hamlet where it is located, begins in 1937 when the Wieser family decided to build a locanda (a typical Italian inn). A year later, during Christmas of 1938, there were already eleven rooms which offered running water and an ensuite bathroom, which was sensational for that time. After more than 70 years, it is still the Wieser family led by Paul and Toni that lovingly own the hotel, offering a unique hospitality that only a pure passion and strong bond with this land can convey.

'What a wonderful world' is the first thought that comes to mind when arriving at Armentarola; everything is so pristine and perfect, from the landscape to the crystalline and pure air. The hotel is in a fairytale mountain setting, built with charm and style. The elements of the interiors are those of a classic mountain chalet. The light shades of wood create a warm and relaxing atmosphere and the fireplaces are protagonists creating corners of pure magic where you can feel pampered with a delicious hot chocolate. The colours of the materials are light, so as to leave full dominance to the landscape, with ample armchairs that invite each guest to enjoy the incredible panorama through the large windows that open onto the majestic mountain scenarios.

The large terraces crowned by a magnificent view of the *Dolomites* are the perfect place to bask in the sun whilst enjoying an aperitivo.

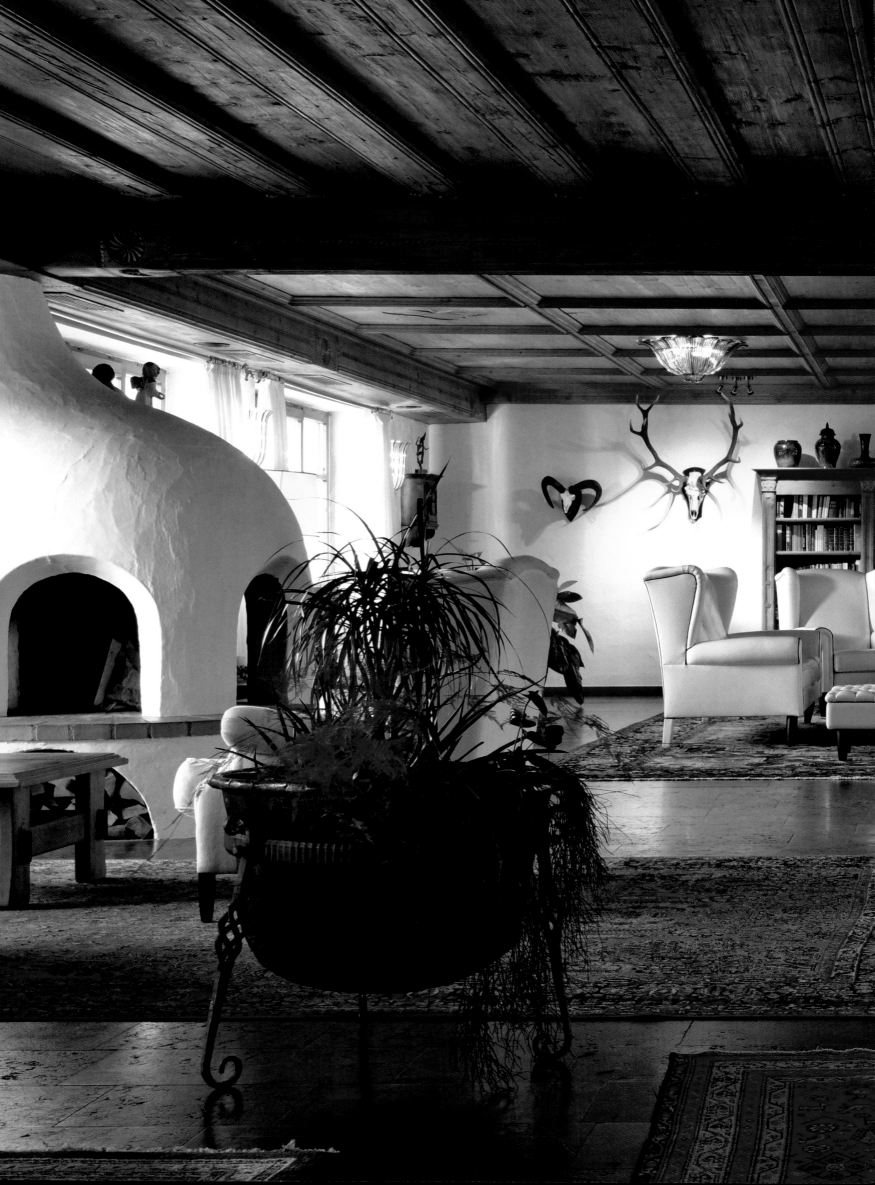

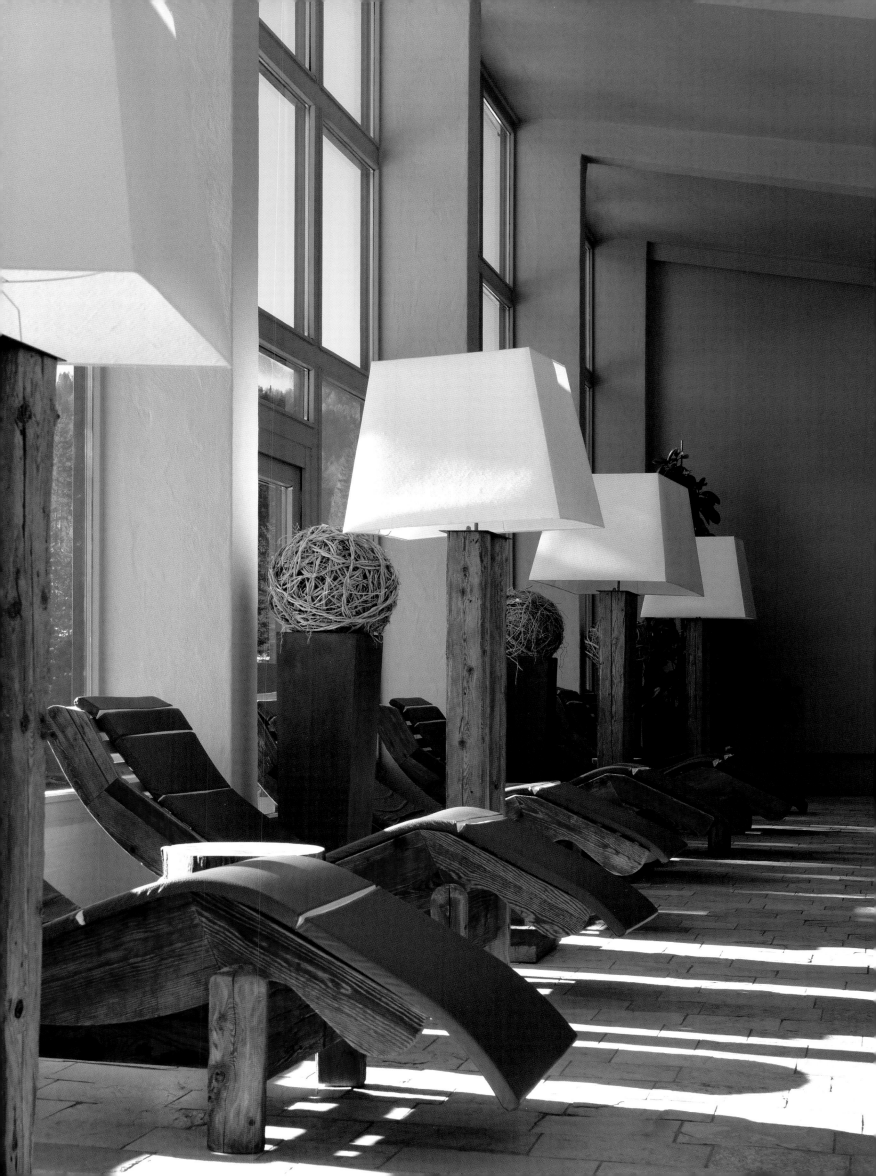

EMILIA ROMAGNA

Happiness inspiration: A region that is divided between the sea and mountains, that has inspired the likes of *Giuseppe Verdi*, the poet *Giovanni Pascoli* and the grand *Federico Fellini*. The inspiration of many delicacies of international fame from fresh pasta, to Bolognese sauce and the unmistakable lasagne.

RELAIS PALAZZO VIVIANI

'Voglio fare un castello in aria, più su delle nubi, più su del vento un castello d'oro e d'argento. Con una scala ci voglio salire … E su un cartello farò stampare: le cose brutte non possono entrare, o filastrocca solitaria si starà bene lassù nell'aria.'
Gianni Rodari, *Il castello in aria*

'I want to build a castle in the air, higher than the clouds, higher than the wind, a castle of gold and silver. With a ladder I want to climb there … And on a sign I will have written: bad things cannot enter, oh lonely verse, up there in the air I will be content.'
Gianni Rodari, *The castle in the air*

Montegridolfo appears as if it has come straight out of an enchanted fairytale book. A striking insight into beautiful medieval Italy made of castles, towers, small hamlets crowned in the hills as jewels, and legends of knights and princesses.

Montegridolfo has gained the prestigious title as one of the most beautiful hamlets in Italy, nestled between the green valleys of *Conca* and *Foglia*, on the border between *Emilia Romagna* and *Marche*. History can be felt everywhere in this fortified hamlet, that was built to guarantee defence to the Malatesta family thanks to its high walls and majestic towers, with only one entrance gate protected by a handsome tower dating back to 1500.

The origin of the name *Montegridolfo* is uncertain, however, the antique *Castrum Montisgredulphi* was a nobile (Italian title of nobility ranking between that of knight and baron) residence of the Gridolfi family who dominated the area in the 14th century.

In one of the most beautiful palaces inside the hamlet, the fairytale continues: here is Relais Palazzo Viviani, surrounded by an extraordinary garden that dominates the enchanting valleys. Guests are welcomed in a palace where every detail creates an atmosphere from the past from the architectural details to the original period furniture and sumptuous fabrics.

Montegridolfo can be completely discovered and explored when staying at Relais Palazzo Viviani as the suites, rooms and apartments are all located in different residences inside the hamlet. It is a sense of 'living' and 'belonging', not simply 'staying' that characterises each guest's stay here, following the trends of today's contemporary traveller who wants to 'feel at home' wherever he or she travels.

Guests are invited to choose between the rooms located in the Casa del Pittore (literally 'The Painter's House') that faces the marvellous outdoor swimming pool and boasts a unique location; perfect for a swim at sunset on a warm, summer's evening after a walk in the valleys. Or why not choose a room in the Borgo degli Ulivi, immersed in greenery with an absolutely splendid view towards the hills? Alternatively, the rooms inside the castle offer the charm of an ancient residence while the apartments are perfect for those wanting to linger a little longer in this chocolate-box hamlet and make the castle 'their own home'.

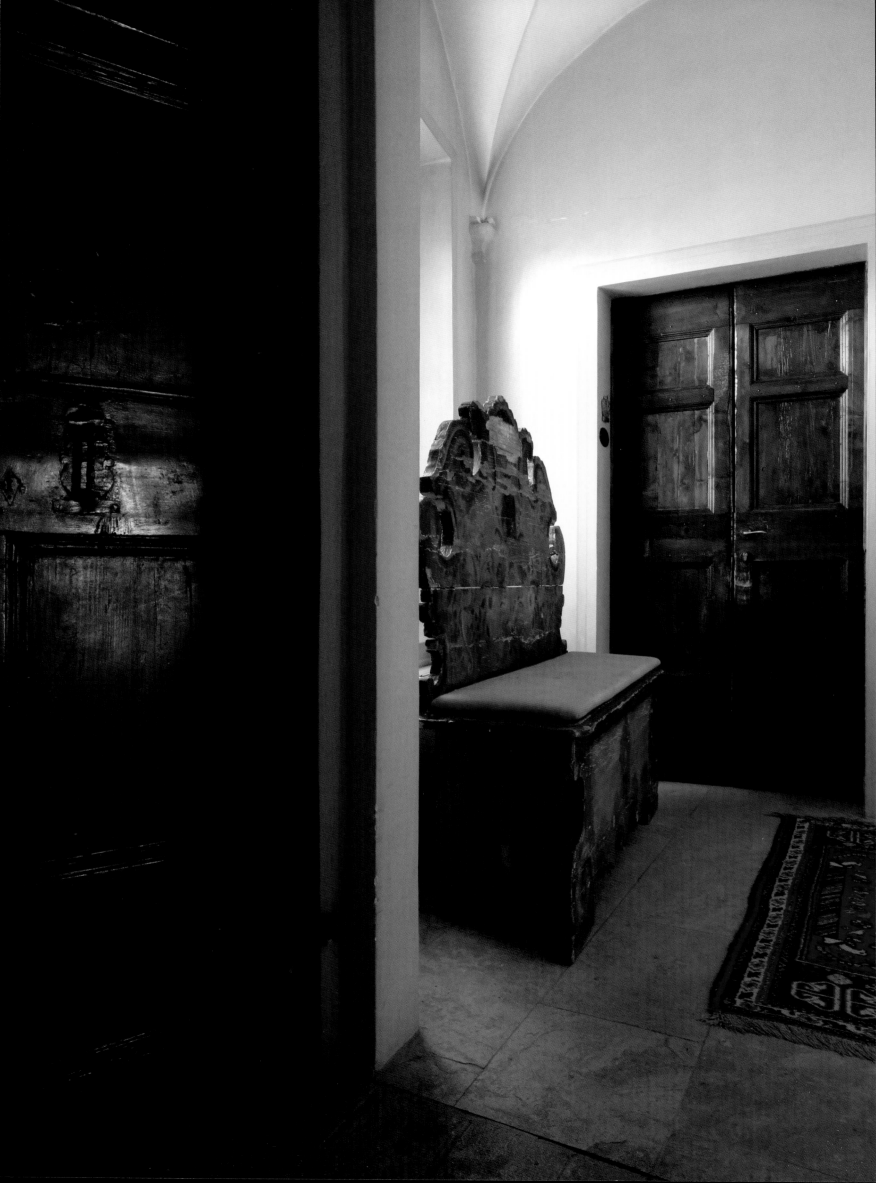

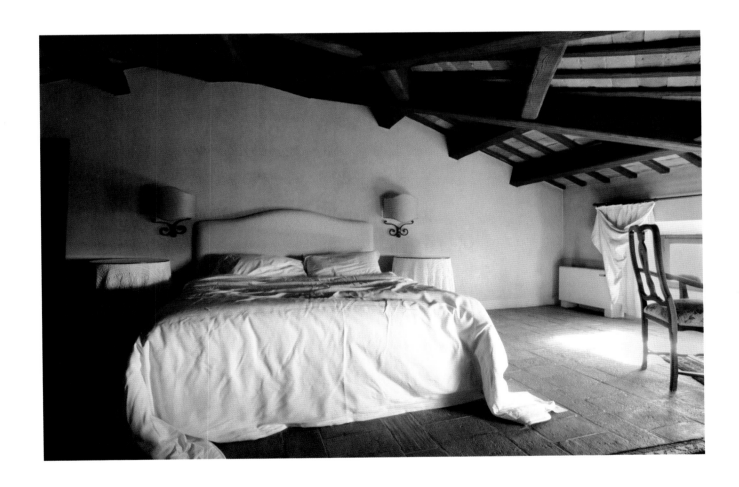

It is fun to explore the local markets after a trip around the area. These offer all the delicacies this splendid region possesses: from fresh egg pasta, to Parmigiano Reggiano, organic vegetables, and the extraordinary selection of fish; not forgetting the numerous wine producers creating divine wines that only Italy can offer. After all this, there is no better way to enjoy mother earth's produce than to cook together.

For guests that prefer a romantic stay, the rooms housed inside the palazzo are the perfect option. The choice of furnishings and colour palettes create an enchanted atmosphere, with wonderful views of the medieval internal courtyard or the pristine green hills. Exposed beams and a crackling fire from the original fireplaces make the suites of Palazzo Viviani the ideal choice. One of the suites indeed appears as if lifted out of a history book, being as it is adorned with frescoed ceilings, terracotta floors and warm, suffused tones.

The excellent cuisine of *Emilia Romagna* is offered in Ristoro Restaurant's beautiful dining room with exposed bricks. An intimate atmosphere is provided by the lights and shadows of the many candles. Or after a day exploring the region, the terrace of the Osteria dell'Accademia is the perfect choice, where whilst reading the menu, diners can gaze at the amazing panorama where the green hills meet the blue sea in the distance.

In this small hamlet many medieval reenactments and tournaments are organised during the year, as well as historic celebrations and concerts inspired by history, which are scattered in the small piazza of *Castello di Montegridolfo*, making each a magical stage where guests can dream of being 'in a castle in the air', 'higher than the clouds, higher than the wind, in a castle of gold and silver'.

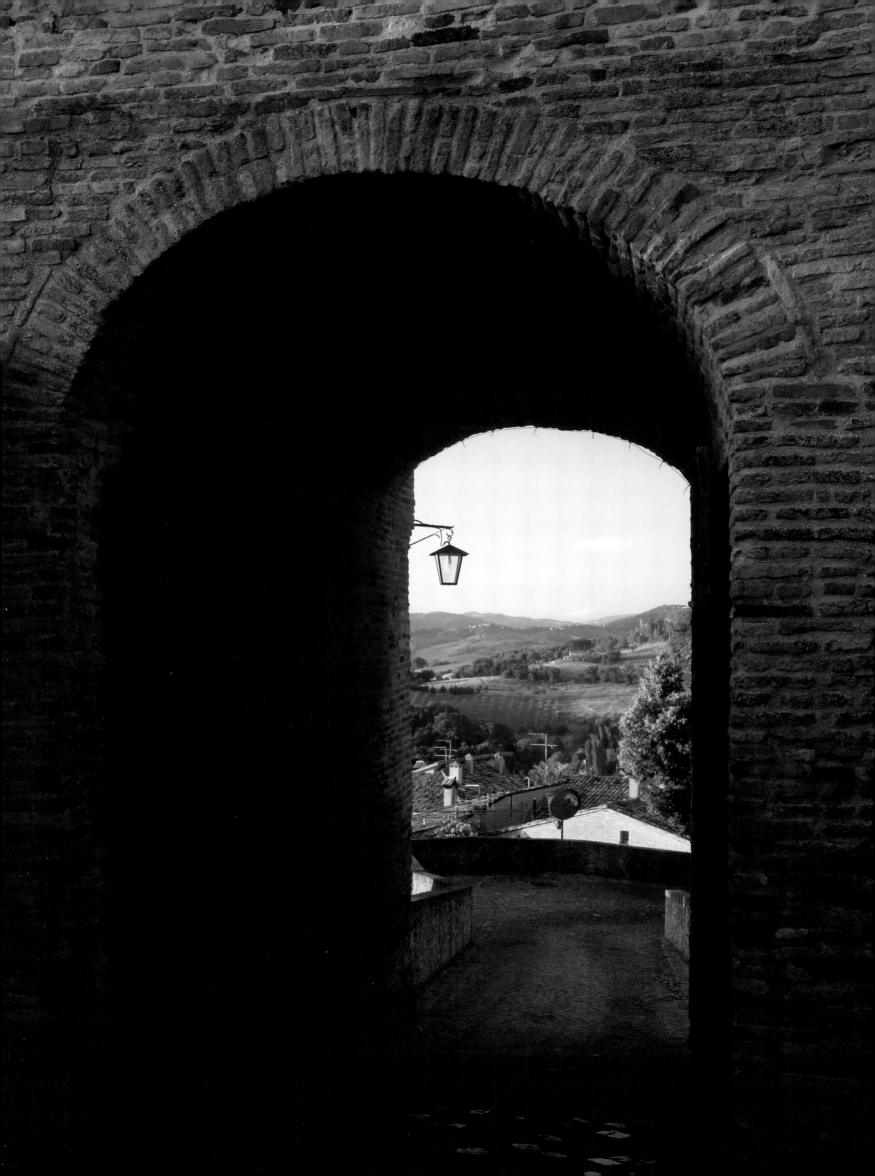

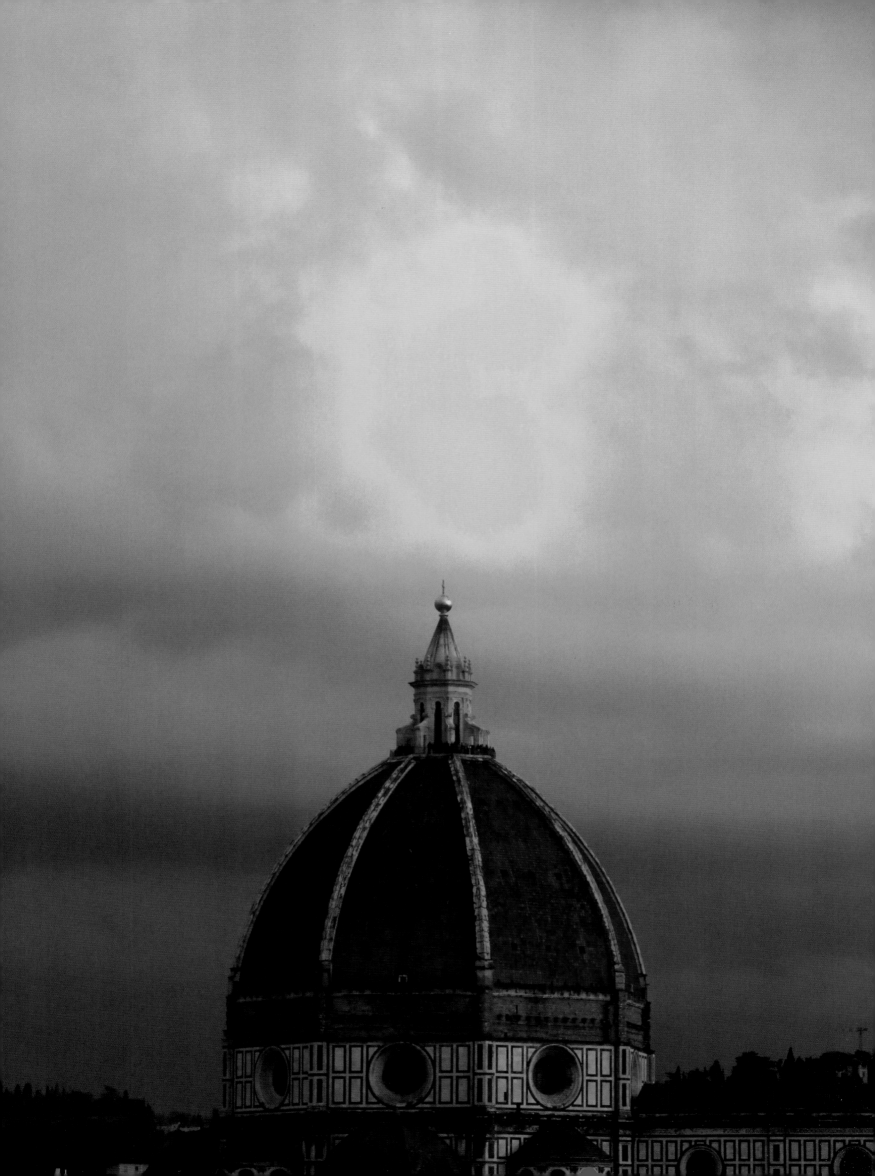

FLORENCE

Renaissance inspiration: This is the cradle of the *Rinascimento*, where beauty originated. A city that has blended over the centuries history with art, nobility with culture, food with traditions, craftsmanship with luxury. It's impossible not to associate this city with excellence, fine art and romanticism, with every corner evoking a thousand tales.

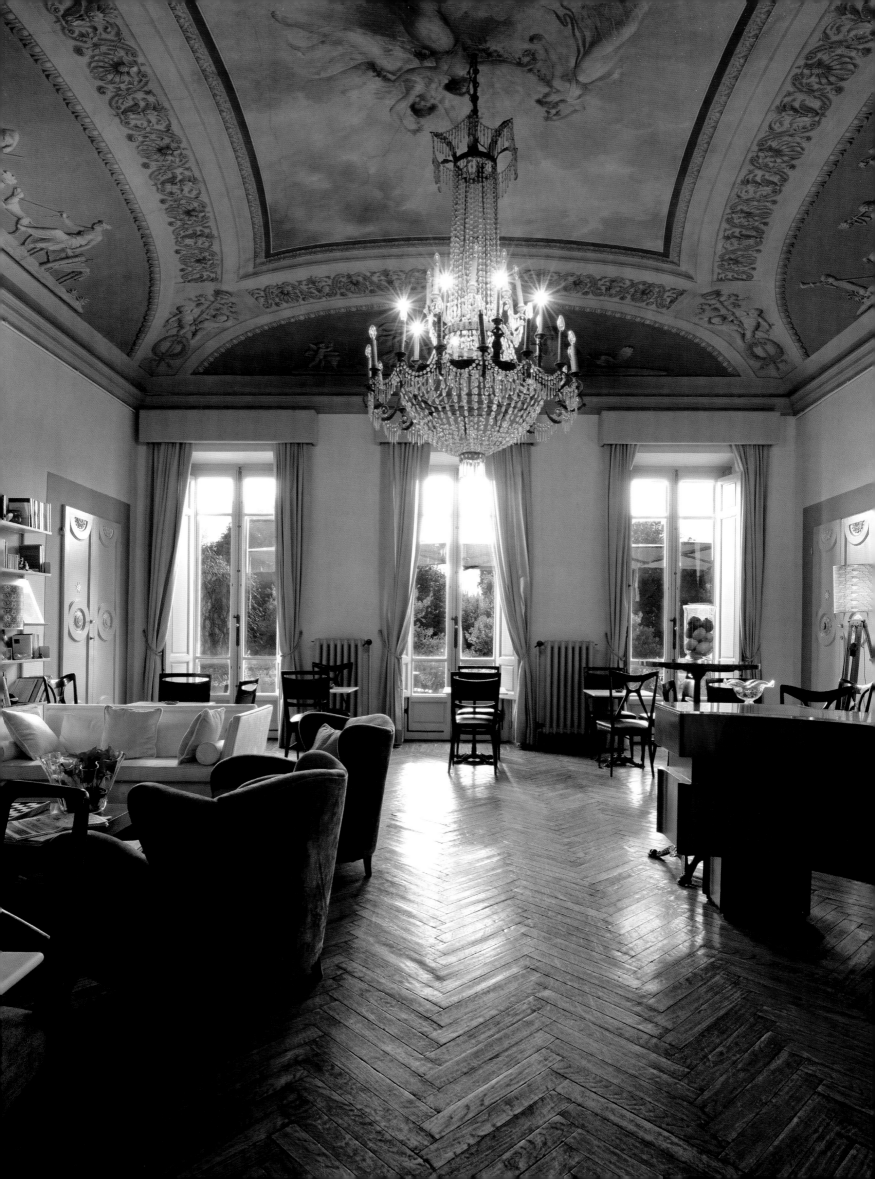

AD ASTRA HÔTEL PARTICULIER

'L'amore che move il sole e le altre stelle.'
Dante, *Paradiso XXXIII, 145*

'Love that moves the sun and other stars.'
Dante, *Paradiso XXXIII, 145*

When discussing hotels, the words 'unique' and 'exceptional' are often overused and repeated many times over. But when it comes to describing this hotel, one cannot use them enough. Even a well-explored city such as *Florence* can have a well-kept secret that in this case, is located in the quieter, and lesser known area of *Oltrarno* (literally on the other side of the *Arno* river), an area known mainly by locals and *Florence* aficionados, and often referred to as the most authentic Florentine district. Ad Astra immediately strikes because of its name. Indeed, it is the first 'hotel particulier' of the city, a name borrowed from Paris, signifying not a hotel but an urban villa for aristocrats. This name was chosen by its owners Matteo and Betty in order that guests can feel at home and experience the feeling of living in their own Florentine neoclassical villa. Upon arriving in the narrow *via del Campuccio*, surrounded by antique shops and privately owned boutiques, guests will need to search for the property. There are no signs or a sumptuous lobby to welcome you, but instead an austere gate that once opened takes you into an enchanted world. Ad Astra is located on the first floor of the ancestral family mansion overlooking the historic Torrigiani gardens, often referred to as *Florence*'s secret garden, and the largest private garden in Europe. The garden dates back to the height of the Romantic movement in the early 19th century, when Marquis Pietro Torrigiani decided to transform his park into an English garden, as was the fashion of the time.

The name 'Ad Astra', literally meaning 'to the stars', links directly to the neo-gothic Tower of Baccani that dominates the gardens, spiralling to the heavens, and built as an astronomical observatory.

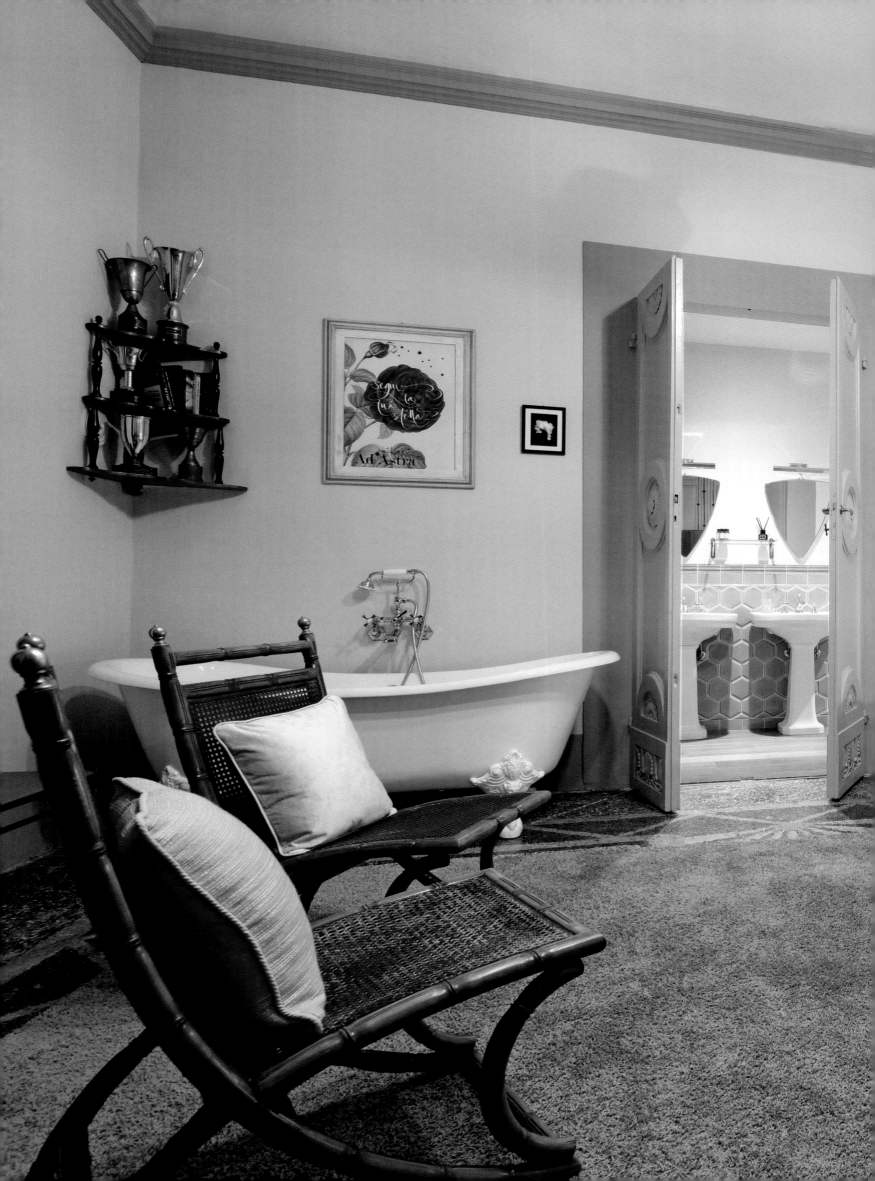

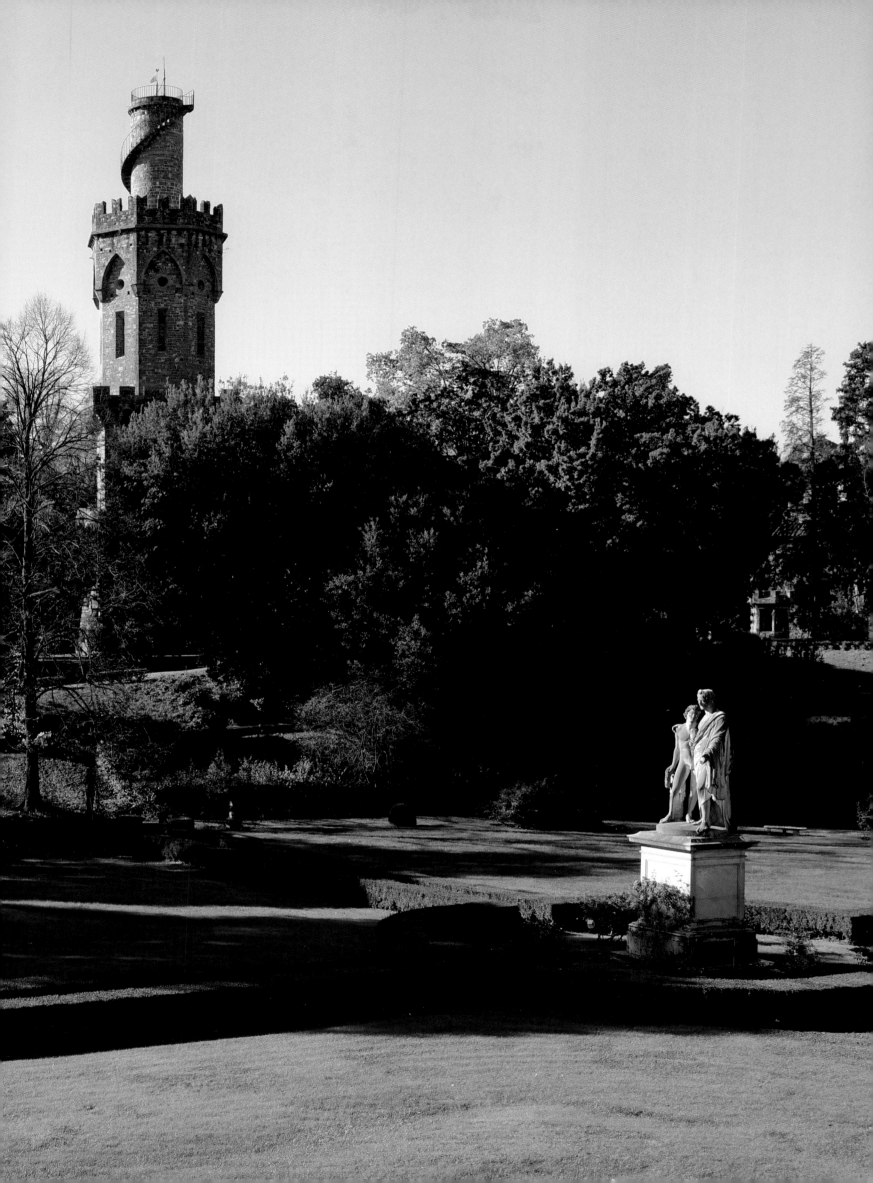

GALLERY
HOTEL ART

'Italy, and the spring and first love all together should suffice to make the gloomiest person happy.'
Bertrand Russell

At the heart of the history of *Florence* there has always been a mystery. How did a city surrounded by commerce also become the centre of a revolution and new approaches in art and ideas? Great wealth is often the enemy of great taste. However, the patrons of *Florence*, mainly the Medici, commissioned some of the world's most beautiful artworks, churches, monuments and palaces, which are still considered masterpieces today. Similarly, Gallery Hotel Art sitting at the heart of *Florence*, owned by the Salvatore Ferragamo hotel group Lungarno Collection, is a hotel filled with great taste and exquisite art.

With a simple concrete exterior, in striking contrast with typical Florentine buildings, this is a contemporary hotel in a building of no architectural distinction. However, the interior is as beautiful as a gown of alta sartoria. Contemporary art is blended with minimalism; culture is infused with light colours of white, beige, grey and brown. As with its sister hotel, Hotel Continentale, it has been dreamt up by Florentine architect Michele Bönan as a meeting place for fashionistas, artists and visitors alike. Located in a quiet courtyard, a few steps away from *Palazzo Strozzi*, this is a hotel where hospitality and art are inextricably linked. Architect *Bönan* states: 'it was a personal challenge to create Italy's first design hotel. I wanted to develop more than just a stylish hotel, I wanted a contemporary meeting place that always had a buzz about it.' Indeed, *Florence* is the cradle of the Rinascimento, and Gallery Hotel Art celebrates the contemporary version, with ongoing vernissages and art exhibitions in the lobby and lounge.

The seventy four rooms follow an Asian theme with a Tuscan style, with locally crafted materials and contemporary art by Italian and international artists. The uniquely named suites, each taking their name from a symbol of *Florence*, are a haven away from the bustling city. The Penthouse Palazzo Vecchio Suite boasts a one-of-a-kind terrace offering enviable views over *Florence Cathedral* and the magical distant Tuscan hills. The Penthouse San Miniato Suite, split over two floors, offers exquisitely designed sumptuous furnishings with yet another open air terrace offering views of the much dreamt about *Florence* skyline.

The hotel's Fusion Bar & Restaurant is the city's best known Asian restaurant, drawing complete inspiration from Asia itself. Guests are also invited to visit the other stunning restaurants of the Lungarno Collection each expertly led by Executive Chef Peter Brunel. Gourmet restaurant Borgo San Jacopo at sister hotel Lungarno Hotel, has recently been awarded the coveted Michelin star, and original Tuscan delicacies with a fresh and innovative approach, with the focus lying on local ingredients, can be tasted just a few steps away from the *Ponte Vecchio*.

Back at Gallery Hotel Art, the Library is the ideal place to enjoy breakfast or a light lunch surrounded by extraordinary photography exhibitions, turning a simple hotel library into one of the most exclusive galleries of the city. Last but not least, the intimate Lounge offers a fashionable hideaway in which to enjoy a romantic cocktail. The room is adorned with authentic furniture pieces from East Africa and the Orient, blended with contemporary art and Tuscan modern art pieces.

Gallery Hotel Art is a contemporary hotel at the heart of one of the most classical Italian cities, perfect for travellers looking for an 'atypical' Florentine experience, yet in one of the most central, historic and magic locations of *Florence*.

The twenty five rooms each contain individual touches from original photographs and glamorous wallpaper individually chosen by Francesco in antique shops and the many vintage markets around *Tuscany*. This scrupulous attention to detail contributes to the intimate and relaxing atmosphere Hotel Cellai guarantees each of its guests; a pleasing retreat away from the bustle of the city.

Continuing on the art theme, Hotel Cellai hosts monthly ArteInCasa events, where young, contemporary artists showcase their work, and where guests are invited to attend art openings, meetings and lectures.

La Terrazza, a cherished roof garden, is absolutely unique, overlooking the Florentine roofs and soft hills that provide a stunning backdrop to the city. During the warm days of spring, guests can enjoy a glass of Chianti from the honesty bar and feel truly at home in this magnificent city.

In the afternoon, guests are invited to the hotel's afternoon tea hour, where complimentary tea and homemade cakes are served. This is an ideal moment to speak to fellow guests about the next day's excursions and the best trattoria to enjoy a hearty Fiorentina.

Another must-visit spot in this adorable boutique hotel is the library. It is a space created to nourish the soul and relax, whilst listening to music, reading a book or enjoying an Aperol spritz.

Hotel Cellai is a charming secret, at the very heart of *Tuscany*'s magnificent artistic city.

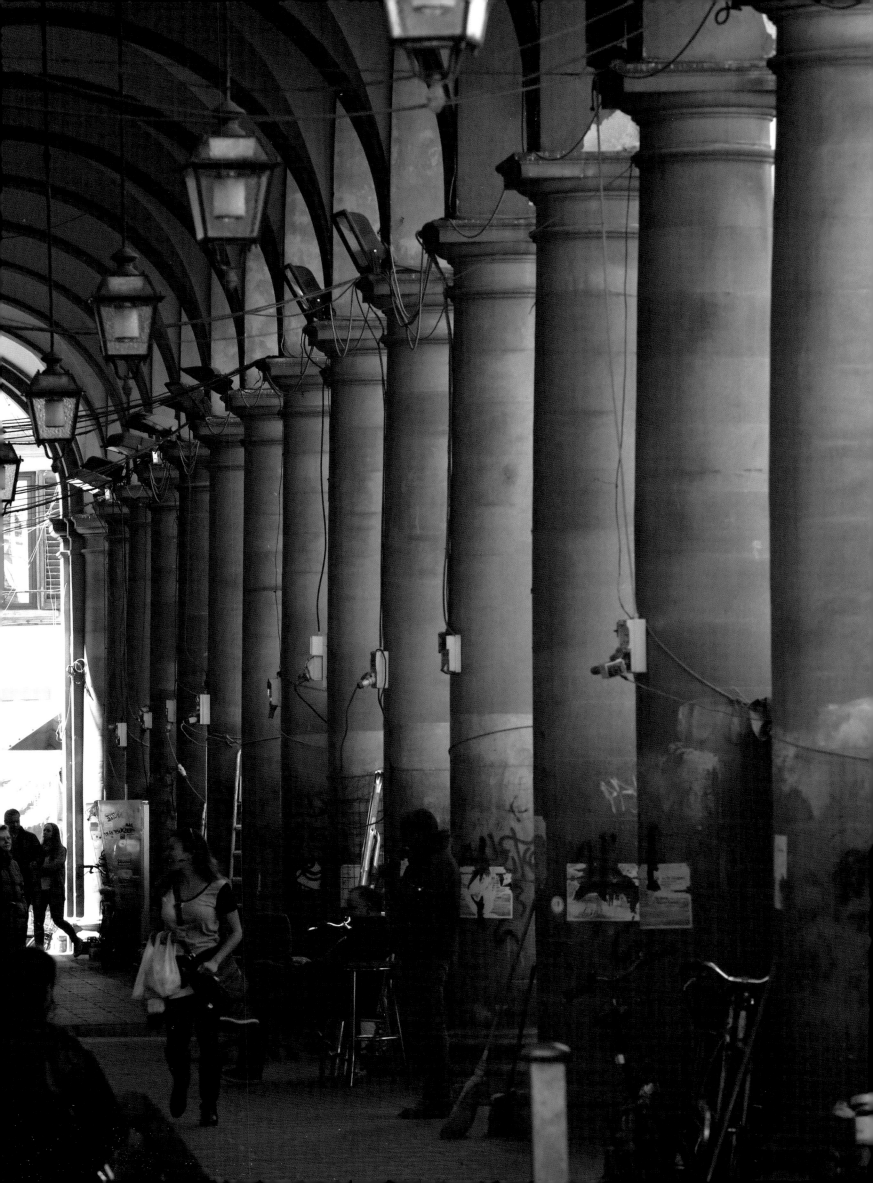

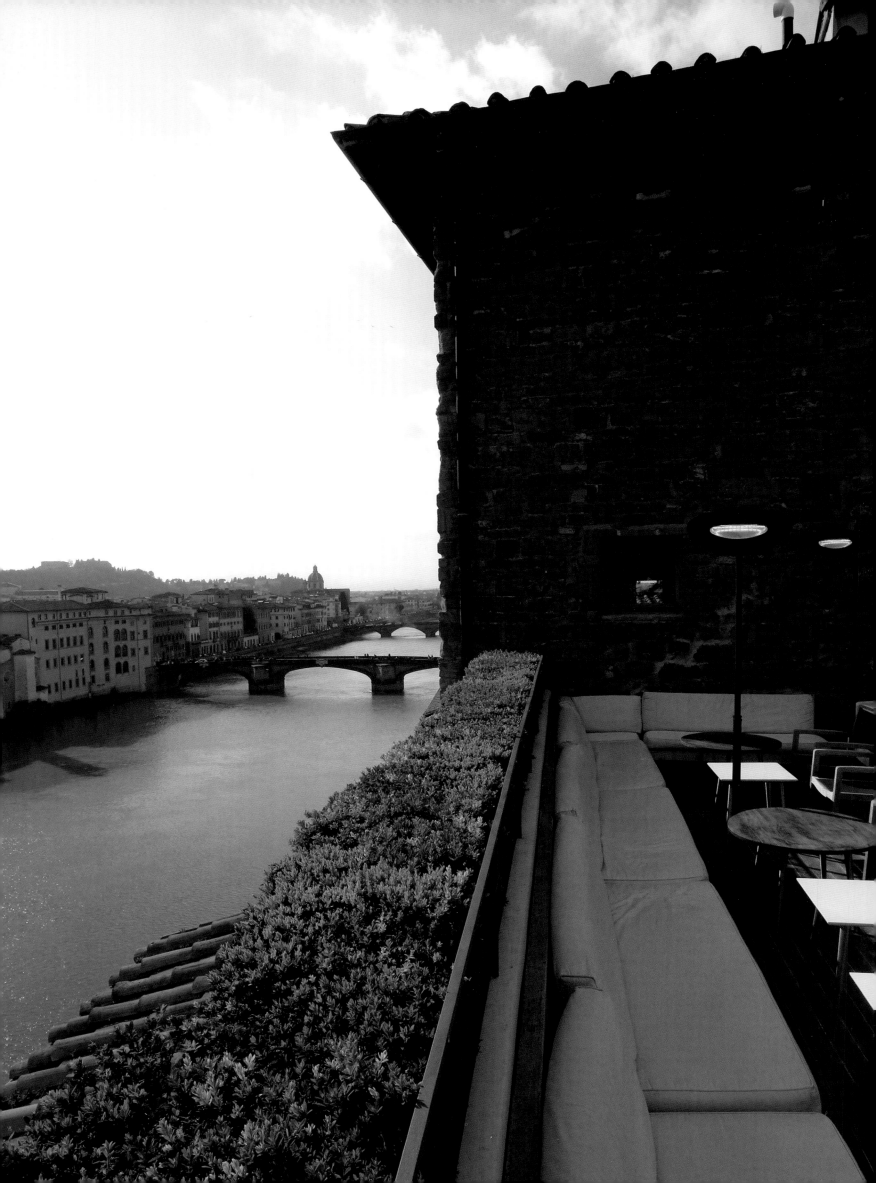

HOTEL
CONTINENTALE

'…Nor was the fame of her beauty and sweetness confined to Firenze;
Roman ambassadors when they returned to the City Eternal
Spoke of it freely, while light-hearted gallants of Pisa and Lucca,
Passing a season in Tuscany's proudest of cities, Firenze,
Spread on returning the praise of the beautiful Florentine maiden.'
Oscar Fay Adams, *A Tale of Tuscany*

As Monica Bellucci once stated, 'in Italy, the concept of family is very important', and this can certainly be linked to the ultra-chic Hotel Continentale. In his teenage years Leonardo Ferragamo entered the family empire of luxury brand Salvatore Ferragamo, and after heading their menswear line and becoming director of sales and development, today he leads the Lungarno Collection of hotels. A true example of a family love affair with their native city, where everything about their hotels inspires Italian elegance and refined craftsmanship for which *Tuscany* is renowned, and the immaculate style for which his family is legendary.

Located in the most famous area of the city, literally in front of the celebrated *Ponte Vecchio* with its myriad of jewellers and goldsmiths, this bridge pays its ode to the Rinascimento, spanning from the *Uffizi Gallery* to *Palazzo Pitti*. The hotel is also just a few minutes' walk from *via Tornabuoni* where shopping is a delight with the flagship stores of legendary Tuscan designers lining the streets.

Hotel Continentale is a monochromatic retreat at the heart of colourful, gilded *Florence*. The hotel pays homage to the quirky 1950s and 1960s, where elegant and inviting white tones are offset with playful notes of bubble gum pink and the right amount of spirited kitsch, evoking fantasy, harmony and simplicity.

Lungarno Collection entrusted Florentine architect Michele Bönan with the redesign of this 14th century palazzo. Having a special relationship with time, the hotel is scattered with a grand collection of clocks and watches; there to remind each guest to relax, as it is time to take a break!

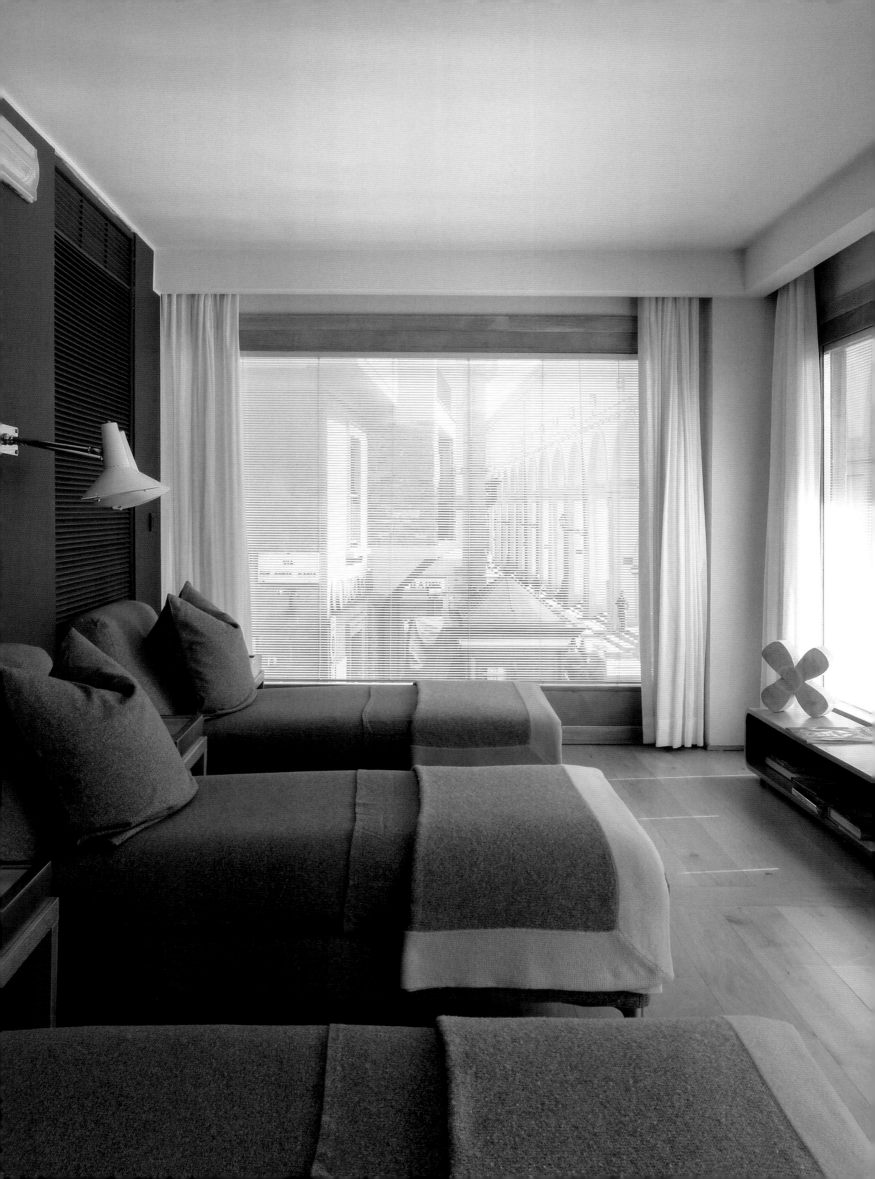

LAZIO

Fairytale inspiration: A magical setting was found at Civita di Bagnoregio with an enchantment that only a fable can bring. History permeates the air of this mystical region with its ethereal atmosphere where we are all made to feel noble.

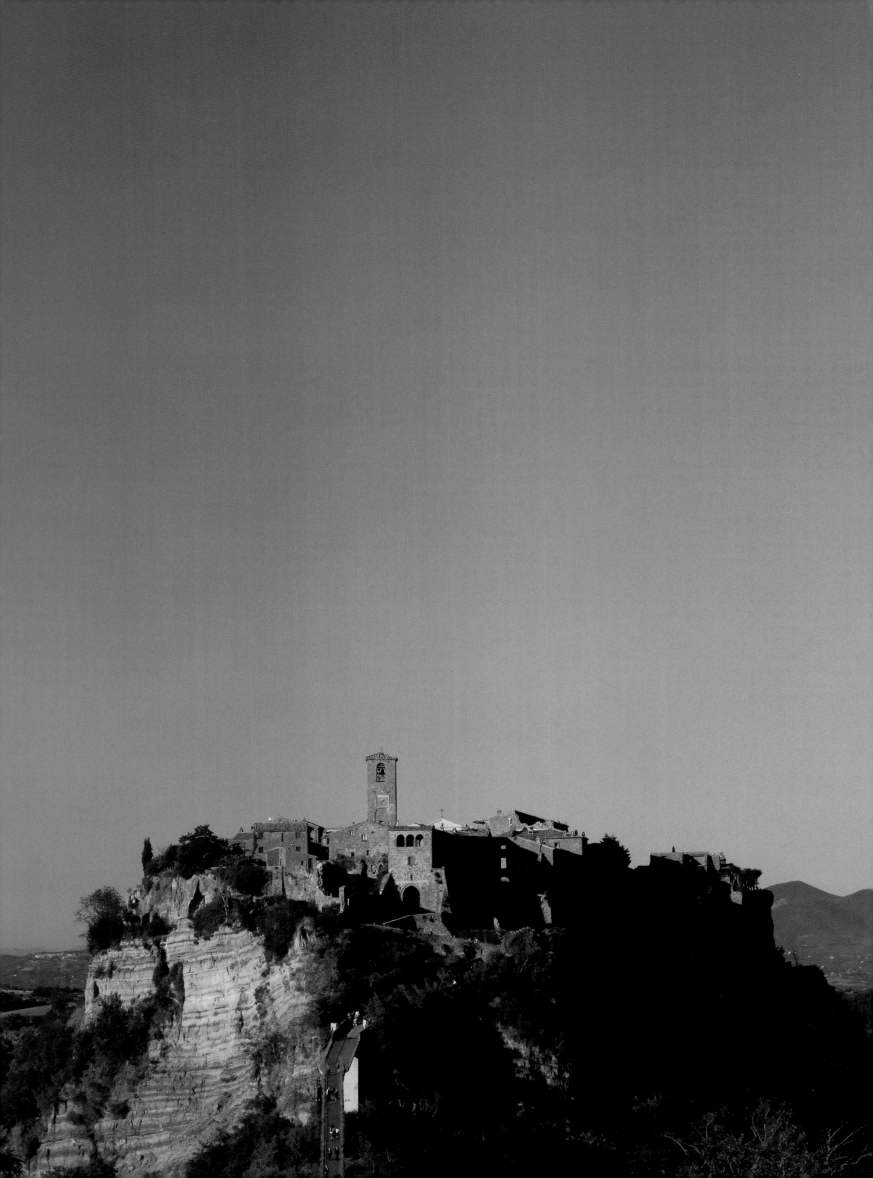

CORTE DELLA MAESTÀ

'Ah! Non credea mirarti
Sì presto estinto, o fiore;
Passasti al par d'amore
Che un un giorno sol durò'
Vincenzo Bellini, *La Sonnambula*
(Amina, Atto II)

'Scarcely could I believe thee
to wither so shortly, oh blossom;
Thus love springs within the bosom,
And dies the self-same hour'
Vincenzo Bellini, *The Sleepwalker*
(Amina, Act II)

This is the most fascinating part of Italy, where no words will ever be enough to describe the awe and sense of astonishment felt when arriving at *Civita di Bagnoregio*. Civita is an ancient medieval hamlet, with a history that spans from the Etruscans to the Romans, nestled majestically on a rocky hill bordering mystical *Umbria* and dreamy *Tuscany*, yet not far from the 'Eternal City' of *Rome*.

A long bridge separates *Civita* from the 'reality' of today's world. This is a rare, tiny hamlet perched precariously on a hill of tuff, challenging nature's forces such as the constant erosion and fragility of the land that sustains it. Devastatingly strong natural forces and continuous erosion has given the place the name 'il paese che muore' (literally 'the town that is dying') to this charming hamlet. However, the same natural forces also offer one of the most striking panoramas to admire at dawn or to dream with at sunset: the valley of the *Calanchi*, the famous clay waves that are constantly mutating and changing according to the mood swings of the sea, wind and sun.

Corte della Maestà is a fairytale residence that is cushioned inside this wonderful hamlet, and has been lovingly restored and designed by Paolo Crepet, famed psychiatrist, writer and art collector, together with his wife Cristiana Melis.

Crepet recounts, 'Civita is a place where we would all like to live, escaping from the noise, the arrogance, the rudeness, the incivility. Here everything is composed to create a place to think and plan a better future that does not taste of surrender or of romantic regression. Marguerite Yourcenar was right in saying that of all the magnificent places where she could have lived, she would have always chosen *New York* and *Civita di Bagnoregio*'.

Corte della Maestà is located in a building, that between the 5th and 6th centuries was given to Bishop Ferdinando de Castillo who created a bishop's seminary. The restoration has maintained all the charm and enchanted atmosphere of years gone by. The magical garden where the protagonists are the roses and hydrangeas that blend with the lush fruit trees, expands like the bow of a large ship to transport the guest in a sensorial journey to the incredible valleys located underneath.

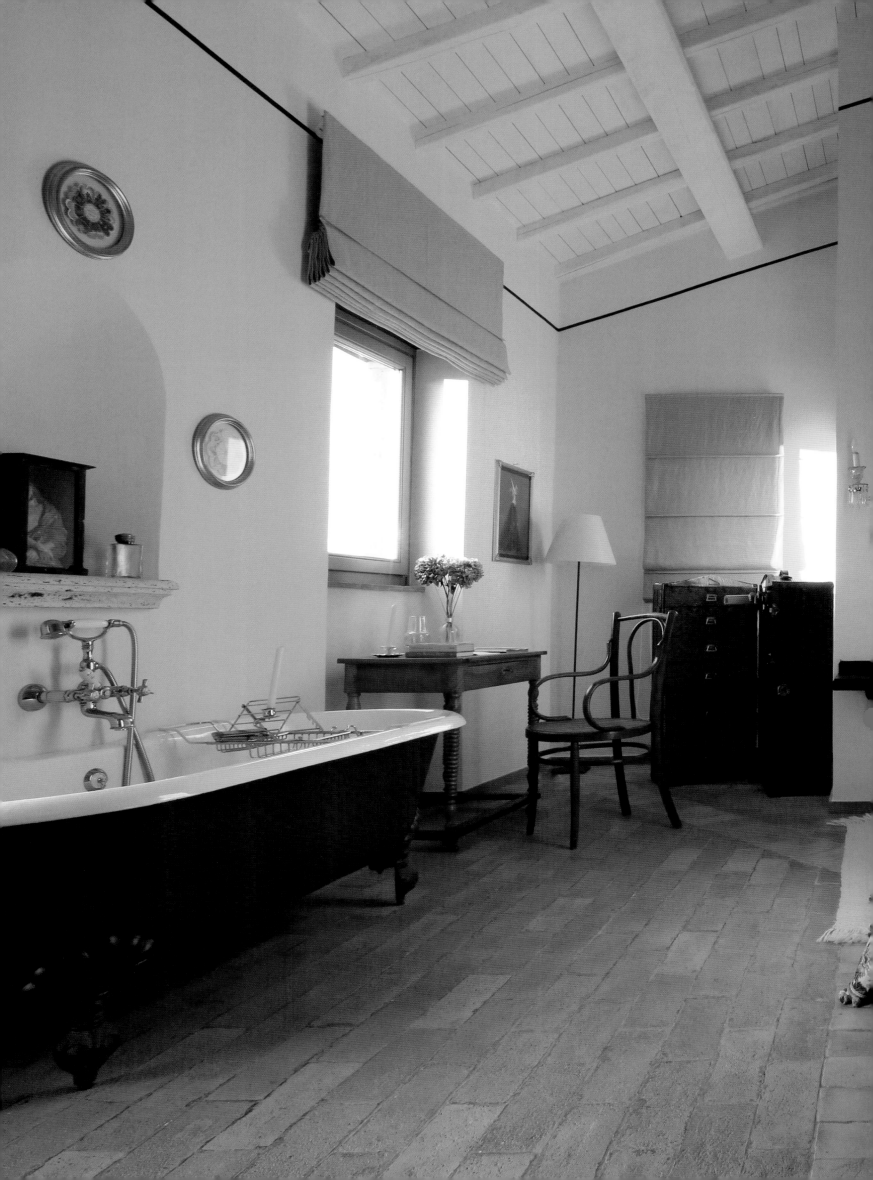

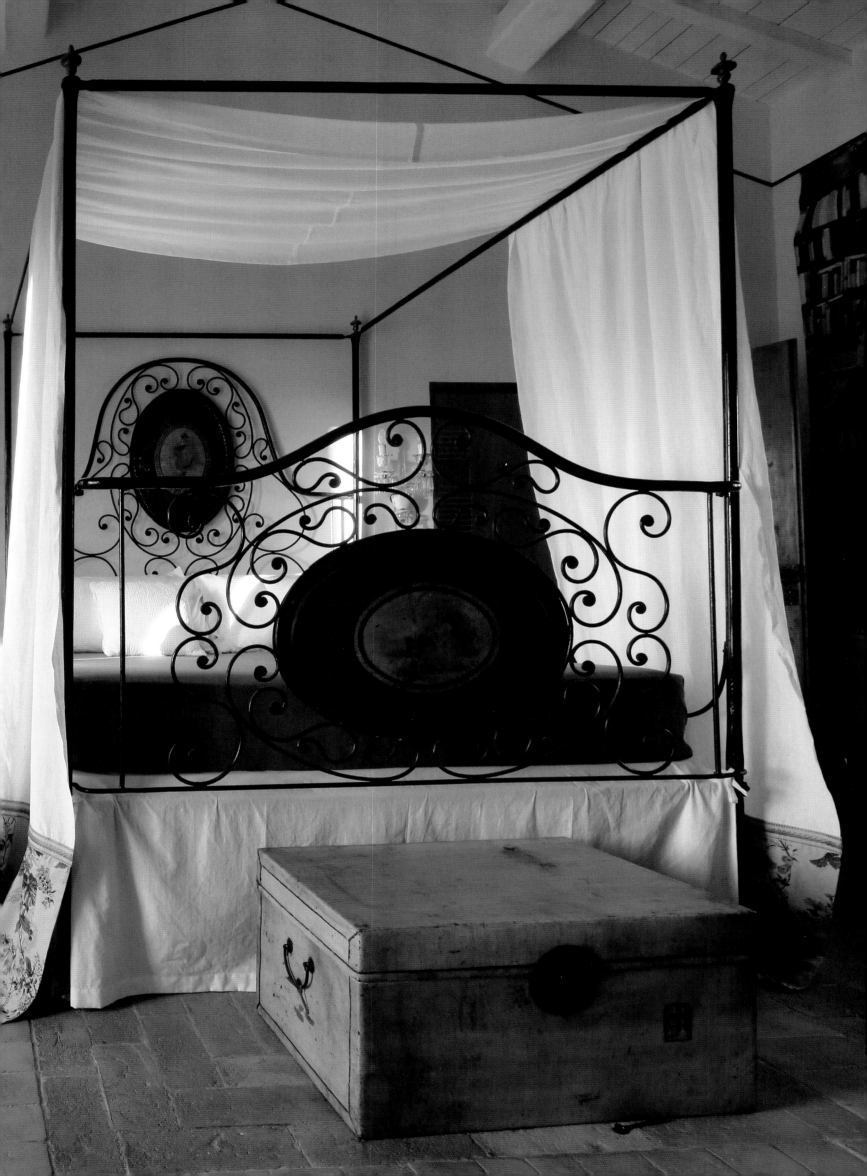

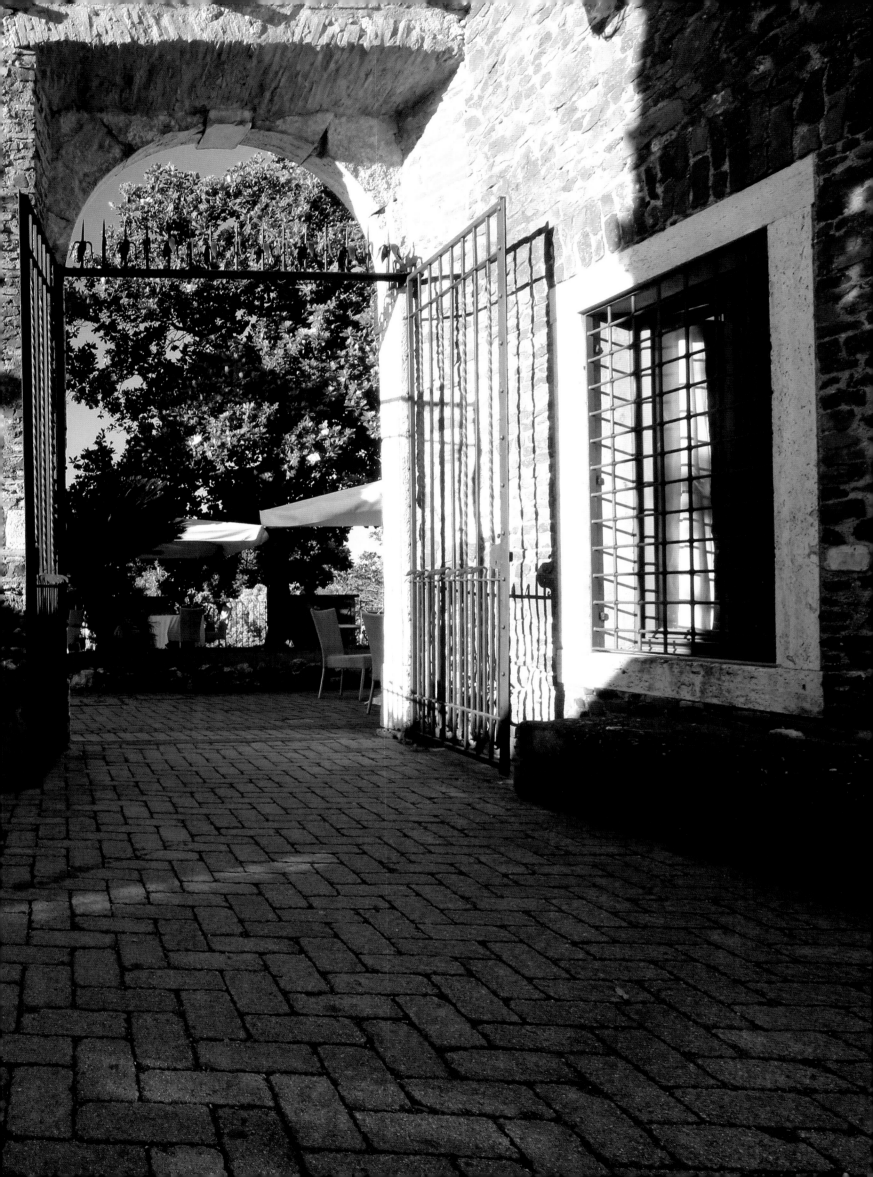

One of the most magnificent suites is the Suite Manzolini, with its blue and gold precious draping and magnificent fireplace which is lit every evening to guarantee warmth and relaxation, especially on the colder winter nights.

To live the fairytale to the full, the Tower Suite is the perfect choice. The suite is split over three floors, with a private drawing room on the ground floor, the bedroom on the second floor with a Franciscan style bed and unforgettable grand fireplace, and on the top floor the breathtaking Terrazza della Torre, the terrace, where on clear days the sea can even be seen in the distance.

During warm spring and hot summer days the beautiful swimming pool, crowned by palm trees, privets and cedars is the perfect relaxation spot. The inevitable Italian-style aperitivo is a must on the Terrazza del Conte (the Count's Terrace) where a glass of chilled white wine can be enjoyed whilst gazing at the sunset over the 'Eternal City'.

For today's princesses and knights a wellness centre is essential, where having laid down our day-to-day living armour, total relaxation can be obtained in the Jacuzzis, hammam and Turkish bath.

Of course being in Italy, food must be mentioned, and here at Castello della Castelluccia an attentive restoration has transformed the ancient Giardino d'Inverno (Winter Garden) with glass ceiling into a restaurant where once again the enchanting atmosphere is at the heart. Candlelight and shadows are essential elements to transport diners into a fascinating ambiance. Using only prime seasonal ingredients in their cooking, which includes typical Roman recipes with Umbrian influences, their delicacies are sure to satisfy even the most exigent guest.

At the entrance of *Rome*, immersed in greenery, in a castle that speaks so strongly of Italy, awaits a holiday that can turn into a beautiful dream...

FILARIO HOTEL & RESIDENCES

'This lake exceeds anything I ever beheld in beauty.'
Percy Bysshe Shelley

*L*ake Como was always an obligatory stop in the early 1900's, the era of The Grand Tour, when illustrious members of the British aristocracy would visit one of the world's most beautiful lakes, enjoying the class and sophistication that this location guaranteed. Lake Como became popular and a favourite destination for the elite and cultured foreign visitor from all parts of the world from Tsarist Russia to Austria and France. It enchanted all with its picturesque scenery, extraordinary location and charming nature.

Equally, today's traveller of The Grand Tour will undeniably be enchanted by *Lake Como*'s newest, design-conscious addition, Filario. Nestled on the shores of the lake and set alongside the lush, green mountains, the hotel has managed to blend in perfectly with the charming scenery. A place where time stands still, where relaxation is the key word, and where the beauty of the surroundings takes charge. 'Filario' signifies a silk thread that stretches over the lake (*Como* has indeed been famous for its silk weavers and factories since the 15th century), indulging each guest in the essential, majestic natural beauty of this corner of Italy.

The design of the hotel has been entrusted to eclectic interior designer Alessandro Agrati, whose philosophy is that of 'dressing' spaces rather than simply furnishing them with prestigious materials, lighting and objects of strong character. At Filario, Italian craftsmanship is a focal point of the design, with most of the furnishings created locally.

A strong passion for hospitality, for the history of his land, the architecture and promoting the magical destination of *Lake Como* is the philosophy of owner, Alessandro Sironi. Having lived between *Milan*, *London* and *Miami* he has brought a wave of innovation, contemporary design and boutique style to this former wire factory in such a timeless destination. Having taken more than a decade to complete, the hotel is glamorous yet simple to allow the context of the hotel to take full charge.

With just eleven deluxe rooms facing the lake, two suites perched on the water and eight residences, this boutique hotel caters for all. The rooms each feature enchanting glass balconies overlooking the lake, connecting guests to it and making them part of the water. With a neutral, minimal colour palette of grey, chocolate brown and black they reflect *Lake Como*'s unique elegance and beauty.

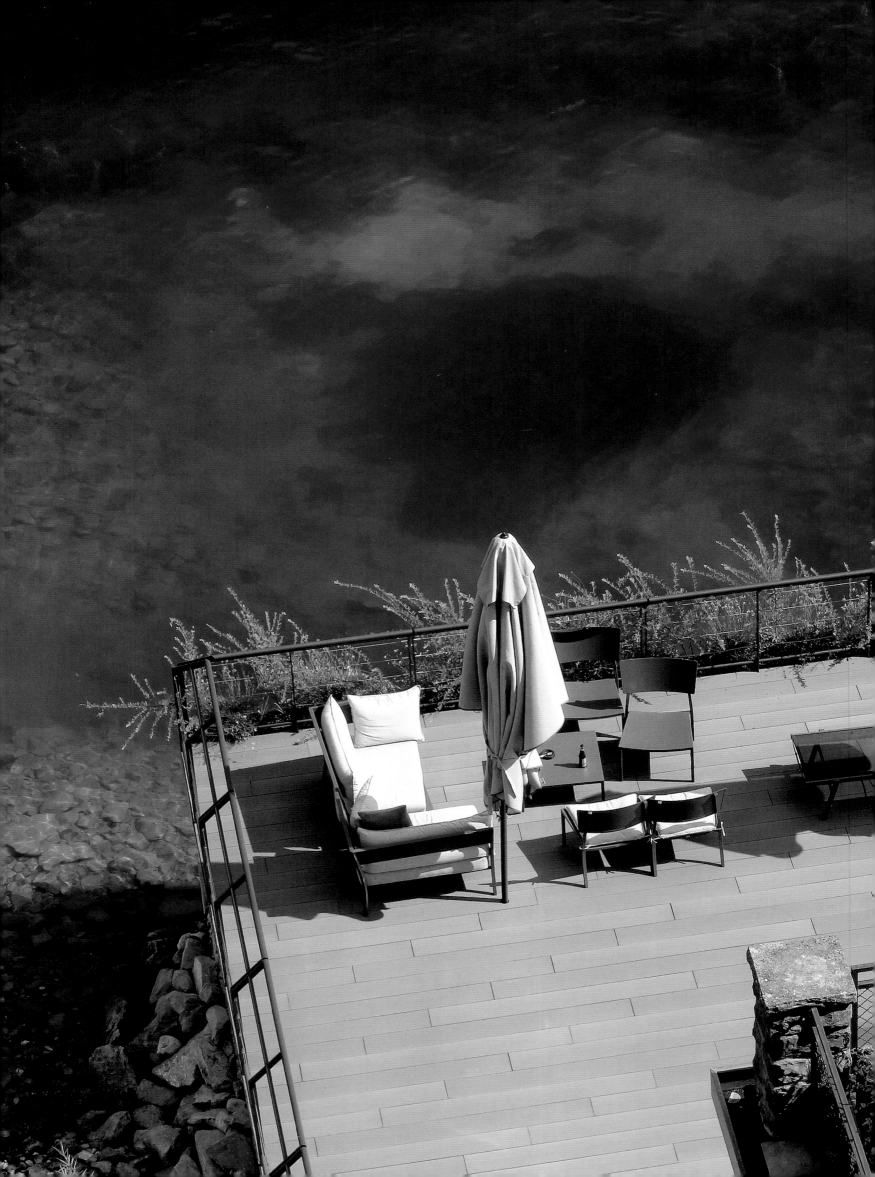

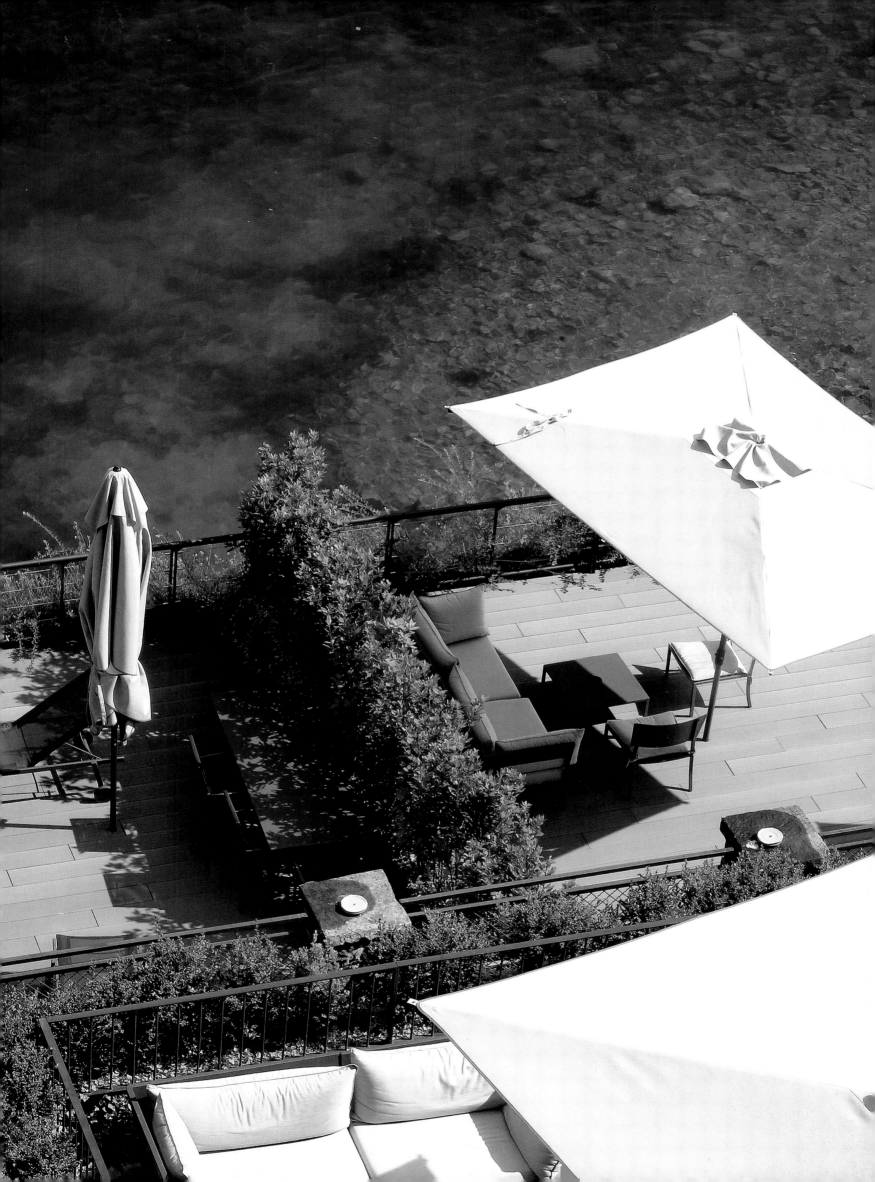

The most exclusive suite on the lake is the Grand Suite, with a breathtaking 110 square metre private terrace perched on the water and private infinity pool. This suite with its essential aesthetics is an unmatched refuge from today's frenetic lifestyle.

To make the destination even more heavenly, Filario's restaurant Bistrò enjoys stunning views, where al fresco dining is a must on the sunlit terrace enjoying the authentic, fresh Italian delicacies.

It would seem impossible to leave this hotel, with a private beach and striking infinity pool floating on the deep-blue lake where there is nothing better than to enjoy the sun, sipping a cocktail and a dip in the pool. However, Filario is also the ideal location to start a Grand Tour of the lake. Just a short drive away is *Bellaggio*, perhaps one of the most charming towns where villas such as *Serbelloni* and *Melzi d'Esti* can be visited. *Villa Serbelloni* is believed to have been built on the site of Pliny the Younger's villa *Tragedy*, whilst his other villa *Comedy* was further down the shore. At *Villa Melzi d'Esti* on the other hand, the English gardens are a marvel to visit with the landscapes enriched by monuments and artefacts such as a Venetian gondola transported to Bellaggio expressly under Napoleon's orders. *Villa Balbaniello* can also easily be reached from Filario, the setting of *Casino Royale* in 2006. The elaborate terraced gardens of this Villa are simply unforgettable.

The hotel ensures each guest an unparalleled level of service and hospitality organising anything from a simple bicycle excursion to an authentic wooden boat tour of the lake, seaplane ride or a chauffeur trip to nearby shopping paradise, *Milan*.

Being immersed in the impeccable details of Filario, the magical landscape and the relaxing nature that permeates each corner of this enchanting lake is enough to guarantee an extraordinary stay worthy of the modern Grand Tour aristocracy.

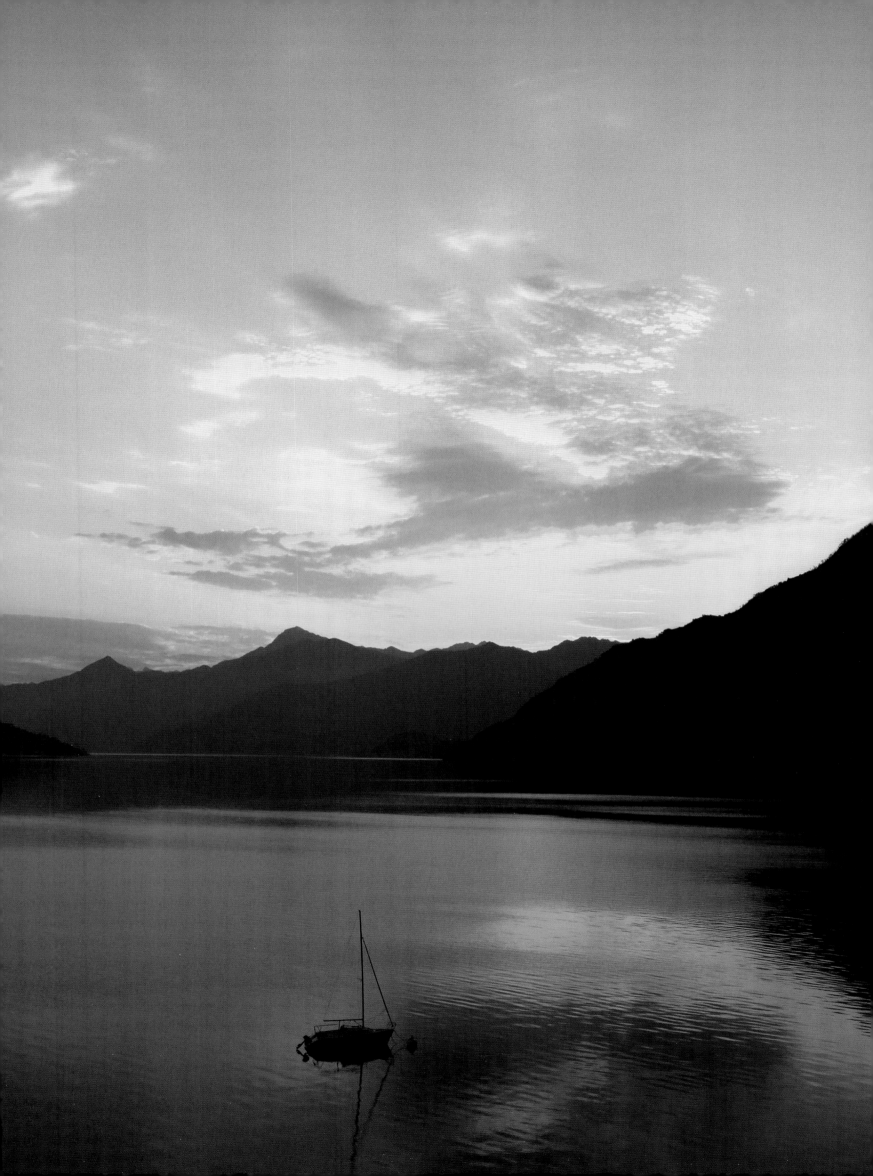

GRAND HOTEL TREMEZZO

'Quel ramo del lago di Como, che volge a mezzogiorno, tra due catene non interrotte di monti,
tutto a seni e a golfi, a seconda dello sporgere e del rientrare di quelli…'
Alessandro Manzoni, *I Promessi Sposi, capitolo I*

'That branch of the lake of Como, which extends towards the south, is enclosed by two unbroken chains
of mountains, which, as they advance and recede, diversify its shores with numerous bays and inlets…'
Alessandro Manzoni, *The Betrothed, Chapter I*

When arriving at Grand Hotel Tremezzo, a 'wow' factor is undeniably guaranteed. This is all the more so when arriving by boat; the shores of *Lake Como* are sure to conquer each guest, with its lush, mountainous greenery and villas nestled in the midst.

Grand Hotel Tremezzo is like a *grand dame*, sitting majestically and proudly in all its beauty on the shores of the lake. This very lake has enchanted generations of poets, musicians and writers and has always been an inevitable destination for the cultural elite and aristocrats that visited Italy during their Grand Tour. At *Lake Como* dreams were created, romances were born, operas were sung, poems were written, all dictated by the charm and magic essence of these shores, of which Grand Hotel Tremezzo is the main interpreter.

This hotel has lived through years of history, born in the years of the belle époque and created by Enea Gandola, who chose the precise spot as it guaranteed the best view of the lake. The desire was to create a hotel which could offer charm and elegance to an elite international clientele that were bewitched by the beauty of the lake and of Italy.

In the 1930s the Sampietro family acquired the hotel and the Grand Hotel Tremezzo continued to welcome an aristocratic and celebrity clientele. Upon entering the doors of the hotel, one can immediately feel like shy Greta Garbo who adored this hotel, and would enter wearing huge sunglasses and haute couture. Her favourite room was 113, now dedicated to her, with a majestic balcony that opens onto a marvellous view of the lake. Her love affair with this hotel was such that she cites it in the film Grand Hotel (1932) as 'that happy, sunny place.'

In 1975 the De Santis family who continue to manage the hotel with the same style and elegance to which it was accustomed to, passing it generation to generation, and most recently to Valentina De Santis, acquired the hotel. Valentina has majestically blended the important history of this hotel with contemporary design elements and furnishings, which guarantee a fresh approach while maintaining the impeccable style and hospitality of this grand property.

169

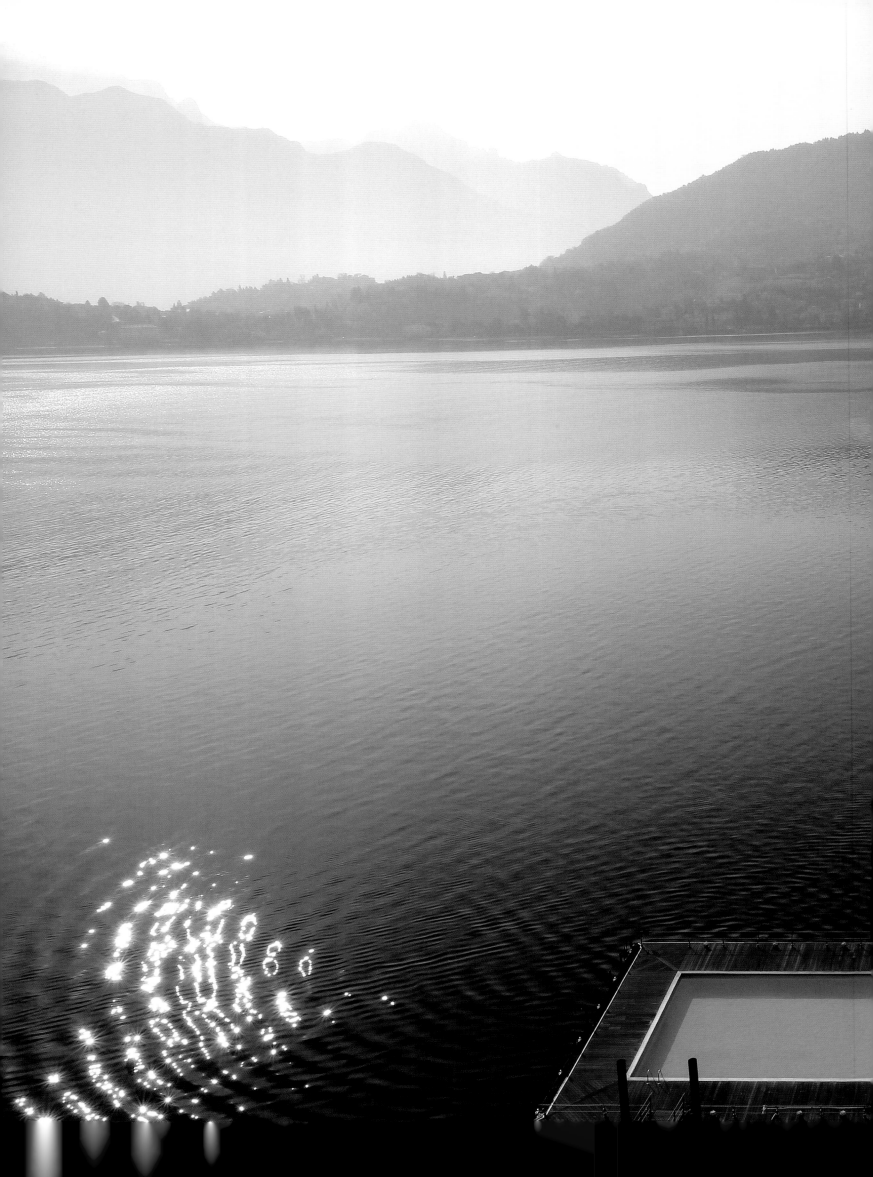

MILAN

Style inspiration: Milan is the city of fashion, of shopping, the city of business and entrepreneurship. Active, fast, contemporary, trend setting, yet, it is also the city of art on which a vast history is nestled, that has left incredible gifts. Milan makes itself loved because of its different vibrations.

BULGARI HOTEL

'...Tut el mund a l' è paes, a semm d'accord, ma Milan l'e' un gran Milan.'
Giovanni d'Anzi, *Oh mia bela Madunina*

'...all the world is like a town, we agree, but Milan is a great Milan.'
Giovanni d'Anzi, *Oh mia bela Madunina*

A better location could not have been chosen for the launch in 2004, of the first hotel from luxury hotel group 'Bulgari Hotels and Resorts'. The ambitious refurbishment project saw the external and internal areas of this majestic building in the heart of *Milan* being completely renovated by Antonio Citterio, architectural master of design, with Patricia Viel and partners.

The stucco facade of the building manages to perfectly blend in symbiosis with the 18th century building juxtaposed against the typical 1930s buildings facing Bulgari.

Strict lines and elegance, accompanied by a motion of lightness are the leitmotivs of this jewel located on a private street in-between the grand dames of fashion: *Via Montenapoleaone* and *Via della Spiga* and the equally striking culture and art havens such as *La Scala* and *l'Accademia di Brera*.

The reception, with its series of large windows and mirrors faces the entrance courtyard, creating a perfect blend between the inside and outside of this fashion hotel. The harmonious lounge sees as its protagonist a striking fireplace in black marble from Zimbabwe.

Guests are awakened with a poetic vision as the windows reflect the scenography of the grandiose 4,000-squared metre private garden, an oasis in the heart of the cosmopolitan city. The garden, a natural extension of the nearby botanical garden, was first mentioned in 1305 in the Ruralium Commodorum of Piero de Crescenza. In this very garden, three peaceful spaces have been created in the midst of the greenery perfectly adapted to host private events.

The aperitivo at Bulgari is a 'must' when visiting *Milan*. The bar is transformed into a fashionable meeting place for hotel guests and locals, where you can enjoy the true essence of this unforgettable city and of course the exclusive Bulgari Cocktail. A small library in the lounge space offers invaluable information about the city for the most curious guests.

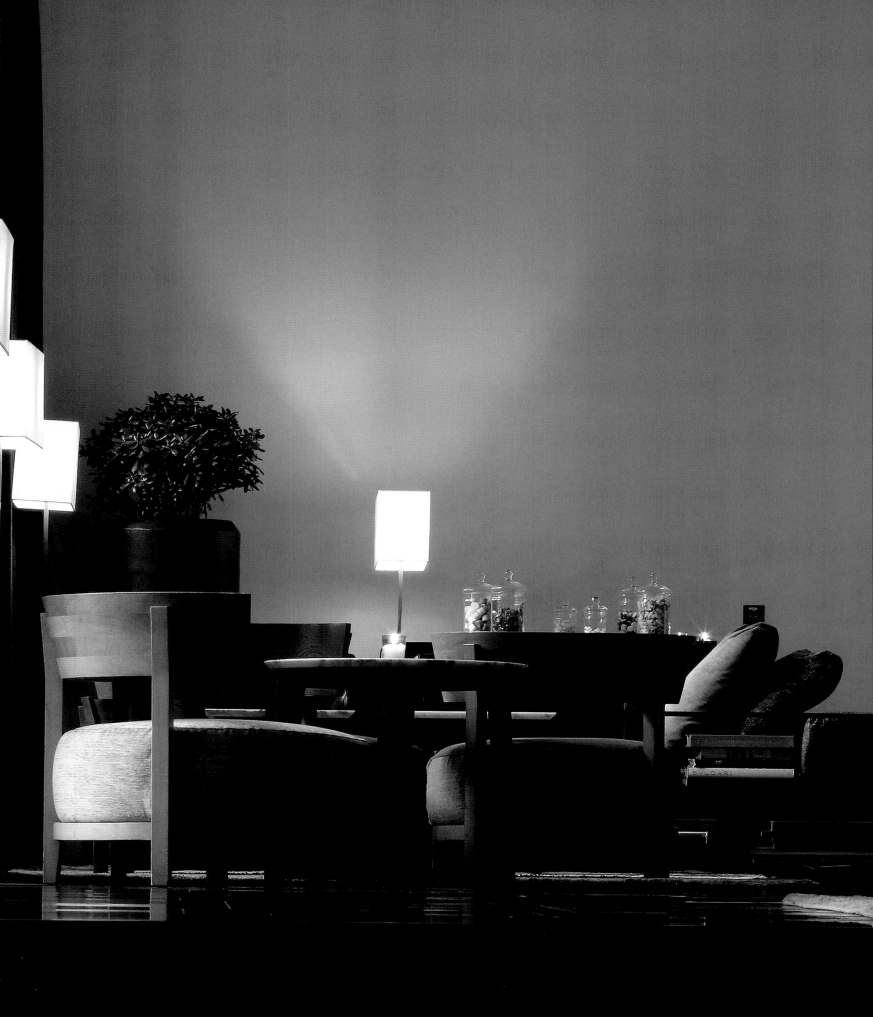

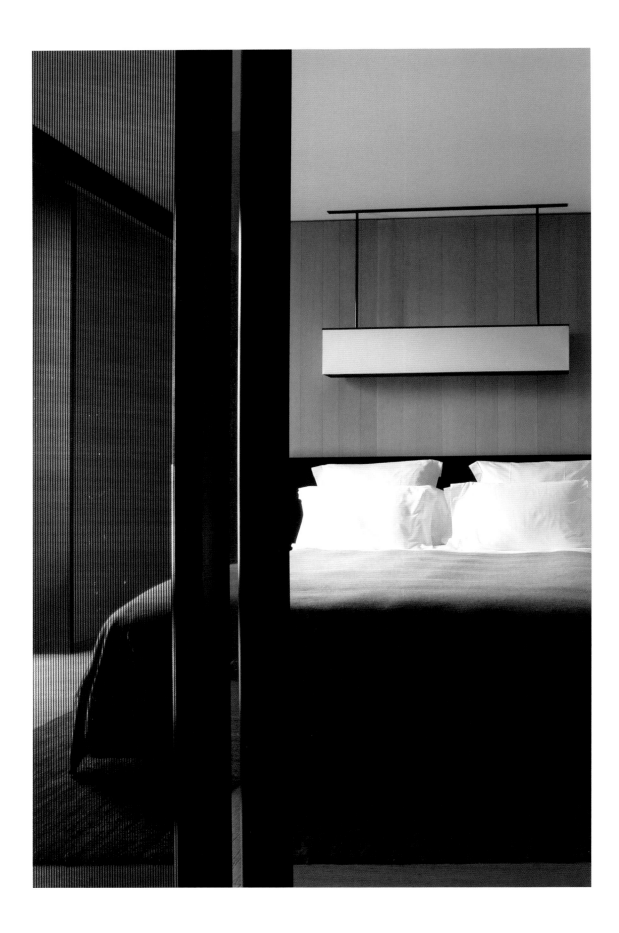

The fifty eight rooms where a chromatic scale of light tones with white durmast blend perfectly with the warm, natural tones of the materials and solid oak floors, strike a contrast with the black, granite bathrooms. To create further authenticity, the furnishings were all specially designed by leading Italian designers B&B Italia. What is striking about the rooms is the incredible luminosity offered by the ample windows that give a sense of warmth and grace. Throughout the whole hotel and in keeping with the philosophy of the Bulgari brand, the taste of grand Italian tradition is infused with that of contemporary Italian design.

The bar area facing the spectacular glass wall offers guests an unparalleled view of the outdoor terrace and the garden, with a unique lenticular ceiling over the beautiful oval bar in black resin.

The restaurant is a contrast in itself, minimal yet luxurious, where the menu is majestically composed by Chef Roberto di Pinto, mixing traditional Milanese delicacies with a grand wine list able to satisfy even the most exigent client.

If instead it is a moment of relaxation you are looking for, the Bulgari Spa is certainly the ideal place, where the indoor pool is bathed in natural sunlight from the glass walls, offering dreamy gold reflections on the solid gold mosaic floor. The Hammam, on the other hand, is furnished with Afyon stone seats sourced directly from Turkey.

Undoubtedly this is a hotel that is out of the ordinary, offering guests an immaculate style and elegance, with flawless attention to detail and the precious elements for which Bulgari is famous.

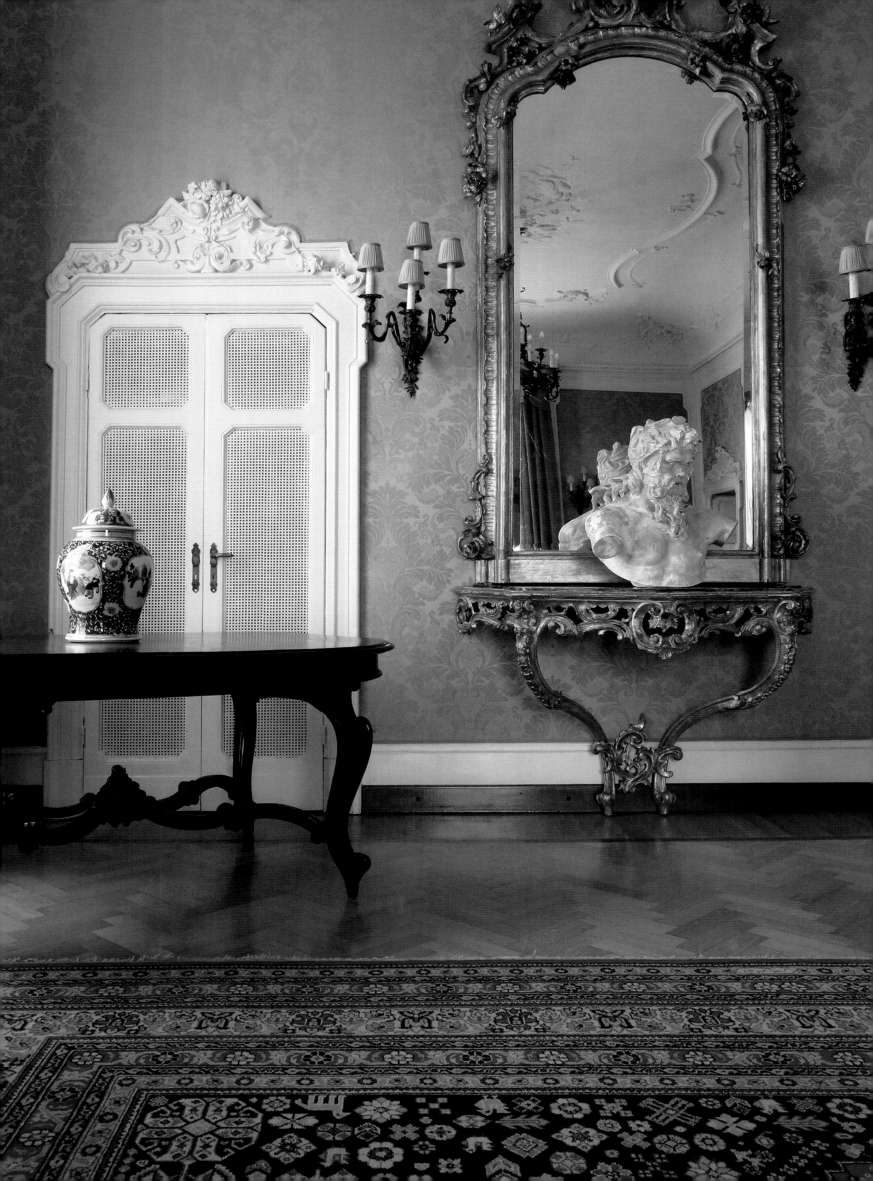

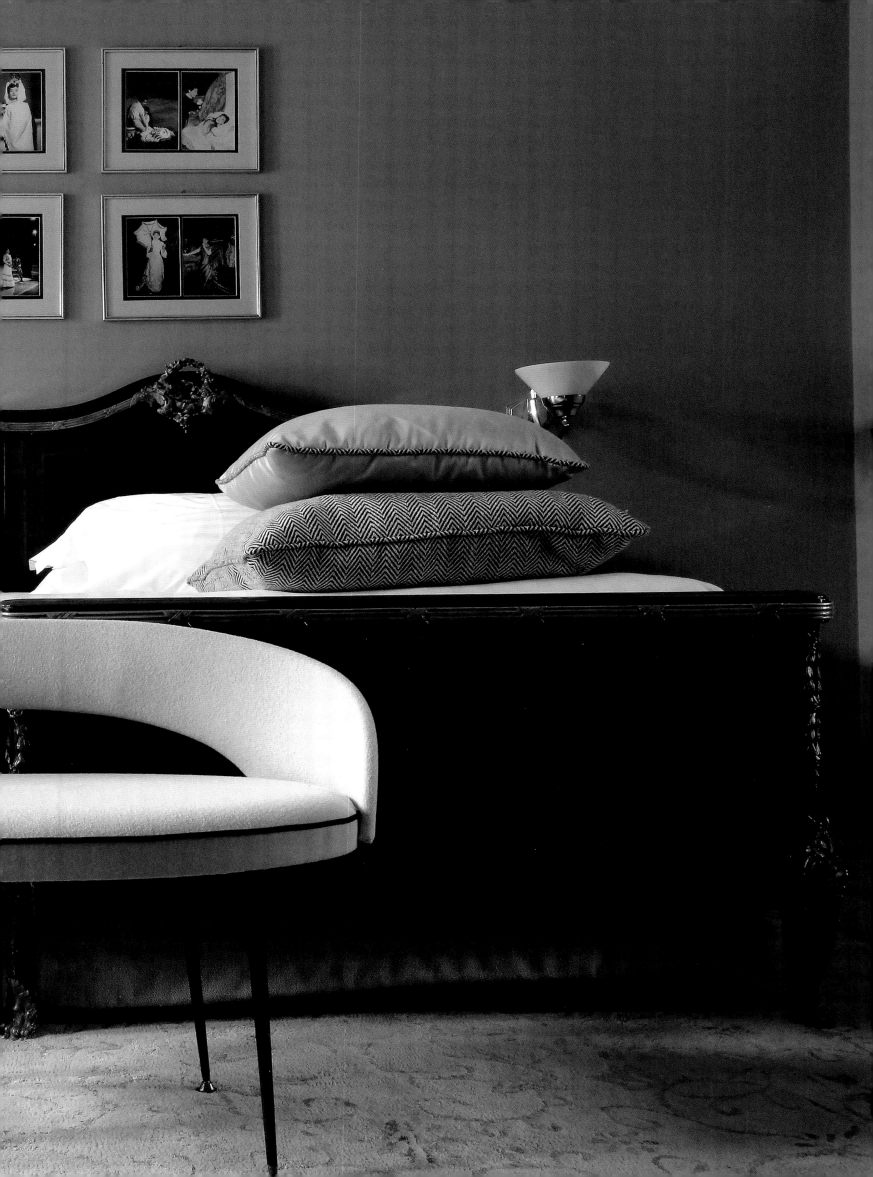

At Grand Hotel et de Milan, an endless list of great personalities who have shaped history have come to relax and live the true spirit of the city: Ernest Hemingway, Maria Callas, Sophia Loren, Stendhal, Nureyev...

Seventy three rooms and twenty two suites, each with a refined and elegant décor, still maintain a contemporary touch and a particular attention to detail that only 'made in Italy' haute hotellerie can provide.

The hotel's hall is as grand as one would expect, with the same refined retro atmosphere that characterises the whole of this establishment.

The two hotel restaurants are rightly dedicated to the Italian opera with the Don Carlos gourmet restaurant offering a delicate and suffused atmosphere, with walls adorned by sketches and paintings of *La Scala*, making it the perfect gourmet restaurant for a post-theatre dinner. Whilst Il Caruso on the other hand is more informal, with a marvellous veranda facing the greenery of *Piazzetta Croce Rossa*, located in front of famous *Via Montenapoleone*.

If one wants to live and breathe the atmosphere of a 'grand Milan' this hotel certainly does just this, and perhaps whilst enjoying a moment or two of silence, guests can fall asleep listening to the notes of the magnificent Maestro playing his pianoforte.

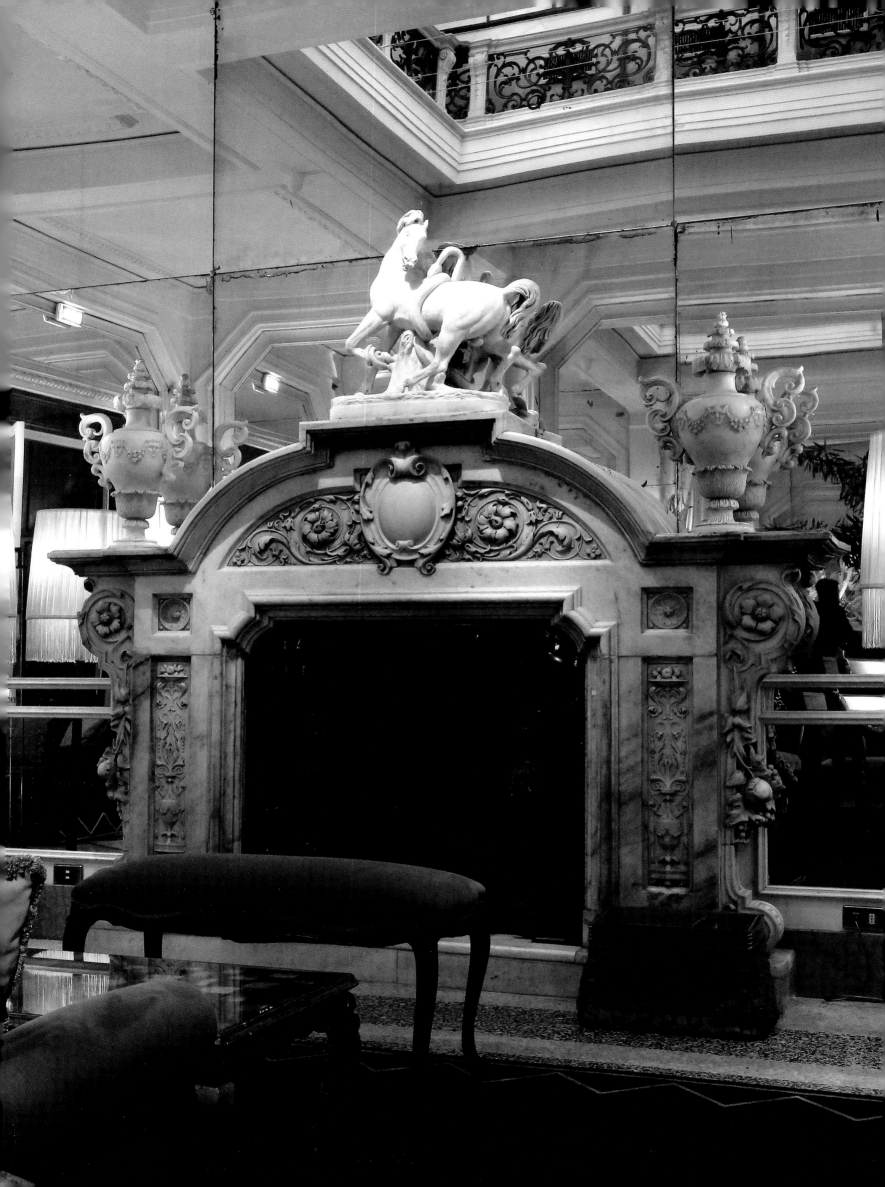

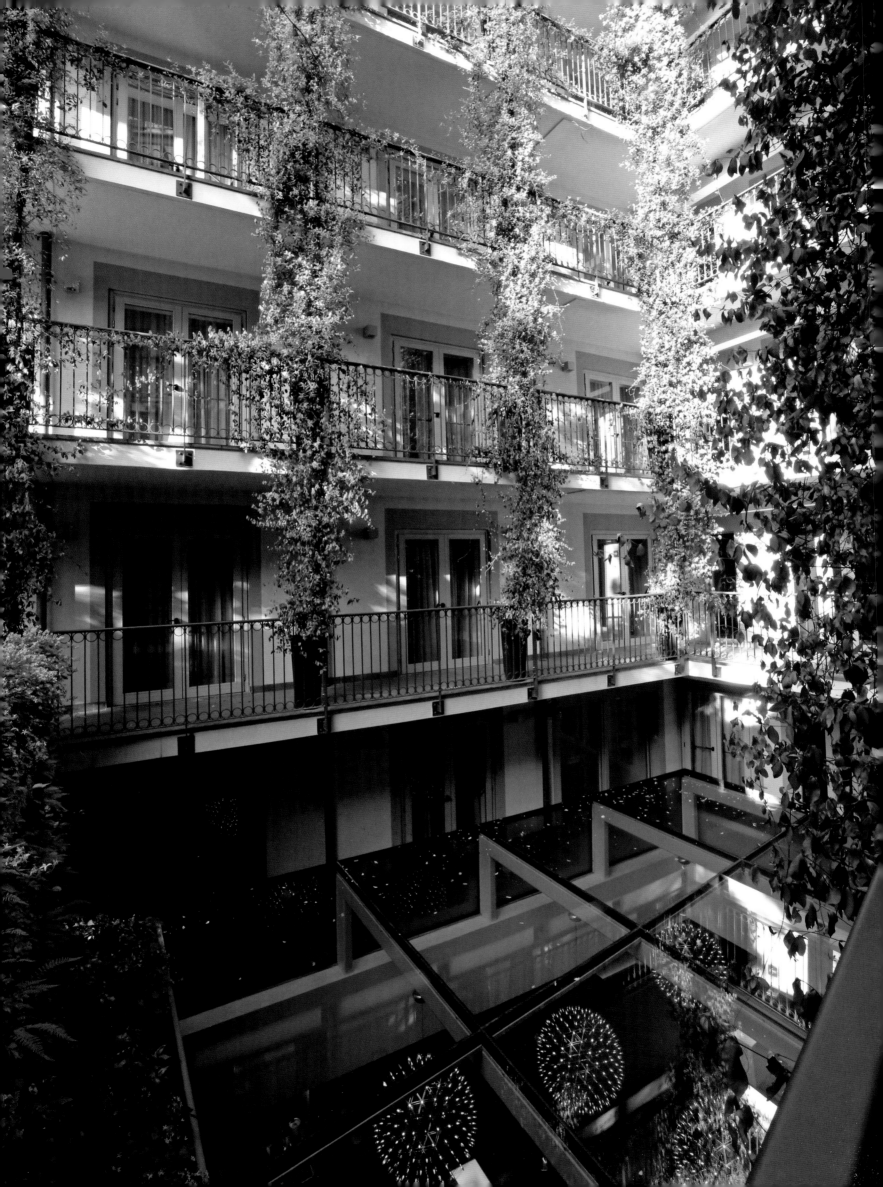

HOTEL MILANO SCALA

Peppino: 'Bello questo che sarà il municipio?'
Totò: 'No questa sarà la Scala di Milano'
Peppino: 'E dove sta?'
Totò: 'Che?'
Peppino: 'La Scala'
Totò: 'Ah e starà dentro no?!'
Dal film Totò, Peppino e la Malafemmena (1956)

Peppino: 'Beautiful what is this, the town hall?'
Totó: 'No, this is La Scala of Milan'
Peppino: 'And where is it?'
Totò: 'What?'
Peppino: 'La Scala'
Totò: 'It's inside, no?!'
From the film *Totò, Peppino e la Malafemmena* (1956) where there is a play on the word Scala, which
is the most famous theatre of Milan but also literally means staircase in Italian.

In the heart of the *Brera* district, in the *Milan* of artists that populated this area and attended the famous *Accademia delle Belle Arti*, the urban style Hotel Milano Scala can be found. *Brera* is now one of the most 'hip' districts of the city, where art continues to influence the area and where charming and exclusive artisanal, artistic boutiques fill its small, cobbled streets and blend with the fashionable, international boutiques that have learnt to call *Brera* their home. An immense selection of restaurants and bars open up onto *Brera*, and allow visitors and locals to enjoy an open-air *Milan* where it is typical to enjoy an aperitivo and people-watch.

This eclectic hotel is only a few steps away from the world-famous *Scala* Opera House, and the very name of the hotel affiliates it with the grand opera house and its unforgettable Italian operas.

Large blow-ups from *La Scala's* historical archive decorate the walls of the hotel without invading the precious space, and remind guests of the success of this jewel in the crown of *Milan* and its Italian Maestros – from Giuseppe Verdi to Giacomo Puccini and Vincenzo Bellini.

Most of the rooms face the ancient internal courtyard framed by jasmine blossom, and some even boast a balcony with a view of the *Brera* rooftops and the imposing *Castello Sforzesco*. Modern and classic meld together, and the dark red textures strike contrast with the large windows as if representing a theatre stage.

The suites are dedicated to the world of opera and each carries a unique name: Don Giovanni, Madame Butterfly and Aida. Some are housed over two floors with transparent balustrades leading to the mezzanine. Warm wood tones and perfumed candles, Jacuzzis and iPod speakers guarantee that guests can relax and be transported from an opera aria '...ma nel ritrar costei, il mio solo pensiero, il mio sol pensier sei tu, Tosca, sei tu!'

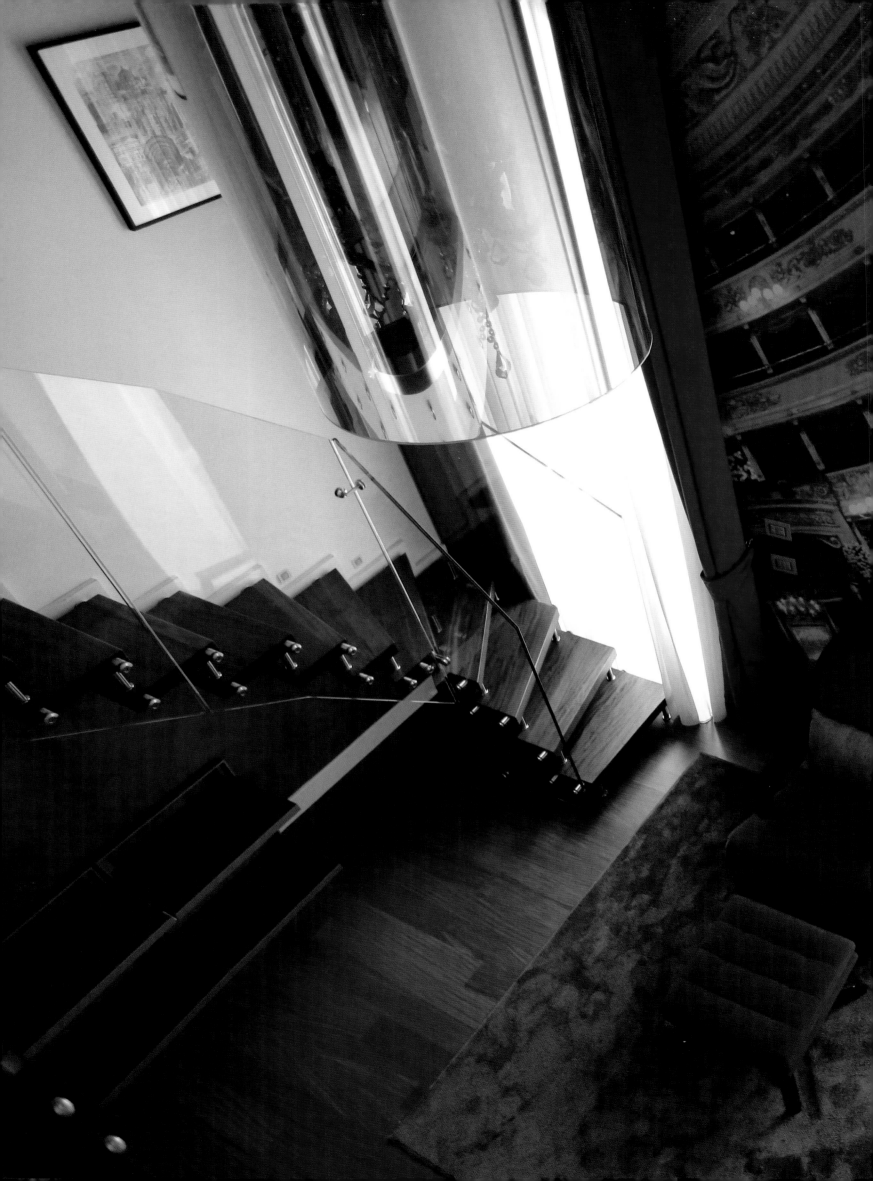

Music is the leitmotif of Hotel Milano Scala and in the morning a live concert accompanies the unrivalled Italian espresso. If in between a shopping spree, a gourmet dinner and an opera concert there is some time left, the hotel offers its guests a library with a crystal roof that opens onto the vertical garden above – a dream!

The urban contemporary style of this hotel can be especially felt in the restaurant Prima Donna, that guarantees unforgettable meals prepared with organic products and seasonal ingredients all grown under 100km from the hotel. The thread that ties music to food can be admired from the wallpaper, all strictly in keeping with the musical theme.

The spectacular terrace on the 8th floor of the palace guarantees a 360-degree view. An aperitivo cannot be missed whilst admiring *Milan* from the sky with the *Duomo* gargoyles, the *Castello Sforzesco*, the vivacious *Brera* district, and the view extending to the newly built, designer skyscrapers that frame this contemporary part of the city.

Perfectly in line with today's trend, Hotel Milano Scala has adopted a 'green' philosophy and has become the first zero-emissions hotel in the city; it even has a small vegetable garden hanging between two floors.

The rules of the house for guests can be found in the lift: 'laugh a lot, never give up, do what you love…', which seems just like the perfect philosophy to have in mind when going out to enjoy all that this splendid city has to offer.

STRAF HOTEL

'Renzo salito per un di que' valichi sul terreno più elevato, vide quella gran macchina del duomo sola sul piano, come se, non di mezzo a una città, ma sorgesse in un deserto; e si fermò su due piedi, dimenticando tutti i suoi guai, a contemplare anche da lontano quell'ottava meraviglia, di cui aveva sentito parlare fin da bambino.'
Alessandro Manzoni, *I Promessi Sposi, Capitolo XI*

'Renzo mounted by one of these passes to the more elevated ground, and, looking around him, beheld the noble pile of the cathedral towering alone above the plain, not as if standing in the midst of a city, but rather as though it rose from a desert. He paused, forgetful of all his sorrows, and contemplated thus at a distance that eighth wonder of the world, of which he had heard so much from his infancy.'
Alessandro Manzoni, *The Betrothed, Chapter XI*

It's a totally new *Milan*; hip, vibrant, aggressive and unique which is offered by Straf hotel. The hotel is located literally in the shadow of the symbolic monument of the city, the solemn *Duomo*, elegant with its array of gargoyles, pinnacles, majestic arches, and marvellous stained-glass windows; a stupendous testimony to the gothic period. Indeed, it is the second-largest gothic cathedral in Europe, counting more than 3,500 statues.

This hotel is located in an unparalleled position at the centre of all that *Milan* can offer: art, history, fashion, shopping in the famous 'quadrilatero della moda', and one of the world's most famous opera houses, *La Scala*.

The contrast in style of the architecture of *Milan* and the concept of Straf is certainly striking. Straf was born from the idea of architect and designer Vincenzo de Cotiis, in which he adopted his aesthetic concept of 'perfect imperfection'. He has magnificently transformed a 19th century palace into a design destination, a hotel that is a work of art.

'Raw' is perhaps the word that best describes the work of this designer; the cement used for the staircase and pavements, the oxidised brass, the dramatically cut slate all offer an amazingly warm atmosphere, even in the presence of such hard materials.

The elements appear as though they have not been completed, but this is only their immediate appearance. There is a defined precision in the rawness of the finishes of this hotel, the association of unexpected colours blend with the precious materials, raw and at times wild, but always holding intense power.

Straf is undeniably removed from all standards. Materials combined according to two strands characterise the rooms: slate or cement teamed with oxidised brass, and walls with scratched mirrors enlarge the rooms in a game of dilated spaces using illusions of perspective.

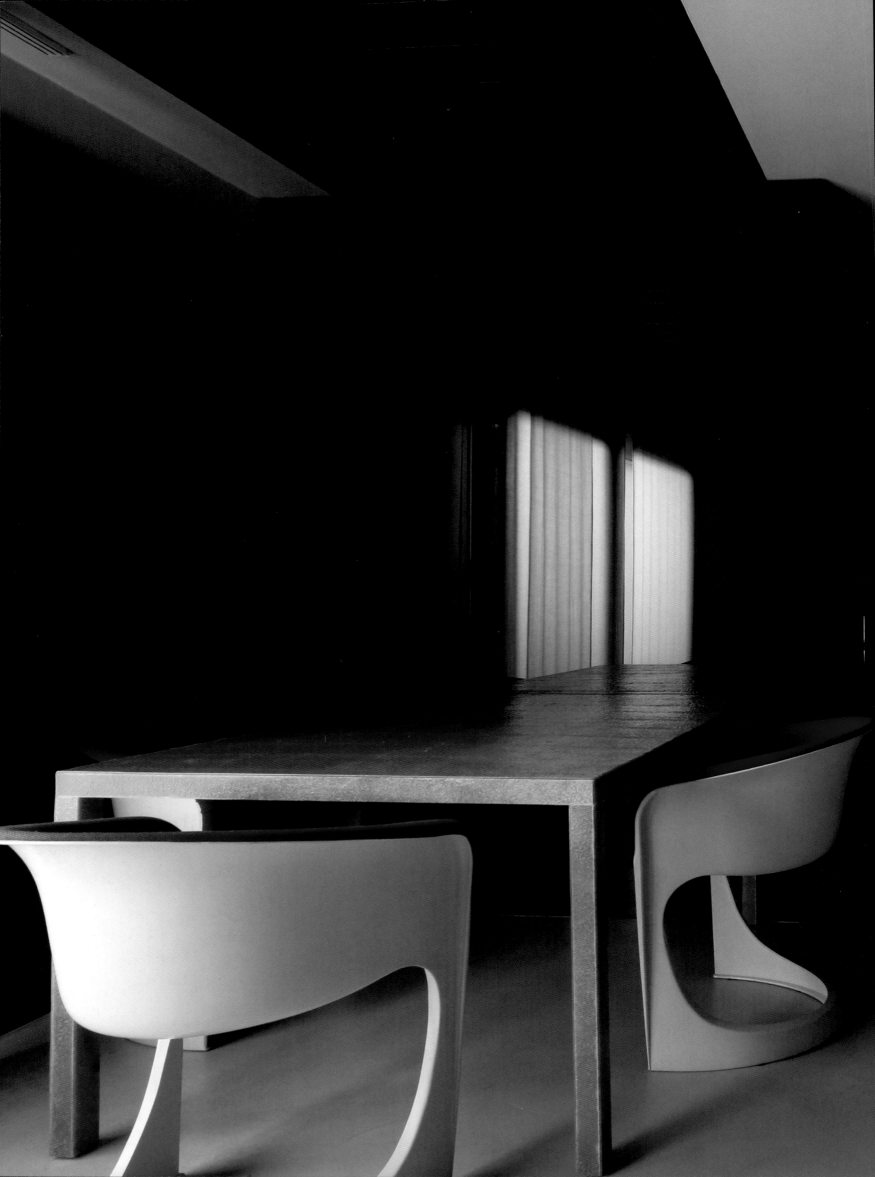

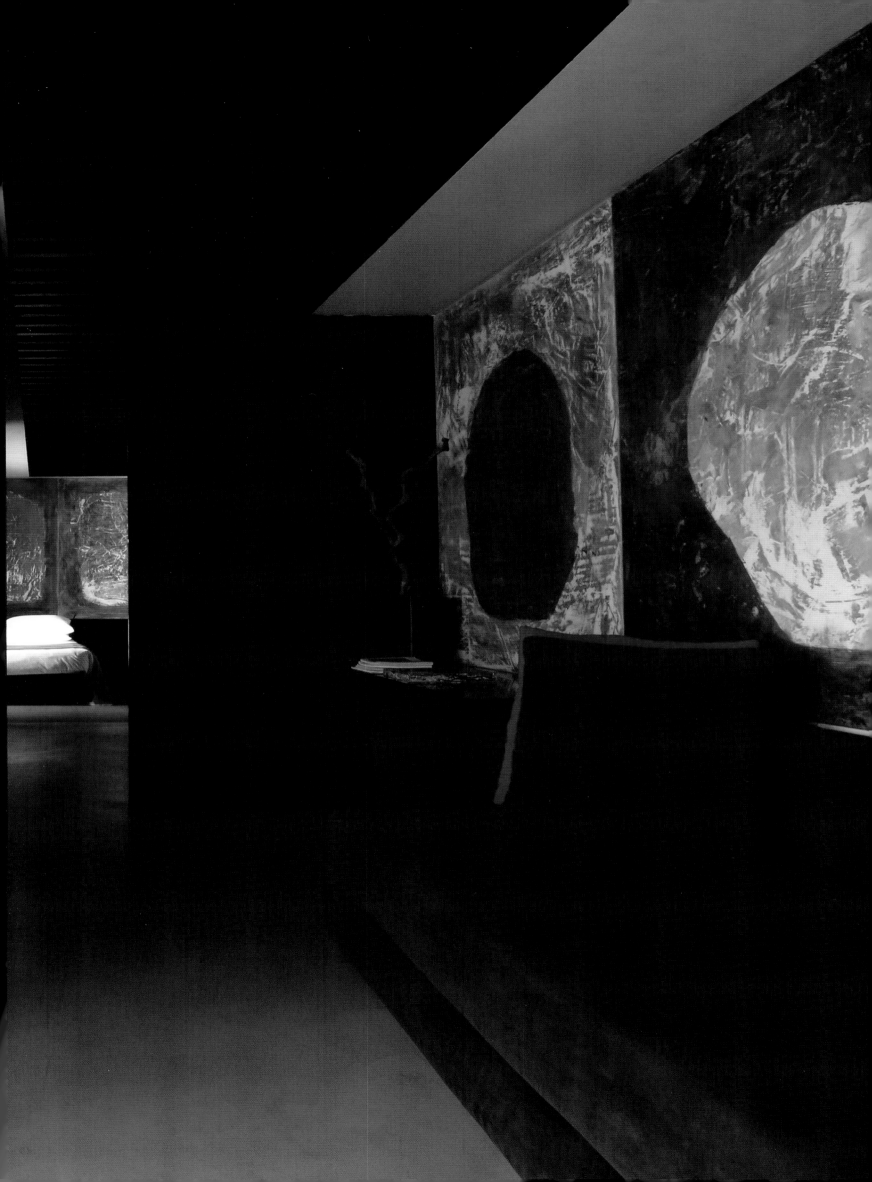

Continuing with the concept of the 'extraordinary', some of the rooms have ample relaxation areas fitted with deckchairs providing integrated tailored massages, aromatherapy and chromotherapy fittings, all harmoniously separated from the sleeping area with crystal walls that reveal the grand dimensions of the rooms. Modern, scratched mirrors and bespoke hand basins adorn the bathrooms.

The 'escape' of Straf from the concept of ordinary hotel standards can be perceived in each element of the interiors from the furnishings to the fittings so that it is realised in a unique and exclusive manner.

As *Milan* is the city of the aperitivo, in such a cosmopolitan hotel a fashionable bar has to be included. The Straf Bar follows the same style as the rest of the hotel, with raw materials, cement walls and pavements adorned with industrial iron panels to accompany the live music and art installations. Many vintage and contemporary pieces can be found, such as the original bright green Plexiglas chandeliers from the 70s and the shaped panels in recycled fiberglass. The atmosphere is lively every night of the week, especially during the warm summer evenings where cocktails are accompanied by live music outdoors.

This hotel has an haute couture concept, where nothing is defined, where new designs dazzle each guest. It is certainly a unique find for a traveller looking for a hotel that defies convention.

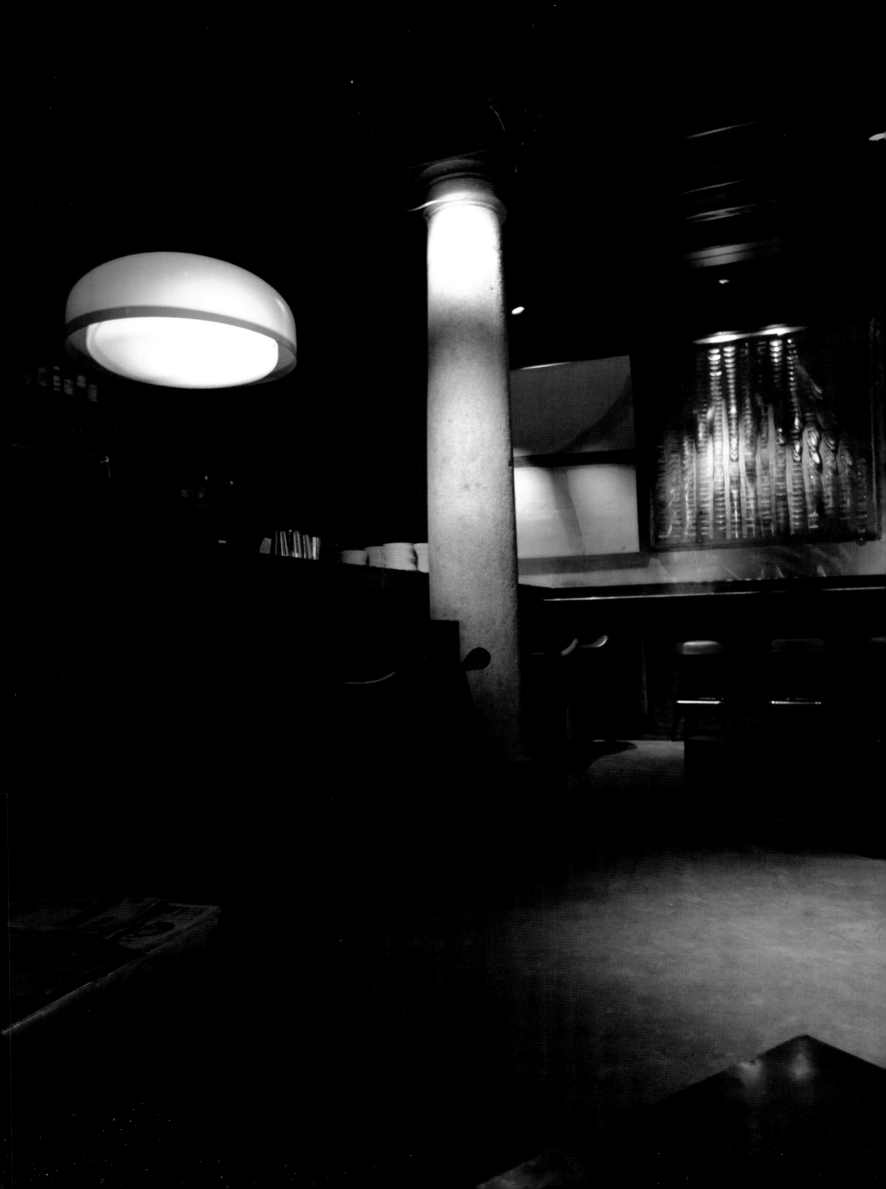

PIEDMONT

Vineyard inspiration: The rolling hills covered in vineyards with a palette of colours offering incredible landscapes during every season, so magical that they gained UNESCO heritage status. Charming landscapes rich in history and culture.

LA VILLA

'Day-coloured wine,
night-coloured wine,
wine with purple feet
or wine with topaz blood,
wine,
starry child
of earth,
wine, smooth
as a golden sword,
soft
as lascivious velvet,
wine, spiral-seashelled
and full of wonder…'
Pablo Neruda, *Ode to Wine*

This is the postcard-perfect Italy, that of rolling hills and vineyards, a landscape that leaves each visitor breathless. This is the essence of a countryside that is 'made in Italy', where man has worked the land for centuries in harmony with nature to create this exceptional land of universal value.

Nestled between the *Monferrato* hills embroidered by rows of vineyards, a dream became reality: La Villa. Chris and Nicola Norton were looking for their ideal holiday home in Italy, when they literally fell in love with these hills, and here they found a palace dating from 1600 that had been completely abandoned. A real 'coup de foudre', that saw them move to Italy with their two daughters, even if their knowledge of Italian did not go further than 'grazie'. The restoration and conversion of this old palazzo was an enormous challenge, and this holiday home soon became a stupendous country mansion. A place that is not only aesthetically beautiful, but also a warm and friendly family home. Indeed, creating happiness was the thread that Chris and Nicola used when creating La Villa.

It is certainly joy and warmth that immediately strikes guests when arriving at La Villa, each corner is permeated with it. Each of the villa's fourteen rooms has a distinct character and is unique. During the restoration process, great attention was paid to not being invasive towards the original features of the palazzo, trying to maintain each immaculate detail and not lose the sense of history that La Villa offers its visitors.

The colours are soft and the choice of furnishings and materials create a balanced harmony of peace and calmness with which La Villa is copiously gifted. Even the bathrooms strike a perfect equilibrium between antique and contemporary, where antique washstands sit alongside luxurious rain showers and romantic bathtubs are placed to take full advantage of the impressive view of the enchanting hills.

Indeed, the scenery here is so unique it is little wonder that UNESCO has chosen the landscapes of nearby *Monferrato*, *Langhe* and *Roero* to be listed as World Heritage areas.

PUGLIA

Divine inspiration: The lush greenery and deep blue sea, an incredible union for this region placed between the Orient and the Western World. With two seas crowning it, the Adriatic and the Ionian, where history, tradition, nature, beaches and coastlines blend in an enchantment that will keep you coming back for more...

MASSERIA ALCHIMIA

'O Puglia Puglia mia, tu, Puglia mia, ti porto sempre nel cuore quando vado via, e subito penso che potrei morire senza te. E subito penso che potrei morire anche con te.'
Caparezza, Rapper & Cantautore

'Oh Puglia, my Puglia, you are my Puglia, always in my heart when I leave you and I immediately think that I could die without you. And I immediately think I could die even with you.'
Caparezza, Rapper & Songwriter

The turquoise colour of the sky, the deep blue shades of the sea, the colour palette of the land, this is the perfect 'alchimia' (alchemy) of *Puglia*, the heel of the Italian boot. It is from the alchemy of love for this land blended with the original creativity of Caroline Groszer, owner with Swiss origins but a strong 'made in *Puglia*' spirit, that Masseria Alchimia was born. An ancient monastery, later transformed into a girls' college, this building from the 19th century has been knowledgably transformed into a property where a traveller can live, not stay, in this wonderful, rural part of Italy. Ideal for anyone wanting to have their own privacy and independence whilst on holiday, almost like being at home but with all the excitement and emotions that staying in a new place can bring.

The location is ideal, the masseria is perched on a green oasis yet only a few kilometres away from the closest town, *Fasano*, with its adorable boutiques and only a few steps away from the crystaline sea.

Colours are the key element at Masseria Alchimia, where both mother nature and Caroline majestically blend them to create a design experience. The pristine white building combines with the lush greenery of the Mediterranean countryside characterised by the century-old olive trees. All five senses are employed when staying in this unforgettable paradise: the aroma of uncontaminated nature, the extraordinary colours, the silence, which is only broken by singing cicadas, the taste of the delicacies that can be sampled only in this part of Italy, and the astonishing taste of the sun-kissed wine that blesses this region.

The design philosophy at Masseria Alchimia is finding a balance between the past and the present. Caroline has used traditional materials and infused them with contemporary interior design. The interiors include pieces by Ron Arad, Charlie and Ray Earnes, Verner Panton, Philippe Starck and Sory Yanagi, to name but a few.

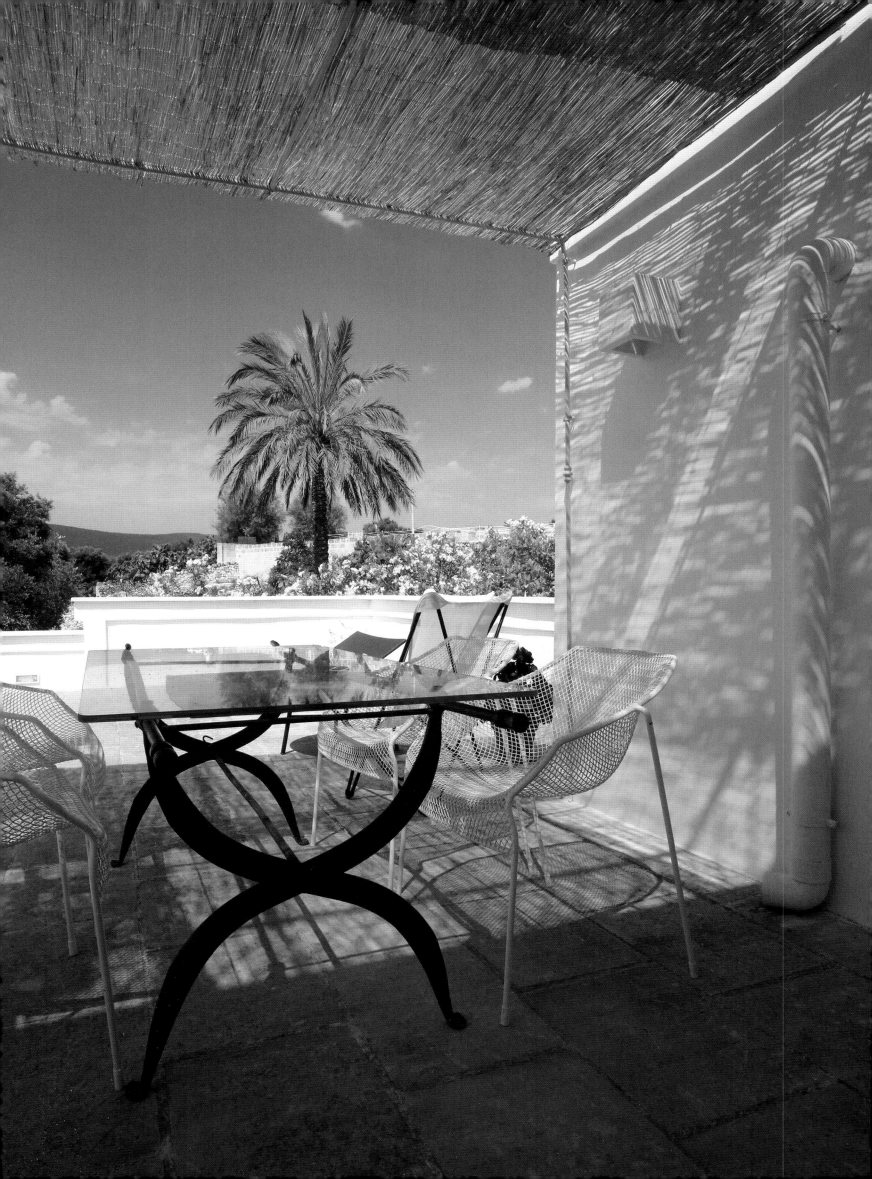

MASSERIA MONTELAURO

'Quannu canta la cicala, fuci, fuci, alla culummara, quannu canta il cicalone, fuci, fuci, allu cippune.'
Filastrocca salentina

'When the cicada sings, run, run, in the fig tree orchard, when the cicada sings, run, run, in the vineyard.'
Traditional nursery rhyme from Salento

A holiday between countryside and sea, in the splendid *Salento*, between the Adriatic and Ionian seas with the inevitable presence of giant olive trees, constellations of little towns, hamlets and villages that recount the incredible history of this piece of Italy. Here we are in the romantic and historic city of *Otranto* with its majestic cathedral dedicated to Santa Maria Annunziata built in 1088, where a temple used to stand. With a blend of byzantine, gothic and roman influences it is one of the finest cathedrals in the area. Then there is the mighty medieval *Aragonese* castle reinforced by Emperor Fredrick II and rebuilt by Alphonso II of Naples, which is one of the finest sights in the city. Since Roman times *Otranto* has been an important city connecting Italy to the Orient for commerce and trade.

A few kilometres from *Otranto*, in a countryside made of olive groves and Mediterranean greenery, in the uttermost tranquillity, stands Masseria Montelauro. 'Masseria' is the term used to define the farms that were scattered in this area and are characterised by sets of buildings opening onto a communal courtyard. The masserias were a community within themselves, where farmers and their families would live, and where the livestock was kept together with the precious grains in large warehouses. Unfortunately, many have been left in disuse and abandoned, but luckily some have been knowledgably restored and brought back to life, transforming them into boutique hotels and charming properties, as tourism is rapidly growing on the heel of Italy.

Masseria Montelauro, an ancient masseria, was born from the love of this land of Elisabetta and her daughters Caterina and Mercedes, who moved to *Puglia* from their native *Milan*, transforming this masseria into the charming boutique hotel it is today. With an enviable position, perched just two kilometres from the sea, it remains nestled within the lush greenery of the *Salento* countryside.

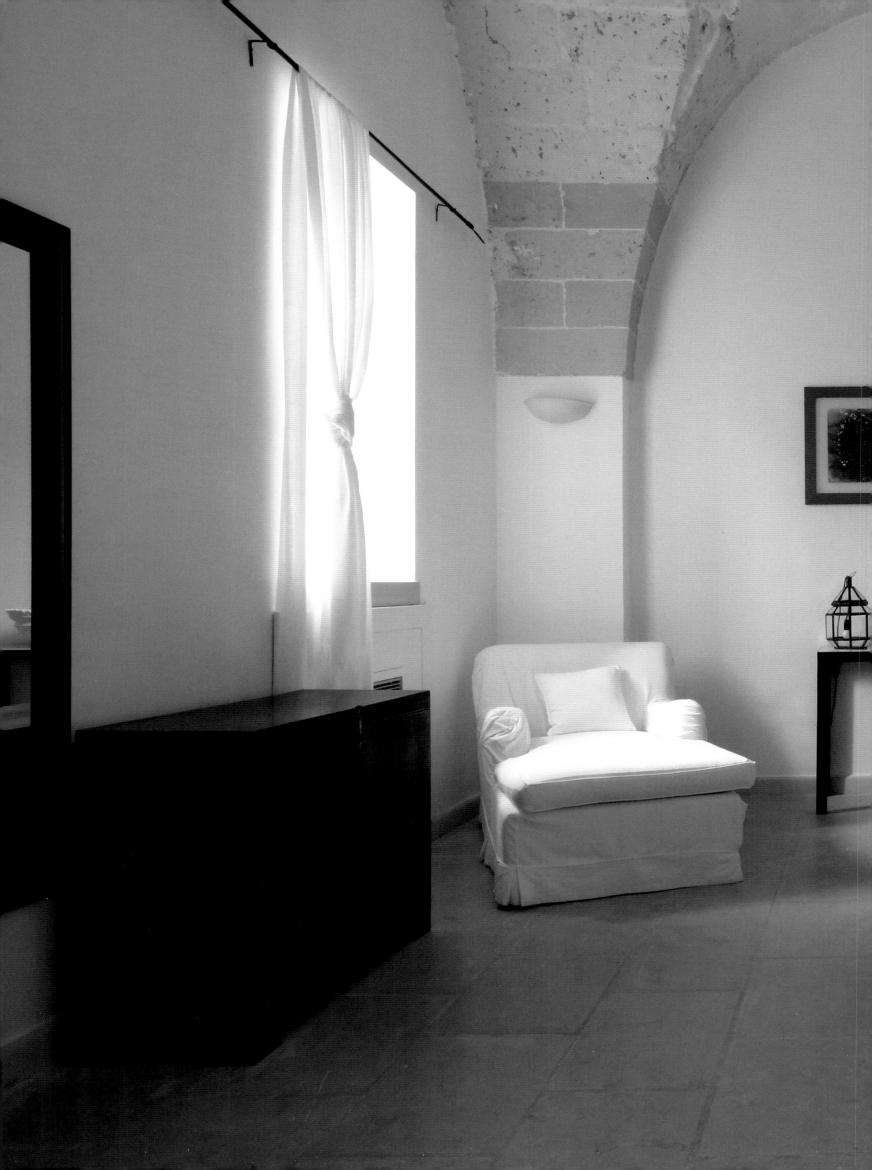

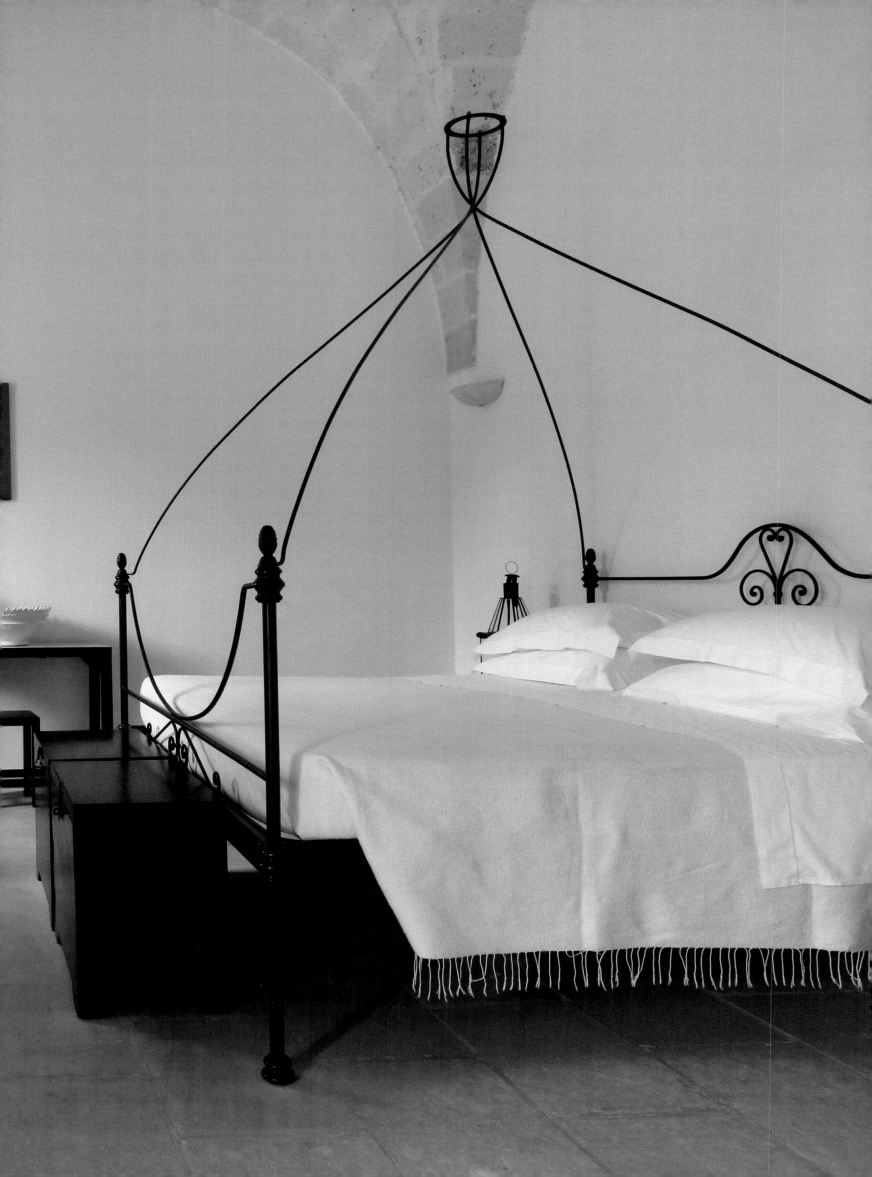

The ancient courtyard of the masseria is now an enchanting garden where guests are invited to relax and grow accustomed to the slow lifestyle of *Puglia*, or to enjoy a swim in the outdoor saltwater swimming pool and then bask in the sun.

Each morning, delicacies are harvested from the vegetable and fruit orchard and are ready to be enjoyed at breakfast or dinner, assuring guests organic and local produce.

The rooms on the ground floor each have access to the garden and adorned with simple furnishings, yet all are extremely elegant and well thought out. The light colours, with a predominance of white, strike contrast with the strong colours of the nature outside and give a sense of freshness during hot, summer days. The beds are all in wrought iron, and add to the traditional atmosphere created by the vaulted stone ceilings. The typical Lecce stone characterises the interiors and the windows are all painted in azure blue as if to remind guests of the wonderful sea outside.

Guests are invited to literally penetrate the warm atmosphere of *Salento* in the little spa and enjoy a massage whilst listening to the cicadas singing. In the evening, perhaps after a visit to one of the nearby beaches or an immersion in the history of *Otranto*, there is no better place to relax than on the masseria's porch crowned with flowers and enjoy the traditional, regional cuisine offered here. Then with a glass of Negramaro wine the evening can be spent looking at the stars and listening to the cicadas, as if suddenly transported into a midsummer night's dream.

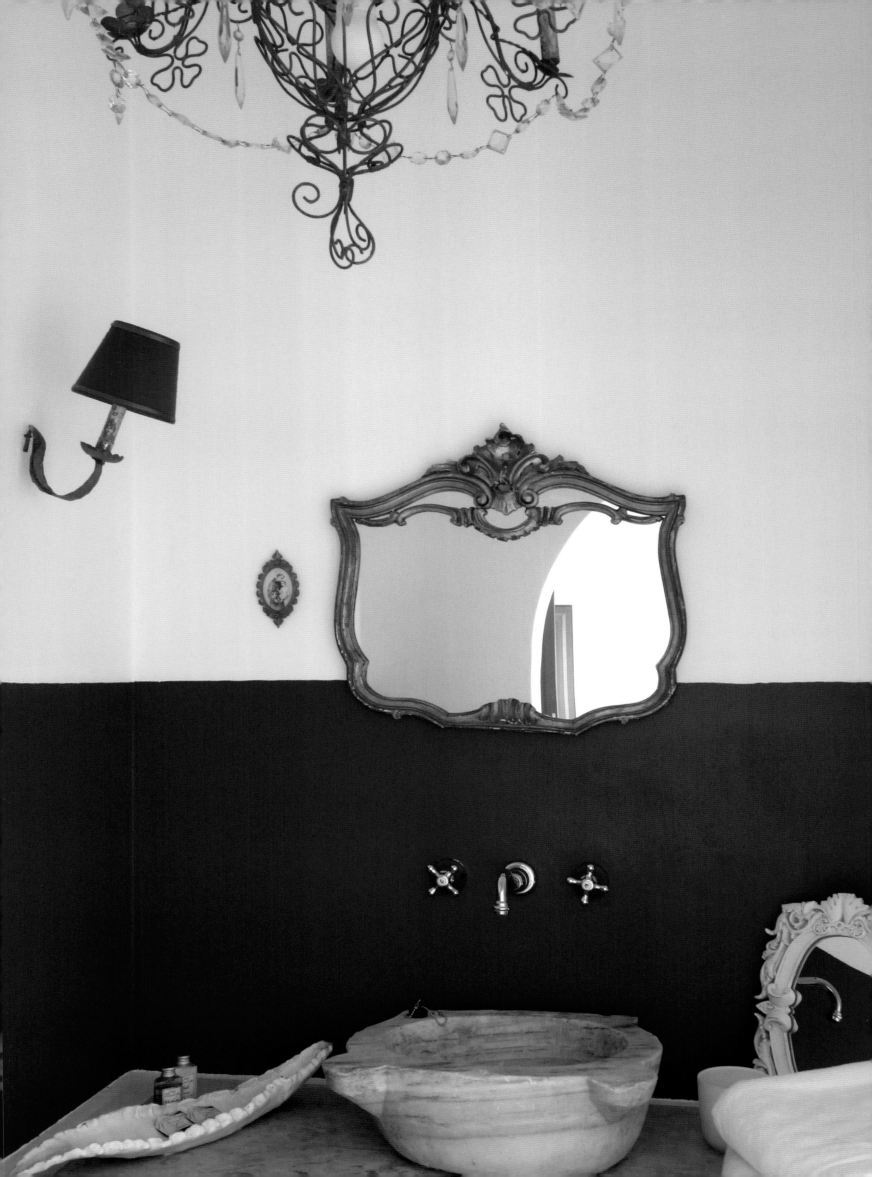

MASSERIA PROSPERI

Masseria Prosperi is another of the incredible creations of entrepreneur Mercedes Turgi Prosperi and her husband Antonio. Having fallen in love with this splendid countryside in the *Salento* they opened the beautiful property Masseria Montelauro. After this proved to be a success they dedicated their time and passions to another masseria, a typical farm of this region, and the result is a charming property for a traveller who wants to enjoy the best that the wonderful sea and enchanting countryside of *Puglia* can offer.

Masseria Prosperi is a few kilometres from the historic town centre of *Otranto* that was classified a UNESCO World Heritage Site in 2010, with its imposing medieval castle, the famous Norman cathedral, its hundreds of little streets and its superb sea view.

The masseria enjoys an ideal location next to the sea, with incredible beaches and cliffs that are unique to the heel of Italy. It is nestled between the greenery of this typical Mediterranean landscape; this area is indeed called *Salento Nascosto* (literally 'hidden Salento'), where a symphony of vegetation extends down to the sea. When the sky is free from clouds and the air is crystalline, the view from the sea out to the Balkans is literally enchanting. This is the ideal location to let yourself be transported by a kite surf, enjoy a horseback ride through the maritime pines or a trek along the coastline.

The philosophy of Mercedes and Antonio is to offer to their guests a new way to experience the countryside, 'our philosophy is simple: to guarantee a unique experience, made of authenticity and intensity'. This singularity can be found in the working farm at the masseria, where donkeys, horses, goats and geese live, and in the evening when sitting outside enjoying a glass of excellent Primitivo wine, a dog or cat will certainly come and ask for a cuddle or to play a game.

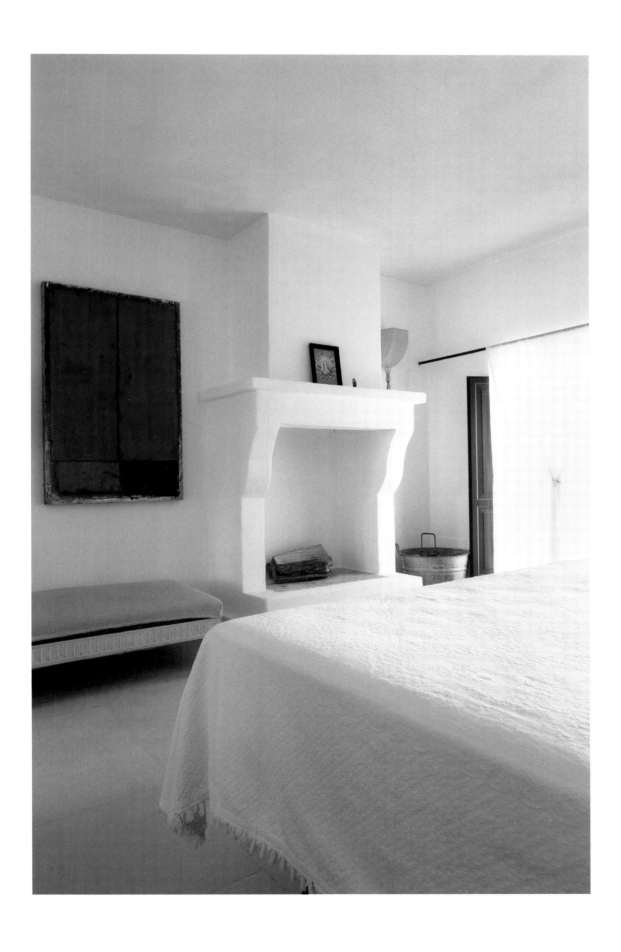

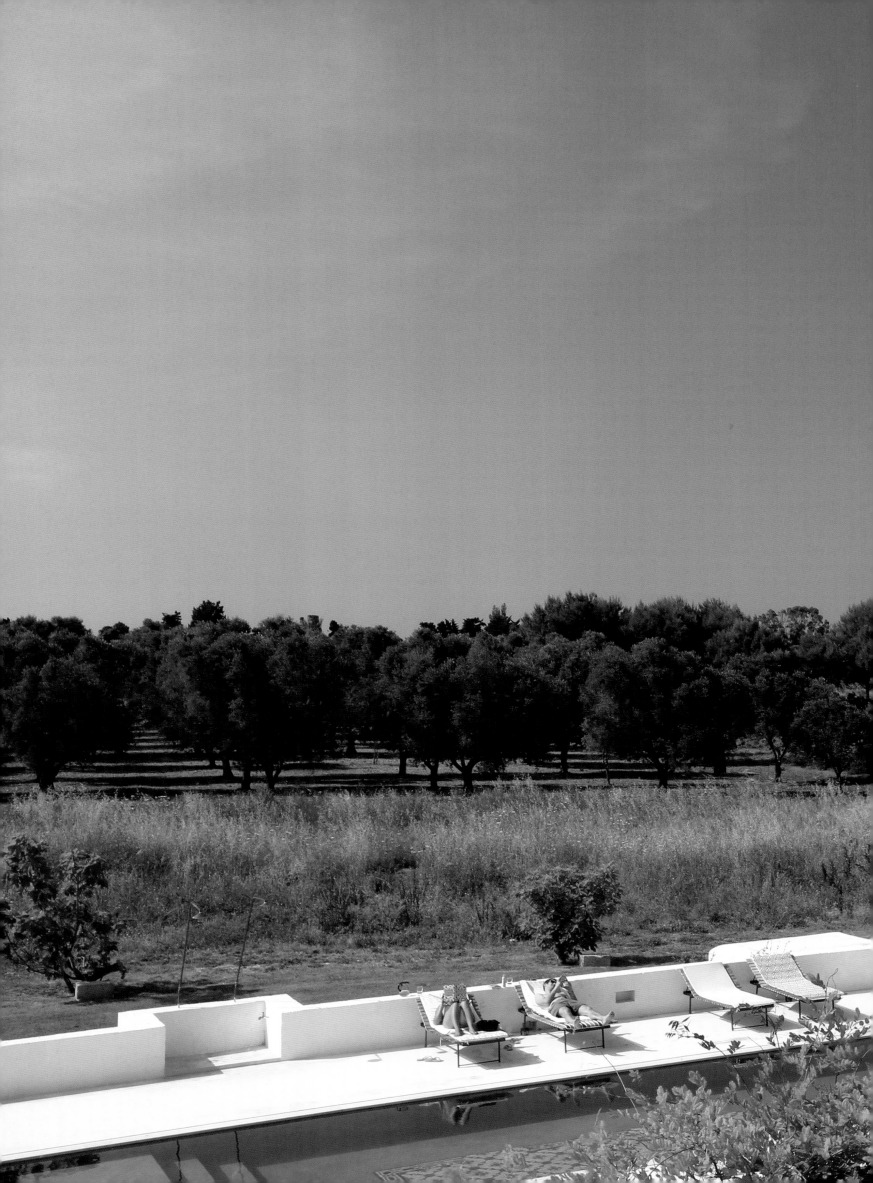

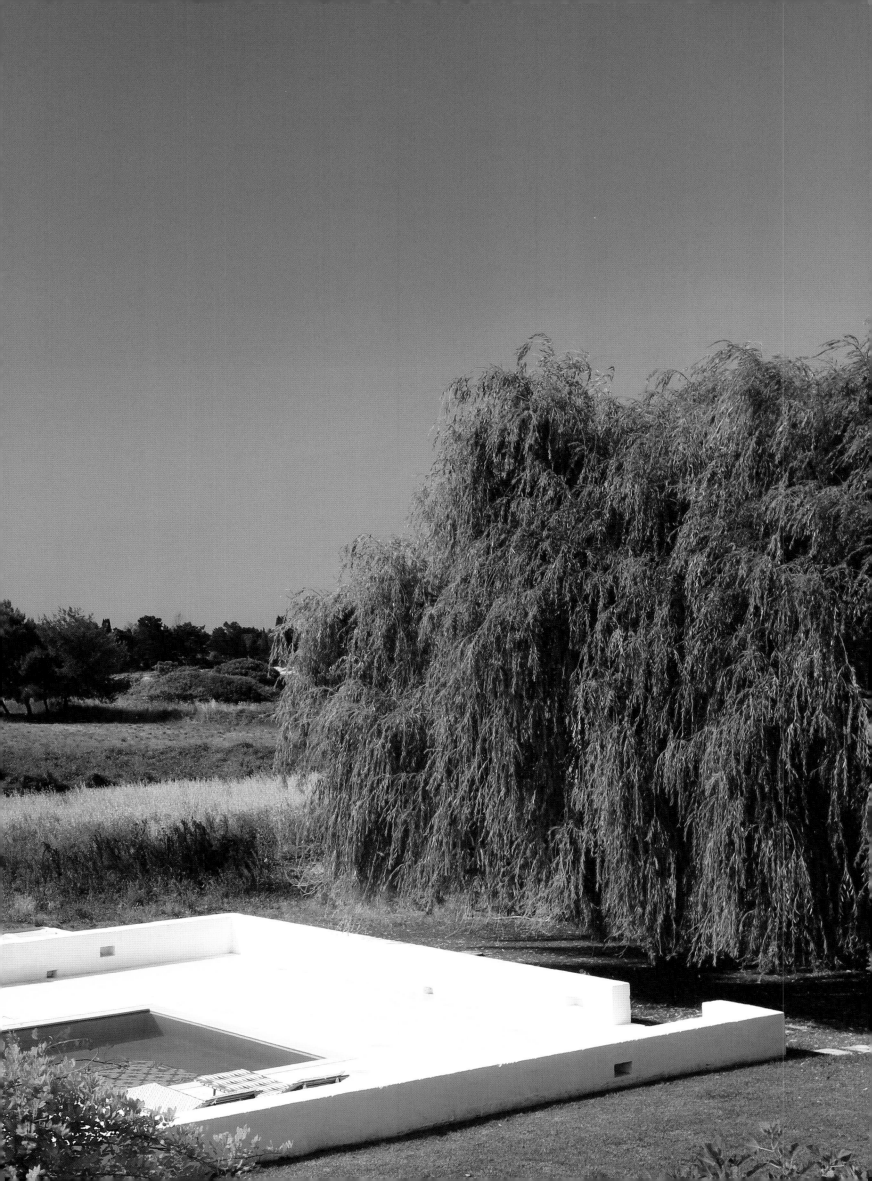

Indeed, this philosophy of a simple country life can be found even in the logo of Masseria Prosperi, which is a stylised donkey.

Coming to this masseria means enjoying the sun perhaps by the outdoor pool, or on colder days enjoying a swim in the indoor heated pool that contains seawater, perhaps relaxing with a massage.

The six rooms are each unique and furnished with extreme care and style, each carrying an element of traditional farm life. Every object is authentic and restored with great care by local artisans. The atmosphere is gracious, and each design element intensifies the country-chic essence. White dominates the colour palette of the rooms, bringing a touch of elegance to the farm.

Lunch and dinner can both be enjoyed outdoors on the patio, with local and traditional delicacies served, such as the unforgettable home-made pasta. Antonio is always around to teach guests recipes and a few culinary secrets, so that it is possible to take home a piece of the *Salento Nascosto*.

If guests want to bring their own horse on holiday, Masseria Prosperi will happily accommodate it as well as give a warm welcome to cats and dogs. Staying at this masseria certainly means living *Puglia* in its authenticity, and living a holiday in a new dimension, which is so desperately needed in today's hectic city life.

BABUINO 181

'A me invece questa Roma piace moltissimo: una specie di giungla, tiepida, tranquilla, dove ci si può nascondere bene.'
Marcello Mastroianni in *La Dolce Vita* di Federico Fellini

'Instead I like this Rome a lot: it's a sort of jungle, warm, tranquil, where one can easily hide.'
Marcello Mastroianni in *La Dolce Vita* by Federico Fellini

Babuino 181, together with Mario de' Fiori 37 and Margutta 54, form the spectacular collection of Rome Luxury Suites, each created by Alberto Moncada. Babuino 181 is the latest example of the collection's ability to transform historical buildings into modern luxury. Indeed, all of these charming properties take pride in their uniqueness; the common thread that unites them is their location in the most sought-after and romantic streets of *Rome*, just a few steps away from the must-see sights the *Spanish Steps*, *Piazza del Popolo* and the famed *Villa Borghese* gardens.

The philosophy of Babuino 181 is to make each guest feel like a protagonist, not a simple anonymous traveller, and therefore leave them the freedom to experience *Rome* according to a modern concept: that of making each guest feel as if in their own home.

There are fourteen rooms and suites distributed in two historical palaces from the 19th century in one of the most famous streets in *Rome*, *via del Babuino*, which connects *Piazza di Spagna* to *Piazza del Popolo* in the exclusive *Tridente* district, where high-end jewellers and fashion boutiques adorn each corner. The history of the street's name is curious: in 1571 Pope Pius V granted three ounces of water to the street, that at the time was called *strada paolina*, in order to build a public fountain where the statue of Silenus was placed. These were figures from ancient Greek mythology that resembled old, bald, fat men that offered grand wisdom and wit, as well as having prophetic qualities and were known as the sorcerers of water sources. The ugly looking statue was soon given the nickname of er babuino (literally meaning 'the baboon') by the Romans. The statue created such controversy that fierce political messages were fixed upon it aimed at the Pope and other important figures of the time.

After a day of full immersion in the beauty and history of *Rome*, returning to Babuino 181 is like returning to your own luxurious pied-à-terre with the privilege of having a boutique hotel-style service. The design of the property was entrusted to the architecture firm Magnaghi. Contemporary elegance and authentic Italian style characterise these suites. There are honey-coloured mosaics and marbles in the bathrooms, whilst the rooms are equipped with state-of-the-art technology and surprisingly large spaces for a city hotel. Some rooms even feature a walk-in wardrobe.

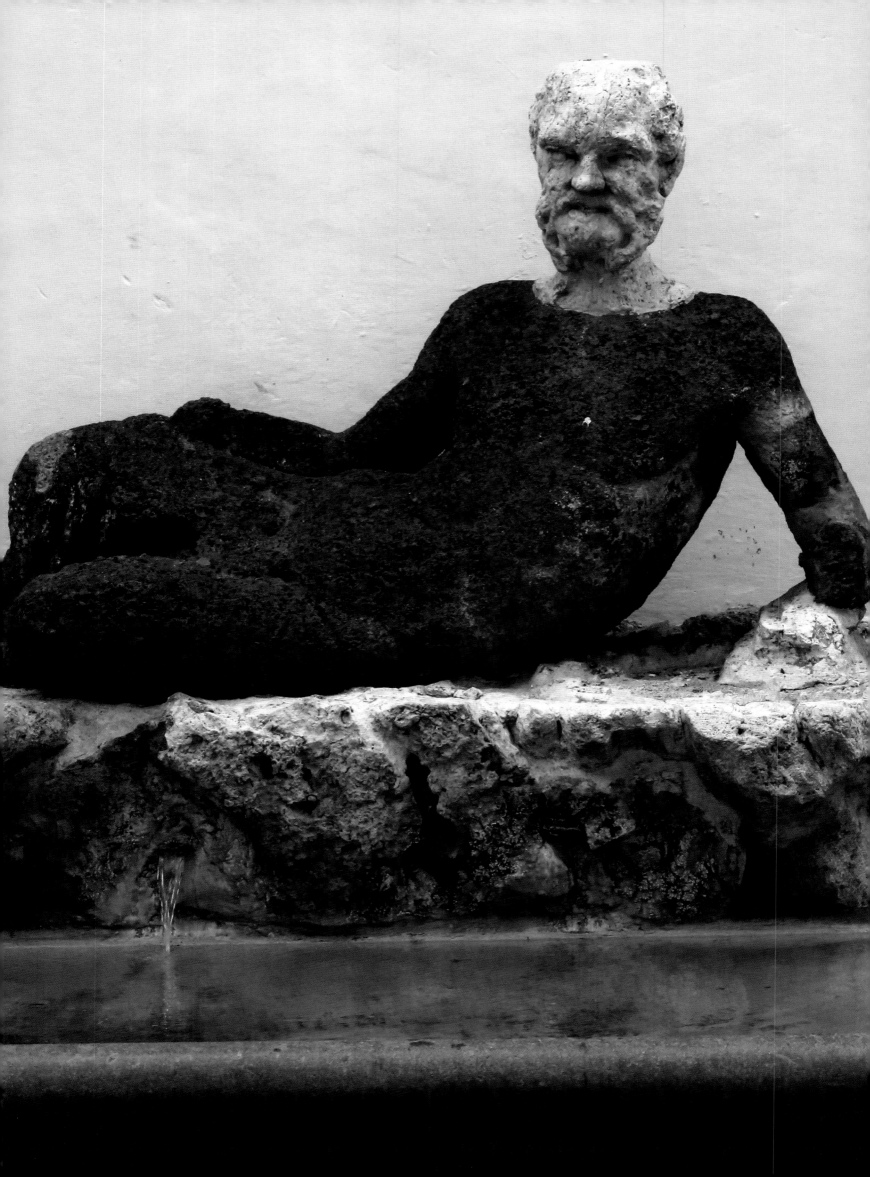

The Babuino Suite has a private balcony where relaxing with a glass of frascati whilst admiring the sunset of over the Roman rooftops is a dream. The Moncada Suite is sumptuous, split over two floors where antique is blended with modernity, and contemporary style is infused with the traditions of a noble Roman family with the reminders of the building's pedigreed past scattered in the suites; from prints of Moncada ancestors to books written on the family. From the elegant Patrizi Suite there is a breathtaking panorama of the dome of *San Pietro* to *Villa Medici*.

Adorning the walls of the property is 'fresco' photography from Diane Epstein transforming the interiors of the townhouse in an innovative way. The large-scale fresco photographs, collages and architectural details in the lobbies, suites and public spaces transport the guest to a virtual voyage discovering the hidden secrets of *Rome* from the ancient bricks to the statues and monuments adorning each corner of the city. This photography technique integrates multiple exposures of crumbling elements to illuminate the splendour of the architecture as well as the imperfections that come from the passage of time, and the result is certainly fascinating.

After a day strolling around *Rome*, a stop on the enchanting roof terrace of Babuino 181 cannot be missed, where an aperitivo can be enjoyed gazing at the Roman sunset and planning the next trip back to one of the most beautiful cities in the world.

HOTEL DE RUSSIE

'Paradise on earth.'
Jean Cocteau

Hotel de Russie: nothing else needs to be added, everyone knows where it is and where it is located. It is a part of *Rome*'s most recent history when comparing it to the centuries-old history of the Eternal City, and has conquered the heart of *Rome* as its Grand Hotel.

Renowned architect Giuseppe Valadier, who designed the nearby *Piazza del Popolo*, began designing the building at the start of the 19th century.

When Hotel de Russie was inaugurated in 1816, it immediately became the favourite destination of Russian clientele, who flooded the city during the warm winter months. Legend recounts that the Romanov family paid a year in advance for their stay at de Russie in order to attend the exclusive Carnival balls that the then owner, Sor Checco Silenzi, organised. Romans started calling the hotel 'the Russian hotel', a nickname that was then transformed into the aristocratic language of the time, French, to give Hotel de Russie.

Hotel de Russie became the favourite property of noble and aristocratic English and American families who arrived in *Rome* following the footsteps of The Grand Tour. Among its most famous clients are Pablo Picasso and Jean Cocteau, who had been both commissioned to design the scenography and costumes of the first Cubist ballet of the time. Olga Kokhlova was one of the ballerinas in the company and *Rome* was the start of her love affair with Picasso.

Now part of Rocco Forte Hotels, Hotel de Russie expresses its personality and authenticity, blending history and contemporary design, classic architecture and art deco elements, which was born through the collaboration of America's interiors guru Tommaso Ziffer with in-house designer Olga Polizzi, Rocco Forte's sister.

Neutral shades have been chosen for the interiors of the hotel and for the rooms, infused with delicate shades of green, blue, ivory and sophisticated shades of amethyst. Interestingly, there is an Asian influence to the furniture, with precious orange and black lacquer pieces adorning the rooms. Each bedroom and suite offers an enchanting glimpse of *Rome*; each facing a different corner of the Eternal City.

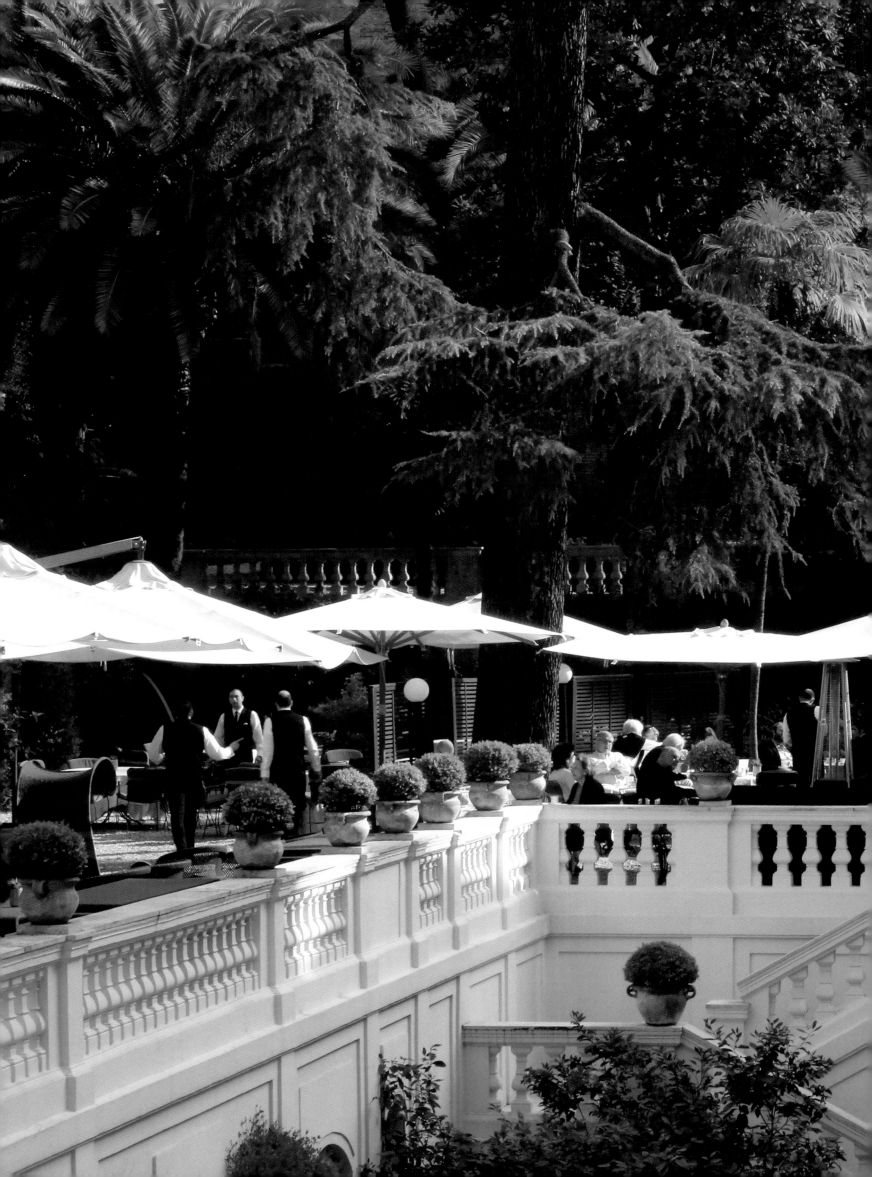

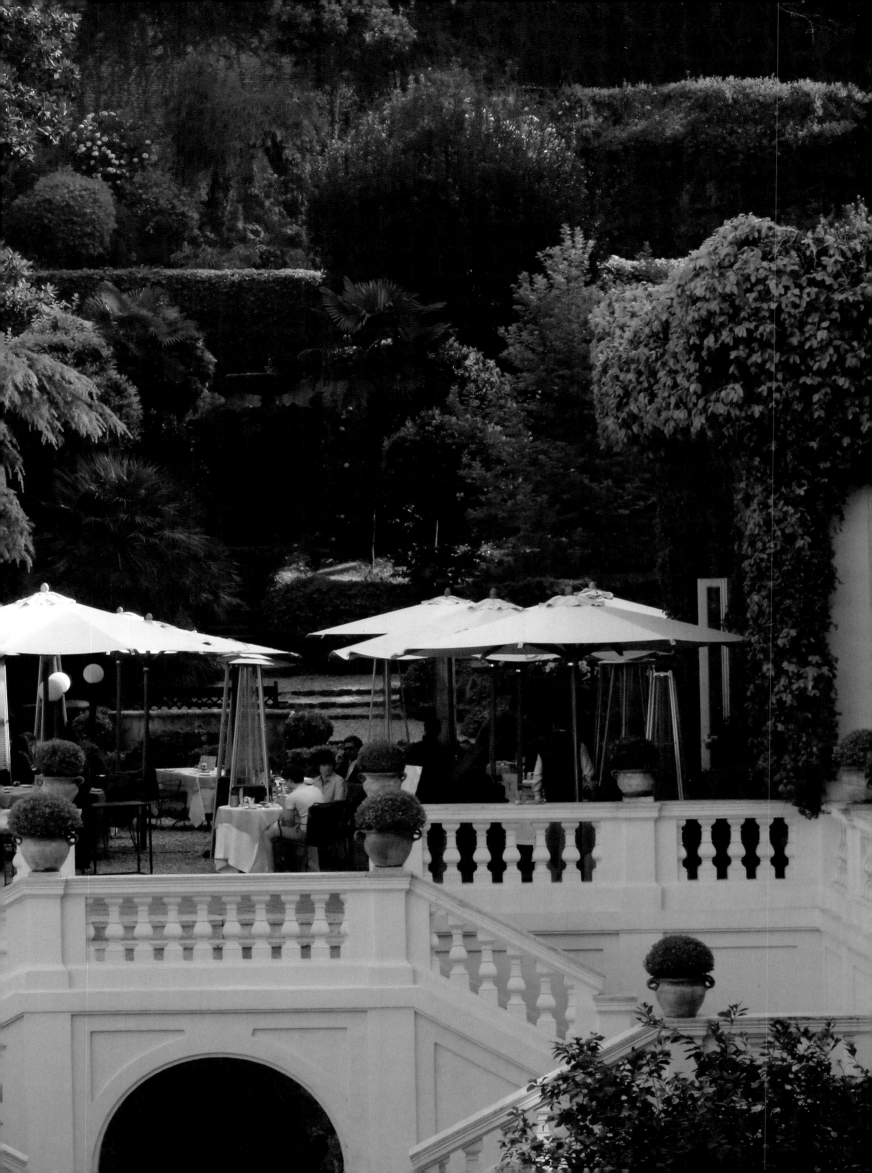

In the 1960s, Maria Teresa Celli who together with her daughter Caterina Valente, represent the incredible spirit of this hotel, bought Hotel Locarno. In the years of the famous dolce vita the Locarno was the meeting point for film stars who arrived from all over the world – from Annie Girardot to Lucia Bosè and Tina Aumont, and great artists such as De Dominicis and Kounellis. At the bar it was possible to meet Umberto Eco, Jorge Louis Borges and Alberto Moravia; to this day Hotel Locarno remains the focal point of *Rome*'s cultural scene.

Another incredible feature of the hotel is the rooftop terrace, where breakfast can be enjoyed on warmer mornings, with a view over the roofs of the 'Eternal City'. The rooms are all unique, with an atmosphere that cannot be found in any other place. An incredible array of marbles, luxurious woods, materials and design elements blend together in order to give guests a sensation of uniqueness and timelessness, as if the globalisation that is synonymous of modern times has remained outside these walls.

Hotel Locarno is the quintessential Roman hotel, in the most idyllic location, where even the air permeates culture.

MARGUTTA 54

'When I was a child my mother said to me, "If you become a soldier, you'll be a general. If you become a monk, you'll be the pope." Instead I became a painter and wound up as Picasso.'
Pablo Picasso

Via Margutta is enchanting, ideally positioned on the *Pincio*, with its characteristic ancient townhouses crowned with ivy and vines. It is a street where visitors can still breathe the bohemian air created by the never-ending selection of art galleries, antique shops, artisanal boutiques and workshops where historic and antique furniture is renovated.

The street became famous in the 1950s in the legendary film Roman Holiday where the splendid Audrey Hepburn, taking the role of Princess Anna, lived in the attic of one of these adorable houses. *Via Margutta* was defined as an open-air museum and its charm lies in its extraordinary past that remains alive and tangible today. This street and its palaces have seen the most important protagonists of 20th century art calling it their home: Picasso, Severini, Guttuso, Gentilini, Fazzini, Maccari, Montanarini to name but a few. The rooms of the 'International Art Association', which in the 19th century hosted grand events, have hosted musicians such as Wagner and Puccini and writers such as Zola, Sartre, and D'Annunzio. A plaque reminds passers by that Federico Fellini and Giulietta Masina lived on this very road.

Via Margutta is known as *Rome*'s most famous art street, and it is on this charming street that another Rome Luxury Suite can be found: Margutta 54.

The suites of Margutta 54 have been knowledgably built inside a former art atelier where famous artists, such as Pablo Picasso, chose *Rome* and *Via Margutta* to seek inspiration. These studios were built in 1855 by the great grandfather of Alberto Moncada, the current owner, who has personally followed the transformation of these historic studios into luxurious suites.

Uniqueness is the key word. Indeed, in order to find the hotel, guests are invited to become a real Roman and enter a private courtyard, surrounded by art galleries, and let themselves be transported by the beauty of the historic palaces nearby, before suddenly finding that in the very studio of Picasso, they have found their Roman home.

Each of the suites is exclusively designed, where literally every centimetre is handmade with an immaculate attention to detail. Italian design blends with contemporary art elements and original antique artworks.

The philosophy that permeates Margutta 54 is one of ensuring that every guest feels at home in a unique house a few minutes away from the *Spanish Steps*, in one of the most beautiful and ancient streets in *Rome*.

MARIO DE' FIORI 37

'Roma nun fa' la stupida stasera, damme una mano a faje di de si. Sceji tutte le stelle più brillarelle che poi e un friccico de luna tutta pe' noi.'
Armando Trovajoli, *Roma nun fa' la stupida stasera (canzone in romanesco)*

'Rome do not be stupid tonight, give me a hand so that she may say yes. Choose the most sparkling stars, and a piece of moon that is only for us.'
Armando Trovajoli, *Rome do not be stupid tonight (song in roman dialect)*

*M*ario de' Fiori, a charming street running parallel to the central *Via Del Corso*, will transport the first-time visitor back in time to the Eternal City of the 1700s on arrival. This small street is infused with romanticism; in a certain sense it is the *Rome* of all our dreams, alive and buzzing, with an incredible atmosphere, especially in the evening when the streets flood with outdoor tables and the trattorie fill with cheerful diners.

The street is named after 'Mario de' Fiori': Marius Pictor Romanus vulgo de' Fiori, a painter who in the second half of 1600 lived on this street, at number 93. His fame was due to the fact that he was specialised in painting only one subject; easy to guess which: flowers (indeed, 'fiori' in Italian signifies flowers). Soon his surname was forgotten and he was known to all by his nickname 'fiori'. A successful painter, he rose to fame when his paintings were requested by the many noble Roman aristocratic families of the time. If this has aroused your curiosity, his flower paintings can be viewed in *Rome's Palazzo Colonna*, *Palazzo Pallavicini* and *Palazzo Chigi*. Giorgio de Chirico, another famous Italian painter, also chose *via Mario de' Fiori* for his 'stays' in *Rome*, hiring a studio where he lived and produced some of his famed artworks.

It is on this historic street, filled with flowers and art, that Alberto Moncada chose a residence from the 17th century to create Mario de' Fiori 37. Not a boutique hotel, but instead a collection of charming suites where Alberto's philosophy permeates the air; that of ensuring that each guest feels at home. It is like owning a fabulous pied-à-terre for a few days in one of *Rome's* most magical and sought-after locations.

The design is modern and linear, with a warm and relaxing atmosphere. The nine suites all have exposed wooden beams and adorable canopy beds. The neutral colour palette contrasts with the vibrant colours of the materials used for the furnishings. On the walls there are original photographs of *Rome*'s monuments, statues and fountains by famed photographer Carlo Gavazzeni.

The rooftop suite is an absolute delight, with timber beams, it is nestled under the townhouse's pitched roof. This is a room where traditional and modern elements blend to create a sensual environment. The junior suite is charming with its romantic four-poster bed and comfortable armchairs, where after a day of sightseeing and shopping, there is nothing better than to relax in front of the fireplace by candlelight while having a glass of wonderful red wine.

The location couldn't be more ideal, situated in the heart of *Rome*, just a few steps away from *Piazza di Spagna* with its famous *Spanish Steps*. Mario de' Fiori 37 is the perfect place to relax after being immersed in the history and beauty of *Rome*, where in the evening dinner can be enjoyed in one of the charming nearby restaurants sitting al fresco, enjoying the city's incomparable climate and gazing at the romantic street of the painter that dedicated his whole life to the beauty of flowers.

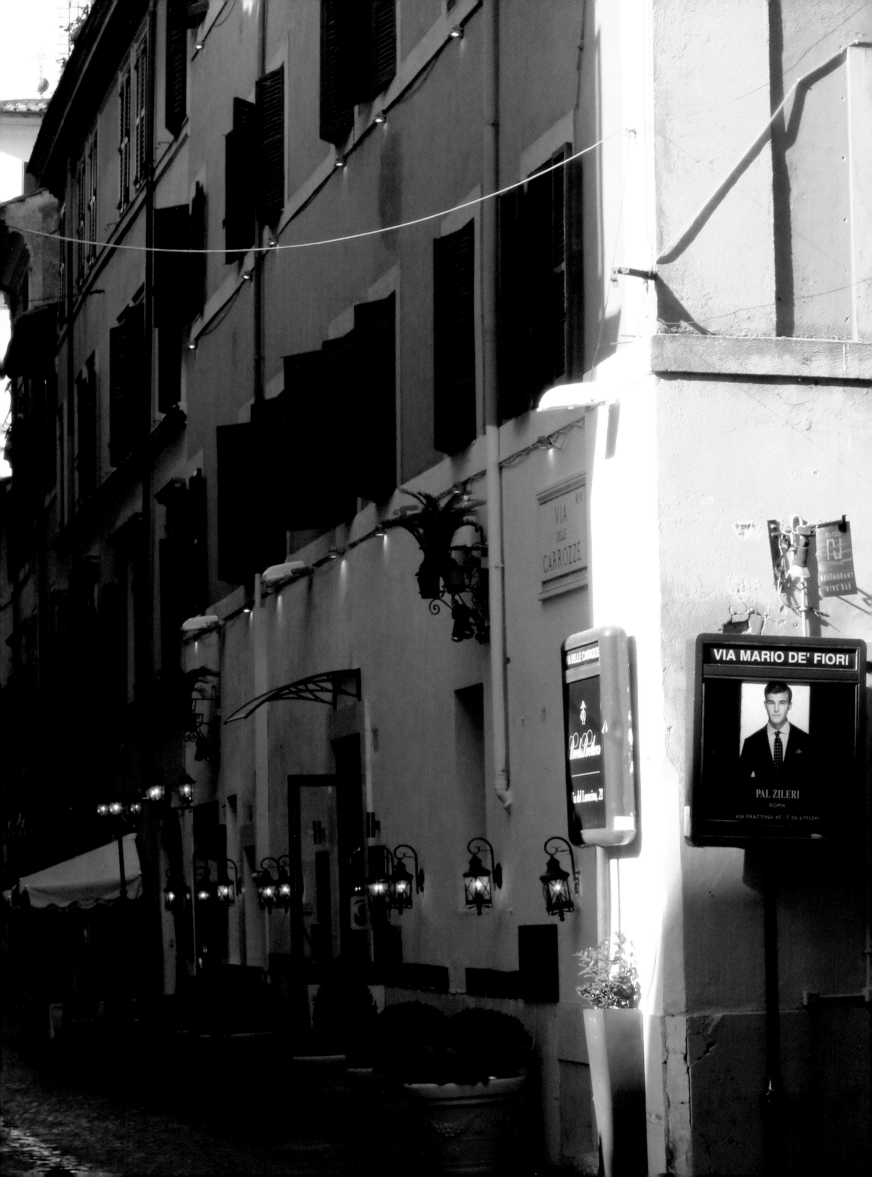

SARDINIA

Dream inspiration: A unique island literally suspended between the emerald sea and the azure sky. Its sunsets are unforgettable with the sun diving into the rose-tainted water in a frame of vibrant Mediterranean greenery, white sand, and magic mistral wind cradling the waves. Its history is endless, its traditions unique. A dream from which you will not want to wake.

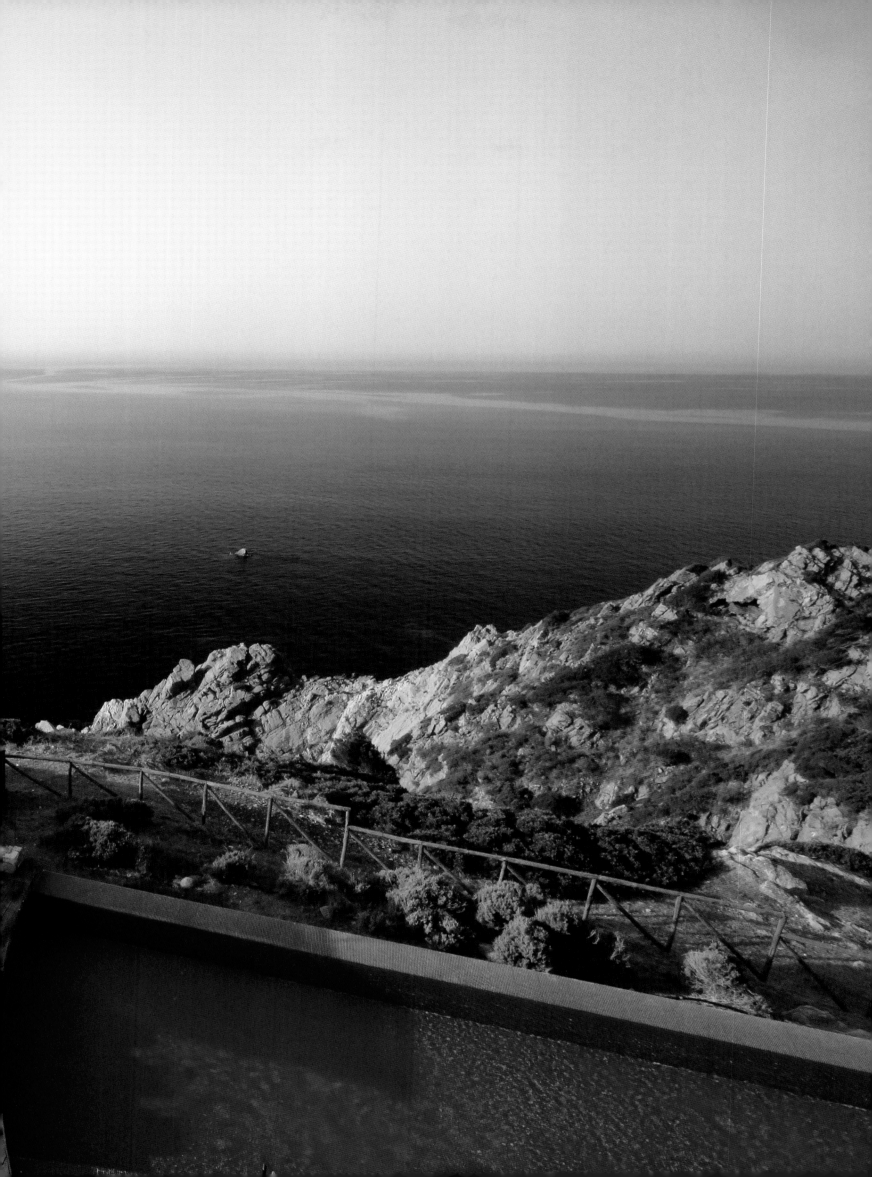

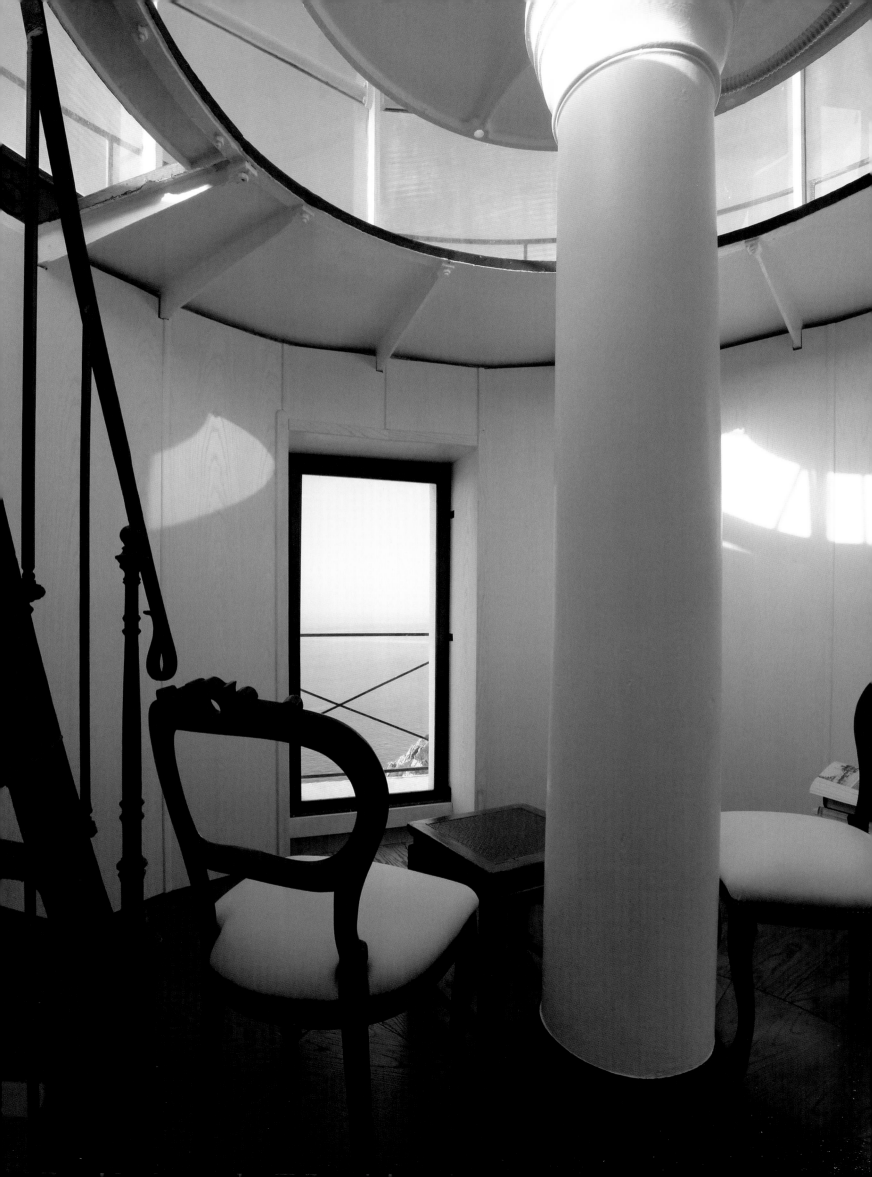

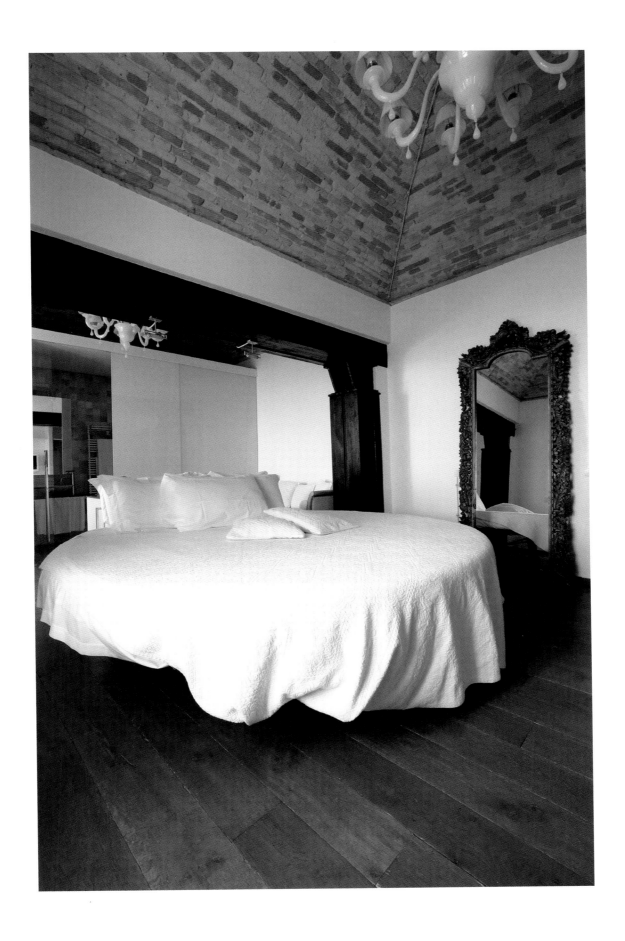

Antique Turkish wagons serve as pool beds on which to relax and enjoy the warm Sardinian sunrays whilst relishing the unparalleled view that grandly unwraps before you. Enjoying breakfast on the terrace, or a glass of chilled Vermentino wine is simply idyllic, when the sun sets and the sea adopts a pink, orange and pale red tone, turning into a magical set of stars.

The interiors of the lighthouse have been expertly and meticulously designed, with vivacious touches of red provided by the handmade Murano glass chandeliers that strike a contrast with the candid white leather couches and the four Louis XIV style chaises longues.

Dinners are unsurprisingly served in the grandiose outdoors, but on rare, colder evenings, the indoor dining room boasts two juxtaposing tables, one in antique solid wood and the other in transparent crystal glass.

A delicate cast-iron spiral staircase leads guests to the basement wine cellar, where precious, vintage wines can be tasted in what used to be the water tank of the lighthouse.

A second spiral staircase, in stone, leads guests to the six immaculate suites each possessing an unmatched minimal style, where white serves as the leading colour striking contrast with the strong colours of the wild nature outside.

Each suite contains a different style of bed, from a round hanging bed to a four-poster bed in cast iron, but all with unbeatable views.

The large roof terrace of the lighthouse is the perfect setting to enjoy a novel or a romantic evening under the falling stars, crowned by the shining, omnipresent lighthouse lantern.

Two small apartments are also now available just a few steps away from the main building, where the striking bedrooms contain a glass roof, making this the perfect way to slip into a tranquil sleep, cradled in the arms of Morpheus, beneath the stars.

The suggestion for this enchanting place is to let dreams run wild, leaving space for fantasy, because in *Sardinia* all these dreams become reality.

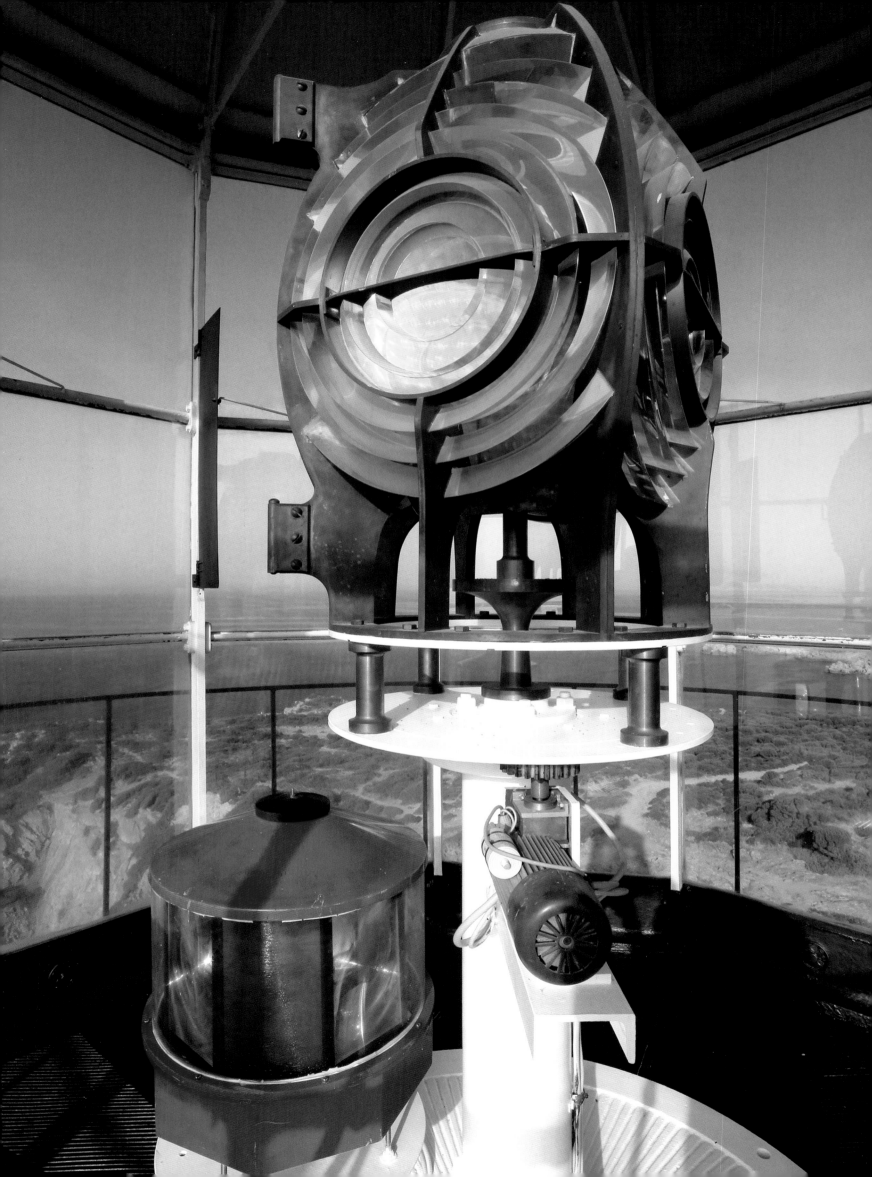

L'AGNATA
DI DE ANDRÉ

'La vita in Sardegna è forse la migliore che un uomo possa augurarsi: ventiquattro mila chilometri quadrati di foreste, di campagne, di coste immerse in un mare miracoloso dovrebbero coincidere con quello che io consiglierei al buon Dio di regalarci come Paradiso.'
Fabrizio de André

'Life in Sardinia is perhaps the best that a man can wish for himself: twenty-four thousand square kilometres of forests, of countryside, of coasts immersed in a miraculous sea, all of which should coincide to what I would suggest to God to grant us as Heaven.'
Fabrizio de André

L'Agnata di de André's history dates back to 1975, when famed Italian songwriter Fabrizio De André and his wife Dori Ghezzi bought the estate of L'Agnata, with 150 acres of meadows, pastures, crops and woodland. At the time, L'Agnata was only a stazzu, an abandoned piece of land where at the centre of the estate was a crumbling farmhouse, dating back to the 19th century, made in typical granite from the *Gallura* area hidden in a forest of oak trees.

In the months following the acquisition, an unforgettable adventure began for the songwriter as soon as the renovation works commenced. This proved to be a chance to connect with nature, dining with candles as the sole source of light, without telephone or contact with the outside world, on an abandoned, coarse land. After three years, L'Agnata was finally ready to be lived in, and De André and his family decided to permanently reside there. In the meantime, the stables were brought to new life as well, where calves and piglets are bred, as well as olives and vineyards, all of which helped to create the restaurant of L'Agnata, which immediately proved a huge success.

From nearby river *rio Caprinnedu*, De André built an artificial lake, which helped L'Agnata and the local population in their struggle against the lack of rainfall.

The beauty and history of the Sardinian land inevitably inspired numerous songs and poems by De André, whose passion for the island grew evermore.

It was only in the 1990s that Dori decided to share this 'piece of heaven' with guests, and the extraordinary boutique hotel was born.

L'Agnata is not solely a charming hotel, it is food for the soul, and it cures the spirit from today's frenetic lifestyles. The very name Agnata in Gallurese signifies 'hidden corner, protected from winds'.

Today's owners Fabrizio and Angelica Olla ensure that the charming country house enchants guests as soon as they walk into the courtyard, which in the evening is lit by the warm, yellow tones of candles, where between ancient olive trees, the two buildings forming the hotel appear. The garden is exactly as de André desired it, with trees, plants and flowers composed in an anthem to mother earth.

The newer building is composed of eight rooms and as every country house should have, a reading room with a delightful open fireplace. The ancient building, where the restaurant occupies the ground floor, has a further two rooms on the second floor.

The restaurant prides itself on offering the best of typical Sardinian cuisine, where simplicity is the key word, and where it is the ingredient that takes charge of each plate, grown from local producers on the island, just as tradition requires. Delicacies such as the zuppa gallurese, the maialetto al forno and the seadas for whoever has a sweet tooth are sure to take each diner on a gourmet journey.

Each room is unique, taking its name from the plants and flowers that De André and Dori adored. Each with its own spirit and personality, it is simplicity and comfort that take prominence here, each room shining in the warm Sardinian sunshine.

One of the most desired is *Faber*, with a balcony facing the evergreen garden, and a view over the valley and woods lit up by the moon. This was De André's very room, where everything has remained intact since the 70s; a true delight for his fans!

A magnificent country house such as l'Agnata could not be without a swimming pool, bejewelled in the midst of greenery with pink granite rocks, creating the perfect setting for a swim whilst the sun sets.

Lastly, when talking about *Sardinia*, one cannot help but think of the sea, and l'Agnata is built on a strategic point, making it an ideal base to visit the fashionable and lively *Costa Smeralda*, the heavenly *Costa Paradiso*, where its legendary transparent waters are a haven for divers, and *Capo Testa* where uninterrupted kilometres of sandy beaches and dunes make this one of the most tranquil beaches even in the busy summer months.

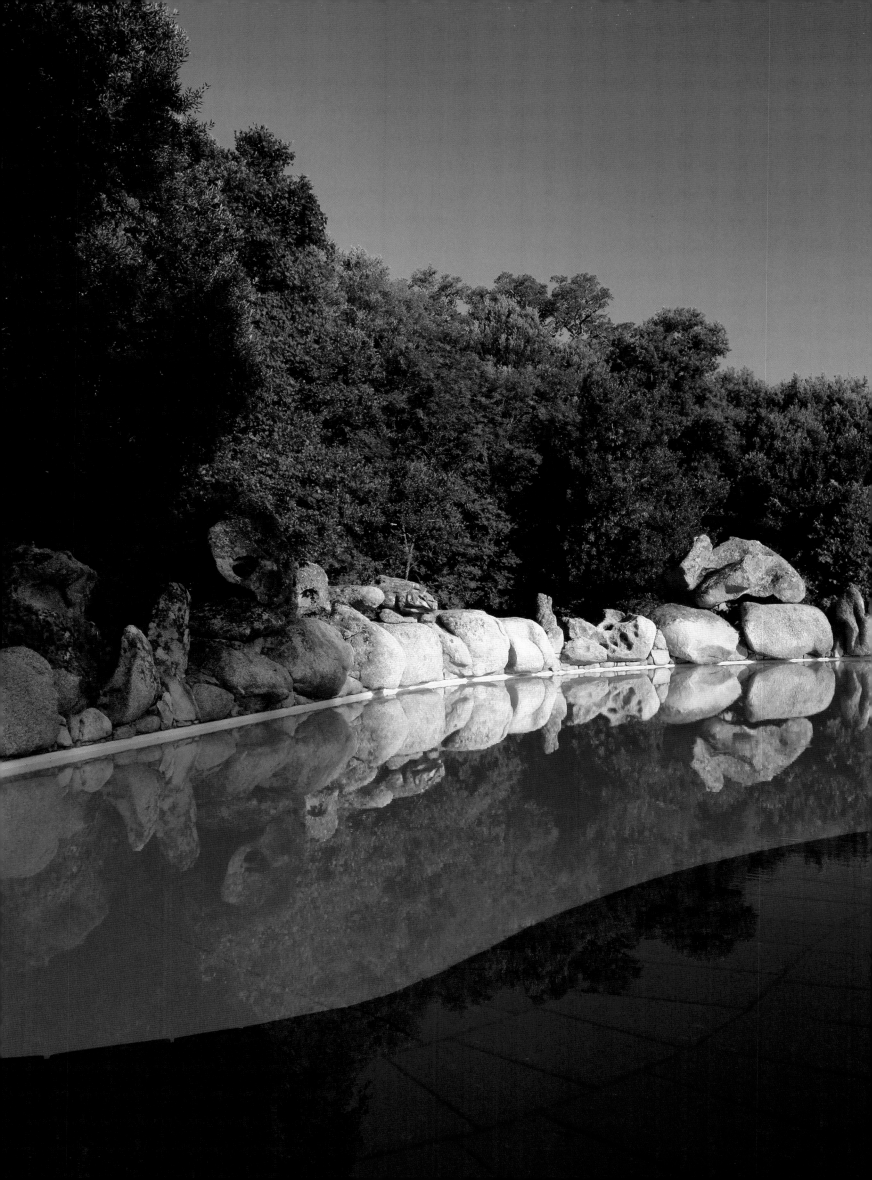

S. BARTOLOMEO

S. GIUDA TADDEO

SANT ANDREA

SICILY

Liveliness inspiration: This island is an ode to life. The vibrant colours meet with exuberant nature, the incredible force and spectacular volcanoes, both loved and feared by Sicilians in a relationship between man and nature that is insoluble. The vivacity of the colourful porcelain, the sea that caresses the land, the history that permeates the air, food that is the energy of this land, the wines that are called 'nectar of the gods', the hospitality that makes you feel like a king.

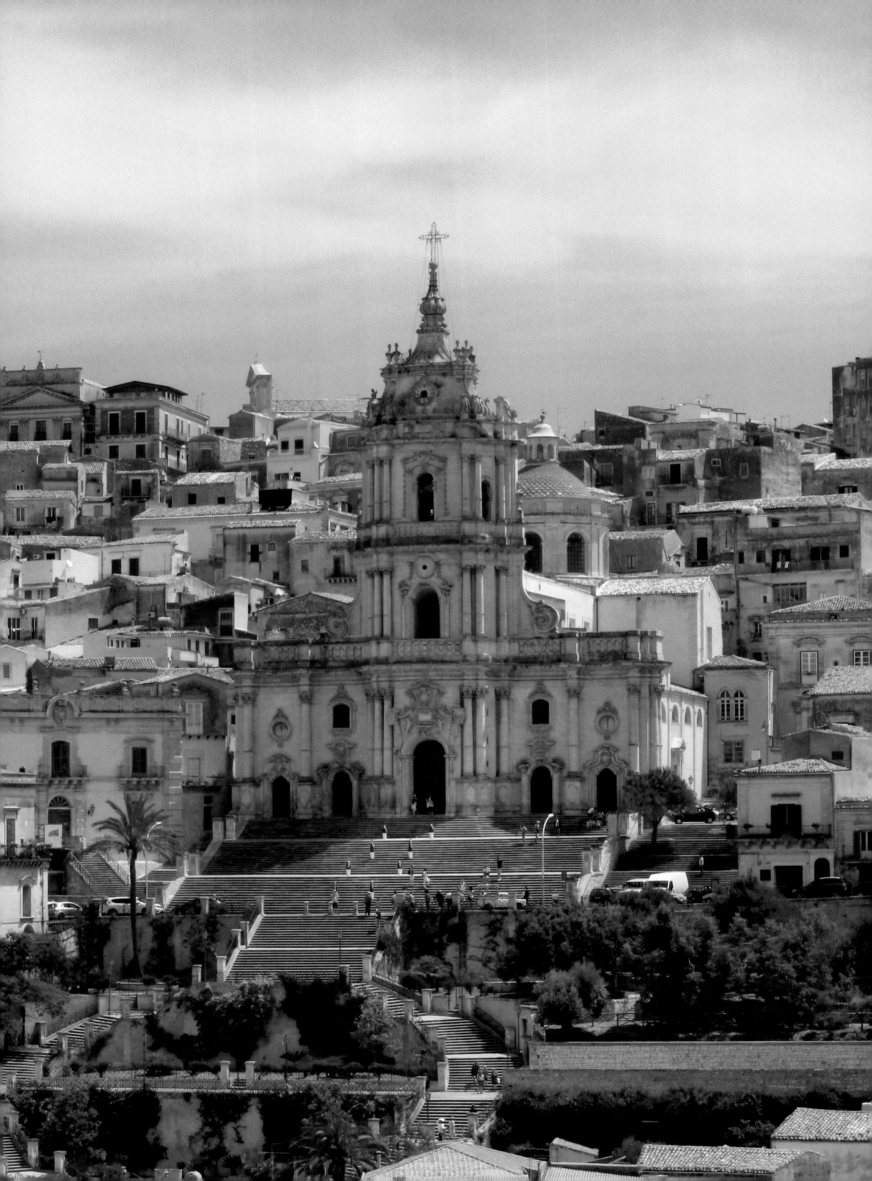

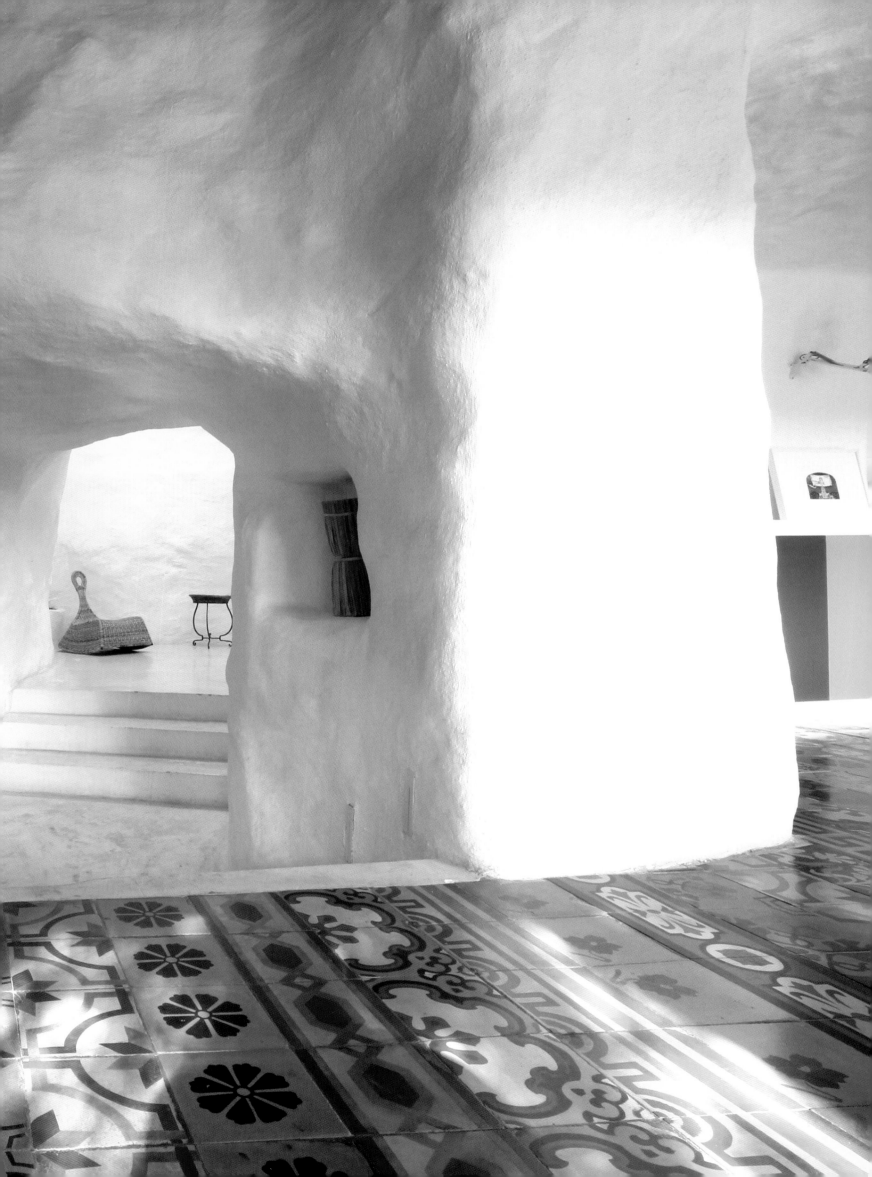

A great deal of research and attention to detail has been paid in selecting the finest design elements, the colours and the atmosphere of the rooms, all transporting guests to the Mediterranean style and the cultures that have infused *Sicily* over the course of the centuries. The result is exceptional: tradition that blends with modern elements, and touches of vibrant colours illuminating the pristine white walls.

Stone walls, cane roofs, polychrome traditional ceramic pavements and lime plaster all combine to create a warm hospitality where relaxing and 'slow living' becomes a must. The materials chosen are all biocompatible and completely natural, in line with the philosophy of the charming hotel.

All of the rooms open onto the garden, and each has it own adorable terrace with a breathtaking view over the ancient town of *Modica*.

Casa Talía offers an alternative way of taking a holiday, slowing down and experiencing everything that *Sicily* has to offer: the extraordinary light, the unique perfumes of its incredible vegetation, the unique tastes of the delicacies of this land such as the exceptional Modica chocolate which is distinctive to the town, or the strong Nero d'Avola red wine. The beauty of nearby cities such as *Ragusa*, *Siracusa*, and a dive in the sea by *Marina di Modica* or *Sampieri* is priceless!

Marco and Vivana want to leave a memory of *Sicily* for guests to take back home with them. And surely the desire to go back to Casa Talía and to its 'slow living' and majestic beauty to discover other treasures and secrets of this extraordinary corner of *Sicily* will be an unforgettable memory.

The rooms have a discreet simplicity, as if they do not want to compete with the elaborate beauty of the nature outside. However, each room has unique touches making them a different discovery. The palette of colours ranges from the predominant white, to beige, light grey and bright yellow that infuses with pervinca blue. The chosen colours inspire tranquillity, and the rooms with their traditional high ceilings offer an invitation to bask in their fresh comfort in the hottest hours of the Sicilian summer.

A typical Italian saying is 'il buongiorno si vede dal mattino' (literally 'you can see a good day from the morning'), and at Hotel Gutkowski this is definitely the case. The breakfast is known as being the most delicious and rich of the island, with homemade marmalades made from local citrus fruits, freshly baked biscuits and cakes, fresh almond milk, ripe fruit and the unmissable granita (a traditional Sicilian drink made with crushed ice, sugar and various toppings). Everything is strictly organic and homemade.

The hotel also has a delicious restaurant Gut Néo Bistrot where Chef Salvatore Storaci recreates traditional Sicilian delicacies. On warm summer evenings dining is al fresco facing the grande Bastione that protects the island from the sea.

The two hotel terraces are completely enchanting, opening up to the spectacle of the unending blue sea. Here, a must is the granita which is offered to all guests at five in the afternoon, in order to find refreshment under the Sicilian sun. A chance to contemplate the sea and this island's vast history, to enjoy an unparalleled sunset, to taste an excellent glass of wine from these fertile Sicilian lands; this is purely and simply the essence of being, which can be found in this charming hotel.

MASSERIA SUSAFA

'Sai cos'è la nostra vita ? La tua e la mia ? Un sogno fatto in Sicilia.
Forse stiamo ancora lì e stiamo sognando'.
Leonardo Sciascia

'Do you know what our life is? Yours and mine? A dream made in Sicily.
Perhaps we are still there and we are dreaming.'
Leonardo Sciascia

The Sicilian countryside is a tapestry made of the most vivid and strong colours, inebriating as the wines that are produced in this land, passionate as the food of this region, extraordinary as the hospitality of the Sicilians.

Masseria Susafa with its stone structure is nestled in one of these Sicilian tapestries, about one hundred kilometres from Palermo airport, in a contrada (countryside hamlet), from which it has taken its name *Susafa*, in a small town named *Polizzi Generosa* in the very heart of *Sicily*. In a strategic location close to the *Parco delle Madonie*, a botanical paradise, to the historic city of *Cefalù*, to *Palermo* and the temples of *Agrigento*, the mosaic of *Piazza Armerina*, and beautiful *Sperlinga*.

The masseria is a farm enclosed by walls that protected the crops and therefore the life of the owners and farmers living inside this micro-village. Housed in an ancient farmhouse from the 18th century, Masseria Susafa is today a charming hotel. It was reborn through the loving restoration of the Saeli-Rizzuto family, landowners and entrepreneurs who have been looking after these lands and buildings with passion for the traditions and cultures of this island for more than five generations. The masseria to this day maintains the large gates that were closed in the past as soon as the sun set in order to protect the stocks of precious grains from thieves.

A delightful living room with an open fireplace welcomes guests to this heaven on earth. The ancient 'palmeto', where wine was produced, is today the masseria's bar, where a glass of Passito, Malvasia, Moscato or Marsala, the famous sweet wines of the region, is a must after dinner. Here guests are immediately transported to the history of the masseria and become part of its spirit, with the large collection of family pictures that witness the moments of pastoral life displayed, and with the aromas of the large, ancient wine barrels and the jars that used to contain the precious olive oil permeating the air.

The outdoor terrace is exactly the *Sicily* of our dreams, with an unending view of the rich and lush countryside, extraordinary during any season. All that changes is the palette of colours that are evermore unique, intense and unforgettable. On this very terrace, tomatoes and almonds are left to dry in the sunshine. At Masseria Susafa days are spent outdoors, perhaps with a break from the sun under the fresh pergola with a glass of refreshing iced water and zammu, an extract of anisette.

Guests are invited to wake up at dawn and witness the milking of the sheep and the preparation of ricotta, assist in the threshing of the mature wheat and the picking of wild herbs. There is no better way to wake up than with a long walk amidst the pure aromas of nature and the wild mint, oregano and broom. In October and November when the countryside adopts its warmest colours, guests may even take part in collecting olives from the estate's groves.

The rooms are situated in the former houses of the farm workers. Here too an authentic Sicilian air can be felt with the wooden roofs, exposed beams, traditional plaster, Sicilian terracotta pavements and original enamel touches. The interiors are simple and warm, with each handmade piece mixed with authentic antique furnishings.

All the rooms on the ground floor open onto the charming garden. By choice there is no television in the rooms, but instead in the 'palmeto' area guests can enjoy film projections together. For guests that prefer a more private and exclusive stay, there is even an apartment with two bedrooms.

Another magnificent view can be guaranteed from the swimming pool, where there is nothing better than to fall onto a sunbed and enjoy the warm Sicilian sunrays.

An unforgettable experience can be enjoyed in the restaurant Il Granaio with its authentic stone walls and arches, built in the ancient barn. The pavement is in Sicilian terracotta and the large fireplace guarantees a relaxing and genuine atmosphere. The strong and vivacious nature of *Sicily*'s ingredients is striking when prepared with such excellent mastery and tradition. It is even possible to take back home a piece of *Sicily*, Masseria Susafa produces olive oil, marmalades, biscuits and traditional cakes from this unforgettable land.

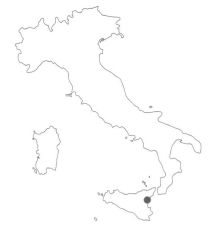

MONACI DELLE TERRE NERE

'Il sesto giorno Dio compì la sua opera lieto di averla creata tanto bella prese la terra tra le mani e la baciò... là dove pose le sue labbra è la Sicilia.'
Renzino Barbera

'...On the sixth day, God accomplished His work And, pleased with all the beauty He had created, He took the Earth in His hands, And kissed it. There, where He put His lips, That's Sicily.'
Renzino Barbera

Zafferanea Etnea is the *Sicily* of our dreams. With perfumed air that smells of broom, figs, almonds and jasmine, the town is nestled underneath one of the most active volcanoes, *Mount Etna*, where the landscape is of an indescribable natural beauty and lush greenery because of the fertile volcanic land. By driving along small, winding country lanes, one of *Sicily*'s most beautiful boutique hotels can be found, Monaci delle Terre Nere.

Owner Guido Coffa discovered the place back in 2007 by chance when travelling to *Sicily* in order to buy a house to return to his native land after years travelling, and immediately fell in love with the run-down 16-hectare estate. The land has a vast heritage, having been chosen by the monks of Saint Anne's order for its special energy and extraordinary charm. The noble baroque villa dates back to the 19th century, which today forms the main body of the hotel, with scattered suites in independent buildings within the estate, where guests are invited to enjoy the true identity of *Sicily*, where nature rules supreme, where silence commands and relaxation is the key word. Guido's philosophy is of 'preserving the identity and local traditions, hence more than being a boutique hotel in *Sicily*, it is a home which I hope retains its intimacy'.

With only fifteen rooms, intimacy is indeed the essence of the property with no televisions or telephones in the room, and each room uniquely designed and named. Each name is related to the language of oenology, connecting to Guido's love of wine from the Armonico room, to the Limpido, Minerale and Sontuoso rooms.

Some of the rooms are located in independent buildings with authentic lava stonewalls and wonderful views out to the Ionian Sea, where traditional Sicilian architecture blends with contemporary art. From hanging beds to exposed wooden beams, exposed antique brickwork, fireplaces, freestanding Jacuzzis and floor-to-ceiling windows, each room is sure to contain something unforgettable. Guido and his wife Ada's exquisite design sense make Monaci delle Terre Nere a hotel like no other, where Philippe Starck chairs are placed in lava stone rooms next to vibrant contemporary paintings by the likes of Olivier Mourao in contrast with the original Sicilian wood furnishings and ancient wine presses.

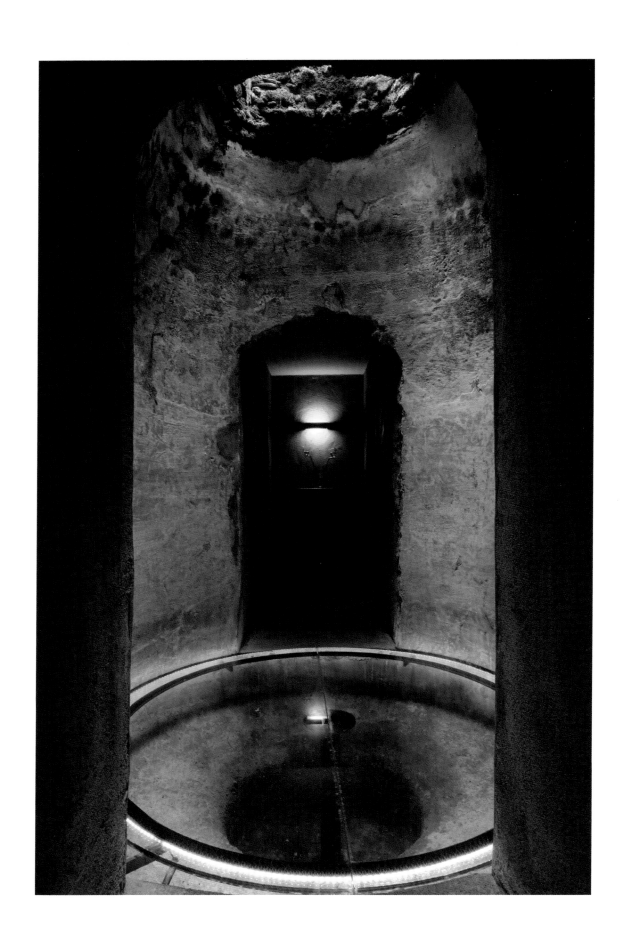

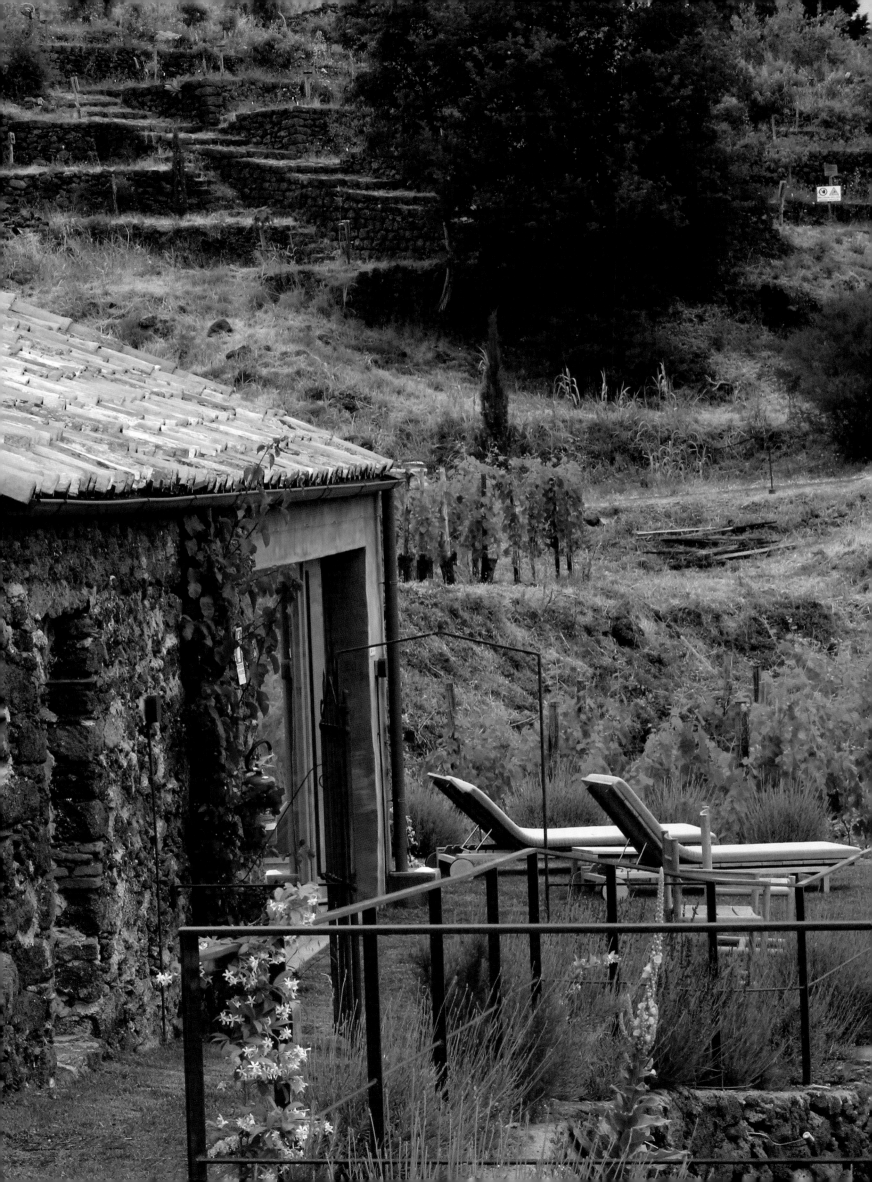

Monaci has become a mecca for organic agriculture, eco-friendly living and local produce, being one of the three 'Eco-Bio' certified hotels in *Sicily*. The organic farm of the estate is set on a terrace overlooking the sea, and provides the hotel's restaurant with its ingredients. Indeed, the menu serving delicious, traditional cuisine is based on dedication to the land and its produce. Ancient and native species of fruit trees, vegetables and herbs have been recovered and provide the ingredients that form the basis of the restaurant menu, from the Mastrantonio cherry tree to the Muscateddu plum tree and the Damaschino apricot tree. All meals are served on the terrace during summer overlooking the colours of the Mediterranean or indoors in the ancient wine press during winter months.

Guests are invited to explore the estate during their stay, to fully comprehend the identity and philosophy that Guido and Ada gave to Monaci; that of flavours and colours but also intense silence and calmness.

The outdoor infinity black lava pool flooding onto the Sicilian countryside is a feast for the eyes, with a dip during the warm summer months almost obligatory.

Monaci delle Terre Nere is the perfect starting point to begin a tour of this splendid corner of *Sicily*, from *Noto* considered the most beautiful baroque town in the world to *Taormina* with its handsome ancient Greek theatre and endless views of the sea to trekking up *Mount Etna* and visiting its smoky mouth at 3,000 metres in height.

Monaci delle Terre Nere will surely leave each guest with unique and unrepeatable sensations, that only such a timeless land, beautiful hotel and passionate owners can guarantee.

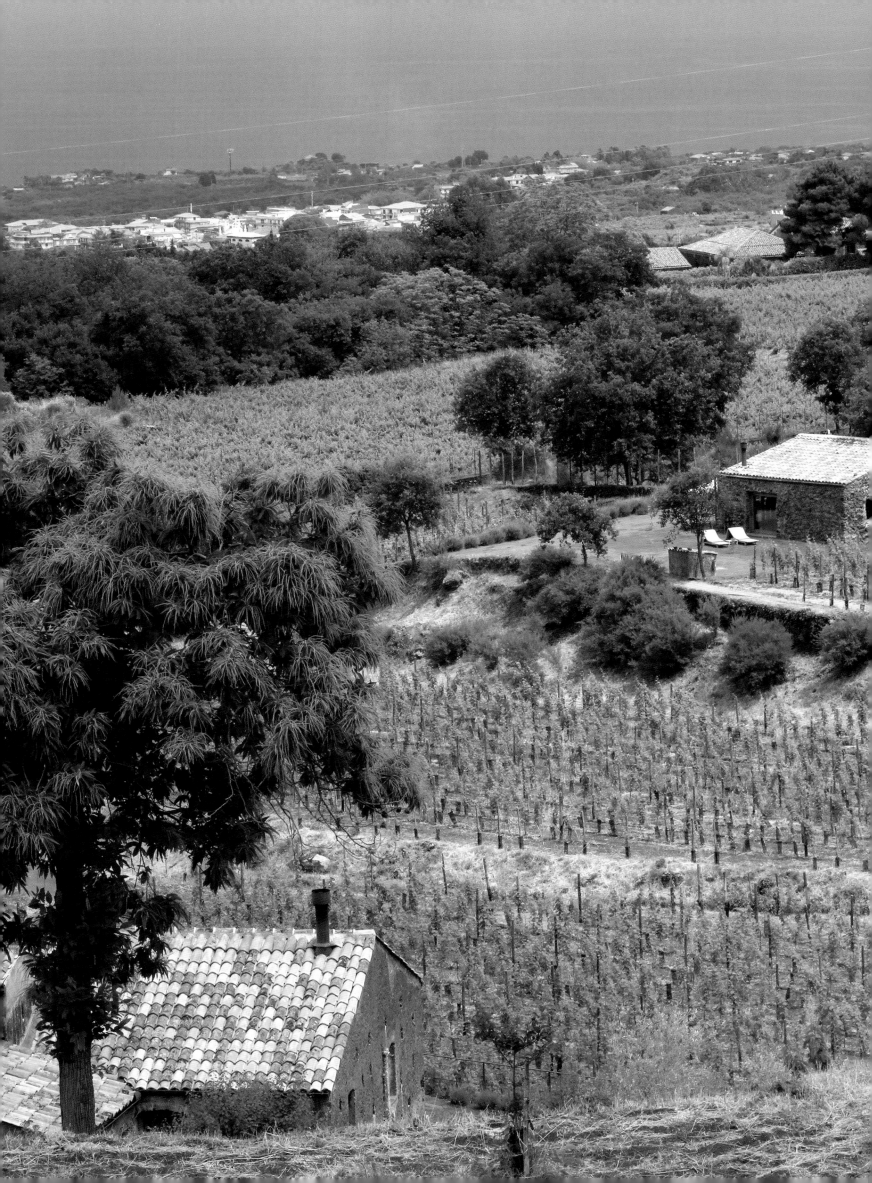

HOTEL SIGNUM

'We came to the Aeolian island (nesos Aiolios); here lived Aiolos, son of Hippotas; the deathless gods counted him their friend. His island is a floating one; all round it there is a wall of bronze, unbreakable, and rock rises sheer above it.'
Odyssey, *Book X, 1-5*

Arriving here means literally diving into a natural therapy of perfumes, colours and tranquillity. The atmosphere that can be experienced here is incredible, perhaps because of the centuries-old history that has forged this magical island, and that is often mentioned in travel stories and legends.

Salina is part of the *Aeolian Islands* that form what is thought of as the most beautiful archipelago in the Mediterranean, and which has been rightly given the title of World Heritage Site by UNESCO.

The ancient Greeks considered these islands the home of the god of wind Eolo, and so gave them the same name. Homer recounts in the Odyssey that in these very islands Eolo offers to Ulysses an urn with the winds that could help him during sailing. Stories and legends blend in tales that taste of fables.

Salina was once called *Didyme*, meaning 'twin' in ancient Greek, because of the two mounts united by a valley that form the island. The cone-shaped mounts serve as a reminder of the origins of this island, as the mounts were all volcanoes, such as *monte delle Felci* and *monte dei Porri*. Heather, arbutus, honeysuckle, wild mint, brooms, maritime pines and chestnuts infuse the National Park of the island.

Located between sea and land, the island was later called *Salina*, because of the salt harvest that has been happening on the island since medieval times. *Salina* is the most fertile and water-rich island of the Aeolians, and therefore has the lushest greenery. The volcanic soil has allowed the cultivation of prestigious grapes from which the world famous Malvasia di Lipari wine is made.

In this paradise literally suspended between the azure sky and the dark blue of the sea, nestled in the hamlet of *Malfa*, Hotel Signum can be found. Owners Clara and Michele Caruso have majestically restored this ancient hotel and they have created a place where dreams become reality. Both love this land passionately and this passion can be found in the philosophy of Signum and in the excellent hospitality provided to guests.

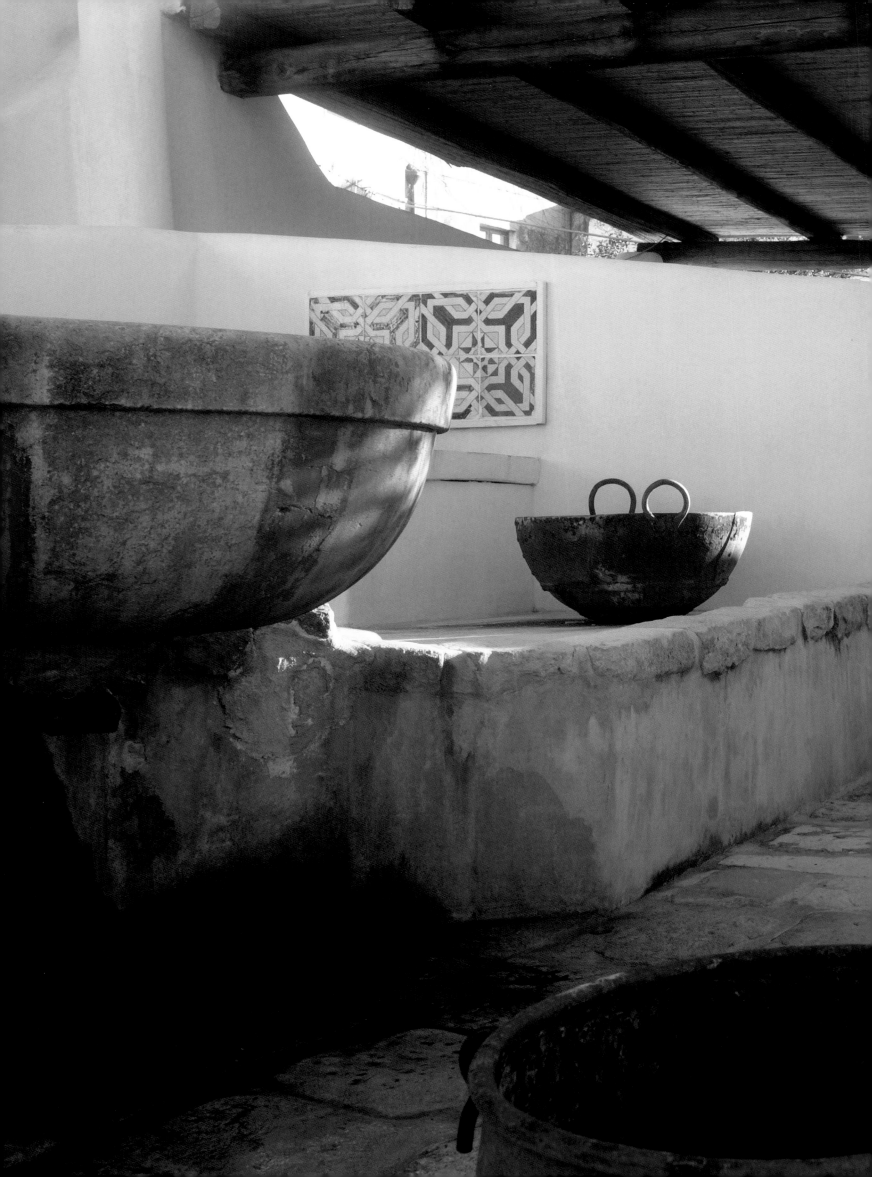

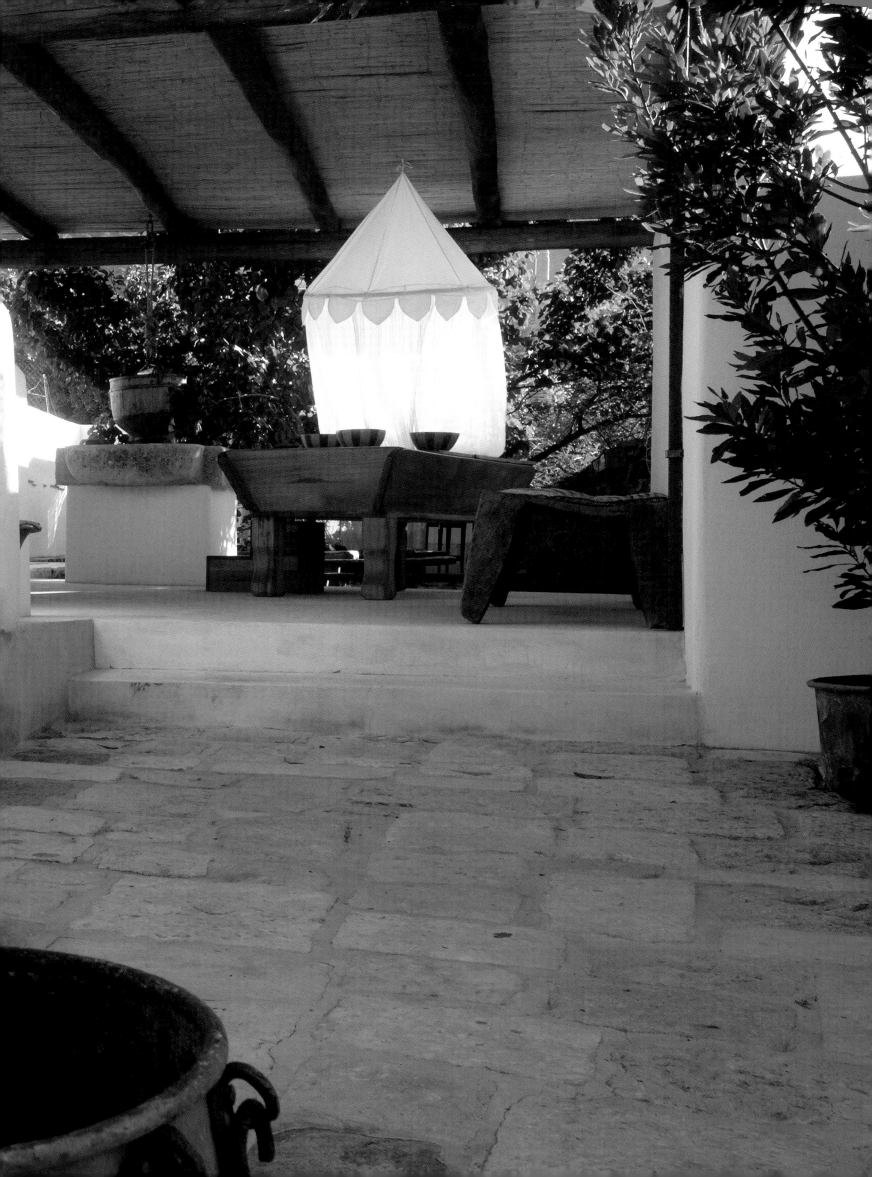

The rooms are permeated with light, each uniquely designed with their names deriving from the local plant names: Ginestra (Broom), Assenzio (Absinth), Malva (Mallow) and Acanto (Acanthus). The design elements alternate between tradition and contemporary design pieces, each with refined, luxurious materials. The bathrooms are all designed to add a zest of colour with typical tiles adorning them. Most rooms feature terraces or balconies looking out across the Tyrrhenian Sea to neighbouring *Panarea* and *Stromboli*, a postcard-perfect view.

The infinity pool is enchanting, and a dive will be irresistible with the air infused by lemons and jasmine blending with the salt of the sea, creating a natural aromatherapy that only this uncontaminated island can offer.

The terraces of volcanic rock are an excellent location to enjoy a glass of Malvasia while waiting for the sun to set over the sea and over the neighbouring islands, offering a moment that is like a dream.

At Hotel Signum all of the family members are dedicated to the guests of the hotel, carrying them on a marvellous journey discovering the treasures of the island, offering insight not only into the history, but also the landscape, nature and gourmet delicacies that can only be found here.

Excellent young Chef Martina Caruso, who has recently gained a prestigious Michelin star, manages the hotel's restaurant. Her delicacies are a marvel to taste whilst sitting on the outdoor patio overlooking *Panarea*, or on the winter veranda crowned with flowers, lemons and Mediterranean plants. To guide guests through the incredible wine list is another member of the Caruso family, Luca, who will ensure a perfect gastronomic journey that will be hard to forget. A must try is the linguine con latte di mandorla e vongole (linguini with almond milk and clams) or the tonno in doppia panatura al profumo di lavanda con scarola (twice-breaded tuna infused with lavender and endive).

Certainly, as well as the fairytale landscapes, guests will take home with them memories of a unique culinary experience.

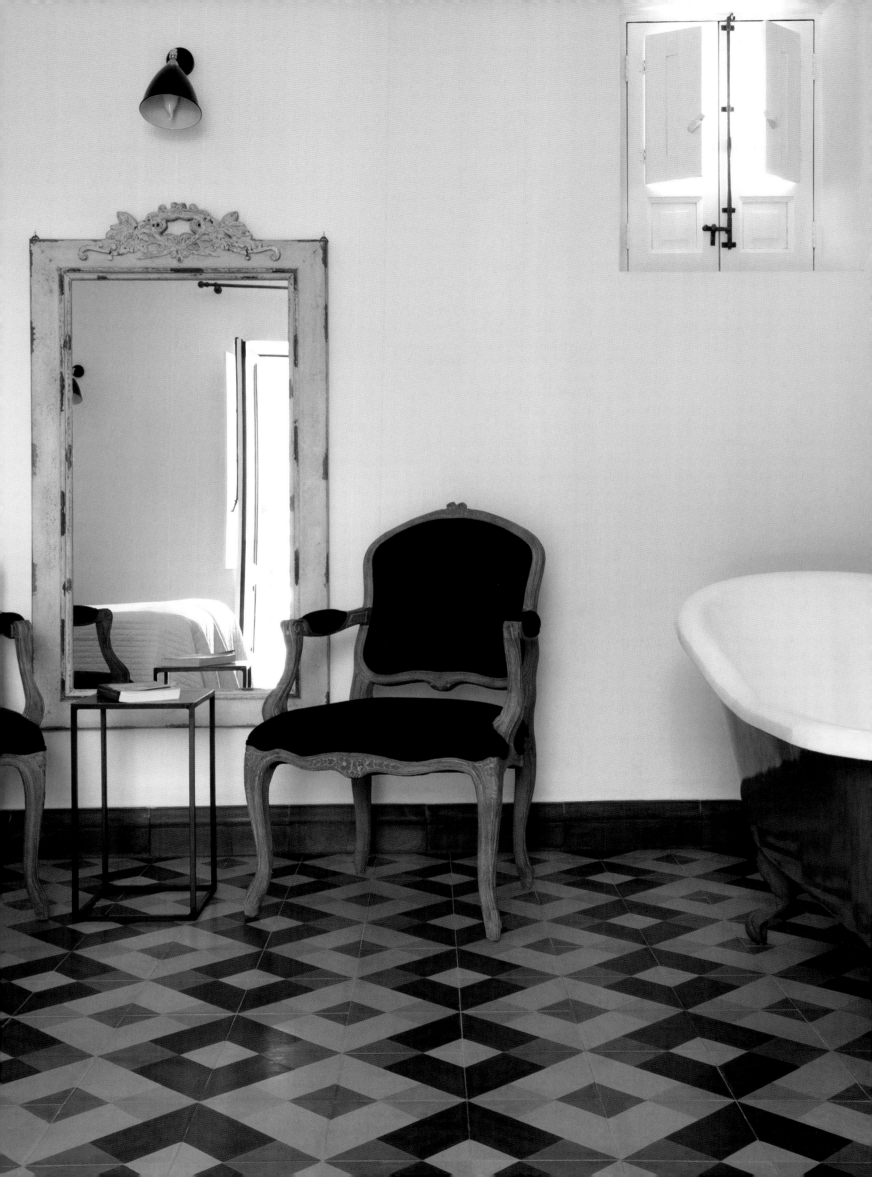

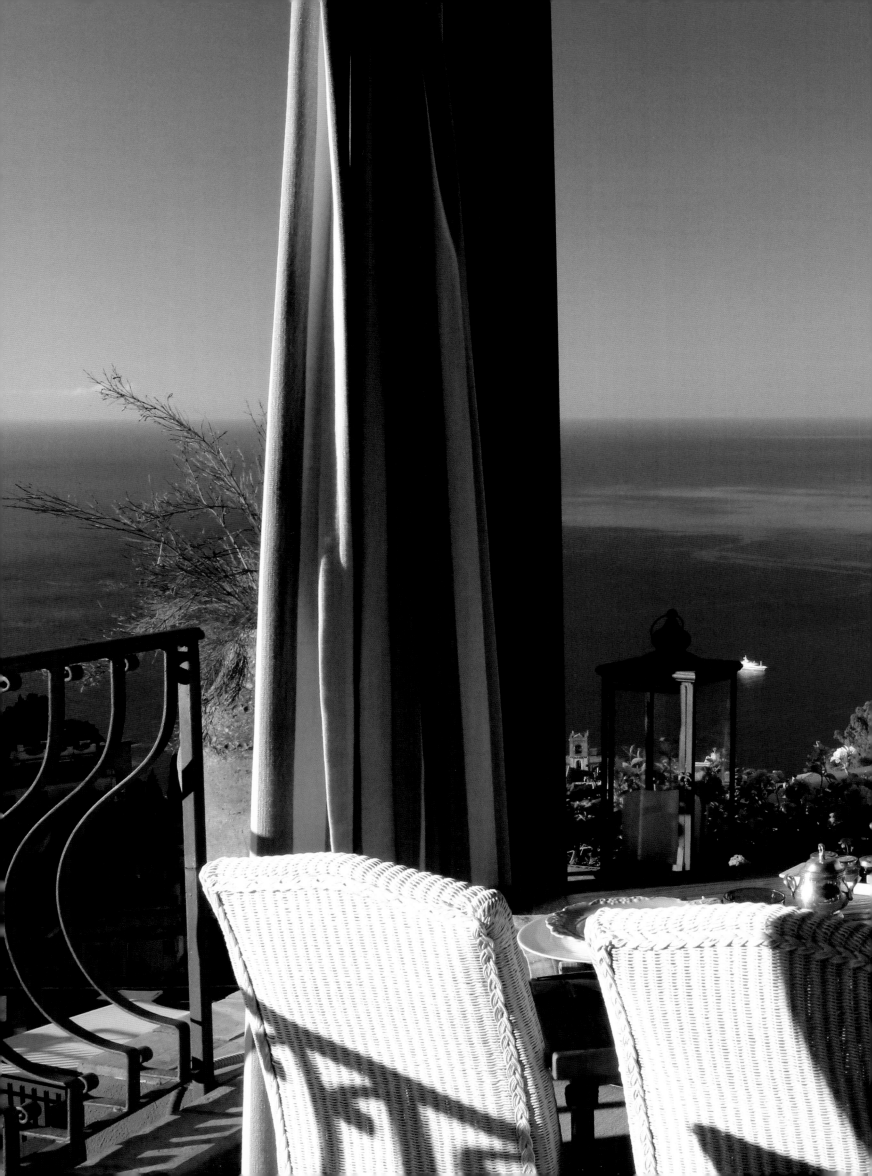

VILLA DUCALE

'And anyone who has once known this land can never be quite free from the nostalgia for it.'
D.H. Lawrence

Upon arrival in *Taormina*, the magical, ethereal atmosphere, which has enchanted travellers for centuries, can immediately be felt. Nestled on the *Monte Tauro* hill, *Taormina* dominates two of *Sicily*'s most beautiful bays, with views over to *Mount Etna* offering breathtaking, dramatic, postcard-perfect scenery. With a millennial history, the Siculi inhabited *Taormina*, and soon later around 700 BC the Greeks arrived on the Sicilian island founding the mythical nearby town of *Naxos*. Later the Romans, Byzantines, Saracens, Arabs, Normans and Spaniards chose *Taormina* as their residential site mainly for its favourable position overlooking the Mediterranean, its mild climate and charming atmosphere. In 1787 J.W. Goethe described *Taormina* in his novel 'Italian Journey' as a 'patch of paradise', and Taormina soon became a regular stop on The Grand Tour. With the likes of D.H. Lawrence, Truman Capote, Oscar Wilde, John Steinbeck and many others choosing *Taormina* as their escape from chaotic city life.

For today's Grand Tour traveller, still enchanted by the timeless majesty of this unparalleled beauty, the ideal stop is Villa Ducale, that has been lovingly transformed by owners Andrea and Rosaria Quartucci (who own another grand Taormina hotel, Villa Carlotta) from an aristocratic Sicilian villa to a charming boutique hotel full of authenticity and charm. Undoubtedly this hotel boasts the best views, immersed in lush greenery, across to the sea and the gardens.

The interiors of the hotel, with each unique piece passionately chosen by signora Rosaria, allows guests to experience the true, authentic Sicilian spirit: from the Caltagirone majolica floor to the wrought iron beds and antique stone walls, every element is sourced locally.

Indeed, each of the seventeen rooms has been inimitably designed by Studio Arena, with the only element linking them being the colour palette of green, yellow and terracotta: the colours of the Mediterranean, the colours of *Sicily*. The views from each room over the bay of *Giardini Naxos*, of the *Etna* volcano or the *Stretto di Messina* are unforgettable.

The villa's soul lies in its expansive panoramic terrace, where delicious, homemade breakfasts

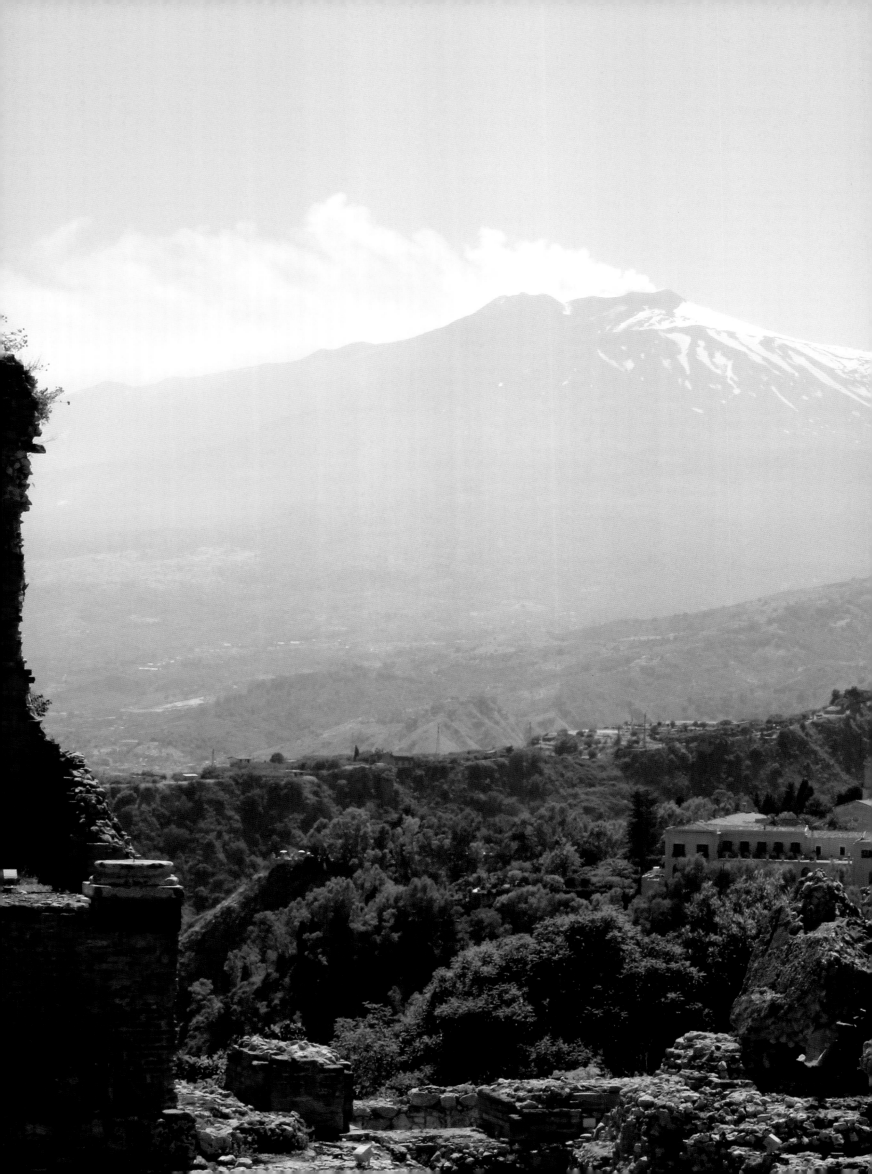

passionately prepared by Pastry Chef Carmelo and featuring Sicilian cakes, biscuits, Mount Etna honey, jams and the traditional cannoli (which cannot be missing from any Sicilian's table) are served. Extraordinary light lunches and romantic candlelight dinners can also be taken on the terrace. They are all created from local, organic products which Chef Santina adoringly prepares for guests recounting the variety, taste and history of the Sicilian land.

Taormina has a plentiful supply of historical sites and places to visit, and Villa Ducale is in the ideal location to see them all. From the *Ancient Greek Theatre* dating back to the 3rd century BC where to this day theatre performances can be admired, to the enchanting medieval hamlet of *Castelmola* towering high at 1,800 feet above sea level, where 360-degree views of the mountains, sea and sky are incomparable. With its white sandy beaches, and incomparable archaeological sites, *Giardini Naxos* is also worth a visit, especially at sunset when an aperitivo taking in the striking views of *Taormina* is a dream.

Villa Ducale is a hotel with a hospitality that knows no equal, with passionate owners, and a charming design with an incomparable view; the perfect 'home away from home' when visiting this ethereal corner of *Sicily*.

VILLA NERI RESORT & SPA

*'To have seen Italy without having seen Sicily is not to have seen Italy at all,
for Sicily is the clue to everything.'*
Johann Wolfgang von Goethe

*S*icily never ceases to amaze, and here is another corner of this enchanting island with many of the characteristics of this stupendous region, whilst simultaneously offering something new and innovative. This is a landscape between sea and mountains, but not a simple mountain; here it is called 'a muntagna' (the mountain), where the population holds reverence and respect towards this majestic natural creation.

'A muntagna' is the majestic *Mount Etna*, the highest and most active volcano in Europe, towering over the *Golfo di Catania* at 3,550 metres in height. Its proximity to the sea makes it all the more fascinating. Indeed this inimitable area has been a UNESCO World Heritage Site since 2013.

Villa Neri Resort & Spa is nestled on the fertile slopes of *Mount Etna*, a few kilometres from the historic town of *Linguaglossa*, founded in 1566 on a lava stream. The name of this ancient town literally means 'tongue-tongue', with lingua being the Latin and Italian word for 'tongue' and glossa the ancient Greek word for 'tongue'. The name seems to refer to the fact that the inhabitants spoke both Latin and Greek.

This beautiful villa in the midst of an ancient olive grove and centuries-old vineyards was born from the love for this land of the Neri family, who entrusted the restoration and realisation of their ideas to architect Salvo Puleo. From their passion for *Sicily* and the traditions that are embedded in this unique region, a modern boutique hotel was born that is located in various buildings, all built in complete harmony with the magical landscapes surrounding Villa Neri.

A contemporary style blends with elements of traditional Sicilian design, with a colour palette of azure, pale orange and yellow deriving from the typical noble Sicilian country houses. Surrounded by lush Mediterranean greenery, there is a large outdoor swimming pool in the midst of olive and birch trees and a unique courtyard named *le dodici fontane*, that offers a glimpse of the ancient communal water troughs that were located in each town.

The twenty four rooms represent the fusion between contemporary and traditional design, representing Sicilian style in a new and creative way. The headboards in each room have been handcrafted in leather, recalling the designs of traditional wrought iron beds that were used for centuries. Antique ceramic jars replace the bedside tables and in each room designs in molten rock have been created. The bathrooms represent a modern take on traditional 18th century Sicilian ceramic designs.

Villa Neri has an immaculate wellness area called Petra Spa that offers treatments created with typical Sicilian products from the marine salt to wine must, herbs, spices, citrus fruit and olive oil. The ice fountain, Turkish bath, whirlpool and sauna are perfect for relaxing body and mind, which is the precise philosophy of Villa Neri.

The list of activities to undertake when visiting this corner of paradise is endless. This is thanks to being located just a few kilometres from the *National Park of Etna* that extends until the mouth of the volcano. Surprisingly, skiing is also possible, as Villa Neri is located only 20 kilometres from the ski resort of *Piano Provenzana*. Signor Neri, a ski instructor and alpine expert, is sure to be the perfect guide for these slopes. In the summer a dip in the nearby sea is a must; understandably this is a hotel that can be enjoyed during all seasons.

The artworks displayed in the suites and communal areas of the hotel are by Salvatore Incorpora, an internationally renowned painter who interprets the beauty of *Etna* and *Linguaglossa*, and who exclusively created the paintings for Villa Neri.

Villa Neri's Le Dodici Fontane is expertly led by young Chef Elia Russo who combines local, organic products to create delicacies with a contemporary twist, in keeping with the philosophy of the hotel.

After a long day of basking in the sun by the majestic pool, or a trek visiting the grand beauty of *Etna*, there is nothing better than to admire the beauty of this untouched landscape with a glass of red wine, and let yourself be immersed in the perfumes of the flowers, olive trees and of the entire nature surrounding this corner of paradise.

The suites are all located on the top floor, with a warm atmosphere provided by the exposed beams that certainly create the cosy ambiance that characterises Seven Historical Suites. Each suite is uniquely designed, and includes a majestic kitchenette. The design elements follow a mix of Mediterranean touches such as the corals that decorate one of the suite's walls, and of classical touches such as the original paintings depicting classical subjects. The Sicilian spirit is expressed in the soul of Seven Historical Suites that wants to be a 'Wunderkammer' of our days, a room of Sicilian wonders where kings, noblemen and learned men would collect and conserve 'naturalia' and 'artificalia' from far away countries. Here in the Historical Suites, vintage and antique items alternate tastefully with contemporary designs such as the crystallised salt and steel lamps. One of the most magnificent touches is the large chandelier at the entrance in 'carta di spagna' from 18th century *Sicily* that illuminates the imposing staircase.

Immaculate detail has been placed on every element of this design residence in order that guests may feel pampered. Noteworthy are the bed sheets from Frette in Egyptian cotton sateen and the sponge soundproofing; a technological innovation to shelter the rooms from the outside noises. Indeed, everything has been chosen with extreme passion to offer exquisite hospitality.

Whilst designing the Suites, the circadian clock was taken into consideration, and for this reason the ample skylights allow natural light to flood into the rooms, whilst at the same time the thick, handmade curtains allow guests to enjoy a peaceful night's sleep.

For this very exquisite hospitality, Virginia has introduced a 'Personal Concierge' service because as she states, 'a holiday is always a unique event, and the same corner of a city will never be the same seen from different eyes'.

Seven Historical Suites are seven magnificent, unforgettable suites that will surprise guests with new details at every stay, located in the heart of the city and in the heart of each guest.

TUSCANY

Poetic inspiration: A postcard-perfect region, with lush green vineyard covered hills, never-ending landscapes with scattered cypress trees and sunflowers meeting the silver waters of the sea. This is the Italy of our dreams with divine food, wine, history, culture, the list is endless. This land makes us all poets of beauty, ambassadors of a unique lifestyle, aficionados of basking 'under the Tuscan sun'.

BORGO SANTO PIETRO

*'To learn what an old Tuscan garden was, one must search the environs of the smaller towns, and there are
more interesting examples about Siena than the whole circuit of the Florentine Hills.'*
Edith Wharton, *Italian Villas and their Gardens*

*T*uscany's magnificence has been written about many times over. Its hamlets and towns are magical, its landscapes heavenly, its cuisine delicious; it is a region bursting with natural life. To find this quintessential Tuscan essence, look no further than Borgo Santo Pietro.

This exquisite 13th century villa, once a healing retreat for pilgrims, was lovingly and skilfully restored by owners Jeanette and Claus Thottrup. Borgo Santo Pietro was born out of a passion to carefully blend nature and luxury, relaxation and wellbeing, art and gastronomy.

From the road, Borgo Santo Pietro is barely visible, with two enigmatic sphinxes guarding the entrance and tall, wrought iron gates protecting the *Tuscany* of our dreams.

The large stone house at the end of the peaceful cypress-lined drive contains interiors inspired from the travels of its owners, blending traditional Italian design livened with murals and cosy open fires. Just as in every grand Italian villa, each guest is invited to wander from one room to the next, enjoying live music from the grand Steinway piano in the music room, or losing themselves in a classic novel in the library.

The rooms, some of which come with their own private garden, are a guarantee of restful grandeur and ultimate seclusion. From the 'Casa dell'Unicorno' dedicated to T. Hardie's novel 'House of the Wind' with its luscious velvets and plump curtains, to the more intimate San Galgano, drawing inspiration from the hand-painted mural depicting the history of the *Abbazia di San Galgano*, one can easily understand that each of these unique rooms has a timeless story to tell.

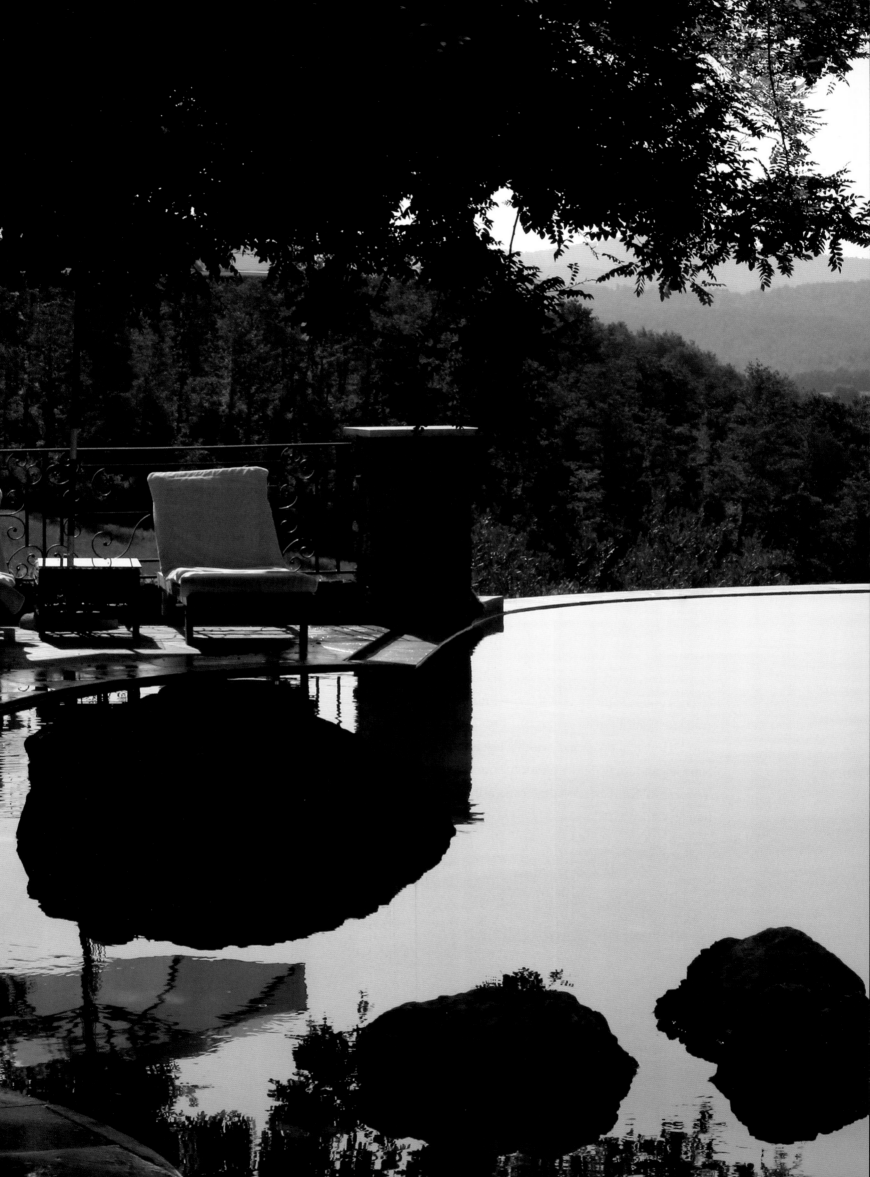

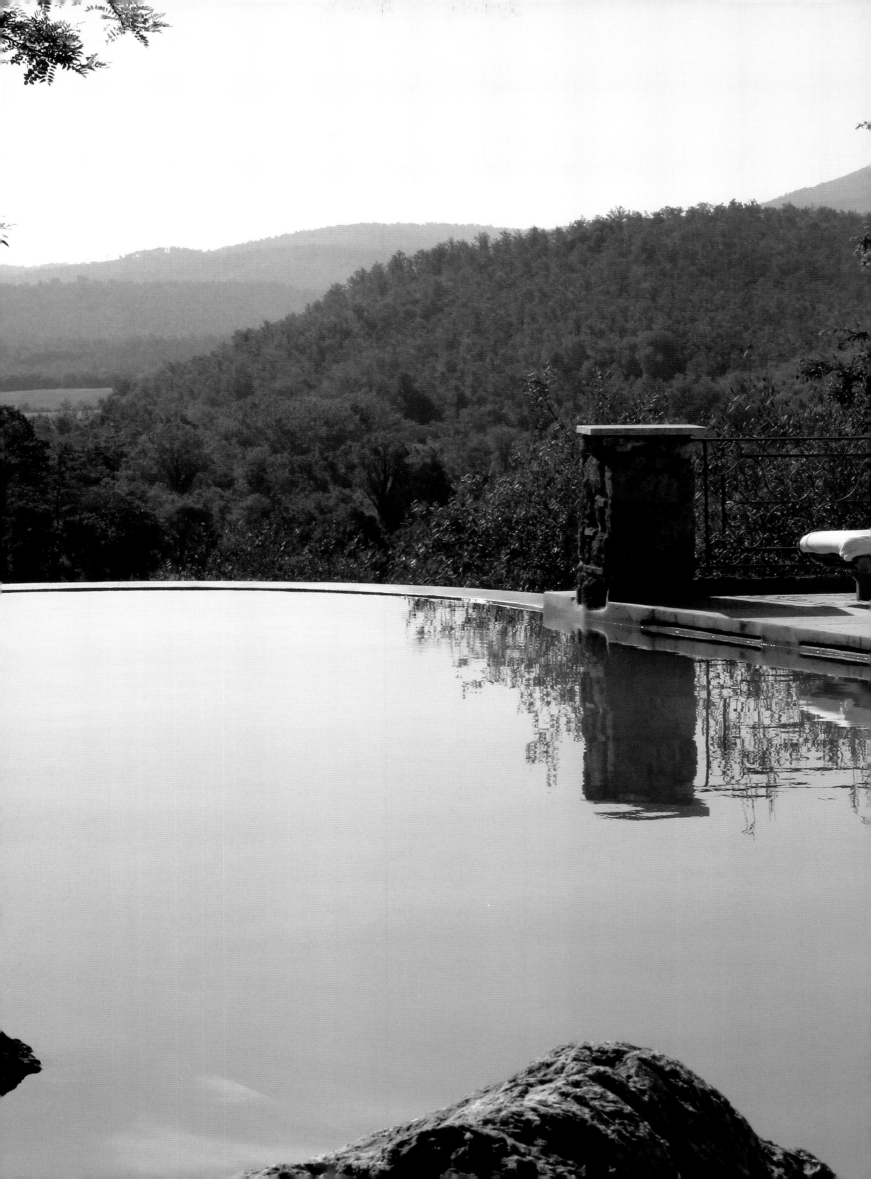

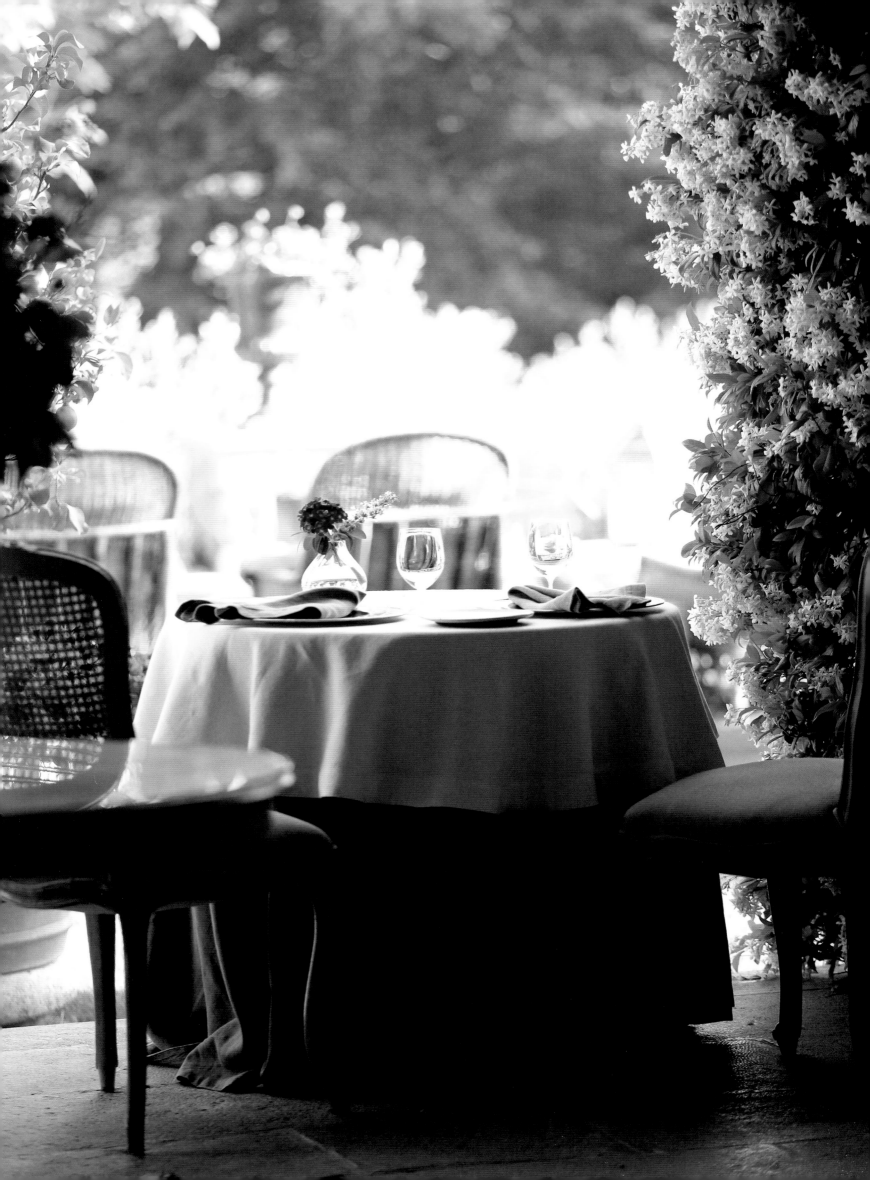

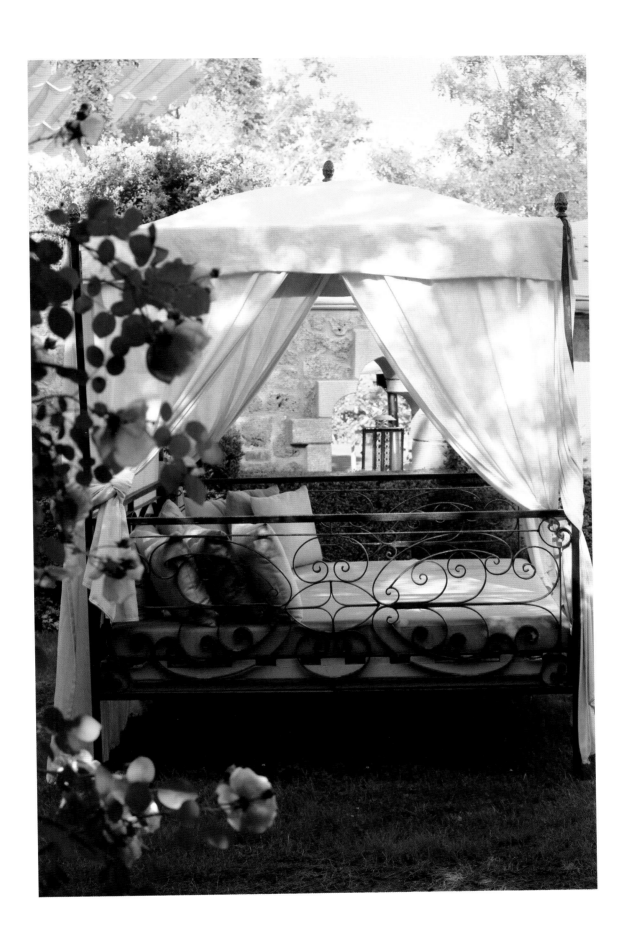

Equally striking are the grounds surrounding this dreamy boutique-style hotel. Guests are invited to help the farmers with their harvest on the working organic farm, with its family of alpacas and Iberian pigs. A herb garden and biodynamic vegetable garden are also ready to welcome you. Each harvest serves to honour the millennial tradition of producing food for this ancient Tuscan hamlet.

The 13-acre garden itself is an eden of secrets, with enchanting paths leading you to the evocative rose garden, the various fountains scattered here and there, to the koi carp lake and last but not least to the magical infinity pool that lightly floats idyllically in the landscape.

At the heart of Borgo Santo Pietro lies its remarkable restaurant Meo Modo led by Chef Andrea Mattei, recently awarded a Michelin star, and with a noteworthy 'farm to plate' philosophy. Indeed, all the land's produce is skilfully and exquisitely turned into creations for one to enjoy.

This idyllic hotel is the perfect pied-à-terre from which to explore the picturesque towns of *San Gimignano* and *Volterra*, as well as the lesser-known medieval towns of *Randicondoli* and *Chiusdino*.

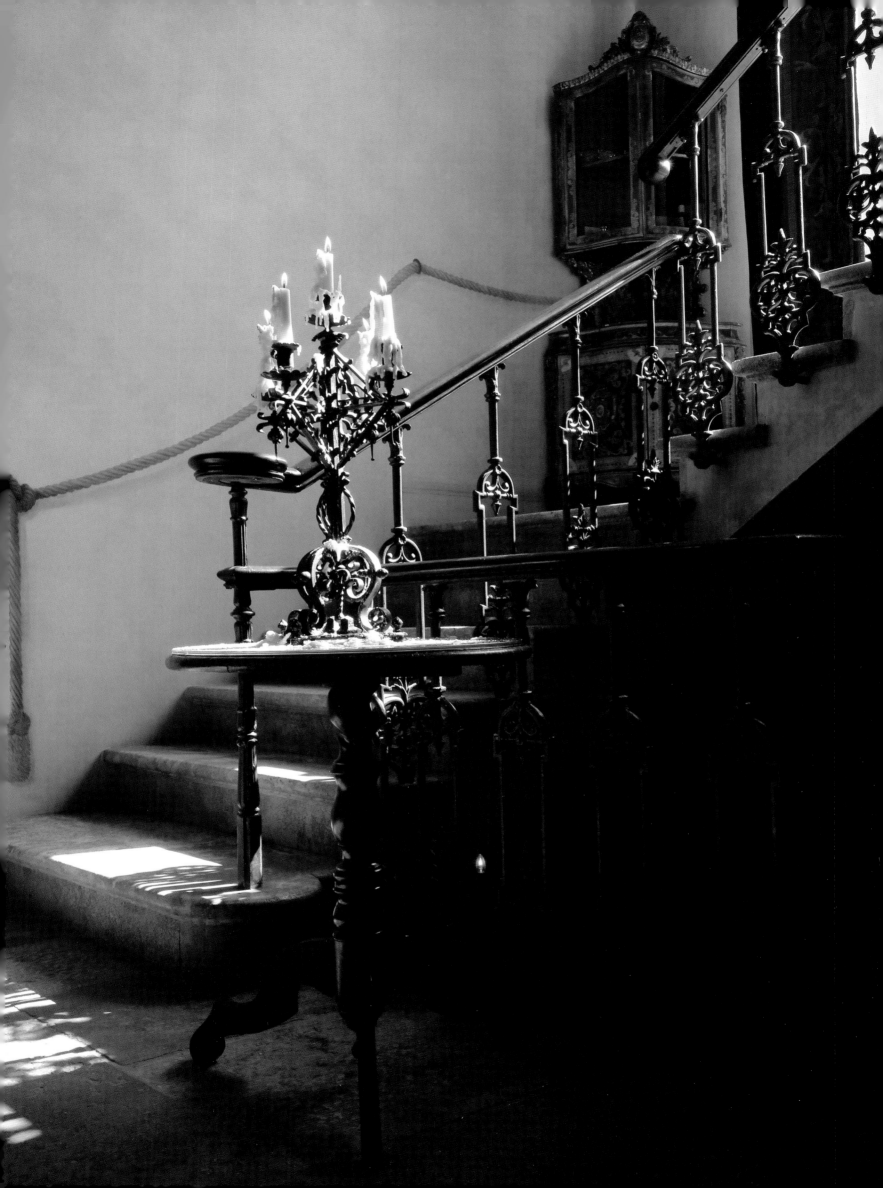

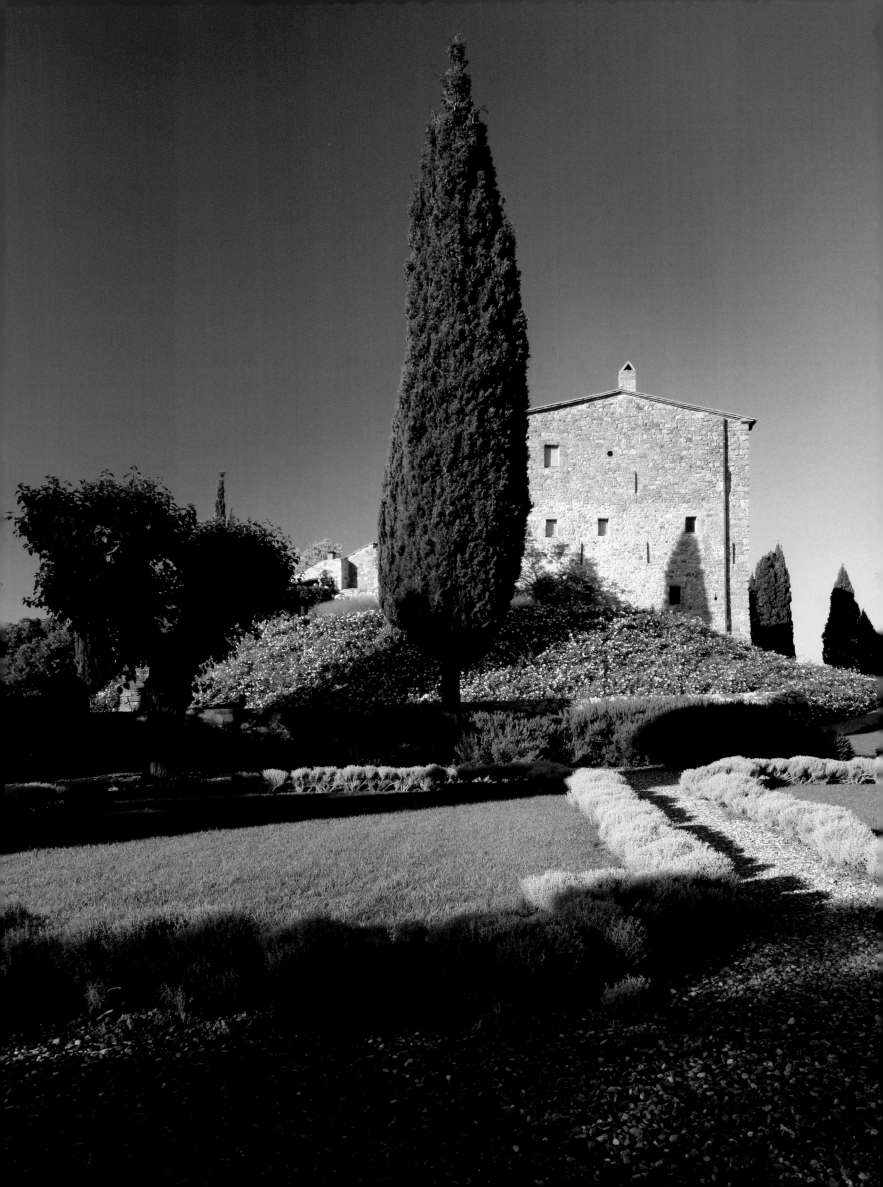

CASTELLO DI VICARELLO

'My idea of heaven still is to drive the gravel farm roads of Tuscany, very pleasantly lost.'
Frances Mayes, *Under the Tuscan Sun*

Timelessness, authenticity and remote getaway are the words that spring to mind when describing this ethereal 12th century castle turned into a rustic boutique hotel in wild southern *Tuscany*. The setting of the castle seems to come straight out of a Rinascimento masterpiece, with spellbinding scenery of lush, green hills, rich olive groves and endless meadows with views of the distant gentle sea.

With only seven suites, this untouched corner of *Tuscany* has been designed and lovingly owned for more than 30 years by Aurora and Carlo Baccheschi Berti, antique collectors, who after years of living in Bali decided to return to Italy and bring their unique touch to the Maremma.

Indeed, opposites attract in this unique property, with oriental touches, bold and modern artworks seamlessly blending with the austere medieval stones, antique furnishings and extravagant four-poster beds.

Each suite carries an individual name as opposed to a bland room number; testament to its style and essence. From the Chinese Room with a handmade Chinese bed from the distant island of Madura, to the Suite Giardino Segreto with an enchanted private garden, antique four-poster bed and original terracotta stove.

At the heart of the castle is the stone-clad kitchen, always open to guests, where irresistible aromas of authentic Tuscan delicacies permeate the air. Guests are even invited to Aurora's cookery courses, where the perfect homemade pasta recipe can be discovered, and then at lunch or dinner in the candlelit courtyard, sampling the results is a must, accompanied by a glass of robust red wine produced by Carlo's vineyard. Speaking of which, if the astonishing interiors, spellbinding landscape and authentic cuisine wasn't enough to make you pack your bags and rush to Vicarello, the castello even produces its own organic wine in its seven hectares of vineyards. Created by expert oenologist Luca d'Attoma, the irresistible Terre di Vico IGT is an exceptional blend of two grapes: Merlot and Sangiovese. Another exceptional product of the castello is its olive oil, one of the most sought after in the region, because of the grove's perfect position between mountains and coastline. In November, guests are invited to join in with the harvesting of the olives, and, following the pressing process, to create the translucent new oil with poetic shades of green and gold. What better way to enjoy it than with a piece of freshly baked Toscano bread and a sprinkling of coarse salt? Wild boar hunting excursions can even be organised on the Castello's special Valle di Buriano estate.

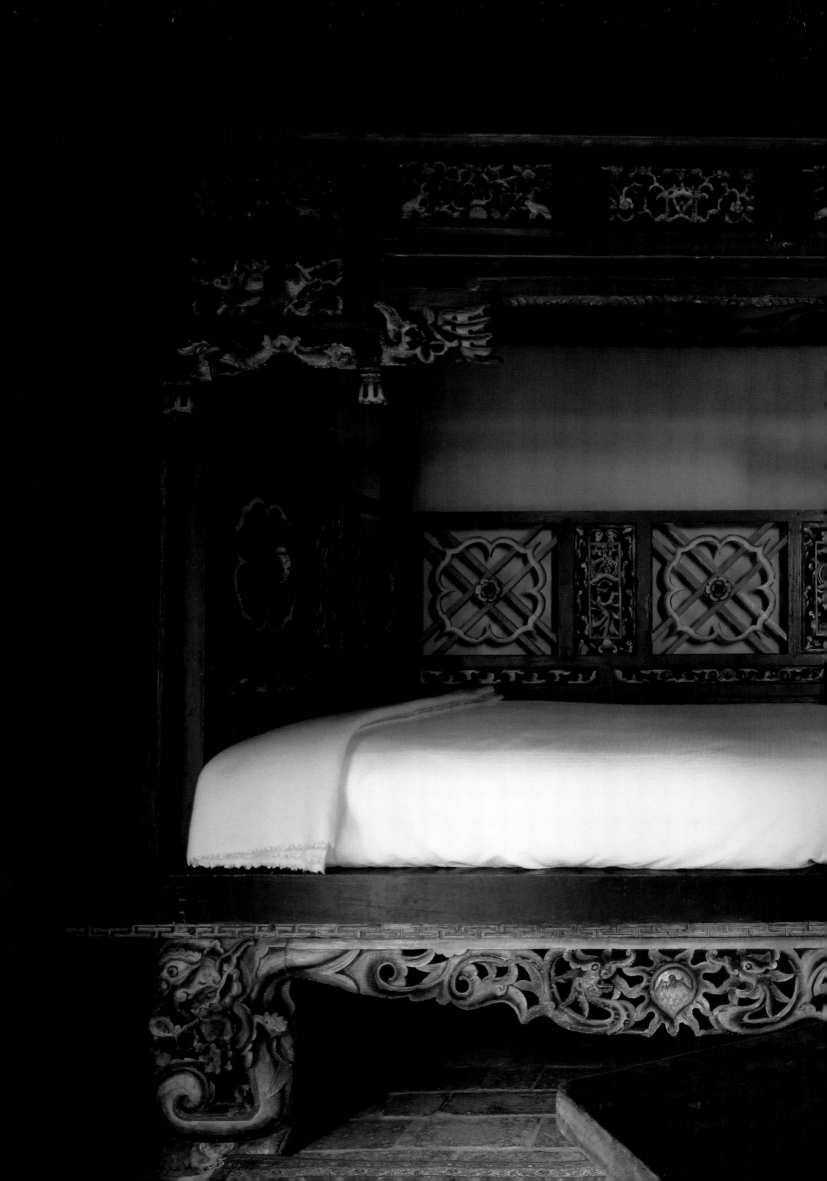

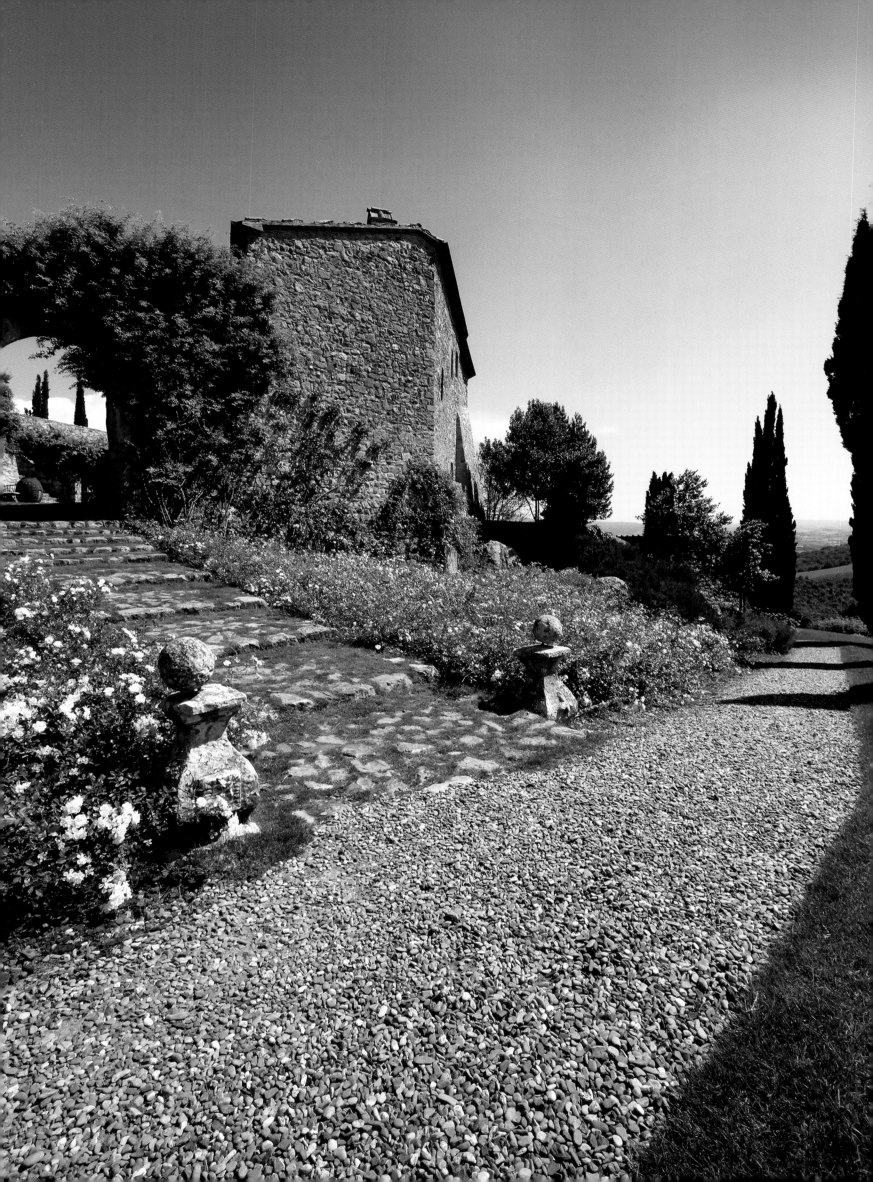

LOCANDA AL COLLE

'E tutta la Versilia, ecco, s'indora d'una soavità che il cor dilania.'
Gabriele d'Annunzio, *Il Commiato (Alcyone)*

'And all of Versilia, here, becomes golden of a gentleness that expands the heart.'
Gabriele d'Annunzio, *Il Commiato (Halcyon)*

Locanda al Colle is a property that seems to have it all: perched on the hills behind *Viareggio*, staying here gives visitors the chance of living *Tuscany* to its full splendour, from the sea and countryside to the hills. Upon arriving at the locanda, leaving the sea breeze of the fashionable *Versilia* coast behind, what immediately strikes you is the beauty of the surroundings. A small country lane climbs up the hill, opening up to an astounding view over *Camaiore* and out to sea, with the scent of the many aromatic plants, herbs and olive trees enchanting each passerby.

Locanda al Colle cannot be described as a hotel, rather it is a home that its owner Riccardo Barsotelli gracefully restored after having worked for more than two decades in the fashion business. He brought with him a glamorous and international flair to the Tuscan hills.

Upon entering, what immediately strikes is the lack of reception, lobby bar or uniformed staff, but rather an atmosphere of laid-back sophistication, harmoniously designed rooms and charming informality. Riccardo's passion for interiors and art is visible in every corner of the locanda, where contemporary art is the prima donna and helps turn Locanda al Colle into an evermore enchanting place, where the atmosphere is infused with art. During the year, guests are invited to view the various exhibitions from local and international artists that rotate here. Interestingly, just a couple of kilometres away is *Pietrasanta* (literally meaning 'sacred stone'), an enchanting town where in the past, marble was produced and where bronze foundries are scattered, a town that artists and sculptors have historically called their home, many of whom choose the Locanda as their exhibition space.

The interiors themselves are an eclectic mixture of furniture from the 30s, 40s and 50s sitting on a typical Tuscan stone floor with exposed wooden beams and a neutral palette of colours serving to highlight the beauty of the furnishings further still. The furnishings come from Riccardo's years of travelling and visiting flea markets and antique fairs, making the locanda appear almost like a chic Manhattan apartment with the warmth of an Italian country house.

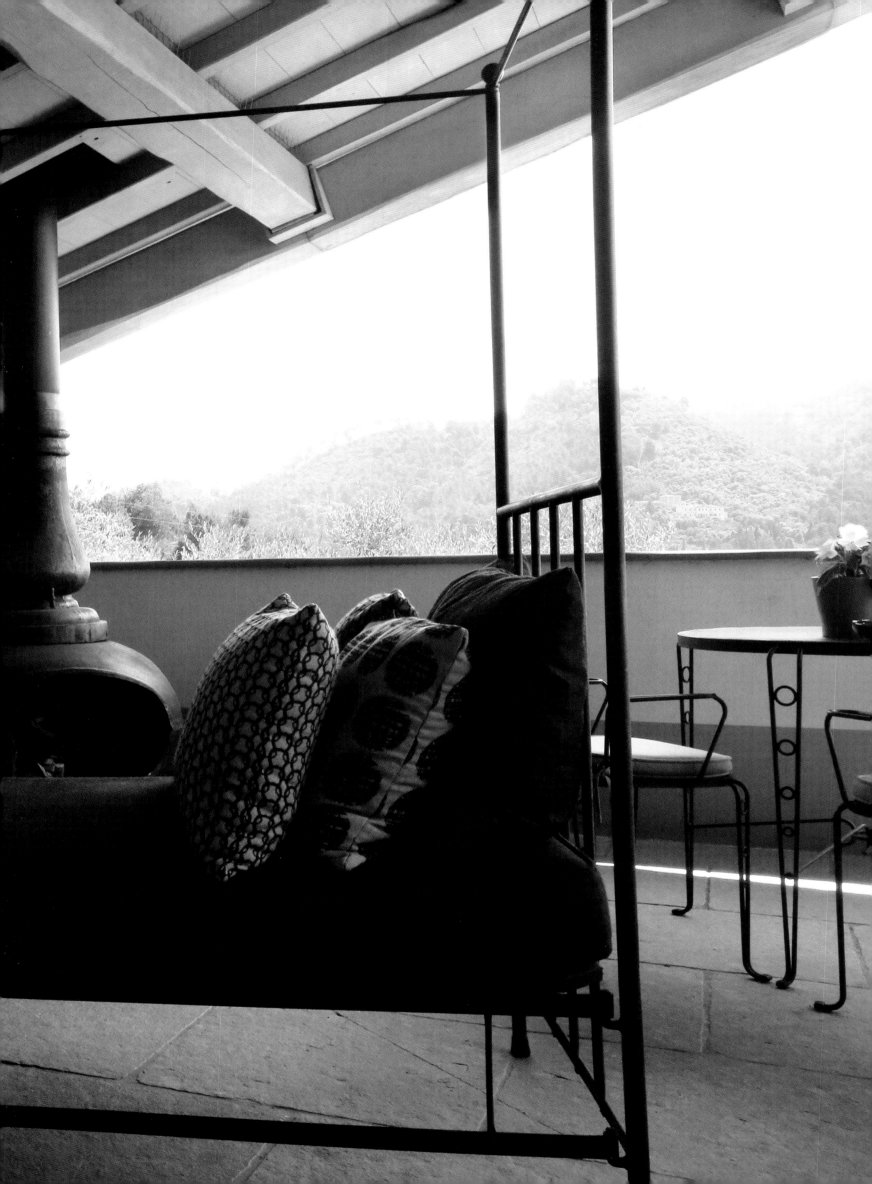

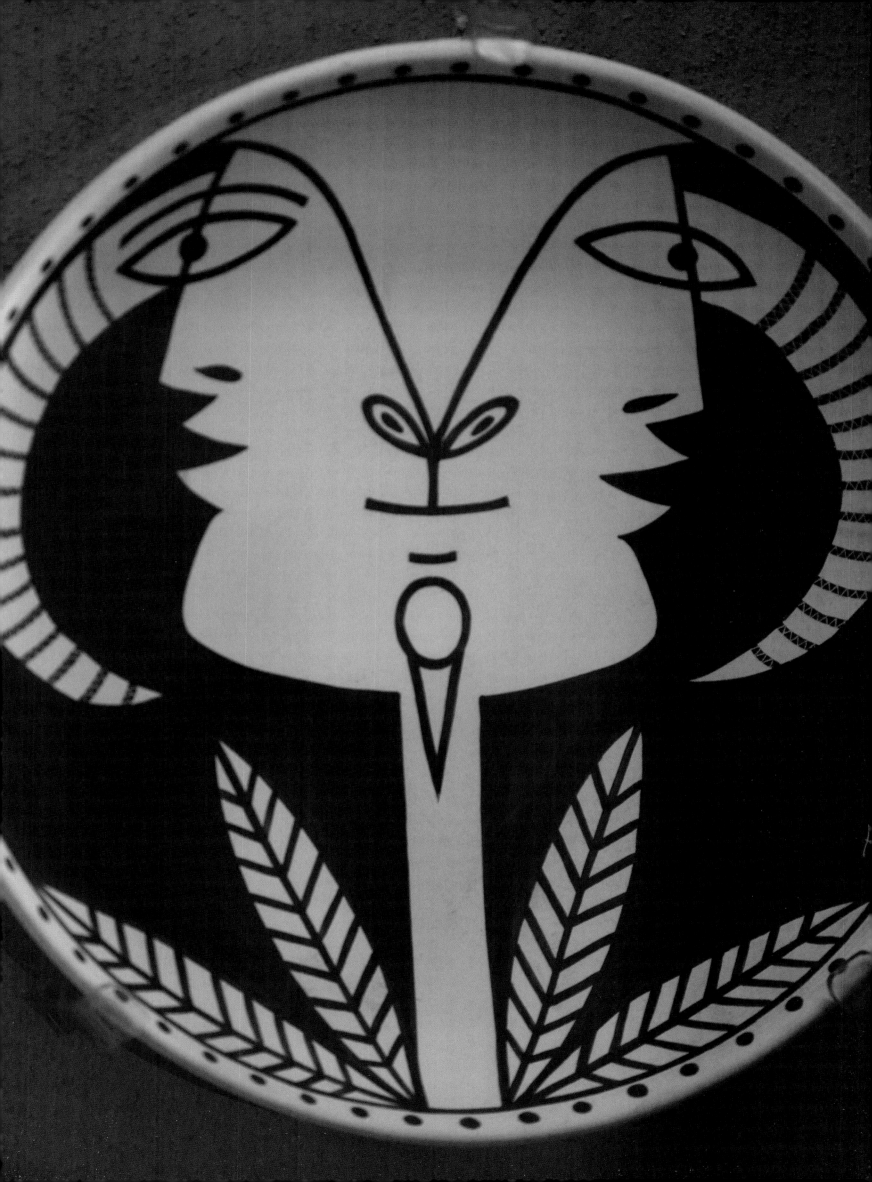

The locanda's three floors are home to the nine unique rooms, each decorated and named individually, from Olivo to Cipresso; each paying homage to *Tuscany*, where tranquillity and privacy reign. Each floor has its own reception room and terrace, making it an ideal space to chat to fellow guests about the best seafood restaurant in *Lido di Camaiore* or the best artisanal shop in nearby *Lucca*.

Yet another special touch is the lack of restaurant. Instead, each Wednesday and Saturday, guests are invited to join Riccardo and his family and friends for dinner under the wisteria pergola admiring the stars and moon melting into the sea. It is this very feeling of joining a family that makes Locanda al Colle the ideal retreat from buzzing cities and daily routines.

The honesty bar is also available for guests all day, so that they can enjoy a glass of wine on the terrace sitting on the elegant iron furnishings savouring the splendid view of the olive grove.

Finally, the perfection of this guesthouse is completed with the heated saltwater pool, an ideal place to relax and soak up the summer sunshine or to read a novel on warm autumn days.

From Locanda al Colle, visiting magnificent *Tuscany* is simple and a must-see. *Forte dei Marmi*, one of Italy's most famous resorts is a drive away, as is the magnificent city of *Pisa* with its medieval palaces, historic churches, and how can one not mention the *Piazza dei Miracoli* with its symbolic cathedral and leaning tower.

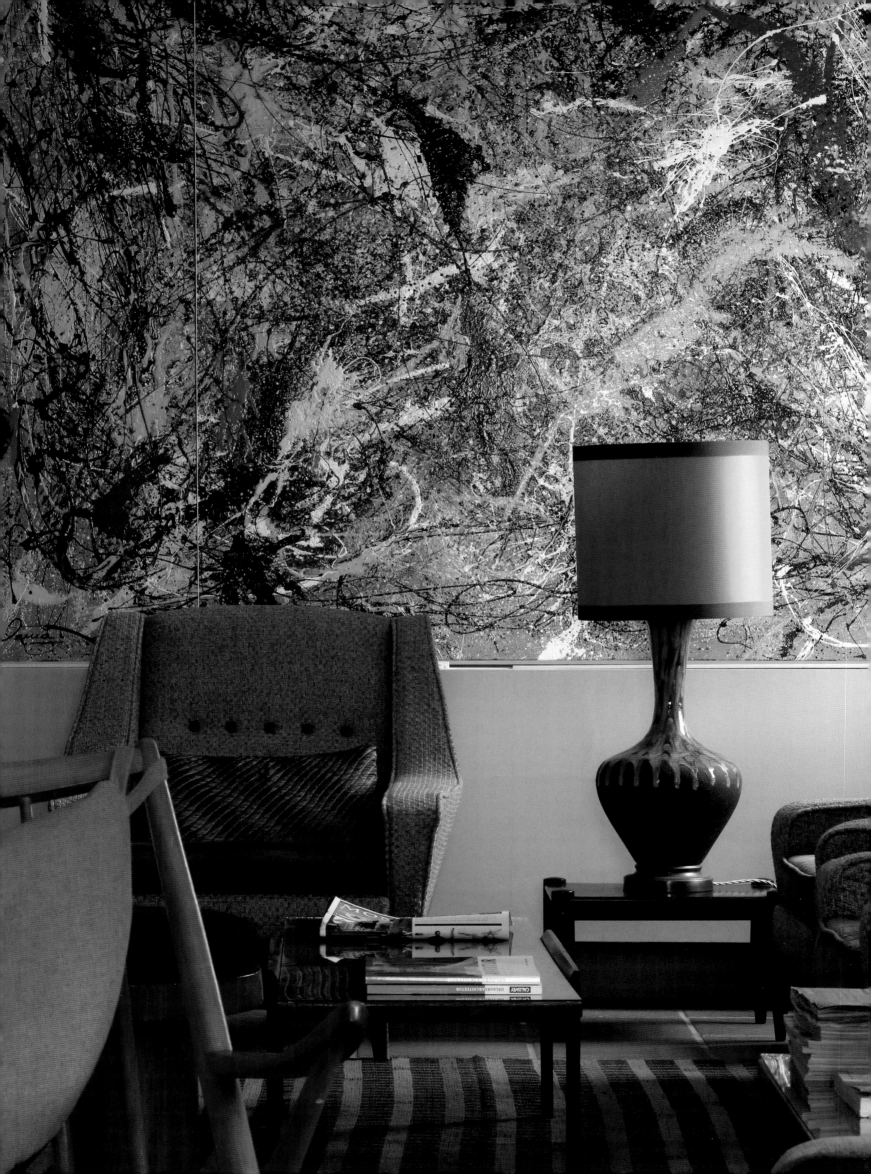

VILLA ARMENA

'For us to go to Italy and to penetrate into Italy is like a most fascinating act of self-discovery, back, back down the old ways of time. Strange and wonderful chords awake in us, and vibrate again after many hundreds of years of complete forgetfulness.'
D.H. Lawrence

The countryside around *Siena* is perhaps the most narrated, filmed and talked-about location in rural *Tuscany*. Pulsating with history, culture and enviable landscapes, this is the idyllic *Tuscany* of our dreams. Villa Armena is fortunate to be in the beating heart of the province, in the *Crete Senesi*, surrounded by the rolling hills, alluring landscapes, inestimable works of art and medieval hamlets. Undeniably, the ruling word in this corner of Italy is beauty.

Villa Armena is a typical structure from the late Rinascimento located on a hill that overlooks the beautiful walled town of *Buonconvento*, reachable from a dusty country lane that opens up, once the imperious gates of the villa open, onto rows of cypress trees, maritime pines and olive groves.

The villa, built by Baldassare Peruzzi in the 16th century, has always been a noble country residence. Owned by the powerful Malavolti family from *Siena*, this is a villa filled with legend, one of which recounts a member of the Malavolti family who, returning from the Holy Land Crusades, fell in love with a beautiful local girl when stationed in Armenia. After being forced to return to Italy and married off by his family, he named his villa after the love of his life who had entered his heart and his life so powerfully, Armena.

After years of neglect and abandon, current owners Edoardo Giacone and his wife Elena (together with their four-legged companion, Franco), bewitched by the charm of the villa, decided to transform it into an intimate boutique hotel, and to its former grandeur and splendour, where friendly service, peace and relaxation are the key words.

Offering just ten rooms, each uniquely designed and named after members of potent local dynasties; each with original paintings, fabrics, terracotta floors, prints and baroque furnishings; each offering enchanting views over the sunflower fields and olive groves or over the equally stunning grounds. Among the highlights are the Orlando di Venusto suite with its rich red and gold velvets and canopy beds, and the Orlandino di Bernardo suite, with its softer gold draping and luxurious wooden furniture.

Outside, the eccentric beach equipped with sea sand that has been created by the pool is the perfect relaxation spot with comfortable sun loungers and plump cushions, making it difficult to leave the villa and its environs.

Villa Armena is run like a home, with Edoardo and Elena organising tours and sightseeing trips for guests as they would for their friends. When staying here, one cannot miss the chance to visit a winery in *Chianti* or in nearby *Montalcino* and *Val d'Orcia*. Back at the villa is an impressive basement wine cellar stocked with barrels and vintage bottles, where continuous research for the best Italian wine is undertaken. Focusing on smaller, genuine, lesser-known vineyards, Edoardo's mother Laura is sure to take guests on a wine tasting that is hard to forget.

As with history, gastronomy is at the heart of Villa Armena. The restaurant, *Sorbo Allegro* (The Merry Rowan), named after the century-old tree in the garden, promises an elegant atmosphere, where tradition meets innovation with a truly 'Made in Italy' approach, using mostly organic and local products with the 'Slow Food' certification, the embodiment of high quality and certified origin. All the delicacies are made on site including the bread, cakes and pasta. A must-try is the *pici*, traditional Tuscan hand-rolled thick spaghetti, excellent with wild boar ragout.

As with any Italian villa, the living room is a convivial gathering space, where large leather armchairs and stylish fireplaces invite guests to enjoy the *vini da meditazione*, literally 'wines for meditation', perfect to sip whilst planning the following day's activities or simply gazing over the most beautiful countryside one can find, the Tuscan countryside.

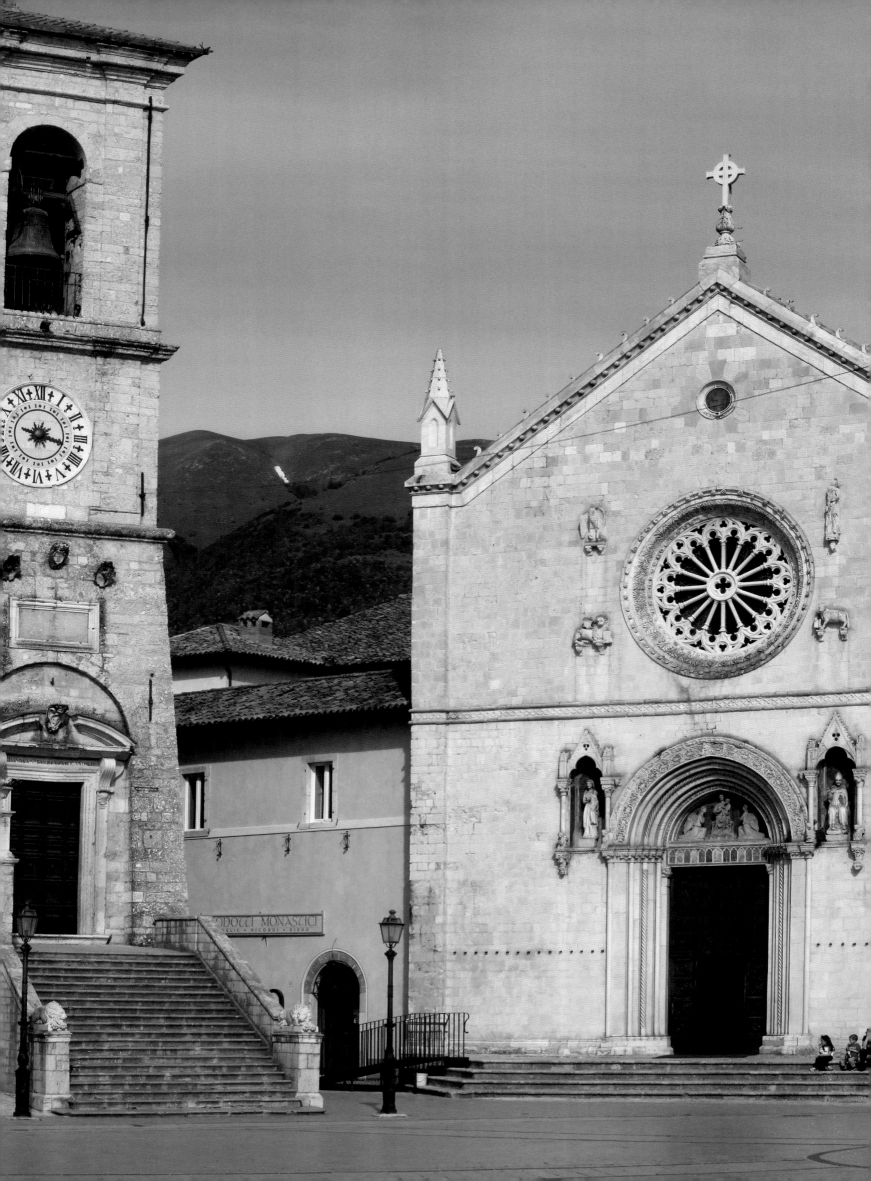

UMBRIA

Romantic inspiration: It must be because in this very region Saint Valentine was born, the saint of lovers, Umbria carries with it a romantic atmosphere. It must be to do with the enchanting hills, the peaceful landscapes, the harmonious architecture blending with the surrounding nature. With Umbria it will be a coupe de foudre.

The fourteen rooms, named celluzze (little cells), preserve the philosophy of the hotel; being that of preserving the ancient luxury of the essential, where time stands still. Pure minimalism and impeccable design define the rooms, kept as close as possible to the ones used by the former inhabitants the hermits, where meditation and prayer were the key ingredients. The wrought iron single beds covered by handmade hemp yarn bedding, handmade lighting by local artisans, a simple stone writing desk with a chair and a bathroom are the essentials of the rooms, with a natural ventilation system keeping the rooms cool in the summer, and a wood-burning boiler to heat the floor in the winter. There is no Wi-Fi, telephone or television in the rooms; instead guests are invited to meditate whilst admiring the lush green valleys from their celluzze.

Meals are an experience in their own right, where dinner is served in the refectory observing silence with a large, open fireplace dominating. The vegetarian meals, containing organic vegetables and herbs grown in the grounds around Eremito, are in line with Umbrian monastic traditions. Freshly baked bread, handmade pasta and divine jams and cakes are served daily to the delight of guests.

The focal point of this eco-hotel is the relaxation area, where complete unwinding is key. It is a space for body and mind, entirely dug out of the local rock, with a whirlpool bath and steam room, where whilst listening to Gregorian chants, guests are transported to a haven of peace.

Eremito organises a myriad of activities for its guests; from horse riding and icon painting to walks in the wood along the picturesque *Chiani* river.

This hotelito with its Franciscan minimalism is a much needed escape from today's hectic world, where guests find space and silence to enjoy the beauty of nature. Its philosophy is that of finding peace in beauty and joy in living, which is perhaps the greatest luxury in the world.

BORGO DI CARPIANO

'Italy is a dream that keeps returning for the rest of your life.'
Anna Akhmatova

The enchanted town of *Gubbio*, dating back to pre-Roman times, is a place where time seems to have stood still. It is an idyllic Umbrian town where medieval, gothic and renaissance buildings blend harmoniously with astonishing views over the green valleys, creating a settlement that seems straight from the Italy of our dreams, an Italian utopia.

Only a short drive away, the ancient castle of *Carpiano* can be found, dating back to the 10th century, once home to Rovaldo Baldassini, father of Saint Ubaldo the patron saint of *Gubbio*. Here is found the magnificent basilica of the town, which still houses the body of the patron saint. In the 17th century the castle was given to the curia of *Gubbio*, who built a church in its place. Once closed, due to the decline in population in the scattered villages of the area, the church was abandoned and left in disuse.

It wasn't until 2001, when current owners Riccardo and Marilisa Parilisi discovered the pile of rubble during a visit to *Gubbio*, immediately fell in love with the area and promised to bring life back to the Borgo.

After many years of restoration and renovation work mixed with devotion and patience, the ruin was transformed into the fairytale hideaway we can see today. Where possible, the original materials were kept and combined with local and traditional Umbrian materials to give Borgo di Carpiano the enchanting aura it has today, making it the ideal 'escape' retreat to soothe the soul.

A small drive leads guests towards Borgo di Carpiano, passing by secular olive trees and lush forests through an untouched valley framed by the *Ventia* creek.

The main building welcoming guests is the former church, lovingly restored with the original frescoes preserved and today containing a charming library and drawing room, where art events and classical music concerts are often held.

The three stone houses that make up Borgo di Carpiano and house the nine rooms are spread within the estate, each leading down to the idyllic saltwater infinity pool that affords a spectacular view over the valleys.

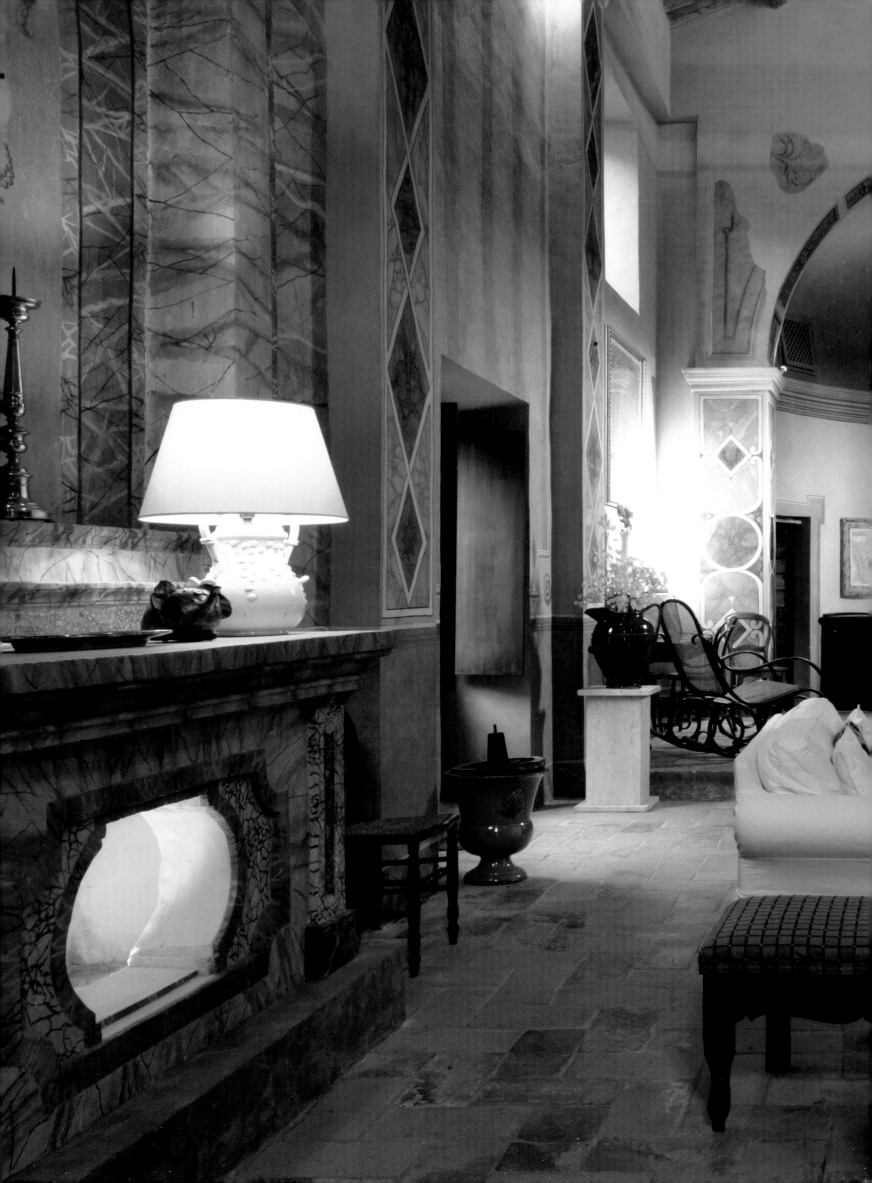

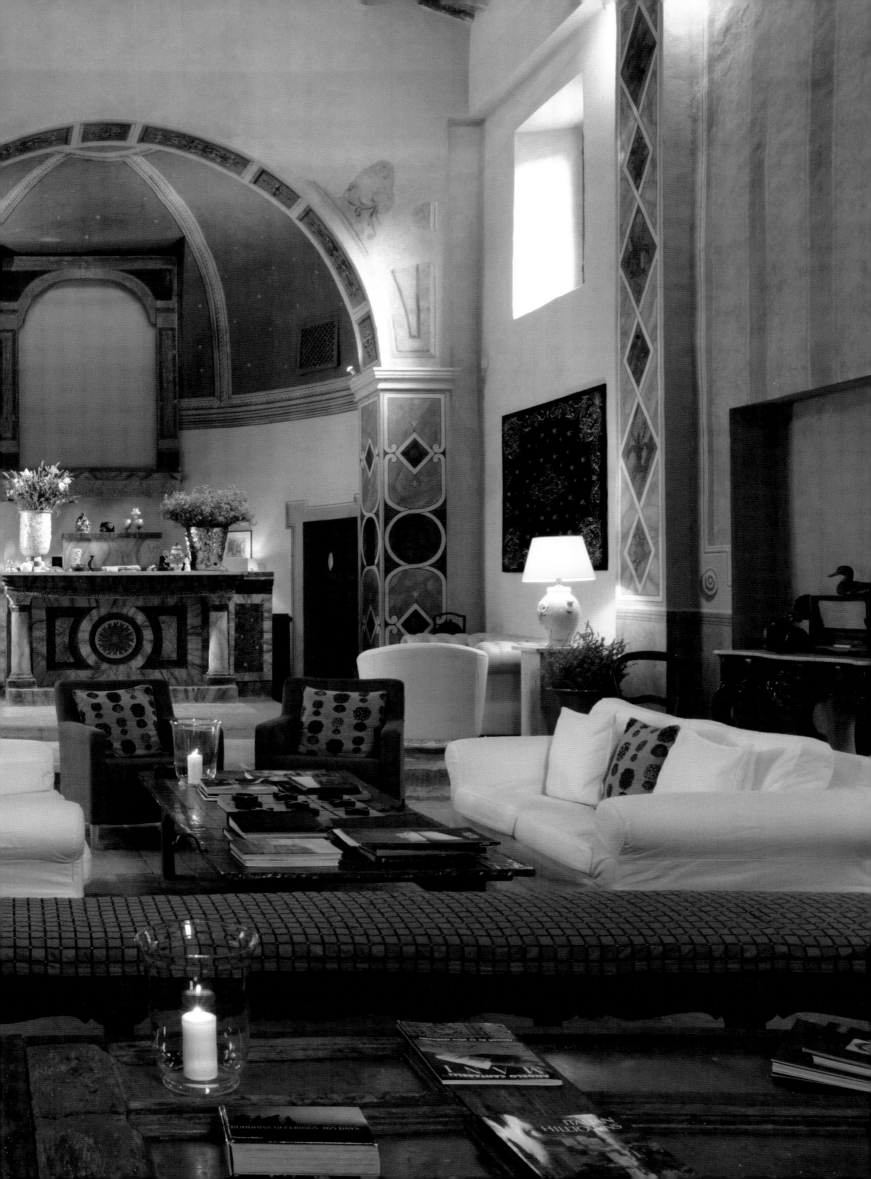

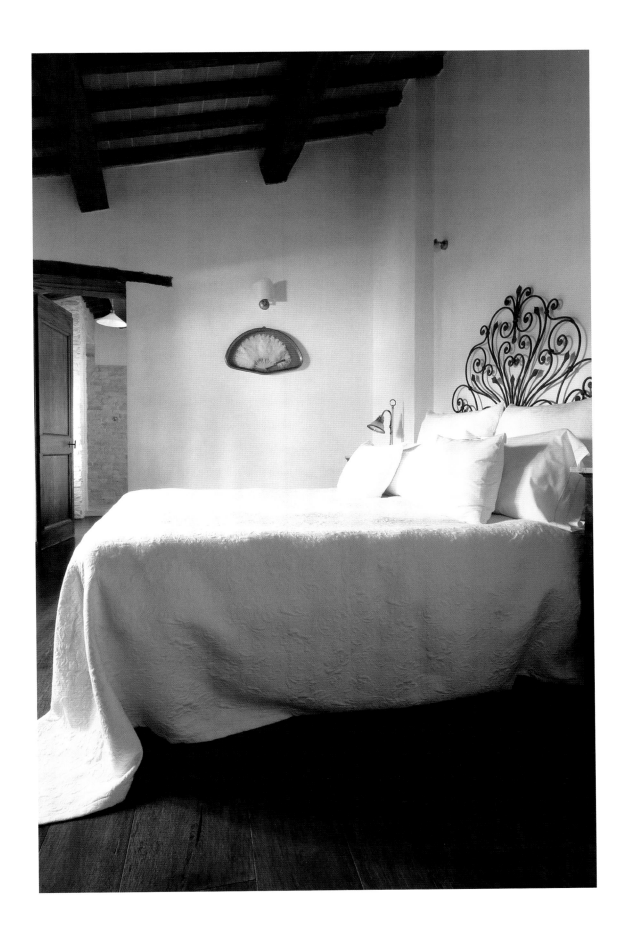

The rooms are all unique and filled with antiques, paintings and silver from the Parisi's private collection. All designed to bring peace and tranquillity to guests, each room is meant to transport guests into a forgotten world, where there are no alarm clocks or computers, but instead old-fashioned keys, linen sheets, and where the evening lullaby is performed by cicadas and the morning anthem is sung by birds. Nearby waterfalls accompany the silence of this valley, a silence that each guest will quickly become accustomed to.

The regional cuisine served at Borgo di Carpiano is an artwork in itself. With homemade bread, biscuits and cakes to delight at each breakfast and organic vegetables grown on the estate served with typical Umbrian products to charm each diner. Each genuine delicacy is served with local extra virgin olive oil, and a glass of local Sagrantino di Montefalco wine. And when in season, a sprinkling of Umbrian Norcia truffle on some fresh egg pasta make this the perfect accompaniment to a delightful evening with friends.

As if this Borgo wasn't relaxing enough, a gazebo immersed in the greenery of nature is offered to guests willing to immerse themselves in an exclusive wellness treatment.

Boasting a unique location near *Gubbio*, and the Etruscan city of *Perugia*, the UNESCO World Heritage Site of *Assisi* is also a short drive away, as is the picturesque *Trasimeno Lake* with picture-perfect towns dotted along its shores. A perfect time to visit Borgo di Carpiano is in mid-May, when on the 15th the annual Festa dei Ceri is celebrated, one of the oldest Italian folklore displays, where the statue of Saint Ubaldo leads the procession carried by a team of Ceraioli clad in their local colours of yellow, blue or black. A magical day, which transports you back in time giving the same effect that Borgo di Carpiano offers each guest, a unique chance to leave today's hectic world and allow the peace and beauty of nature to soothe you.

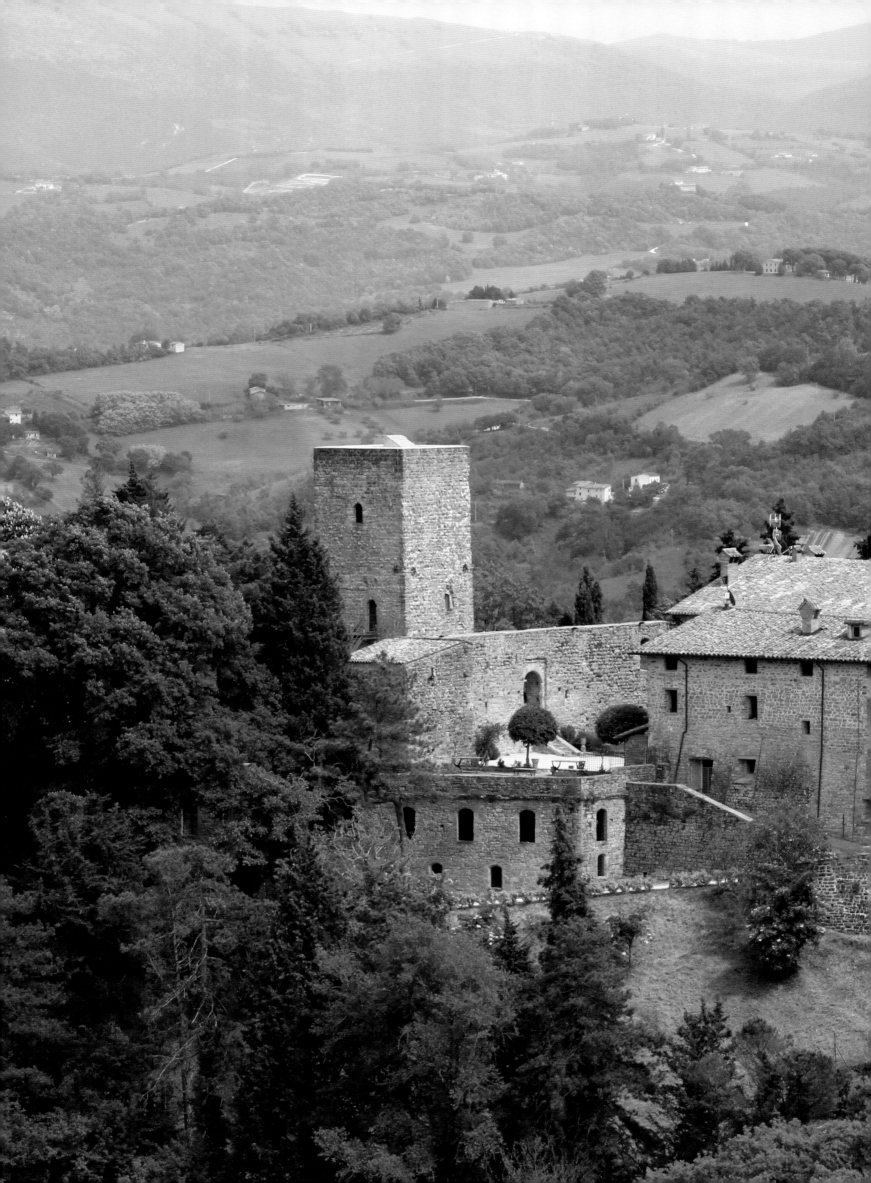

Just as magnificent are the spacious deluxe suites with whirlpool baths tucked beneath vaulted ceilings and pearl mosaic showers. Some even feature original four-poster beds and dark oak wooden beams, making this the perfect refuge for couples.

Equally astonishing is the Accomandugi Hall housed in the grand hall of the castle's restaurant with stone walls, timber roof and candles. The Chef, Andrea Laurenzi originally from *Umbria*, creates delicacies from the famed local products such as black truffle from nearby *Norcia*, lentils from *Colfiorito* and the home-grown fruit and vegetables from the castle's orchard. The superb and prestigious Chianina meat, one of the most ancient cattle breeds, is reared in the castle farm (over 700 acres of estate).

Breakfast is celebrated in the Guidubaldo Hall, once the setting for the private celebrations of the noble families living at the castle. A mouth-watering selection of Umbrian norcineria (cured meats), warm bread directly from the local bakery and homemade fig jam definitely makes this the most important meal of the day!

Castello di Petroia is the perfect starting point for plenty of activities that can be enjoyed within the estate. The overabundance of truffles on the estate, close to the oak and hazel trees, makes truffle hunting one of the most popular activities that guests can enjoy. Cesare, the castle farmer, and his adorable dog Stella will teach you all the secrets to find fresh truffles which are immediately brought to Chef Andrea who will create an amazing tagliatelle al tartufo. Swimming can also be enjoyed in the pool perched behind the castle and surrounded by roses, cypress trees and apple orchards. The Umbrian landscape can also be enjoyed in a more 'natural' way by going for a ride on one of the stunning Fresian horses or walking along the castle trails that lead to the 'Franciscan Path of Peace', which links the nearby towns of *Assisi* and *Gubbio*.

What makes Palazzo Seneca even more unique is its restaurant, Vespasia, recently awarded a coveted Michelin star. Chef Emanuele Mazzella and his team respect and appreciate the territory's ingredients and turn them into delicacies with admiration for the raw material and excellence at the heart of everything they serve. Interestingly, when guests open the menu the first word that stands out is 'love', which is the love for beauty, land, cuisine, where every dish that is created renews the pleasure of sitting at the table with loved ones. The excellent menu contains local ingredients such as the 'slow-cooked Cinturello suckling pig, cabbage, apples and hazelnuts' as well as the semifreddo truffle with Sibillini mountain hazelnuts, chocolate and bitter cocoa sauce that are a dream for all our senses. The restaurant itself is set in a dining room amongst candles and wooden furniture, and when the warmer weather steps in there is nothing better than sitting in the interior garden between the lemon trees, where the view of towers and the Sibillini mountains is enough to leave diners starstruck.

Umbria has always been the perfect region in which to relax and regenerate energy, and inside Palazzo Seneca there is the idyllic place to do just this. The wellness centre with its evocative and mystic atmosphere promises the perfect location in which to enjoy a relaxing massage or sip a herbal infusion. It is also equipped with a hydro-massage stone bathtub, Turkish bath and sauna, in a private room, which can welcome up to six people.

For the more adventurous guests, Palazzo Seneca offers a myriad of choices as daily activities. From cooking classes where all the local flavours and products can be turned into excellent dishes, to truffle hunting with an expert hunter and his dogs in the *Sibillini Mountains National Park*, to visiting a cheese factory and learning how to produce ricotta cheese. Palazzo Seneca also allows guests to be in real contact with nature, offering rafting in the nearby *Corno* river and skiing in the Sibillini mountains where the peaks are covered in abundant snow for eight months a year.

Palazzo Seneca is the perfect Umbrian home, and an ideal location to discover the most important destinations of *Umbria*, as well as the uttermost attentive service from the Bianconi family – an ideal holiday!

VENETO

Lovers inspiration: The Veneto region is enchanting, a region where it is possible to walk through history and discover the cities and hamlets, each with unique beauty. The romantic destination, retracing the footsteps of the greatest love story: Romeo & Juliet. An art history lesson in open air: this magical atmosphere enchanted Shakespeare too.

HOTEL VILLA CIPRIANI

'Asolo is a place where the Italian architecture, the landscape, the gardeners, the manufacturers and God are in total design agreement.'
Mary Quant, *My Autobiography*

Villa Cipriani, a noble countryside residence and *Asolo*, defined by the poet Giosuè Carducci as 'the city of the one hundred horizons', are undeniably tied by an incomparable beauty and fascination.

Villa Cipriani carries the name of one of the masters of the art of hòtellerie and hospitality; Giuseppe Cipriani, creator of the famous Venetian Harry's Bar. Indeed, in the 1960s Rupert Edward Guinness called upon Giuseppe Cipriani to help him transform Villa Cipriani from a simple locanda to a refined and precious jewel.

With a remarkable history and an unending list of celebrities, the walls of Villa Cipriani date back to the 16th century, and are just a few steps away from the historic city centre of *Asolo*. This city carries with it all the spirit that poet Robert Browning, one of the many famous owners of the villa, described as 'Asolando' (the title of one of his poems), which tells of the tranquil walking without precise destination through the paths and gardens of the city. Or, perhaps to use words more familiar to today's world, the ability to disconnect oneself from a busy lifestyle and be immerged in one of the one hundred horizons.

One of these horizons can certainly be found in the beautiful garden of Villa Cipriani, literally floating between the hills and nearby mountains that in spring, as Freya Stark described, 'take on a pale colour and become remote and intimate as a dream'. These very gardens are adorned with thousands of tulips in April, cascades of roses in May and vibrant colours in autumn. Here, a splendid panoramic pool affords guests yet another horizon, adorned with olive groves and cypress trees. The pool, open in the summertime, also allows guests to enjoy an enveloping Jacuzzi bath.

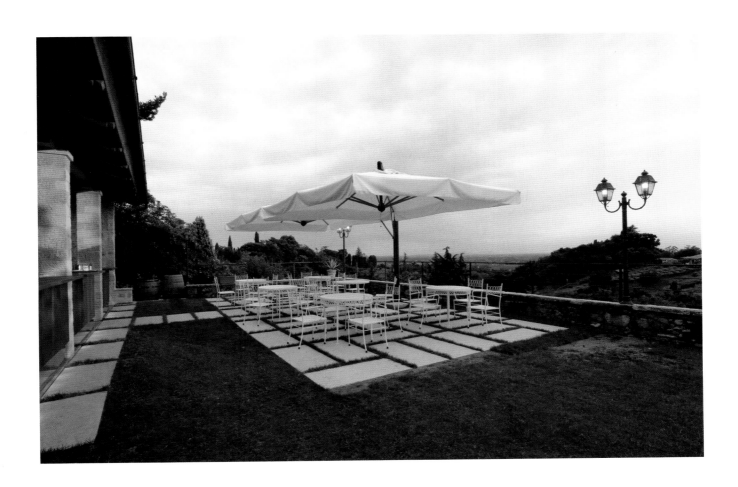

Villa Cipriani is divided between the Villa and Garden House buildings; thirty one rooms with furnishings taking inspiration from the noble villas of Venetians that were scattered in the surrounding countryside. Fine Italian artisanal touches, exposed wooden beams, luxurious marbles, fine terracotta, delicate watercolours and pastel colours are all in harmony with the soft colours of the *Asolo* hills. One cannot help but notice the gracious pavements in local terracotta from *Possagno* and the bright colours of the *Vietri* porcelain tiles.

Guests are invited to choose between rooms with striking terraces overlooking the valley and the nearby mountains, or overlooking the garden where you can steal a glimpse of delightful *via Canova*.

The restaurant, serving delicacies inspired by the traditions of the region, opens up to yet another spectacular horizon, the Italian-style garden, where one cannot miss an aperitivo on a warm summer evening. Speaking of drinks, incredibly, the bar is a perfect copy of the Harry's Bar of *Venice*.

A wellness space by Sphera completes the vision of this idyllic hotel, where oriental philosophy and special regional touches blend together in the Japanese garden. During the restoration of the villa a tunnel was found here, that legend says connected it to the magical castle of *Regina Cornaro*.

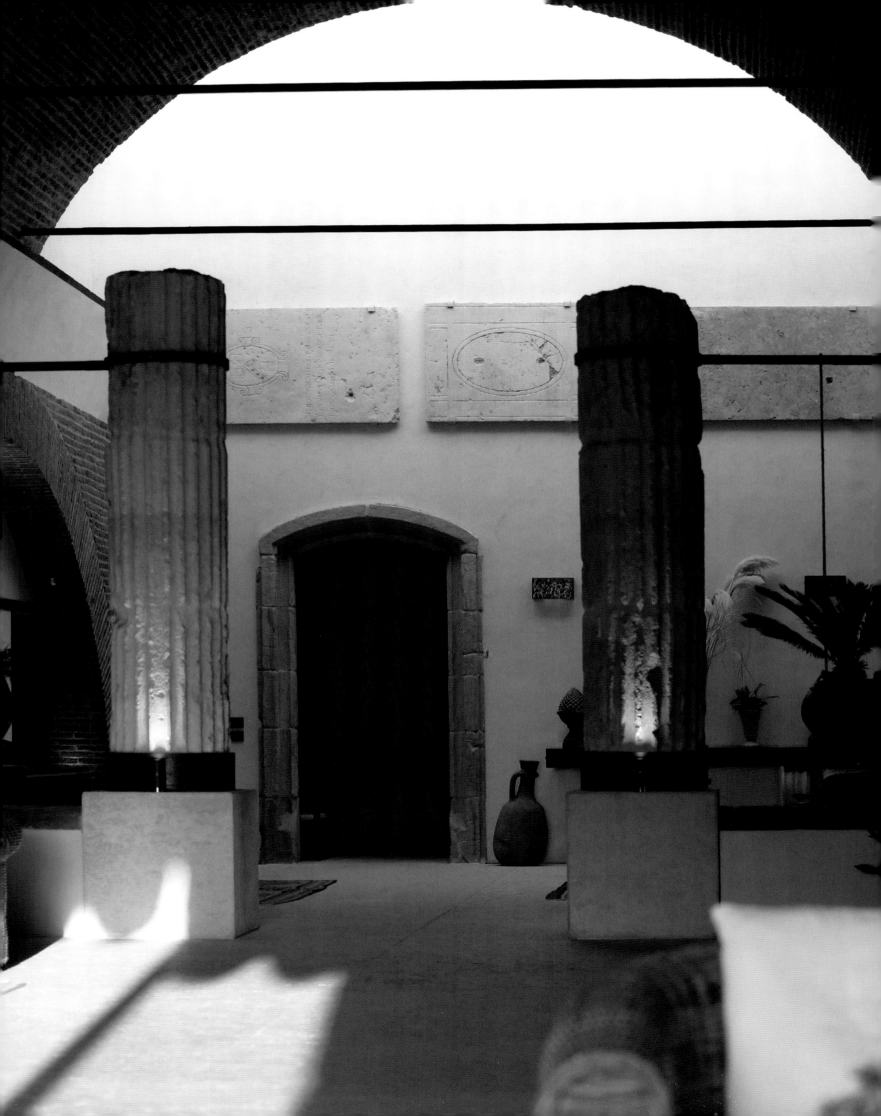

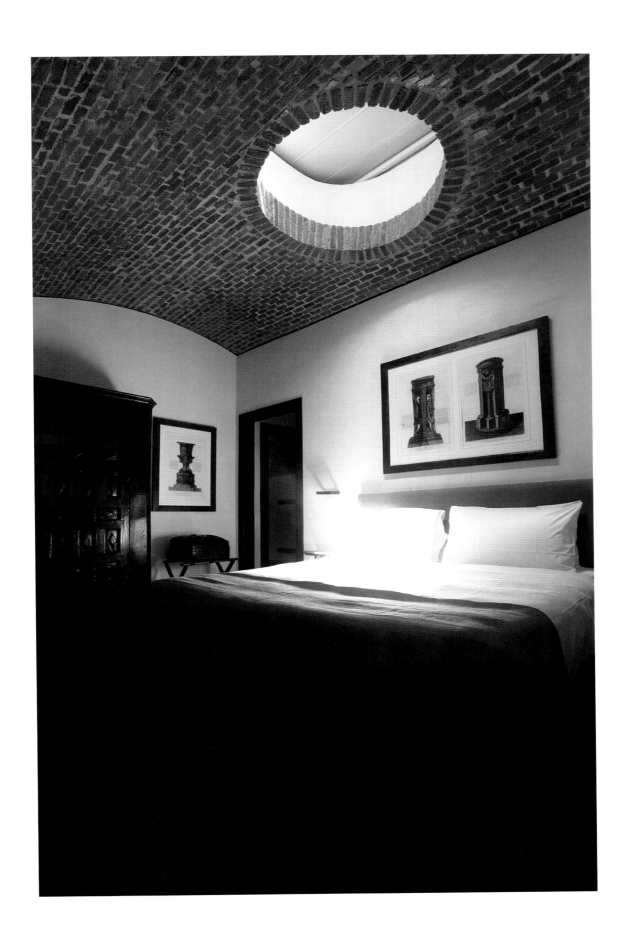

The motto of Alberto is ars convivendi, meaning the art of living together, which is the philosophy of the property with elegance, simplicity, sobriety and discretion. Ars hospitandi, another statement from Alberto, is the art of hospitality. Of knowing how to treat each guest individually, with large rooms and a warm atmosphere, traditional wooden floors, stucco ceilings, and original 16th century furniture.

There are only eight rooms, allowing guests to enjoy a particular intimacy and feel as if Delser is their own private home.

Breakfast is served in the magnificent garden, where one can breathe the heavenly air of this corner of *Veneto* on warm spring days.

Delser also offers ars bibendi, the joy of winetasting whilst chatting with fellow guests or perhaps meditating with the spectacular panorama of *Verona* opening up beneath your very feet. In fact, to make Delser even more distinctive, they are dedicated to producing their own wine and olive oil. Vineyards and olive groves, grown on these lands since Roman times, are looked after with the same philosophy and genuine respect for the environment that characterises this property.

Delser Manor House certainly offers an aesthetic experience which is unique to its genre; living *Verona* in a matchless dimension.

RELAIS VILLABELLA

'...white as fragrant lilies,... pure wine of regal colour and of special taste... the sweetness of this can be savoured with incredible soavità... the grapes chosen in autumn from the vineyards is gently laid ...and withers.'
Cassiodorus' Letter (485 AD – 580 AD)

Halfway between the beautiful cities of *Verona* and *Vicenza*, situated in the calm Veronese countryside, Relais Villabella takes its name from the small hamlet in which it is situated. It is located close to the spectacular Castello di Soave, one of the best-preserved medieval castles of the region elegantly perched on *Monte Tenda*, with its remarkable walls that cascade down the hill encountering the medieval town.

A noble country mansion, Relais Villabella exudes history, as do all the surrounding buildings of this historic and magical region. Built in the second half of the 15th century, Relais Villabella is the result of a passionate desire by its owner Ave Cherubin to expertly bring it back to life as a relaxing and elegant country refuge. Welcoming each guest and taking loving care of the hotel today is son Mario, who like his mother, has made it his mission to manage the property as his own home.

Leaving the busy main road, a small country lane leads to the vast garden that embraces the relais: a profusion of greenery and colours, peaking in May and June when the air is perfumed by roses, but with an undoubted splendour during every season; something that can only be guaranteed in the countryside.

A splendid swimming pool with Jacuzzi, floating in the greenery, promises moments of relaxation and sun. Guests are invited to enjoy this magnificent garden at all times during the day; at breakfast, during lunch or dinner, which is elegantly served around the pool, guaranteeing a magical dining experience under the stars.

The interiors are nothing less impressive, giving guests the feeling of having walked into a noble country mansion. Indeed, the twelve rooms are unique; different colour palettes for each, but the same thread weaving through that is evident in the refined and elegant choice of materials, marbles, Venetian Murano lamps and mythological-themed prints.

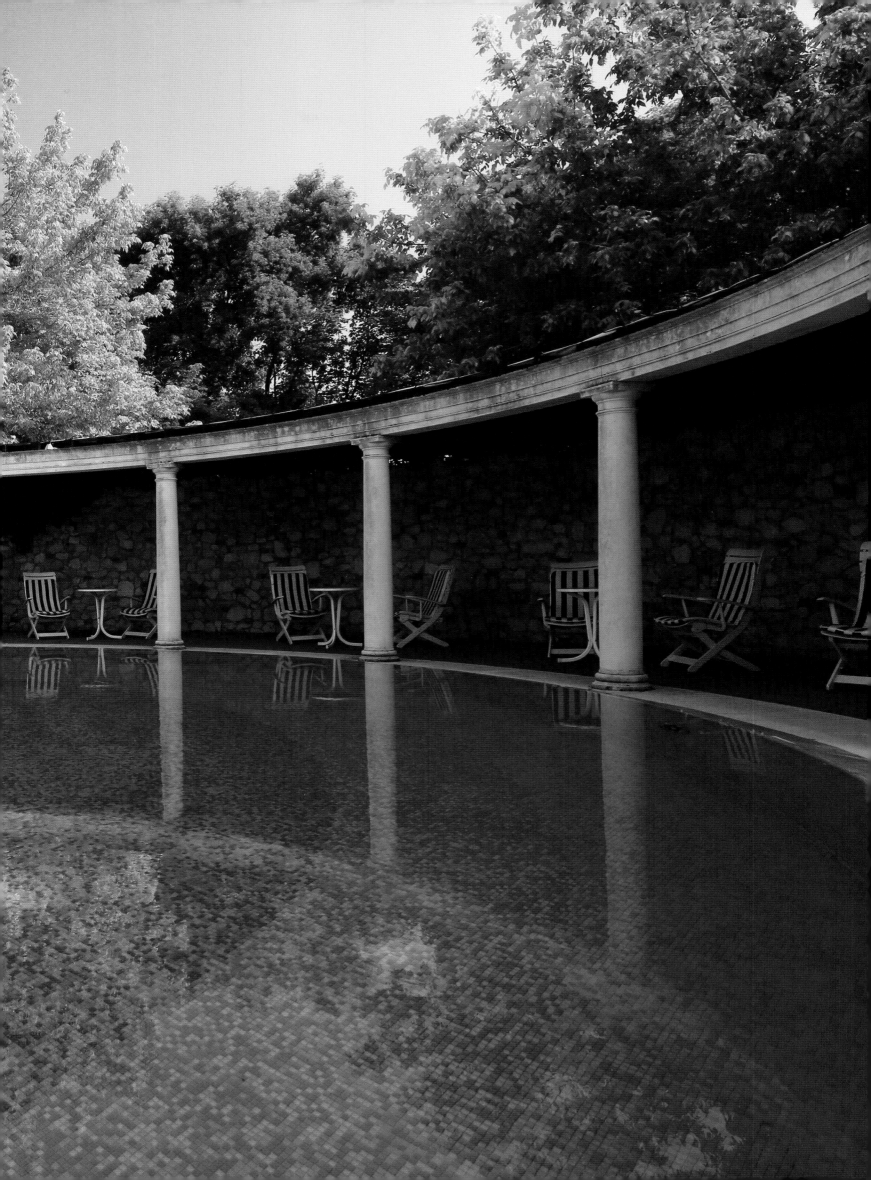

The four Romantic suites are incredibly charming and an ideal choice for cold winter nights as each is furnished with an open fire.

Yet another grandiose area of the relais is the dining room, filled with light and aromas from the garden, which it majestically faces, and where once again the impeccable and researched interior design of Ave Cherubin can be noted. To make evenings even more unforgettable, dinners are accompanied by a live pianoforte. The restaurant has recently acquired a young and talented chef, Davide di Rocco, and his creations have brought traditional *Veneto* cuisine to a new dimension. A lunch or dinner at the restaurant is a must, perhaps after a walk around the medieval town of Soave, and a trek around the vineyards of this part of the Veronese countryside, where the famous Soave wine was born. Interestingly it is not known whether the wine gave its name to the town, or the town to the wine. Legend recounts that Dante Alighieri spent the night at the castle, and on this occasion gave the name *Soave* to the town, because of its delicious, sweet and fragrant wine.

Returning to the relais, as well as by the pool or in the main dining room, dinners can be served in a small private, candlelit dining room adorned with an elegant fireplace, and what better way to conclude the evening than with a cocktail at the piano bar Club Villabella. Indeed, the club has been recently renovated, and is positioned on two floors, with a private room for parties and an elegant balcony over the dancefloor. Different musicians alternate each evening to entertain guests.

If you are in the mood to relax, Relais Villabella is connected to the nearby Wellness Club, a spa where massages and beauty treatments can be enjoyed. History, music, art, gourmet dining, fine wine and wellness; what better place to spend a romantic holiday?

The Gentleman of Verona is not only a hotel, but a residence where guests are invited to enjoy the interiors and the art, and as each piece can be bought, guests can take home with them something containing the feeling of love and passion that only a city like *Verona* can provide, and a piece of atmosphere that only this Grand Relais can provide; certainly an original souvenir!

To continue on the art route, the meeting room of the hotel often invites young and promising artists to display their works of art, or singers to entertain guests during aperitivo time.

After a long day of sightseeing and shopping, one can feel pampered at the bar and enjoy an excellent glass of wine, of which this corner of *Veneto* is rich, from the hotel's well-equipped winery. Or, why not enjoy a refined dinner in the Salotto bistro that offers traditional delicacies with a modern twist, revisited by the expert chef.

For the perfect gentleman, a cigar after dinner cannot be missed in the Cigar Room, unique in its style, with a large selection of prestigious national and international brands.

For the ladies of the manor, this hotel offers the most complete and modern treatments in the Blue Spa of Verona, that can even be reserved for exclusive use.

The bar, restaurant and Blue Spa are also open to non-residents of the hotel, so if *Verona* happens to be your local city, now you too can be pampered by the superb services of this astonishing hotel.

'I am easily satisfied with the very best', is a famous quote by Winston Churchill that fits perfectly when looking for words to describe this jewel of hospitality. Their guarantee: at Gentleman of Verona you enter as a guest, and you leave as a friend.

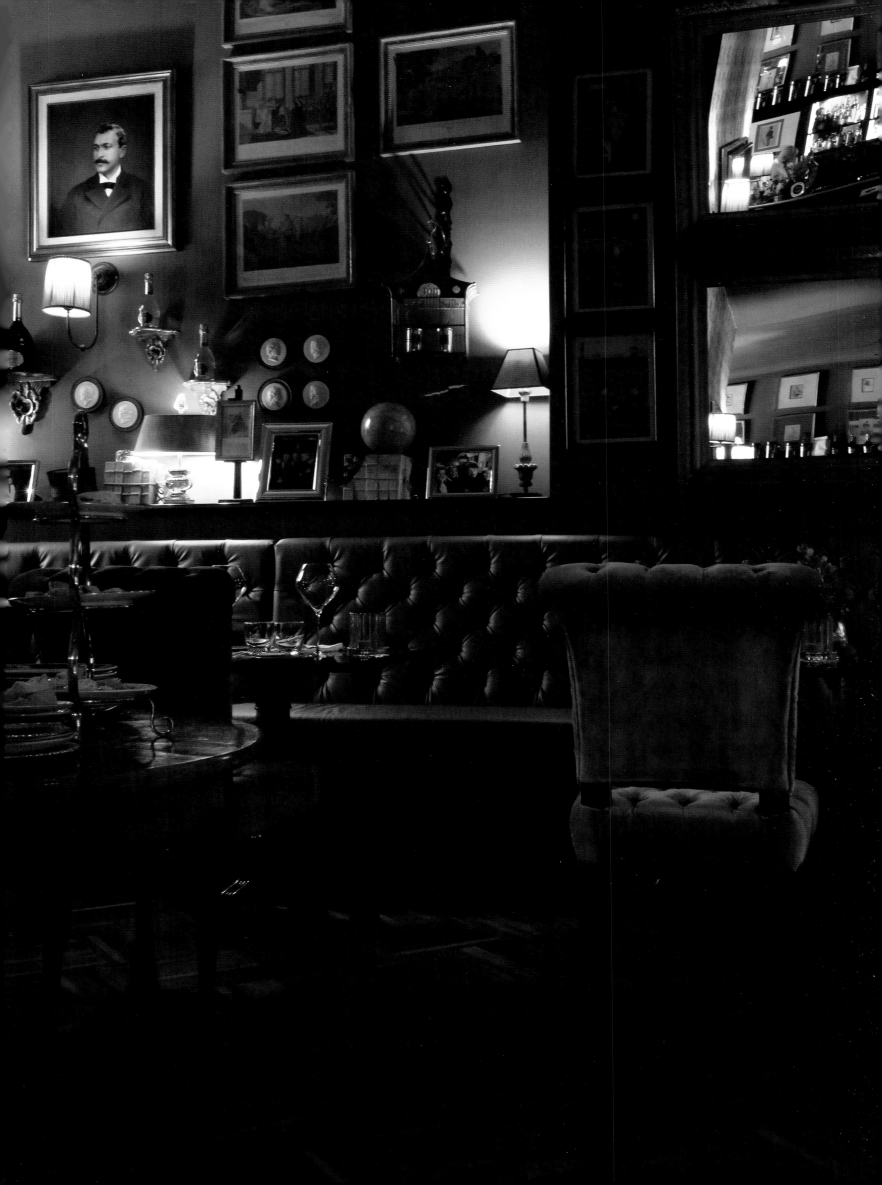

VENICE

Enchantment inspiration: Venice is enchantment and fascination together, a unique city magically floating on the water; it's beauty reflecting the aristocratic colours of the lagoon. Regal luxury infused with contemporary art, gondolas blending with water taxis, history permeating each corner... this is the world's most unique city.

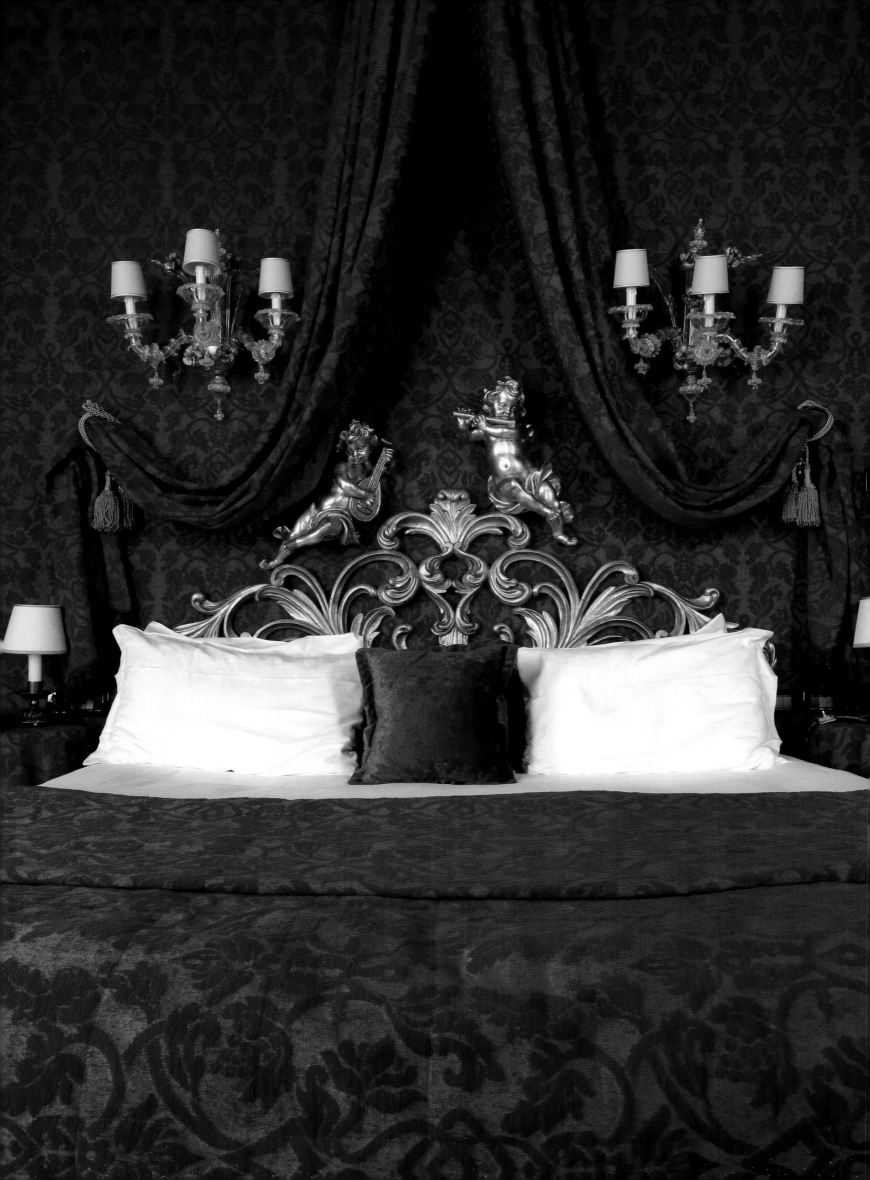

CA MARIA ADELE

'Venice is like eating an entire box of liquor chocolates in one go.'
Truman Capote

When exploring the calle and campi of *Venice*, a hotel can be found on every corner, from the most modern to the ones that take you back to the magnificent carnival balls of Casanova. Yet none can boast the atmosphere of Ca Maria Adele. Located literally besides one of the grandest basilica *Santa Maria della Salute*, built as a votive offering for the city's deliverance from the plague, its beauty has inspired the likes of Canaletto, Turner, John Singer Sargent and Francesco Guardi. Indeed, Ca Maria Adele enjoys a prime position in one of *Venice's* most residential, charming and tranquil districts, *Dorsoduro*, just minutes away from *Piazza San Marco* and from the appealing *Guggenheim* collection.

Arrival at the hotel can be organised by private taxi, crossing the *Grand Canal* and entering the hotel directly from the water as the canal leads straight to the reception. Ca Maria Adele is located inside a typical, imposing palazzo from 1700, which has been majestically renovated by brothers Alessio and Nicola Campa. Their style knows no parallel, being able to blend contemporary pieces with typical Venetian grandeur and, in so doing, they create an incredibly romantic and completely decadent setting.

Upon entering, the resplendent gold marble and dark African wood of the reception hits you. This leads to the cosy living room with open fire, ponyskin sofas, wooden boat sculptures and glamorous, feathered lights. This is the perfect room, canal side, to enjoy the most delicious breakfast, which is ordered the evening before from a never-ending menu of delicacies: an assortment of eggs, delicious juices and homemade pancakes with gianduia cream.

The hotel has twelve rooms, with five unforgettable, exquisitely designed themed rooms. The grand and luxurious Doge's Room with its imposing Murano chandelier, velvet blood-red chairs, lavish golden furniture and regal wallpaper, that resonates with the glorious era of the Venetian Empire, is the city's best kept Royal secret. The sensuous and intimate Sala Noire with its shiny black Murano chandelier, maroon wallpaper and gold armchairs, inspiring mystery and audacity, sets a highly dramatic scene and makes the perfect room for a romantic weekend. Then there is the Oriental Room with its antique Chinese wardrobe, decorative original Chinese vases and scattered Buddhas inspiring meditation and harmony. Similarly, the Moorish Room, with its sapphire blue and white furnishings and its statement Moor lamps, is a place where you can fall asleep with the water lapping gently under the windows. Lastly, there are the two suites, refined in their design with typical damask wallpaper and a terrace with an unforgettable view of the city.

The charming terrace, inspired by the Far East as well as Morocco with antique coloured lamps and wooden windows decorating the space is adorable. It is the perfect area to enjoy a glass of prosecco from the honesty bar, while watching the San Marco flag dancing in the wind. Or while listening to the soft murmur of classical music that permeates the whole of Ca Maria Adele as you read a good book. There is nothing more magical. This hotel is the new definition of Venetian hospitality, in a glamorous and decadent setting, just like the city itself.

CHARMING HOUSE
DD724

'…and at night they sang in the gondolas, and in the barche with lanterns, the prows rose silver on silver, taking light in the darkness.'
Ezra Pound

Charming is certainly the word that best suits this house, which has been transformed into a small treasure trove of design. The curious choice of letters and numbers that forms part of the name is the acronym of the address, refering to the the *Dorsoduro* district and the door number 724. In *Venice* there is a unique numbering system for each of its six sestieri (districts), a system that has existed since the origins of this magical city.

Charming House DD724 is located in one of the most beautiful and lively *sestieri* of the city. *Dorsoduro*, so called because in the past it was an area completely covered by compact sand dunes, and therefore the terrain was a dorso duro (hard back).

DD724 faces the enchanted *Rio Torreselle*, just a few steps away from the beating heart of the Venetian art district: from the *Peggy Guggenheim Collection* inside *Palazzo Venier dei Leoni* facing the *Grand Canal*, to the *Gallerie dell'Accademia* with its astonishing Veneto paintings, to the *Rinascimento*, and the *Museo d'Arte Contemporanea* in *Punta Dogana*. In Dorsoduro the *Squero San Travaso* can be found, one of the last places where visitors can admire how a gondola is built, and the *Scuola Grande dei Carmini* with its paintings by Tiepolo.

Walking along Dorsoduro leads visitors to walk 'a bocca aperta' (a typical Italian expression meaning to walk in awe), where palazzi such as *Ca' Rezzonico* appear as if emerging from the *Grand Canal*, with its magnificent rooms frescoed by Tiepolo and scenes from 18th century *Venice*. The extraordinary beauty that is *Santa Maria della Salute* also lies within reach.

It is clear why 'art, poetry and light' is the perfect motto for this boutique hotel, with its interiors patiently designed like that of an haute couture gown. The take on hospitality here is that of creating a relaxing haven, with the same privacy of a private home. It is the perfect place for an inquisitive guest who is constantly searching for new spaces and alternative ideas, where style dominates when organising their city break.

EGGY GGENHE
COLLECTION
LOMON R. GUGGENHEIM

The six ultra-chic rooms are designed with contemporary furnishings, and guests can choose between rooms with adorable terraces on which to enjoy breakfast, or the popular rooms with views onto the *Canale della Giudecca*. The sunrays entering the vast windows in the morning create a delicate atmosphere, where technology and modern design blend perfectly. On the walls, artworks by contemporary Italian artists take pride of place.

As should be the case with every welcoming home, novels, travel books and art journals are available for all guests to enjoy in the evenings after a long stroll through the calle of *Venice*. The lounge is where breakfast, full of local delicacies, is served each morning; the perfect way to start a day before exploring the many museums and galleries.

The philosophy of Charming House DD724 is to ensure each guest feels as if they are at home, in a building perfectly located between the calle of *Venice*, where it can feel glorious to get lost and find hidden bacari (local bars) and traditional osterie (restaurants). And where between a cicchetto (small bite) and a spritz, one can meet with friends and recount the adventures of the day.

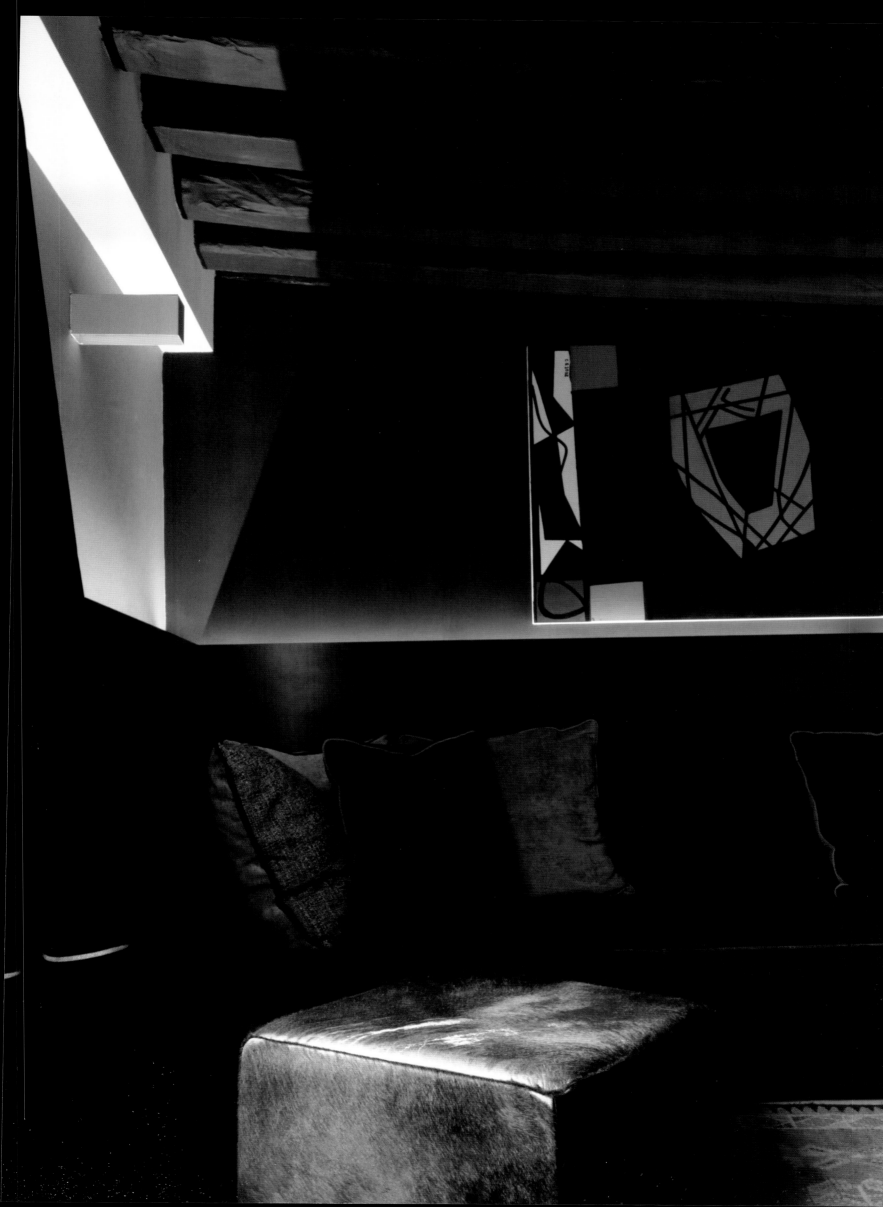

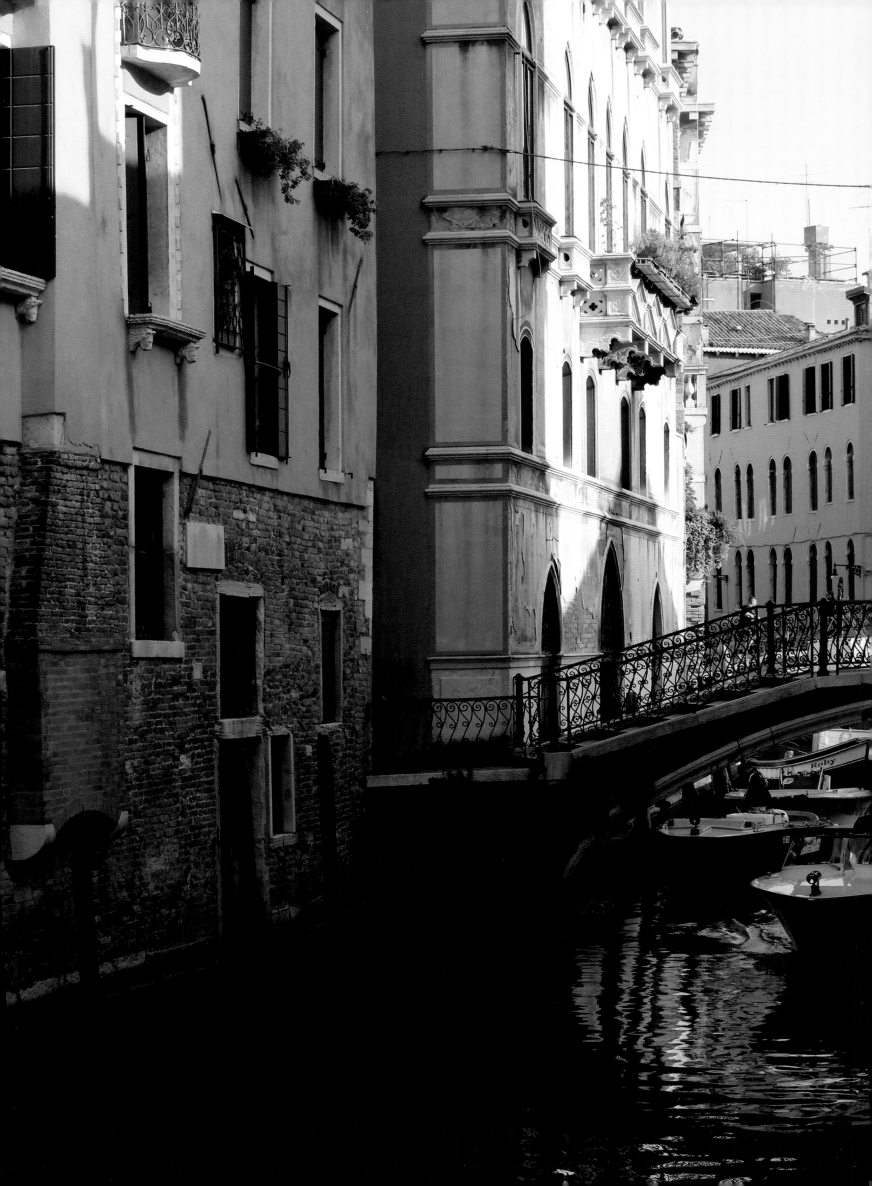

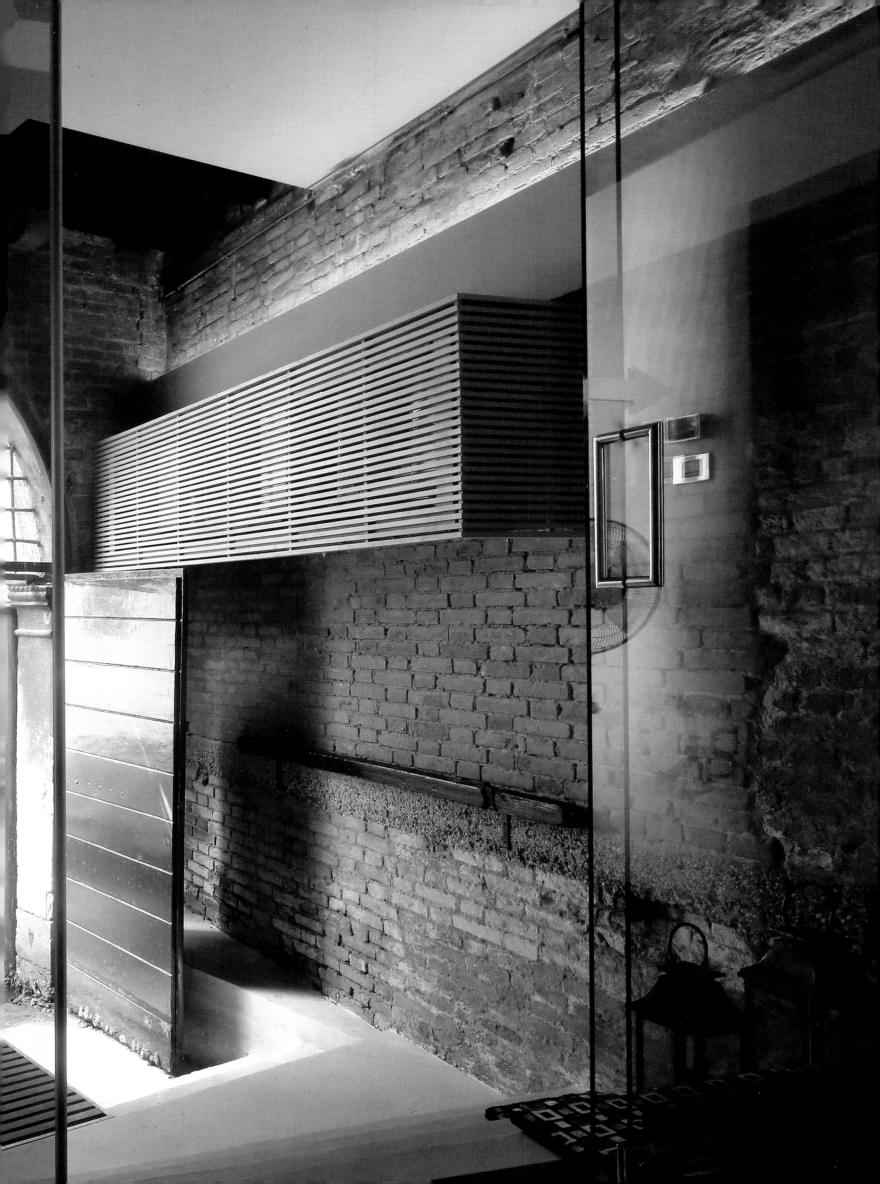

The owner, Chiara Bocchini, assigned her ideas of a 'contemporary stay' in this 'Eternal City' to renowned architect, Mauro Mazzolini. The result is warm minimalism, strong colours, bricks and touches of vivid red. The view from all the apartments is that of the most important element of this city: water. Indeed, all face the typical canals with the passing by of gondolas and boats, as well as the quintessential internal Venetian courtyard with its mascaron wellhead and 15th century wooden ceiling porch.

Materials, textures and furniture have been chosen with great care, and blended with works of art by famous Italian artists. Even the lights are in harmony with the Venetian atmosphere; pleasing and sensual.

Being a guest at iQs is enough to guarantee an unforgettable stay in this unforgettable city. But to make each stay even more idyllic, Chiara and her team are always on hand to ensure guests live the alternative aspects of *Venice*, perhaps by visiting the Murano glass furnaces, enjoying a gondola tour, or a dinner of traditional Venetian cuisine in an osteria. When you return to iQs after a day of sightseeing, you will no doubt think, 'yes we have really fallen in love with *Venice*'.

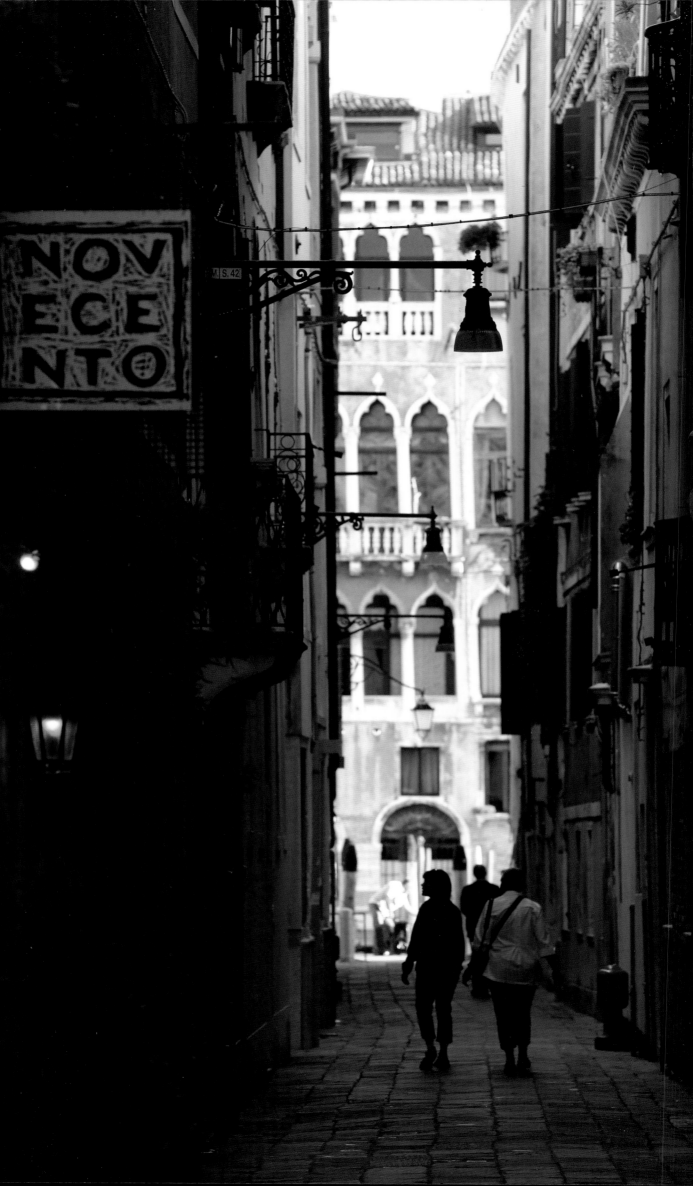

NOVECENTO
BOUTIQUE HOTEL

'I stood in Venice, on the Bridge of Sighs; A palace and a prison on each hand; I saw from out the wave of her structure's rise As from the stroke of the enchanter's wand: A thousand years their cloudy wings expand Around me, and a dying Glory smiles O'er the far times, when many a subject land Look'd to the winged Lion's marble pines, Where Venice sat in state, throned on her hundred isles.'
Lord Byron, *Childe Harold (canto IV, st. 1)*

Venice: the jewel city of Italy, the most unique city in the world, with its labyrinth of canals and crowned by the majestic *Piazza San Marco*. A city famous for its grand hotels and luxurious palaces that appear as if emerging from the waters. In this 'Eternal City', a distinctive boutique hotel full of charm can be found, where family is at the centre of its very being.

The Romanelli family have worked in the hospitality business for half a century, dating back to the 60s with Hotel Flora, a small fifteen-room pensione (guesthouse) that they lovingly and passionately transformed into the charming, larger hotel that it is today, with renowned excellence in service and a loyal clientele.

After that success, Ruggero Romanelli with his son Gioele let their imagination run free and opened Novecento Boutique Hotel.

What immediately strikes about this nine-room, boutique hotel is the personal touch that is present. The hotel is run by Gioele and his wife Heiby, who are always on hand to provide impeccable service and to give tips in order to see the city as 'real Venetians'; suggesting alternative itineraries to discover the hidden gems of the city.

While the building was undergoing its lengthy renovation, months were spent seeking out the furnishings, fabrics and objects that give Novecento its impeccable style.

The hotel captures its main inspiration and indeed its name from the Fortuny Style founded by Mariano Fortuny, of the early 20th century, a multi-talented artist, based in *Venice*, with expertise in painting, fashion and scenography to name but a few. His chameleonic talent was being able to experiment in all areas of art, and his pleated gowns and velvet creations were long admired even by Parisian high society.

These very silk gowns and velvet creations inspired Novecento's bohemian style, with each room featuring richly coloured silks and tapestries and unusual bedside lamps collected during the family's travels to Morocco and the Far East.

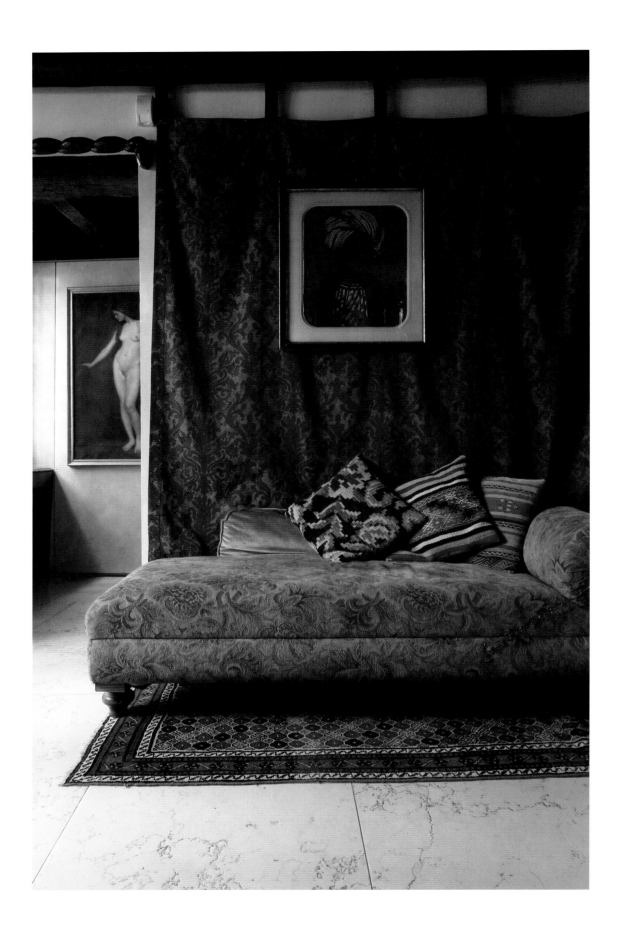

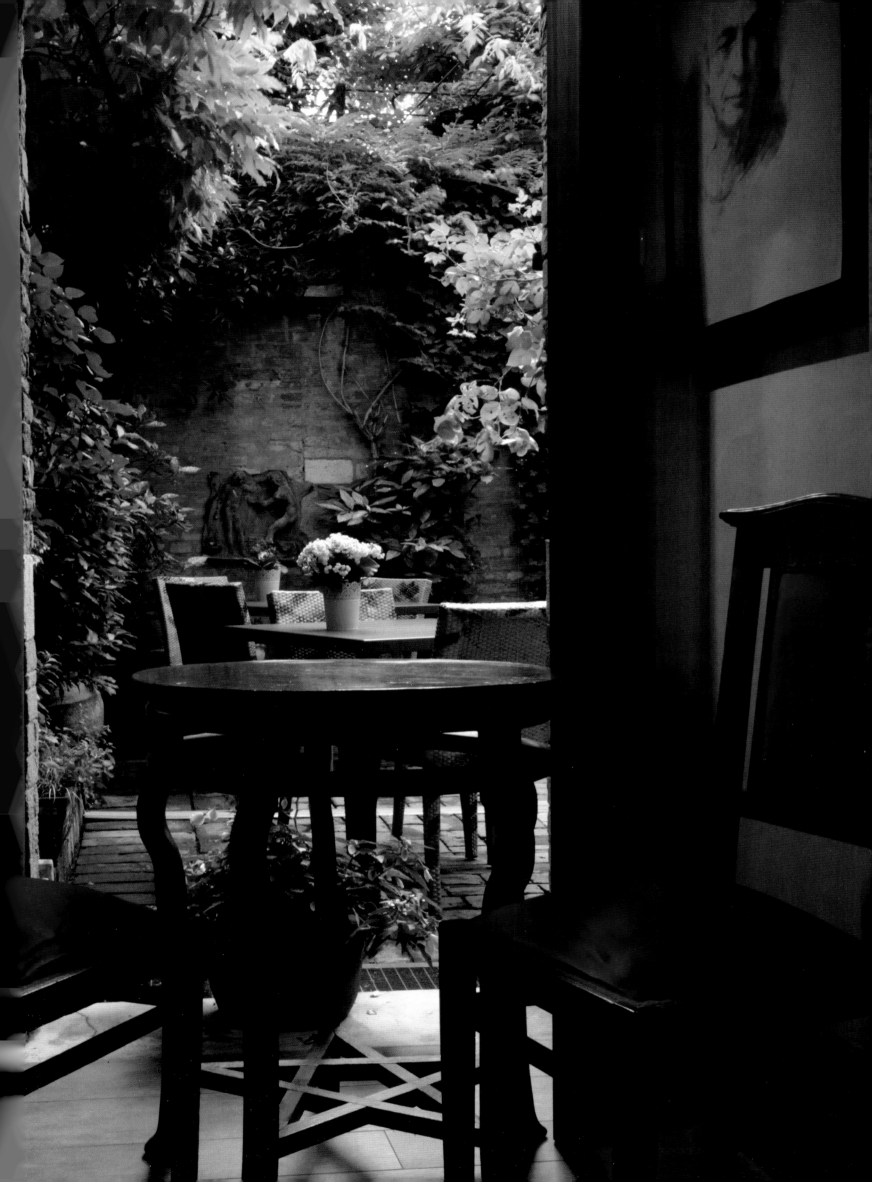

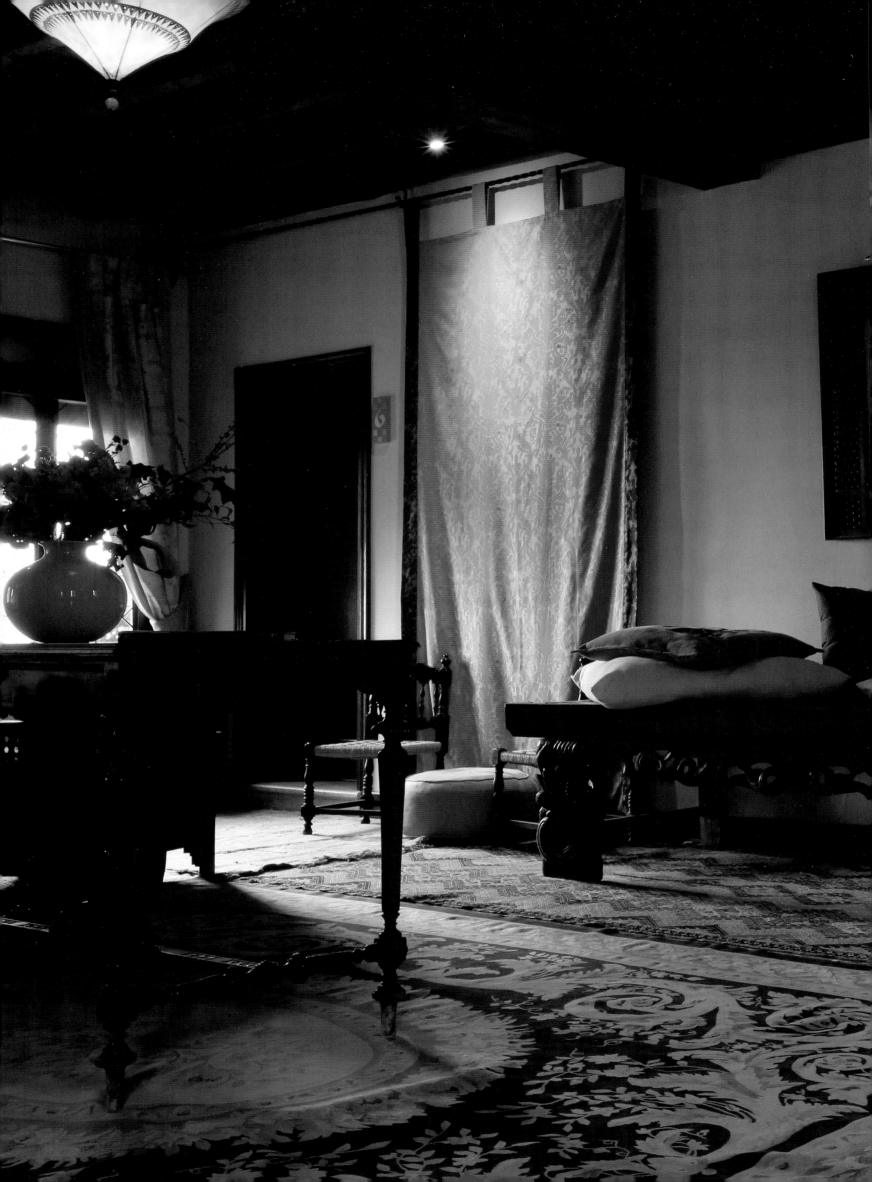

Tinged with history, the relationship that the *Serenissima Repubblica di Venezia* (the Republic of *Venice*) has always had with the Orient comes to mind when staying at Novecento. It was indeed a Venetian, Marco Polo, who became the first traveller to venture to China in 1261, arriving in present day Beijing, and opening the Silk Road, where Venetians prized the Chinese silks and spices from the Orient.

The powerful Oriental influence and eclectic décor blends harmoniously with the 20th century furnishings, creating an innovative and fresh hotel in such an iconic and magical city.

Creativity and art are at the heart of all Ruggero and Gioele strive for, and a series of art exhibitions alternate at the hotel, making each stay at the hotel even more exceptional. Indeed, every month, local and international artists display their artworks throughout the hotel.

Waking up at Novecento is an experience you will want to have every day, with homemade delicacies sourced directly from the local market served in the charming and secluded internal courtyard.

As with every family home, the reading room equipped with international newspapers and books is the perfect place to unwind after a long day of sightseeing on the nearby islands of *Murano*, famous for its unique glass, or *Burano*, the celebrated colourful island of lace. A sweet treat of pastries and biscuits served with the best Italian coffee is always available. Or, in the late evenings, the perfect after-dinner ritual is to meet with fellow guests and enjoy a glass of grappa from the honesty bar.

The location is perfect in its own right, tucked in a little calle just off *Piazza San Marco*, away from the crowds and bustle of the main sights.

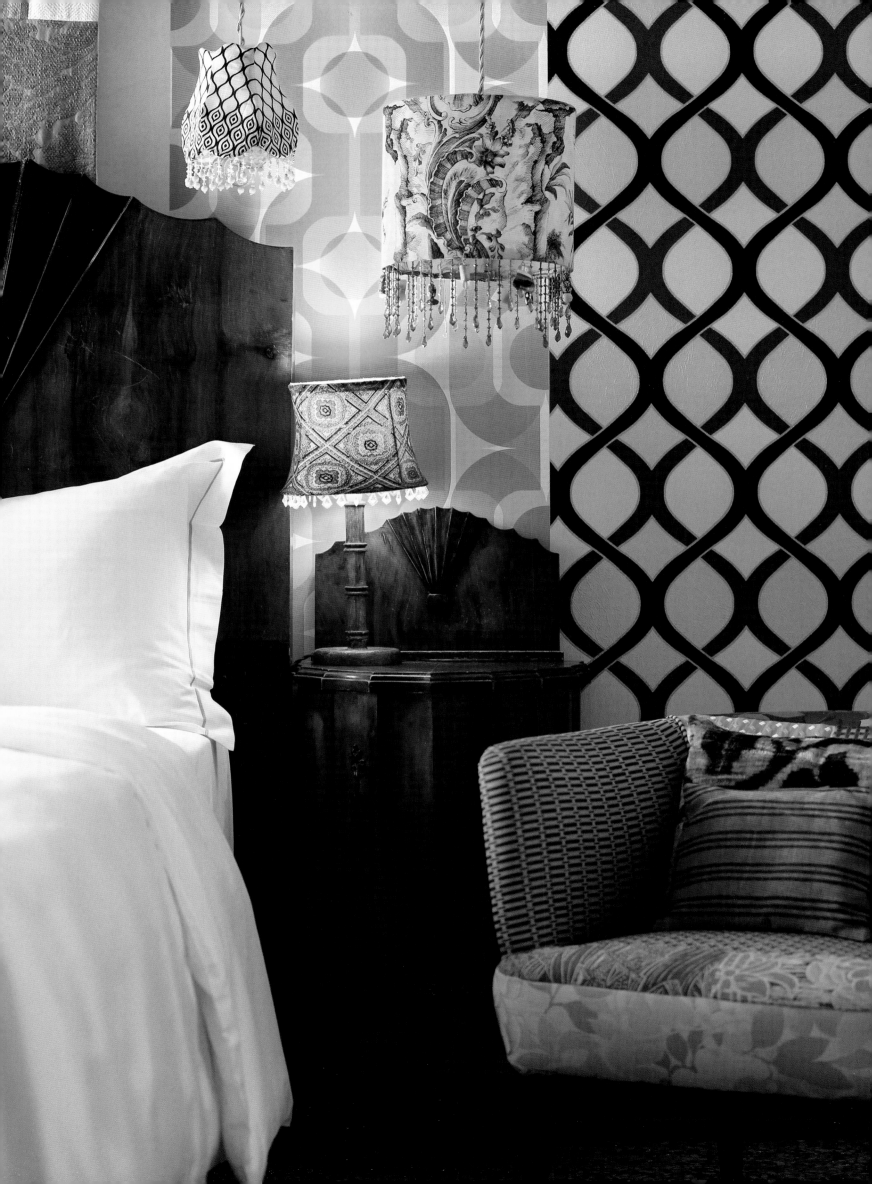

PALAZZINA G

*'...since I was young I've always been "somewhere": lost in my dreams, in projects. I've spent my
existence as a ghost. Like smog, like a spray, like a cloud. I've never tasted every day life...'*
Philippe Starck

Mix together the innovation, enthusiasm, entrepreneurship and irrevocable passion for *Venice* of the late Emanuele Garosci, with the creative geniality of Philippe Starck, and a sprinkle of the unique charm of this marvellous city and the result is astonishing: Palazzina G.

This is the first hotel to be designed by the famed French designer in Italy, who played with the architectural schemes and traditions of a noble Venetian palace. It faces the most iconic view: the *Grand Canal*. Staying in *Venice* leaves visitors in a whirlwind of emotions, and these emotions will be even more heightened when staying at this hotel, which unsurprisingly has won the most coveted awards for design.

2,800 square metres distributed between two historic palaces that have been joined to form one exceptional hotel, one from the 16th century and the other from the 19th century, create a unique selection of sixteen rooms and six apartment-suites. The figures for this hotel are astounding: 4,000 antique Venetian bricks gathered from an ancient, demolished farmhouse brought to new life in order to cover some of the internal walls on the ground floor of the hotel; 289 lighted mirrors handmade especially for Palazzina G that can be found in the rooms and lobby giving a dreamy aspect to the hotel; nine unique pieces made in Murano glass by renowned artist Aristide Najea; two jewelled monolith tables measuring more than seven metres decorating the lobby and the restaurant majestically. The list of incredible features is infinite... each detail, each corner, each single centimetre of this hotel continues to provide guests with new emotions; occupying each of our senses in a unique aesthetic journey inimitable in its genre.

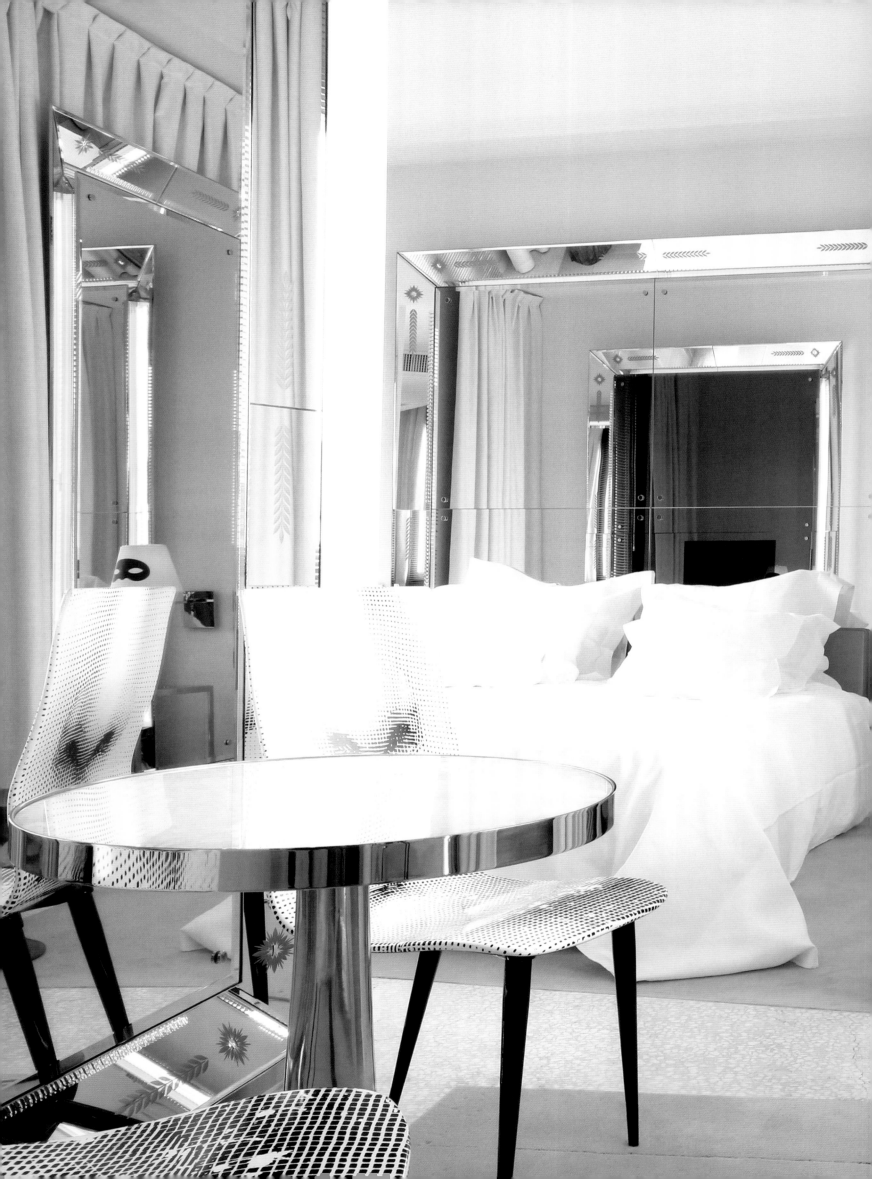

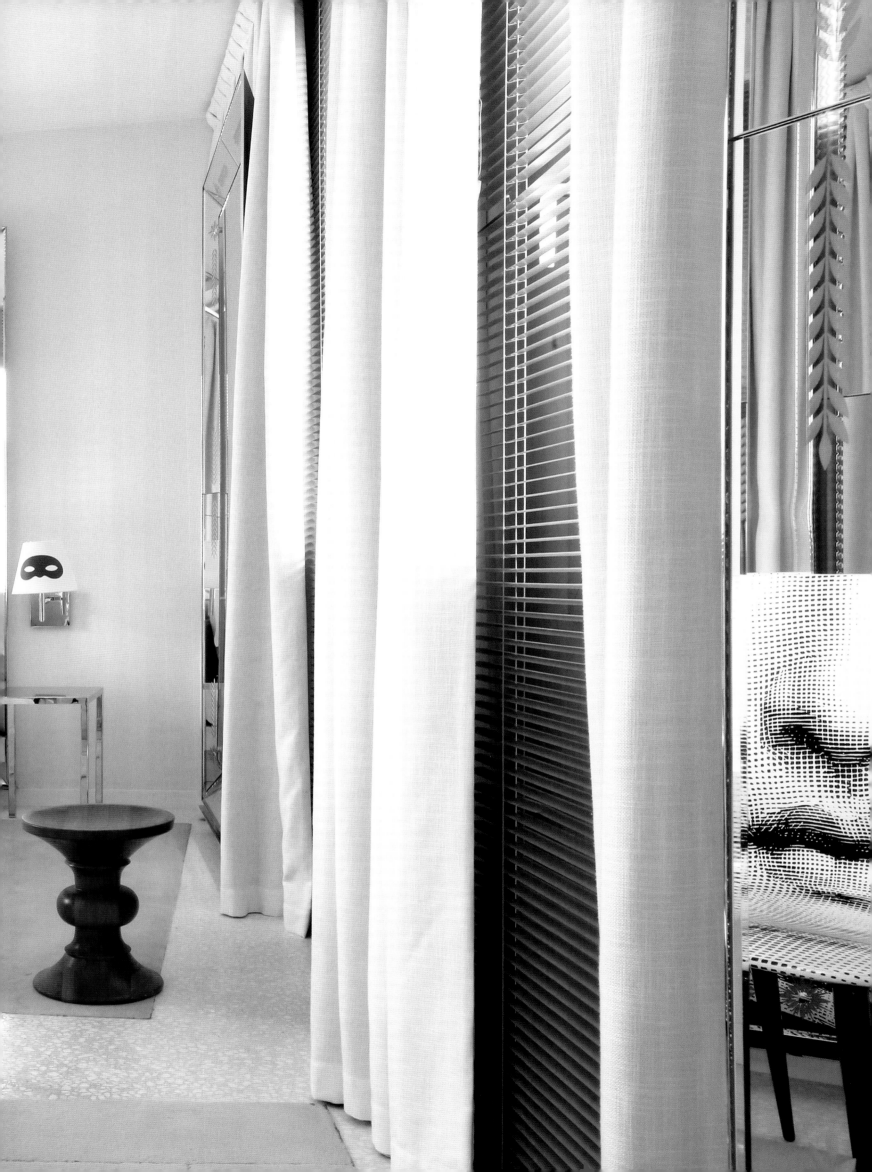

The philosophy that permeates Palazzina G is that a guest should feel temporarily Venetian. Arriving by boat to an unmarked door, it's as if each guest is entering his own private Venetian palace, where mirrors, glass sculptures and vintage objects lead guests to another dimension: this is a different *Venice*, a new *Venice*, a pleasing *Venice*.

The rooms all have a warm atmosphere, with unbeatable views of the Venetian palazzi rooftops. Dark woods and soft lights reflecting magically on the Murano mirrors guarantee a surreal experience. In the apartment-suites light is again a key player, where even the wardrobes are built in transparent glass.

Another sublimation of the philosophy of Palazzina G and its continuous research for excellence in interiors, hospitality, and inspirational choice of local products and traditions can be found in the restaurant PGs Restaurant in *Venice*. The show kitchen guarantees guests a unique gastronomic experience, in a completely Venetian setting guided by Chef Matteo Panfilio, who transports guests on a voyage through local food markets and bacari rionali (regional osterias).

In the 16ᵗʰ century wing of Palazzina G, facing the *Grand Canal*, and accessible directly from the water or from a small, side calle lies another precious gem of this extraordinary hotel: the Krug Terrace, an exclusive lounge of the prestigious maison de champagne Krug. This is an exceptional lounge, and the perfect place to sit and admire the passing by of Venetian life; whether for an aperitif, dinner or an after-dinner drink. It makes a magical setting under the stars in this dreamlike, ethereal city.

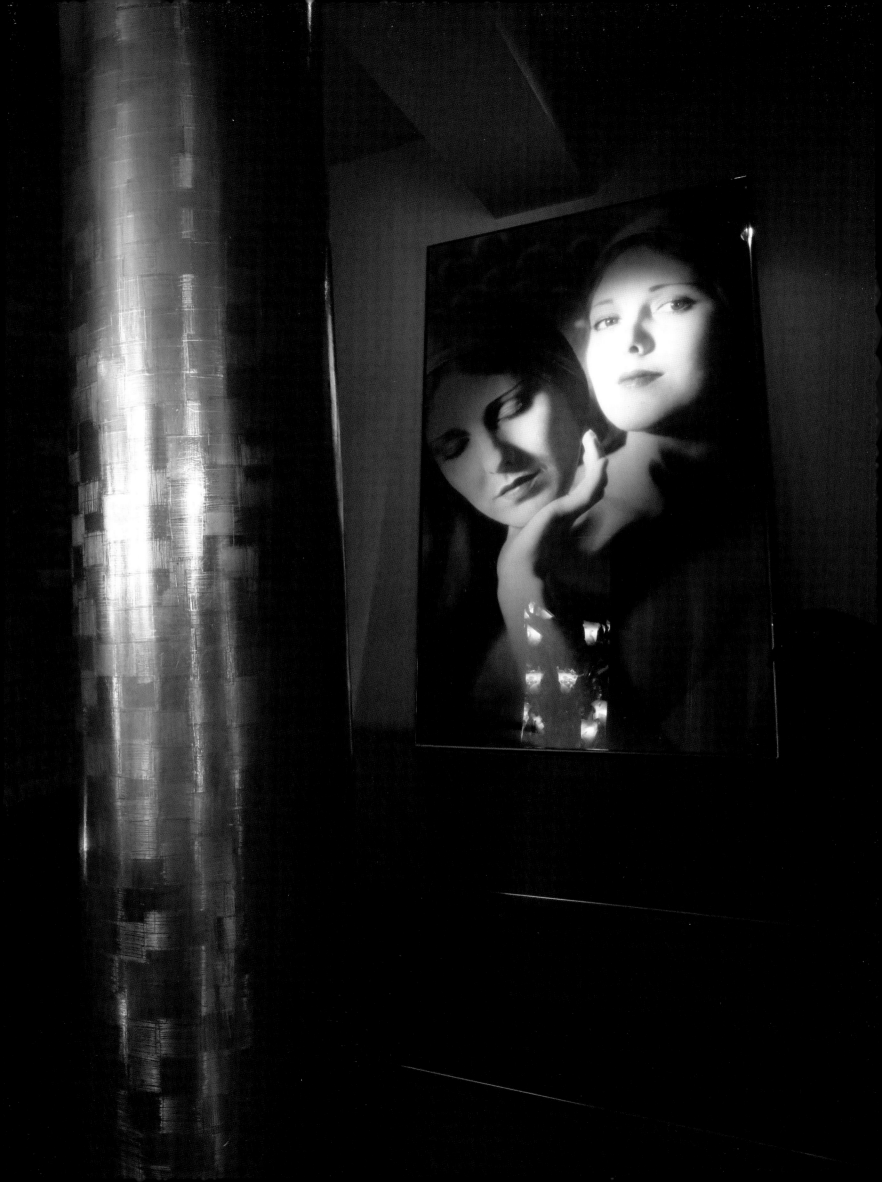

PICTURE CREDITS